THE ENGLISH PARK

Royal, Private & Public

Also by Susan Lasdun

VICTORIANS AT HOME
MAKING VICTORIANS:
The Drummond Children's World 1827–1832

THE ENGLISH PARK

Royal, Private & Public

SUSAN LASDUN

THE VENDOME PRESS

For my brother

Published in the USA in 1992 by
The Vendome Press, 515 Madison Avenue, New York,
NY 10022

Distributed in the USA and Canada by
Rizzoli International Publications
300 Park Avenue South, New York, NY 10010

First published in 1991 by
Andre Deutsch Limited
105-106 Great Russell Street
London WC1B 3LJ

Library of Congress Cataloging-in-Publication Data
Lasdun, Susan.
The English park ; royal, private & public/Susan Lasdun.
p. cm.
Includes bibliographical references and index.
ISBN 0 – 86565 – 131-0
1. Parks-England. I. Title.
SB484, G7L37 1992
712'.5'0941-dc20 92-3624
 CIP

Printed in Singapore
by Craftprint

CONTENTS

List of illustrations

Foreword

1	ANCIENT ORIGINS	*1*
2	THE MEDIEVAL PARK	*5*
3	THE COUNTRY HOUSE PARK: *Sixteenth-Century Beginnings*	*21*
4	RISE AND DECLINE: *The Park from James I to the Commonwealth*	*39*
5	THE RESTORATION: *A Return to Park-Making*	*57*
6	THE LANDSCAPE PARK: *From Bridgeman to Brown*	*77*
7	PAVILIONS FOR PLEASURE: *Park Buildings*	*105*
8	*RUS IN URBE: The Royal Parks of London*	*119*
9	THE PUBLIC WALKS DEBATE: *Or Parks for the People*	*135*
10	PARK MANIA	*157*
11	ARCADIAS FOR ALL	*167*
12	PARKS UNDER THREAT	*187*
	Notes	*204*
	Index	*214*

ACKNOWLEDGEMENTS

I have had so much help and information, kindness and advice, hospitality and encouragement, from so many people during the research and writing of this book, that I am quite unable to thank each person individually. I hope they will understand and forgive me for not mentioning all of them by name. I am particularly indebted to a number of directors, keepers, curators and staff of record offices, art galleries, auction houses, the National Trust, English Heritage and museums and libraries. In respect of the latter, I can only say that I could not have written the book without the London Library. I also wish to express my gratitude to those who have loaned or given me illustrations.

I would also like to thank Susan Moore, Joy Chamberlain and my son James for their editorial help and advice and Lord Briggs and Robert Williams for reading my manuscript and giving me the benefit of their scholarship. I am very grateful to Anthony Thwaite for his patience and expertise in editing my book, and to Howard Davies for his copy-editing.

I also wish to thank Julia Brown for her very helpful collaboration with the illustrations and Don Macpherson for his elegant design. Lastly, I would like to express my appreciation to my brother John Bendit for his valuable help with the research.

LIST OF ILLUSTRATIONS

The author and publishers would like to thank the following museums, libraries, photographers and private collectors for kindly allowing their works to be reproduced. Photographic credits are in brackets.

Page

3 Palace of Nineveh, carved slab, c.645 BC. Reproduced by courtesy of the Trustees of the British Museum, London

9 Queen Mary's Psalter, c.1300, clubbing rabbits (Royal Ms 2 B VII). By permission of the British Library, London

10 above left Gaston Phoebus, Comte de Foix: *Le Livre de Chasse*, 1430. (Sotheby's, London)

10 above right Gaston Phoebus, Comte de Foix: *Le Livre de Chasse*, c.1480. (Sotheby's, London)

10 below The Pursuit of Fidelity, tapestry, German, c.1475 – 1500. The Burrell Collection, Glasgow Museums and Art Galleries

11 Map showing the distribution of parks in medieval England. From *Geography* Vol 64 (2) by Cantor and Hatherly *The Medieval parks of England*. By courtesy of The Geographical Association, Sheffield

16 Free Warren Charter, 1291. Reproduced by permission of the Syndics of the Fitzwilliam Museum, Cambridge

19 Licence to empark granted to George Wynter, 4 July 1620. The National Trust, Dyrham Park (Colin Wilson)

22 A. van Wyngaerde: Richmond Palace from the north-east, c.1562, pen & ink. Ashmolean Museum, Oxford

23 A. van Wyngaerde: Hampton Court Palace from the north, 1558, pen & ink. Ashmolean Museum, Oxford

25 R. Blome: Coursing with greyhounds, 1686, engraving from *A Gentleman's Recreation*. Private Collection, London

26 J. Siberechts: Longleat, Wiltshire, 1678. The Tate Gallery, London

28 above Survey of Holdenby, 1580, from the map book of Hatton estates. By courtesy of the Trustees of the Winchilsea Settled Estates. (Northamptonshire Record Office, Northampton)

28 below Survey of Holdenby, 1587, from the map book of Hatton estates. By courtesy of the Trustees of the Winchilsea Settled Estates. (Northamptonshire Record Office, Northampton)

30 Map of Theobalds, Cheshunt, Hertfordshire, 1611 (Cotton Ms. Augustus li 75). By permission of the British Library, London

33 C. Saxton: Map of Kent, Sussex, Surrey and Middlesex, 1575. By permission of the British Library, London

34 Burleigh Saxton Atlas Map of Lancaster, 1590 (Royal Mss.18D iii f.81v – 82). By permission of the British Library, London

36 R. Blome: A keeper maiming a deer, 1686, engraving from *A Gentleman's Recreation*. Private Collection, London

43 Attrib. J. Vorsterman: Greenwich from One Tree Hill, c.1680. National Maritime Museum, Greenwich *(Country Life, London)*

44 W. Hollar: Bey Albury, 1645, engraving. Reproduced by courtesy of the Trustees of the British Museum, London.

45 left B. Hare: Map of Wimpole Parish, 1638. County Record Office, Cambridge

45 right G. Geldorp: William, 2nd Earl of Salisbury, 1626. The Marquess of Salisbury, Hatfield House.

46 J. Siberechts: Wollaton Hall and Park, Nottinghamshire, 1697. Yale Center for British Art, Paul Mellon Collection, New Haven

48 – 49 H. Danckerts: Badminton House, Gloucestershire, 1670s, pen & wash. Reproduced by courtesy of the Trustees of the British Museum, London

53 L. Knyff: The Southeast Prospect of Hampton Court, Herefordshire, c.1699. Yale Center for British Art, Paul Mellon Collection, New Haven

54 E. Prideaux: Euston Hall, Suffolk. From the collection at Prideaux Place, Padstow (R.C.H.M., London)

55 above A. van Diest: Dunham Massey, Cheshire. The National Trust, Dunham Massey, Cheshire

55 below John Harris the younger: Dunham Massey, Cheshire, 1751. The National Trust, Dunham Massey, Cheshire

56 – 57 T. Smith of Derby: A View of Chatsworth, Derbyshire, c.1743 – 4. (Christie's, London/The Bridgeman Art Library, London)

58 P. Patel: Perspective view of Versailles, 1668. Chateau de Versailles (The Bridgeman Art Library, London)

59 L. Knyff and J. Kip: Wimpole, Cambridgeshire, 1707, engraving. The British Architectural Library, R.I.B.A., London

64 L. Knyff: Hampton Court Palace, Middlesex, c.1700. Reproduced by Gracious Permission of Her Majesty the Queen

65 L. Knyff and J. Kip: Badminton House, Gloucestershire, 1707, engraving. Private Collection, London

67 T. Robins the elder: Charlton Park, Gloucestershire, c.1740. Cheltenham Art Gallery and Museums (The Bridgeman Art Library, London)

68 above A General prospect of Vauxhall Gardens, engraving by I. Muller. The Trustees of the Victoria and Albert Museum, London

68 below Attrib. M. Ricci: A View of the Mall from St. James's Park, c.1710. National Gallery of Art, Washington D.C., Ailsa Mellon Bruce Collection

69 Anon: Charlecote Park, 1695 – 1700. The National Trust, Charlecote Park, Warwickshire.

71 Dyrham, Gloucestershire, engraving by J. Kip, 1712. Private Collection, London

72 L. Knyff and J. Kip: Ashdown Park, Berkshire, 1707, engraving. The British Architectural Library, R.I.B.A., London

73 Attrib. J. Kip: Moor Park, Surrey, c.1696 – 1700, pen & wash.

Surrey Local Studies Library, Guildford

78–79 C. Fielding: Blenheim Palace, from Havell's view of the seats of England, engraving by R. Havell & Son.
Guildhall, London (The Bridgeman Art Library, London)

80 J. Constable: Malvern Hall, Warwickshire, 1809.
The Tate Gallery, London

81 above Claude Gellee (Claude Lorrain): Landscape near Rome with a view of the Ponte Molle, 1645.
Birmingham Museum and Art Gallery

81 below H. de Cort: View of the Mausoleum with Castle Howard in the distance c.1800.
From the Castle Howard collection (The Courtauld Institute of Art, London)

82 View of the Lake in the Villa Cusani at Desio, 1801, engraving.
The British Architectural Library, R.I.B.A., London

85 A View of Woobourn, Surrey, 1759, engraving by L. Sullivan.
Reproduced by courtesy of the Trustees of the British Museum, London

88 C. Bridgeman: Plan of Blenheim, 1709.
Private Collection (Country Life, London)

89 View with the pyramid from Views of Stowe, 1739, engraving by J. Rigaud.
Reproduced by courtesy of the Trustees of the British Museum, London

90 G. Stubbs: Lady reading in a wooded park, 1768–70.
Private Collection (The Bridgeman Art Library, London)

91 above View of the Queens Theatre from the Rotonda, detail, from Views of Stowe, 1739, engraving by J. Rigaud.
Reproduced by courtesy of the Trustees of the British Museum, London

91 below Attrib. G. Lambert: The new ha-ha and lake at Claremont.
Henry E. Huntington Library and Art Gallery, San Marino

92 W. Kent: North Lawn at Holkham Hall, Norfolk, with clumps of trees and North Lodge.
Viscount Coke and the Trustees of the Holkham Estate

93 W. Kent: The Cascade, Chatsworth, unexecuted design, c.1725.
Devonshire Collection, Chatsworth.
Reproduced by permission of the Chatsworth Settlement Trustees (Country Life, London)

94 R. Greening: Design for replanting the garden to the North of Wimpole Hall, c.1752.
Wimpole Hall, Cambridgeshire (The Courtauld Institute of Art, London)

96 J. Turner: Petworth Park, Sussex, engraving by J. Cousen.
West Sussex Record Office, Chichester

99 S. Gilpin & S. Barrett: A View of the Lake, Painshill, Surrey, 1770s.
Roy Miles Fine Paintings, London (The Bridgeman Art Library, London)

100–101 F. Nicholson: Stourhead, 1813.
Reproduced by courtesy of the Trustees of the British Museum, London (The Bridgeman Art Library, London)

103 Plate 1 from Practical Treatise on Planting and the Management of Woods and Coppices by Samuel Hayes, Dublin 1797.
The Royal Horticultural Society, London

104 Edward Barnes, the woodman at Erdigg, 1830.
The National Trust, Erdigg

106 F. C. Turner: Heaton Park Races, 1835, engraving by R. Reeve.
Yale Center for British Art, Paul Mellon Collection, New Haven

107 The Temple of the Four Winds, Castle Howard, Yorkshire, A.F. Kersting

108 The Triangular Lodge, Rushton, Northamptonshire. A.F. Kersting

109 T. Robins: Alfred's Hall, Cirencester, 1763, engraving.
Private Collection, London

110 Anon: Basildon Park lodges, Berkshire, 1816.
Henry Potts Collection, Northumberland.

111 J. Seymour: The Kill at Ashdown Park, 1743.
The Tate Gallery, London

112 above D. Wolstenholme: Hunting Scene.
David Messum Fine Paintings, Marlow (The Bridgeman Art Library, London)

112 below J. Wood: Rams at Stowe Park, 1831.
By courtesy of Iona Antiques, London

113 R. Adam: proposed ruin at Kedleston, Derbyshire, c.1759–61.
Trustees of the Victoria and Albert Museum, London (The Bridgeman Art Library, London)

114 Easton Church and crinkle-crankle wall, Suffolk.
Suffolk Photographic Survey, Ipswich

115 above Anon.: Folly at Wolverton, Hampshire, 1810.
Henry Potts Collection, Northumberland

115 below T. Leverton: Designs for rustic lodges, 1804.
The British Architectural Library, R.I.B.A. Drawings Collection, London

116–117 W. Kent: Triumphal Arch, Holkham Hall, post-1744.
Viscount Coke and the Trustees of the Holkham Estate

118 J. Papworth: Plate 25, detail, from Rural Residences . . . 1818.
The British Architectural Library, R.I.B.A., London

119 G. Lambert: St. James's Park from the Terrace of No. 10 Downing Street, c.1736–40.
The Museum of London

120 P. Sandby: Windsor Castle, view from Mother Dod's Hill in the Home Park.
Private Collection (The Bridgeman Art Library, London)

121 The Temple of Concord, Green Park, 1814, engraving.
Reproduced by courtesy of the Trustees of the British Museum, London

122 F. Mannskirsch: A View of St. James's Park from Buckingham House, 1809, engraving by H. Schutz.
Guildhall, London (The Bridgeman Art Library, London)

123 B. Lens the younger: View of the Mount in Kensington Gardens, 1736.
Local Studies Collection, Kensington Public Library

124 W. Heath: Dandies in Rotten Row, 1819, engraving.
Trustees of the Victoria and Albert Museum, London

125 F. Wheatley: The Bathing Well, Hyde Park, 1802, engraving.
Reproduced by courtesy of the Trustees of the British Museum, London

126 R. Adam: View of the South front of the Deputy Rangers' Lodge in Green Park, 1768, engraving by T. Vivares published 1778.
Reproduced by courtesy of the Trustees of the British Museum, London

127 J. Rigaud: A Prospect of St. James's Park, 1750, engraving.
Reproduced by courtesy of the Trustees of the British Museum, London

131 B. Read: Winter Fashions for 1838 & 39, engraving. The Costume Society, Guildhall, London (The Bridgeman Art Library, London)

132–133 J. Martin: Richmond Park, 1843.
By courtesy of Hazlitt, Gooden, Fox, London

134 Anon.: View of the Coronation Fair in Hyde Park, June 28th 1838.
Guildhall Library, London (The Bridgeman Art Library, London)

136 G. Phillips: Fore Street, Lambeth, engraving.
Greater London Record Office, Corporation of London

139 G. Pickering: Liverpool from Toxteth Park, engraving by J. Sands.
The Mansell Collection, London

143 C. Dodd: Churchill's Calverley Hotel, with the Park and Pleasure Grounds, Tunbridge Wells, engraving by J. Wedgwood. The Mansell Collection, London

144 above The Crystal Palace and Norwood Park, Surrey, engraving published 1854. Guildhall Library, London (The Bridgeman Art Library, London)

144 below E. Lami: Scene in Hyde Park, 1880.
Trustees of the Victoria and Albert Museum, London

145 Loudon's proposals for breathing zones round London, 1829.
Private Collection, London

147 Laying out Corporation Park, Blackburn from *The Illustrated London News*, January 16th 1864.
The Illustrated London News Picture Library, London

148 Greenwich Park, Easter Day, 1804, engraving.
Greater London Record Office, Corporation of London

153 The Ride in the Park, song cover by T. Packer.
Local Studies Collection, Kensington Public Library, London

154–155 J. Ritchie: Summer Day in Hyde Park, 1858. The Museum of London

156 above Monster Free Gala in Peel Park, Bradford, engraving.
Private Collection, London

156 below Tom Browne: Victoria Park, London. Private Collection (The Bridgeman Art Library, London)

157 E. Jackson's balloon ascent from Derby Arboretum, 1840, engraving.
Derby Museums and Art Gallery

161 Gymnasium Primrose Hill, from *The Illustrated London News* 29th April 1848.
The Illustrated London News Picture Library, London

162 Opening of Birkenhead Park, from *The Illustrated London News*, April 10th 1849.
The Illustrated London News Picture Library, London

166 The Queen's visit to Aston Park, from *The Illustrated London News*, 12th June 1858.
The Illustrated London News Picture Library, London

168 Victoria Column and Park gates, Bath, engraving.
Bath Central Library

169 The Victoria Drinking-Fountain, Victoria Park, London, 1862, engraving.
Greater London Record Office, Corporation of London

171 Hawkestone, c.1807, engraving.
Private Collection, London

173 H. Repton: Fences called invisible.
The British Architectural Library, R.I.B.A., London

174 Prince Pückler's Park at Muskau.
Private Collection, London

181 above H. Repton: View before improvement at Livermere Park, Suffolk.
From the Red Book for Livermere Park, 1791. Lord de Saumarez (George Carter)

181 below H. Repton: View after improvement at Livermere Park, Suffolk.
From the Red Book for Livermere Park, 1791. Lord de Saumarez (George Carter)

182 above H. Repton: Window at Barningham Hall, Norfolk, 1819.
The British Architectural Library, R.I.B.A., London

182 below The Two Flags, Grove Park, Weston-super-Mare, postcard, c.1910–15.
Brent Elliott Collection, London

183 Floral Piano, Bowling Park, City of Bradford, postcard, 1925.
Brent Elliott Collection, London

189 Mowing the grass, Dulwich Park, c.1905.
Greater London Record Office, Corporation of London

191 Sheep leaving Hyde Park, c.1950.
Greater London Record Office, London

193 Holland Park, 1958.
Greater London Record Office, Corporation of London

194–195 Susan Lasdun: Park Sketches, 1991, pen & ink.

196 Our Homeless Poor, St. James's Park, 1887, engraving.
Greater London Record Office, Corporation of London

199 V. Pasmore: The Park, 1947.
By kind permission of Adrian Heath, and of Victor Pasmore (The Serpentine Gallery, London)

200 Susan Lasdun: The Bandstand, Kensington Gardens, 1991.

203 Jak: 'Bloody weather!' Battersea Park, May 3 1990, cartoon for the *Evening Standard*.
By kind permission of Jak and the *Evening Standard*

FOREWORD

This book is an attempt to chronicle the different stages in the evolution of the English park as a distinct and enduring feature of our environment. It charts the journey from royal and rural to public and urban, throughout which the park has retained its essential characteristics as an enclosed piece of land with turf, trees and water. It does not endeavour to catalogue the hundreds of parks, both private and public, which have existed in England. However, by drawing attention to the remarkable history of the park over a span of nearly a thousand years, I hope that this account will help ensure the preservation of those that remain and encourage the continued making of new ones. The need for places of refuge in which to relax, reflect, exercise, and enjoy nature, has probably never been greater than it is today.

Susan Lasdun
London, 1991

1

ANCIENT ORIGINS

Parks, like so many other expressions of our present civilisation, originated in Asia. They existed in ancient Assyria, Persia, India and the Far East, as well as Egypt, Greece and Rome. Archaic parks are referred to in inscriptions on tablets, pictorial reliefs and paintings on tombs; in sacred documents like the Avesta of the Parsees; in descriptions by Homer, Xenophon and Aristophanes, and in the works of poets and writers such as Vitruvius, Virgil, Pliny and Tacitus.

More than three thousand years ago King Tiglath-Pileser I of Assyria boasted of parks in which he planted trees brought back from the countries he had conquered, and of how he stocked the park around his palace at Assur with 'wild oxen, stags, goats, young elephants, letting them grow up like sheep'.[1] He dug fishponds for the fish received as gifts from foreign potentates. His successors added complex water systems, temples and shrines on small hills. They attached parks to their own palaces as places for hunting as well as for assemblies and celebrations. At his Incomparable Palace at Nineveh, Sennacherib, around 700 BC, created a park complete with trees, water, a royal stela and a summer house.[2] Semiramis, the legendary queen of Assyria, whose empire stretched from Babylon to India, was said to have made a park wherever she built.

In the fifth century BC, the Buddha preached his first sermon in the old 'deer park' of Varanasi, sitting under a bo-tree or peepul tree, and figures of Buddha frequently portray a pair of deer at the base of his throne. Even today in India a deer park signifies a place where aesthetics and wisdom reign together, and in some places may therefore form the setting for a temple.

The Persians, for whom tree planting was a sacred pastime, continued the tradition. They called their parks *pairidaēza*,[3] and thereby gave the world a word for a universal concept of a state or place of bliss. They laid out their gardens with streams and trees, symbols of eternal life, while they enclosed their parks to harbour wild beasts. They planted them with

groves of fruit-bearing trees and enjoyed the pleasures of walking and riding within them. In the fifth century BC, Cyrus the Younger had a park at Celaenae, the capital of Phrygia, and filled it with wild animals for hunting. He is also said to have reviewed one hundred and thirty thousand Greek troops there.[4] After the Persian wars Xenophon wrote of the Persian *paradeisoi*, urging his countrymen to imitate them.

In the Han dynasty of China (206 BC–220 AD) there were imperial parks such as the famous Shang-Lin Park, a vast walled enclosure where exotic animals exacted from vassal states were kept for the emperor to hunt. A successful hunt was regarded as a blessing from heaven – a good omen signifying that the emperor was an enlightened ruler. Such heaven-sent phenomena were called *xiangru*.[5] These hunting parks were also used for military practice, and in both functions symbolised the emperor's power, authority, splendour and wealth. Even then, such symbols had their critics and the poet Ssu-ma Hsiang-ju satirised the parks and hunts of the kings of Ch'i and Ch'u for occupying nine tenths of their domains so that ' . . . the land cannot be cleared and the people have no space to grow food'.[6] Disapproval of royal and aristocratic parks on similar grounds was to be heard again in later centuries.

However, the ancient world also had its public parks and gardens. In Greece such parks were the grounds of the gymnasia where training for the great games took place. They were also from the very beginning places of public resort, where people met to converse and watch the athletes practise their sport. Jean Delorme in his book on ancient gymnasia describes how the Academy looked at the end of the Archaic period: 'It must have resembled a great park, well-founded where religious monuments and sporting facilities were scattered amongst the greenery and shade of the trees.'[7] By Plato's time gymnasia and their settings had become so integrated that it was customary to site a gymnasium in a scene of natural beauty. Open glades and treed walks were planted, anticipating the playing fields and belts of trees of our public parks today.

Likewise Cimon, ruler of Athens in the fifth century BC, anticipated the nineteenth-century philanthropists when he made a bequest of his own beautiful gardens to the people of his city. History has rightly praised him.

Aristophanes celebrated the arboreal pleasures of the Academy in his play *The Clouds*, first performed in 423 BC. In it he 'recommends an athletic education bidding the young Athenian to pass his hours in the Academy where he will find relaxation under the sacred olive trees enjoying the scent of white poplar and the carefree bindweed'.[8]

Epicurus (342–270 BC) was credited by Pliny with the idea of making gardens in towns, the *rus in urbe*, when he bought a plot of land near the Dipylon Gate within the walls of Athens and made a garden for himself and his scholars.

The Romans too had their pleasure parks, and developed a country

A low relief sculpture of King Sennacherib's Park: carved c.645 BC.
Virtually a blueprint for the landscape parks of the future.

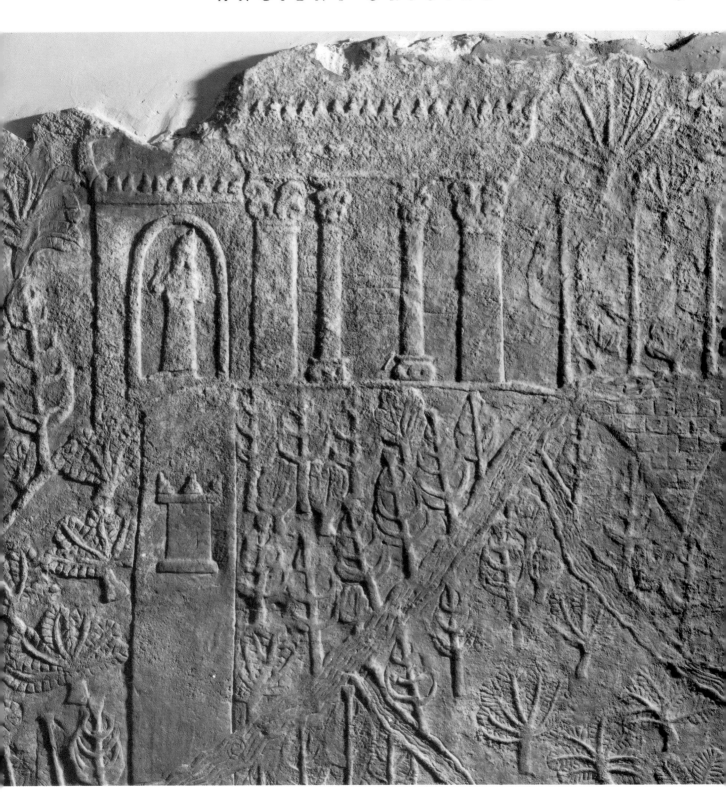

house lifestyle in order to escape the heat of the city. This was the practice known as *villeggiatura* in sixteenth-century Italy, which the English aristocracy were to cultivate in the eighteenth century. The grounds of Nero's Golden Palace in Rome as described by Tacitus, with their lawns and lakes, groves, open prospects and pleasure gardens, were a forerunner of the parks and gardens of the English landscape.

These foreign and ancient creations directly and indirectly inspired the development of English parks, while English climate, vegetation, topography and a genius for assimilation have transformed them into uniquely English artefacts.

2

THE MEDIEVAL PARK

I t was with the Norman Conquest in 1066 that these ancient traditions of park-making were brought to England. Parks had undoubtedly existed here before – Ongar Great Park, for example, the oldest known park in England, was mentioned in an Anglo-Saxon will of 1045 under *deerhay* or *deerhag*, an enclosure for deer,[1] and Dyrham Park whose name, probably derived from the Saxon *deor-hamm*,[2] another word for deer enclosure, suggests that it too predated the Conquest. However, our knowledge of such parks is scanty and while it is possible that they were part of a continuing tradition from the East brought over by the Romans and kept alive by the clergy who travelled so much in the time of the Venerable Bede, there is little hard evidence to support this conjecture.

What is certain is the rapid increase in their numbers from the thirty-one parks recorded in the Domesday Book in 1087 to over nineteen hundred at various times during the period 1200–1350, the heyday of the medieval park.[3] Meaning 'enclosure' at its simplest, the word *park* occurs in numerous field names especially in the West Country. At first parks in England were simply areas of land, sometimes comprised of natural woodland, which had been enclosed and thereby physically separated from the surrounding countryside. Enclosure also distinguished a park from a forest. These enclosures were made primarily as preserves for beasts of the chase – deer in particular, which were driven into *haias* – pens – from the surrounding countryside and transferred into the park. Columella, the Roman writer on agriculture in the first century AD, describes similar enclosures in Gaul, which again suggests a continuing tradition which the Normans brought with them. In any case the Normans would certainly have encountered parks when they began their conquest of Sicily in 1060, where deer and hunting parks had been established by the Arabs, their predecessors in conquest.

Medieval parks in England were to a large extent utilitarian enterprises, their purpose to provide food for the enormous households of the period.

The native red and smaller roe deer, and in particular the more easily reared fallow deer introduced by the Normans in the twelfth century, were reared in these parks. Fallow deer were natives of the Levant and again may have been discovered by the Normans in their conquest of Sicily.

Deer could be fed, bred and fattened more efficiently in parks than in the wild. For example, one park of eleven hundred acres yielded on average forty-four fallow deer annually in the years 1234–63; whereas an unenclosed area of 'royal forest' in Essex, ten times the size, yielded precisely the same.[4] Wild cattle, sheep, studs for horses, eyries of falcons, and herds of swine were also kept in parks. By the end of the thirteenth century swine had all but vanished in some parts of the country and were only to be found in parks, their stock reduced perhaps by the rapacity of preceding kings, such as Henry III who ordered one hundred boars for his Christmas banquet in 1254 from the forest of Dean.[5]

Rabbits or 'conies' were introduced in the thirteenth century, bred in specially constructed warrens – 'long low earthworks called pillow mounds'.[6] At Petworth William de Percy, the eighth baron, made a new park especially 'for his cunegeria'.[7] Two parks at Petworth were partly used for deer and grazing cattle and horses, while within the Great Park there was a garden or orchard in which were over two hundred and fifty apple and pear trees probably grown for cider.[8]

Within the great parks a number of enclosures or small parks were made in order to separate different breeds of animal; for example the horse park at Whitestaunton,[9] or the stud in Edward I's park at Beckley, Oxfordshire. In some instances there were different enclosures for varying species of the same animal. Smaller game such as hares, partridges and pheasants were raised in warrens which might also lie within the park.[10]

This variety of game, known indiscriminately as venison when it reached the table, ensured an abundant supply of meat which could be salted down for winter use. A heavy emphasis on meat in the diet was in part due to the belief that meat promoted virility and strength, all-important to a military society. Aside from the flesh and fat, the various organs, especially of the deer, all had specific medicinal properties ascribed to them, while the horn was considered an antidote against venom. The hide, of course, produced some of the softest leathers.

Fish too were kept in specially dug ponds called vivariums or stew ponds, many of which were later turned into the ornamental lakes of eighteenth-century parks. The advantage of a number of detached ponds meant that fish of different species or ages could be separated for better management. It also meant that there was a constant supply should one pond require emptying for cleaning.[11] Fish was a necessary part of the diet on fast days and during Lent.

Lastly dovecotes – a ubiquitous and much hated feature of the medieval landscape – were often erected in parks. In the park of Higham Ferrers,

there were two dovehouses as well as a grange (a barn), oxhouse and sheepfold, valued together at six shillings and eight pence.[12] Dovecotes were the peasants' bane as the pigeons which inhabited them fed on their precious crops in the neighbouring fields. Nevertheless, pigeons provided the lord and his household with a welcome change of diet and a source of fresh food round the year.

Put to all these uses, the medieval park functioned as a kind of auxiliary farm. In addition to meat, it was an important source of fuel and building timber, and was frequently compartmented so that wood management and deer management could be carried out without detriment to one another. The felling and selling of timber and underwood was a notable source of revenue, as the accounts for Higham Park in the fourteenth and early fifteenth centuries clearly show.[13] Hay too was sometimes grown in yet other enclosures within the park, to augment the winter feeding of the deer.[14]

Some parks were rented out for cattle pasture, by a process known as 'agistment', or were even partially turned into arable land. There are several records of part or total rentals on the Cumberland, Yorkshire and Sussex estates of the Percies.[15] The practice occurred with greater frequency after the Black Death of 1348 when the population was severely depleted and the shortage of labour made it expensive to maintain land in the form of parks.

At first, parks were the properties only of the monarch and the great territorial magnates – the ecclesiastical and secular nobility who held their lands from the Crown in return for services. These leading members of the nobility were called Tenants-in-chief and numbered 170 after 1066. They further divided their lands among smaller holders on a complex variety of terms. The bishops and abbots were granted twenty-six per cent of the land and the lay barons forty-nine per cent.[16]

The territorial unit by which most land was organised was called a manor, and every manor had a lord. In theory manorialism was an autocratic system of land ownership that mimicked the relationship of monarch to his subjects: 'The lord divided his manor, as the state divided the kingdom – in two parts: one he retained for his own support … the other he parcelled out.'[17] The land he kept for his own use was cultivated by his bond tenants and called his demesne land; the rest was divided in return for services. By the thirteenth century, when feudalism had declined, these services were commuted to money and rents. Rents became the main source of revenue of landed estates and the one which continued down the centuries to make them such valuable properties. In practice, however, manorialism was never a standardised system as it was continually adjusted to suit differing needs.

A man's social standing was indeed estimated by the amount of land he held – the size of his estate – which might consist of a number of

manors.[18] Thus to own a park was from the outset a symbol of power, privilege and prestige. Gradually that ownership descended through the ranks of society to the lesser nobility, down to the newly created gentry at the end of this period, who acquired them through wise marriages, growing wealth, a widening land market and above all by the system of primogeniture – inheritance of the first born. Not all methods were like these legitimate. Armed occupation of another's estate on some probably invented claim was yet another means of gaining land.[19]

The king owned the greatest number of parks, followed by the bishops and abbots. Despite a continual sale of Crown lands from Henry I's reign onwards, at the time of the Commonwealth there were still between ninety and one hundred parks which belonged to the Crown.[20] Castles often had a park adjacent. The castle at New Buckenham in Norfolk and the Bishops Castle at Merdon, Hampshire, both had parks.[21] The castle of Sheriff Hutton lay just outside its park. Sometimes the park was set at some distance from the castle, as at Higham Ferrers where the castle stood in the town and the park, at its nearest point, lay three miles away.[22] By contrast, the park belonging to the castle in the nearby town of Kimbolton began at the end of the market place.[23] Monasteries and abbeys were likewise set in or near parks, as at Fountains Abbey and Jervaulx in Yorkshire, or Milton Abbas in Dorset, where the park lay north and west of the abbey.

Most great landowners held manors scattered in different parts of the kingdom, partly due to the fortunes of marriage and partly to the Crown's concern that no baron should hold too much land in any one area. The Percy family, the greatest magnates of the North, had lands and parks not only in Northumberland but also in Lincolnshire and Petworth in Sussex. The Earls of Lancaster were said to hold forty-five parks at various times during the middle ages, the Dukes of Cornwall twenty-nine, the Bishop of Winchester twenty-three, the Archbishop of Canterbury twenty-one and the Bishop of Durham twenty.[24]

Manor houses were generally at some distance from their parks, which tended to lie beyond the cultivated strips of the open fields on unimproved or marginal lands. They were not conceived as aesthetic enhancements to a place of residence until a later period, when this became one of their most important roles. Sometimes there was no residence nearby at all, and lodges were built to house the lord and his household on their hunting trips to the park.

On the other hand the king's houses – his civil residences, where he stayed on his progresses through the land – were often sited in the middle of his parks and forests in good hunting country, enabling him to combine affairs of state with those of the chase.[25] At times expenditure on these residences exceeded that on military construction. The Pipe Rolls in the reign of Henry II reveal that £537 was spent on military construction as

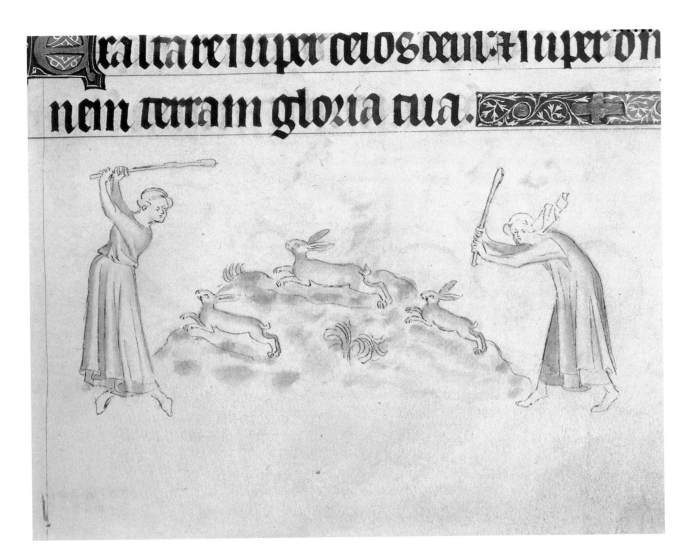

ealtare luper celos œli: 71 luper oïï
nem terram glioria tua.

against £566 for civil. At Clarendon, for example, he turned his hunting lodge into a great rural palace large enough to accommodate the magnates attending the Council of 1164.[26]

At first the king's houses were scattered all over the Midlands and the South of England, but as royal government became more centralised and Westminster became the administrative capital, these houses were gradually given up in favour of ones within a day's ride of London. Edward III had a ring of satellite houses and hunting lodges around Windsor so that wherever he chose to hunt he had somewhere to eat and sleep. Windsor Castle was his main dwelling and the manor house in the park his 'private retreat'.[27] Incidentally, such privacy was to become one of the supreme assets of the park and a cause of its increasing popularity.

Lodges such as the Lord's Lodge or Great Lodge at Higham Ferrers,

Queen Mary's Psalter: c.1300. A man and woman killing rabbits with clubs as they run over a 'pillow-mound'.

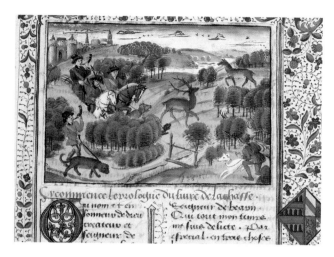

Stag hunting at force with a castle in the distance, Flanders, c.1480.

Trapping a boar. An ambush of men armed with spears hide in a wood and a concealed ditch, into which a boar has fallen, Brittany, 1430

'The Pursuit of Fidelity.' Tapestry, c.1475–1500. Here the deer has been driven into a roped enclosure before being pulled down by hounds.

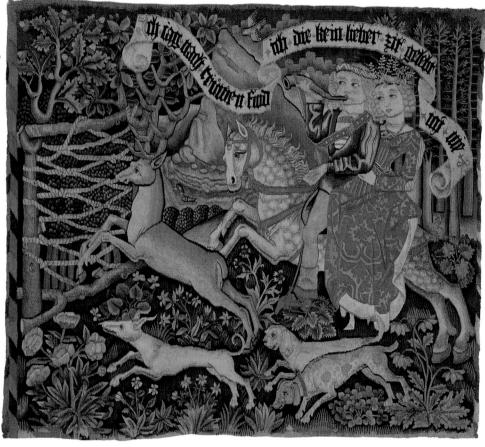

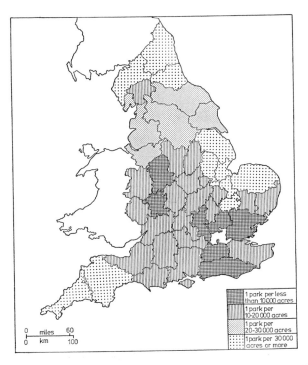

Map showing the distribution of parks in medieval England.

Legend:
- 1 park per less than 10 000 acres
- 1 park per 10-20 000 acres
- 1 park per 20-30 000 acres
- 1 park per 30 000 acres or more

which stood near the principal entrance of the park, were to all intents and purposes major dwellings – comprising in this case the hall, chapel, chamber, bakehouse and brewhouse, and surrounded by a broad moat. Other lodges were primarily the dwelling place of the parker or ranger and were much simpler buildings, although in subsequent centuries they became the kernel or site of major residences or seats. The most comprehensive cataloguer of such lodges was Leland, the father of English topography, who toured England between 1535 and 1543 and noted their numbers and condition.

The office of parker was much sought after, especially by the younger sons of noblemen whom primogeniture – almost universal by the thirteenth century – had left poor and with little means of livelihood. In 1469 the king appointed Richard Milton 'Parker of the Parks of Assheley & Guddesber, in the Manor of Tiverton, County Devon, [and] 6d daily as his wages for the above office during his life'.[28] In the same year he conferred the office of parker on Richard and William of the park of Cornbury, Oxford, at '3d a day for life ... These to be paid by occupiers of the Manor of Wodestoke.'[29] Many of these appointments are listed in the Calendar of Close Rolls. Today the surname Parker is a reminder of this widespread and much coveted office.

The average size of a park during this period was probably between one hundred and two hundred acres.[30] Knowsley, Eridge and Ongar, three of the oldest parks, were very much larger, as were some of the royal parks

such as Woodstock, Windsor and Clarendon, each having a circuit of about seven miles, representing an area of some two thousand five hundred acres. At the furthest extreme was Lancaster Great Park in Sussex with its fourteen thousand acres.[31] By the sixteenth century in Norfolk it was said that a 'circuit of one mile appeared fashionable' – an area of six hundred and forty acres.[32] However, throughout their history, individual parks have increased and decreased in size many times as the fortunes of their owners changed.

Before emparking – the term used for the process of enclosing land to make a park – the boundary was established by a perambulation, a ceremonial walk around the proposed area for the purpose of defining and recording it. This practice was much used before the making of maps and was continued until the seventeenth century.[33] Parks were mostly elliptical or circular in shape, the easiest and most economical form to enclose.[34]

The methods used to enclose were various: the commonest was a combination of a bank and a fence – the park 'pale', a word which gradually became synonymous with the park itself. The fence consisted of stout posts and strong stakes of cleft oak fixed to a horizontal rail, surmounting a bank with a ditch. These 'deer banks', as they are called, were quite formidable earthworks, measuring some thirty feet in width;[35] remains of them can still be seen in a number of parks today such as Hursley Park, Hampshire. The ditch was usually on the inside – though in some counties it was dug on the outside, and is known as a reverse ditch. John of Gaunt's famous park in King's Somborne, Hampshire, had a twelve-foot high bank ditched on the outside, traces of which are still visible.[36] Even more impressive must have been the boundary of Ashdown Forest, East Sussex, when it became another of Gaunt's properties and was re-named Lancaster Great Park after his duchy in Lancaster.[37] Its fourteen thousand acres were said to have been enclosed by a ditched bank and fence around the year 1300 in order to make a hunting park. The scale of such an operation seems almost inconceivable today and it has been questioned whether the entire area was in fact enclosed; but an abundance of place names such as Chuck Hatch, Pound Gate, Greenwood Gate surrounding the park suggest that this was indeed the case, and that these were the gates through which it was entered. In addition is the evidence from the survey in the reign of Henry VIII which states 'the Forest is about by the pale 35 myle ... '[38]

Sometimes hedges, living or dead, replaced fences. The park at Higham Ferrers was 'fenced with a ditch and a dead hedge'.[39] Water could also form a natural boundary and, in stone country, stone walls encircled the park. Among the oldest known of these are the walls built by Henry I at Woodstock and Richard I at Wotton Lodge.[40]

It was in fact beholden on a lord to make his park secure against both

animals and men. The Statute of Winchester in 1285 declared that not only had the boundary to be two hundred feet from any highway but the lord must 'make a wall, dyke, or hedge that offenders may not pass, or return to evil'.[41] The evil, presumably, was poaching.

Boundaries in any case were jealously guarded. Despite the fact that writing was a rare accomplishment except among the clergy, there are a number of written documents like that between the Earl of Winchester and his neighbour Baron Dudley at Bradgate Park, Leicester, specifying in great detail their mutual hunting rights.[42] As well as entry gates, the boundary was punctuated by a construction called a deer-leap, or saltory. This was a device whereby deer were able to jump into an enclosed area but not out again. Licence to construct one had to be sought from the king who claimed sole right to deer. When granted, this licence was known as the Right of Saltory or Saltatorium.[43] The park at Wolseley was granted this right and one of these deer-leaps was still in use in the nineteenth century. It has recently been restored by the Forestry Commission.[44] Before emparking, as many deer as possible were driven from the outlying land into the park. The king made a number of gifts of deer to help owners stock or restock their parks, records of which abound in the Close and Pipe Rolls of the twelfth and thirteenth centuries. Out of six hundred and seven deer taken in one year by Henry III, over one hundred were given away live to stock parks.[45]

The primary physical characteristics of a park were some source of natural water, woods and 'woodpasture' (the admixture of turf and trees). The trees gave cover for the deer, and the grassland or 'launds' provided pasture. Launds might be treed or treeless. Sometimes there were single trees, pollarded to provide browse wood for the deer. Such trees – often ancient oaks – are still characteristic of many deer parks, as are unpollarded trees, with their canopies all nibbled to the same level at their base by the deer. The vista of uninterrupted grassland glimpsed between tree trunks beneath this so-called browsing line, has become the quintessential image of a park, defining more than any other characteristic our term 'parkland'. It was an image which the landscapists of the eighteenth century were to make into a great aesthetic, and one which has given our parks their uniquely English appearance.

It is often said that medieval parks bore little resemblance to their landscaped descendants, but the very endeavour of the landscapists was to recreate the natural environment of the original parks, albeit in an idealised form. Moreover, although medieval parks were not created for ornament, there is evidence that aesthetic considerations sometimes had an influence on the planting and disposition of land, with the aim of enhancing its visual aspect. Since the Norman conquest of southern Italy and Sicily between 1060 and 1091, a knowledge of classical and Islamic gardens and parks had steadily filtered through Europe to England.[46]

The Normans often visited their relations in Sicily and were no doubt influenced by what they saw. The Arabs established game preserves and gardens of great sophistication, a tradition which the Norman king of Sicily seems fully to have exploited, according to this description of his palace by Archbishop Romuald of Salerno – a description which, like that in Samuel Purchas's *Purchas his Pilgrimes*, might almost have been a source for Coleridge's Kubla Khan.

> In order that none of the joys of land or water should be lacking to him, he caused a great sanctuary for birds and beasts to be built at a place called Favara, which was full of caves and dells; its waters he stocked with every kind of fish from divers regions; nearby he built a beautiful palace. And certain hills and forests around Palermo likewise enclosed with walls, and there he made the Parco – a pleasant and delightful spot, shaded with various trees and abounding with deer and goats and wild boar. And here he also raised a palace, to which the water was led in underground pipes from springs from whence it flowed ever sweet and clear ... In the winter and in Lent he would reside at Favara, by reason of the great quantity of fish that were to be had there; while in the heat of the summer he would find solace at the Parco where with a little hunting, he would relieve his mind from the cares and worries of state.[47]

The Bishop of Coutances in Normandy, Geoffrey de Montbray, nephew of William the Conqueror who granted him vast lands in England and France, visited southern Italy soon after its conquest by the Normans and would have seen such palaces as King Roger's. He must have been greatly impressed by what he had seen, for on his return to Normandy, he built a palace, laid out a park, planted a large coppice and a vineyard, dug pools, planted oaks and other forest trees to shelter deer brought from England – the essentials of a Moslem paradise. Such features became manifest in parks in England. At Havering in Essex, Henry I made a garden and park with pools and palisades. When he enclosed Woodstock, he built a palace, laid out gardens and stocked his park with fishponds, deer and a menagerie of exotic animals,[48] including lions, leopards and lynxes – the first collection of its kind in England and the start of a long tradition.

At Woodstock also began the melancholy legend of the 'fair Rosamund'. Rosamund Clifford was the mistress of Henry II whom he hid in the famous bower called Everswell which he built for her. It was set around a spring, the water from which was used to fill a number of rectangular pools encircled by cloistered courts[49] and all concealed within a maze. Queen Eleanor, Henry II's wife, was alleged to have followed a silken thread which led to Rosamund's bower, and poisoned her. Whatever the truth of the story, many parks including St James's Park had their Rosamund – or Rosamond – ponds and Rosamond wells in her memory, consecrated to disastrous love and elegiac poetry.

Woodstock continued as a favourite royal residence into the fourteenth and fifteenth centuries. Each king came in turn to hunt and many royal children including the Black Prince were born there. In 1354 a timber balcony was installed outside the chamber of Edward III's daughter, Princess Isabella, then aged twenty-two, to give her a view over the park.[50] In the same period the chronicler Matthew Paris was chastising a member of the nouveau riche, a certain Paulin Peyvre, for 'displaying the wealth and luxury of earls when he bought up estates and beset his manor house with a palisade, orchard and pools'.[51]

By the middle of the thirteenth century most castles, monasteries and manor houses had small enclosed gardens – arbours – attached to them. They were generally square and divided into four quarters, with gravel paths and a fountain in the centre fed by a channel of water, a metaphor for 'the four quarters of the World fed by the water of life',[52] and an image of paradise to complement that of the larger park. The subsequent intertwining of the history of gardens and parks had its roots in this period.

Of all the uses to which a medieval park could be put, the most desired was that of a private hunting ground. This more than any other purpose lent the park its aura of exclusiveness, and made it a 'status symbol par excellence'.[53] The king claimed possession not only of all deer, but of all other beasts of the chase as well, together with the sole right to hunt them. Others might do so on his authority alone. Twenty years after the Conquest, the king designated throughout the country enormous tracts of generally wooded land 'forest', wherein he and his Court alone had the prerogative to hunt, occasionally granting the privilege to others.

A complex system of rules and harsh penalties known as 'Forest Law' was established both to enforce his claim and to protect and conserve the deer in those areas. The term 'forest' had nothing to do with a forest in the physical sense: it was a purely legal term stemming from the Latin *foris* meaning outside.[54] Forest law did in fact lie outside the common law of the land, having its own bureaucracy of officials and its own courts to administer it. Transgression of these laws was harshly punished: 'Whosoever should slay a hart or hind, should be blinded.'[55] It was considered less criminal to take another man's life than that of a beast of the chase.

Forest law also included the protection of the 'vert' – the trees, undergrowth and herbage needed by the beasts of the forests for cover and food. For this reason many who owned land within 'forest' areas found that not only had they no hunting rights but their rights to timber and 'pannage' – the acorns and beechmast foraged by swine – had also been lost to the Crown.

A park was one of four recognised hunting grounds: forest, chase, park and warren – the latter three being areas in which private individuals

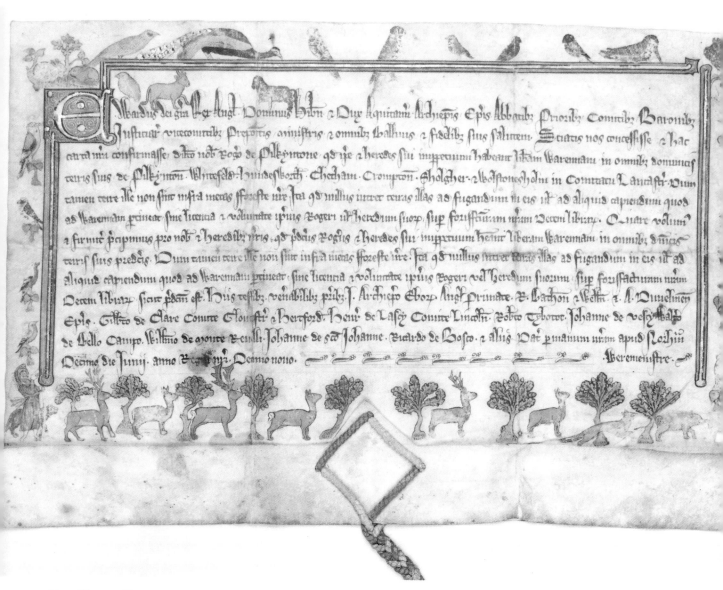

Free Warren Charter, 1291. Edward I's grant of game rights to Roger de Pilkington at Norham.

were allowed to hunt, and exempt from forest law. A chase was a large unenclosed area of land in which a few great individuals were granted hunting rights. A warren was initially an enclosed area of private land over which the owner had the right to hunt smaller game such as rabbits, hares and pheasants – a game park. By the time of Henry II, a quarter of England had been declared royal 'forest'.[56] Forty-two forests are mentioned in the Calendar of Close Rolls for 1244–1326. Needless to say the forest laws were greatly resented by rich and poor alike and were one of the issues which united the barons with the people against King John. It was stated in Magna Carta that 'All forests which have been afforested

by the King in his time shall be disafforested ...'[57] Even so it was not until 1298 that the forest laws actually began to wane and land gradually became 'disafforested'.[58]

Certain forests were granted by the Crown to noted individuals; Edward II gave the forest of Lancaster and Pickering to the Earl of Lancaster, and Richard II later granted the forest of Dean to the Duke of Gloucester.[59] However, as more land became available for private landowners parks grew in number while forests diminished.[60]

By this period hunting had developed from basic necessity into a highly ritualised sport with its own laws and observances, brought to England by the Normans. As the growing literature of the chase reveals, these laws invested it with an almost religious solemnity with a specialised terminology for its procedures. Like chivalry, that other great medieval institution, the chase provided opportunities to develop 'courage, endurance, honour, discipline and horsemanship', proficiency in fighting on horseback being the mainstay of Norman military power. Courtesy and the spirit of fair play were an integral part of the chase, and beasts had to be taken with 'nobleness and gentleness ... and not killed falsely'. Falseness was 'the method pertaining to villains – to common people and to peasants'.[61] Both hunting and chivalry were reserved for the upper classes. The 'chivalrous spirit was above all a class spirit', in that courtesy only extended towards someone of one's own rank: 'a knight may treat all below that rank with any degree of scorn and cruelty'.[62] With its moral import, hunting was considered a part of the education of a boy from the age of eight. Perhaps this attitude to hunting helped the clergy to justify their predilection for joining in the chase. Though officially forbidden to hunt with dogs and hawks purely for pleasure – 'Cum canibus aut accipitribus, voluptatis causa' – they were permitted to do so for the sake of recreation or health – 'recreationis aut valetudinis graciâ'.[63] A neat distinction which was abolished in more zealous times.

A body of literature on the laws and rituals of the chase was produced for the aristocracy, most of it at first in French. Among the earliest and most influential were *Le Livre du Roy Modus*, and *Le Livre de Chasse* by Gaston Phoebus, the Comte de Foix – begun in 1387 and translated by the second Duke of York in 1406 as *The Master of Game*. Two early English treatises were *The Noble Art of Venery* by William Twici (*c.* 1314) huntsman to Edward II; and the *Boke of St Albans* attributed to Dame Juliana Berners, 1486, and a reminder that women also hunted. Among the literature were also discourses on the art of hawking – a subject of only slightly less consequence than hunting.

Because of limited space, hunting in parks necessarily differed from 'hunting at force' when mounted horsemen with servants, horns and hounds give chase to a stag for miles, galloping along great swathes cut through the woods of royal forest or private chase – the characteristic

image of the 'sport of kings'. The method of hunting in parks was given in a lengthy dissertation by the Duke of York in his translation of Gaston Phoebus. In brief, men leading specially trained hounds went into the coverts in the early morning to find the game by scent; without disturbing it, they reported back to the master of the game, who would decide which report sounded best. The chosen beast was then roused by running hounds, driven out by beating – the 'battue' – and chased around the park by hounds and horsemen who drove it towards the stand where the king or queen stood waiting to shoot with a crossbow. A 'feuterer' was a man who led a greyhound; a 'limer' was a bloodhound; 'teasers' were small hounds which teased forth game in the coverts. Buck, the male of the fallow deer, were the most popular deer for hunting in parks, being smaller than the stag, the male red deer, and thus easier to confine. This form of hunting was to reach its zenith in the Elizabethan period.

By the fourteenth century it was necessary to own land worth forty shillings a year, 'a very considerable amount, to qualify to keep greyhounds, use ferrets, nets or other means of taking deer, hares and rabbits'.[64] One year's imprisonment could be imposed for breaching this law. The common man was thereby excluded from hunting, as he still was two centuries later. James I was to state: 'it is not fit that clowns should have these sports'.[65] Hunting, and deer hunting in particular, retained its reputation as a socially exclusive pastime right up to the nineteenth century when it was criticised by the radicals for being a 'feudal sport'.[66]

As might be expected, poaching by the poor became a passion, the only means by which ordinary people could come by game. A landowner was charged by the king not to allow unlawful entry to his hunting grounds, and if he failed to do so he was fined ten pounds. However, with such large areas of unpopulated country poaching was hard to prevent. Stories of men pursuing buck with greyhounds and armed with bows and arrows were commonplace. Records of the manorial courts are full of them. Four men were prosecuted for breaking in to a park which belonged to the Bishop of Norwich and killing three buck there in 1285. On another occasion a man was excommunicated for deer poaching in the same park.[67] Tickling perch in park ponds was another widespread form of poaching.

From the beginning of the thirteenth century until the middle of the seventeenth century it was necessary to have a licence to make a park. Emparking without one could lead to heavy fines. Roger de Rannes was fined forty marks for emparking without the king's leave.[68] A kind of land search was also carried out to see if any loss of rights to the king or others would be sustained by emparking. A local jury was empanelled to report its findings to the Crown. There are numbers of records arising from the 'inquisitions ad quod damnum' – what loss will there be.[69]

Parks often took in the waste or marginal lands of a manor, and also at

times common lands where peasants had customary rights of 'estover' (wood and fuel) and pasturage – rights often held since time immemorial.[70] Such rights were jealously guarded, and any who tried to revoke them were fought in the courts. The Statute of Merton in 1234 was created to ensure that those rights were maintained or that those about to lose them were compensated elsewhere. When the Bishops of Ely used their manor at Hatfield in the Chilterns for hunting, they were obliged to allow their tenants to continue to exercise their rights of pasture in the thousand-acre Great Park. Even Edward IV had to compensate the townspeople of Windsor for loss of land when he enlarged the park in 1467; likewise when he enlarged his park at Castle Donington, Leicestershire, in 1482 he gave up four hundred and two acres of his demesne land to his tenants to persuade them to relinquish their common

A seventeenth-century licence granted to George Wynter of Dyrham, to enclose and empark land with a right to Free Warren. It is thought that this was for enlarging the existing Elizabethan park for which a licence had been granted in 1511. Such licences were a way of filling the royal coffers.

rights in the area where he wished to build a house.[71]

Nonetheless there were instances when rights were lost and no compensation given, and parks, like the forests, were much resented, particularly where highways were diverted for the purpose of creating them, though this too had to be agreed in law. On the deaths of both William I and Henry I their parks were routed by the people and nearly all the game lost. As in ancient times, laying waste to a park was still a recognised form of protest.

By the end of the thirteenth century there was less waste land for parks owing to increased cultivation. There was also more pressure on land from the peasantry as a result of increased population. Emparking became more unpopular as the peasants saw potentially arable land disappear into private parks. In 1285 the Statute of Westminster allowed manorial lords to enclose land providing they left enough for their tenants. What was enough was of course open to dispute. Thus emparking, like other forms of enclosure, began its long and contentious history.

With the labour crisis following the Black Death, sheep grazing played an increasingly important role in the economic viability of the park, along with the leasing out of pasture noted above. However, by the second half of the fifteenth century wealthier landowners were already beginning to perceive the park more as an amenity than a resource. They began to build their manor houses alongside their parks or even within them. Thomas Grey, first Marquis of Dorset, was also one of the first to build such a house, placing it in the ancient park of Bradgate, Leicestershire.[72]

Meanwhile in the South of England Archbishop Bourchier (1404–86) 'rebuilt the manor house of Knole and enclosed the park around the same'.[73] There he resided until his death in 1486. A new phase in the history of the park was emerging.

3

THE COUNTRY HOUSE PARK:

Sixteenth-Century Beginnings

The arrival of the Tudors brought relative peace and stability to the greater part of England. The gradual breaking down of the manorial system continued, freeing the courts of law from the powerful nobility. Armed retainers were no longer allowed; and a strong central government and judiciary maintained law and order in rural areas.[1] The area under forest law diminished while the laws themselves fell into decline.

These changes were accompanied by an increasing general prosperity brought about by the expansion of foreign trade. Foreign influences in art, architecture and gardening began to filter through, especially from the Low Countries, where trade in the wool and cloth industries most flourished. A wave of domestic building followed which was to guarantee the survival of the park not only as a game preserve but in its new role as an amenity of the house.

Parkmaking was soon to become so widespread that a commission was set up to enquire into the number of new parks and the enlargement of old ones. Its purpose was to find a means to control the increasing number of acres being converted into parkland; however, in this respect it would appear that the commission was unsuccessful.[2] The peasantry found themselves increasingly without means of livelihood, as their lands, along with their hamlets and burial grounds, disappeared behind the park pale, and their grievances were a continual source of discontent.

Land remained the key to society, its ownership still conferring the greatest economic and political power as well as the highest social status. Indeed insufficient land could prevent a noble from being summoned to the House of Lords, and could even lead to a loss of titles and privileges, as more than one luckless duke discovered.[3] Peers of the realm were still expected to be the largest landowners, and lands were often granted to them on their elevation to support their crucial role in the royal administration. In 1485 there were some four dukedoms, fifteen earldoms all bearing the names of the counties of England, and fifty barons. Beneath

the peerage in descending order were the baronets, knights, squires and gentlemen who together formed the gentry, and who from the Elizabethan period were gradually to supplant the power of the nobles and clergy.

This period of comparative peace saw the emphasis continue to shift from the defensive to the domestic in architecture. Large numbers of manor houses were built, and the castle as stronghold was transformed into what we now think of as the palace, its crenellated towers and turrets reduced to mere symbols of political power and social prestige. A deer park and a garden were now prerequisites for both house and palace. It was said that 'any manor house of any pretension had a deer park ... sometimes two, one for fallow deer and one for red'.[4] The Percies at this time had twenty-one parks and forests scattered through Northumberland, Cumberland and Yorkshire, containing over five thousand head of red and fallow deer. In addition were their parks in Sussex and other southern counties.[5]

The trend for setting buildings inside the park itself, which had begun in the middle ages, continued to develop gradually in this period, marking a growing association of the park with the house. This was ultimately to influence the course of garden design by suggesting the connection of garden and park. By the end of the seventeenth century the design of one had become an integral part of the layout of the other, and in the eighteenth century become a fusion of the two.

In 1499 Henry VII gave the lead in domestic splendour with his glittering Gothic palace at Richmond, setting it in the old deer park of Sheen, where it replaced the former royal manor recently destroyed by fire.[6] There, as an adjunct to his palace, he created an enormous garden in the form of a series of huge, banked, hedged or walled enclosures, sited close to the palace to provide its immediate setting. His large gardens foreshadowed

Richmond Palace from the north-east: A. Van Wyngaerde, c.1562. The park (with figures in it) lay immediately outside the walled gardens.

what subsequently became a major royal and aristocratic preoccupation –
the art of gardening.

This initiative passed to Cardinal Wolsey who in 1524 built the most
magnificent house in England, Hampton Court, on the site of an old manor
belonging to the Knights Hospitallers. The land had already been partially
emparked. There was House Park, 369 acres emparked in 1400 (its name
already signifying proximity to a former house); Middle Park, 370 acres
and emparked in 1500, and the 380 acres of Hare Warren, emparked in
1514.[7] Wolsey set his mansion so that it was bounded on the north and
south-east by the parks and to the south by the river. To the north-west
lay pastureland and fields. In this park and river setting Wolsey enclosed
and walled a further 750 acres as well as making a moated garden.[8] From
the first the parks were a part of the grounds of his new mansion,
extending from the village of Hampton in the north-west, to Thames
Ditton in the south-east. The first gardens were planted in 1525, suggesting
from the outset an integrated concept of house, garden and park.

The grandeur of this enterprise contributed to Wolsey's downfall; it was
unwise in an age of absolutism to compete with one's monarch. Although
Wolsey continued to live at Hampton Court until his death in 1530, he was
obliged to make it a gift to the king. Henry VIII began, even before Wolsey
died, to extend its magnificence both inside and out and turned it into the
most splendid of all royal palaces, at least until he built Nonsuch. Intent
on competing with his rival François I who had vast parks and gardens at
Chambord, Blois, Gaillon and Fontainebleau, and for whom hunting had
replaced war as his main occupation, Henry VIII laid out gardens in
emulation of these French models, themselves derived from the great
Italian renaissance gardens like the Vatican Belvedere and the Villa d'Este.
Lying within a fortified wall marked with turrets, they were filled with

Detail of Hampton Court
palace from the north: A. Van
Wyngaerde, 1558. This shows
the extensively walled but
bare looking parks which
surrounded the palace

topiary, geometrically arranged beds planted with flowers and herbs. Coloured sands and earths were arranged in elaborate patterns called knots and placed beneath the windows of the state apartments from which they were to be viewed. Heraldic beasts of wood or stone bearing the royal arms were mounted on posts and set here and there among the beds, a uniquely English contribution to both gardening and the exaltation of monarchy. He placed a banqueting house on a 'mount' – a manmade hillock – to give views beyond the garden into the parks which he further extended, stocking them with game of every variety, including a number of warrens for rabbits. In 1537 he walled in a large area in the House Park (Hampton Court Park) called the Course, where the sport of coursing would take place. Coursing is hunting by sight rather than scent, suitable for hare, fox and deer. In this form of the sport the quarry was held in an enclosed paddock (also called a *parrox* or *parroc*) within the park. It was released from the paddock into a paled or walled course, measuring a mile long and a quarter of a mile wide (though enlarging in width at the far end). There the quarry was chased by dogs or shot down by huntsmen standing behind the wall or fence. At Hampton Court a stand was also built from which to view the sport. In the same year Henry VIII added 183 acres to the north-west and formed Bushy Park.[9]

In 1538 he surpassed even Hampton Court with his palace of Nonsuch in Surrey, razing the entire village of Cuddington to make room for parks and gardens which, as at Hampton Court, surrounded the palace. As the German traveller Paul Hentzner observed: 'The palace itself is so encompassed with parks full of deer, delicious gardens, groves ornamented with trellis-work, cabinets of verdure and walks so embowered by trees, that it seems to be a place pitched upon by Pleasure herself to dwell in along with Health.'[10] Appropriately enough the term 'pleasure gardens' begins to make its appearance during this period.

The setting of palaces and great houses surrounded by gardens and hunting parks reflected a growing desire for privacy, marking the end of the old feudal relationships. Previously manor houses had tended to be built at the edge of a village or grouped with the church and other buildings, their lands stretching away behind them. But by the mid-sixteenth century it had become 'fashionable to live remote from social inferiors'.[11] Within the house this was already reflected by the private chambers which had begun to supplant the great medieval hall and its communal mode of life. Privacy was pursued in the garden too, with 'privy' gardens like hedged rooms, and small garden buildings, erected for private encounters or entertainments. As in the house there were now private as well as public spaces out of doors.

To accommodate the new desire for privacy landowners either had to follow Henry VIII's example at Nonsuch, and raze the village to the ground to make room for their gardens and parks or, if they did not own

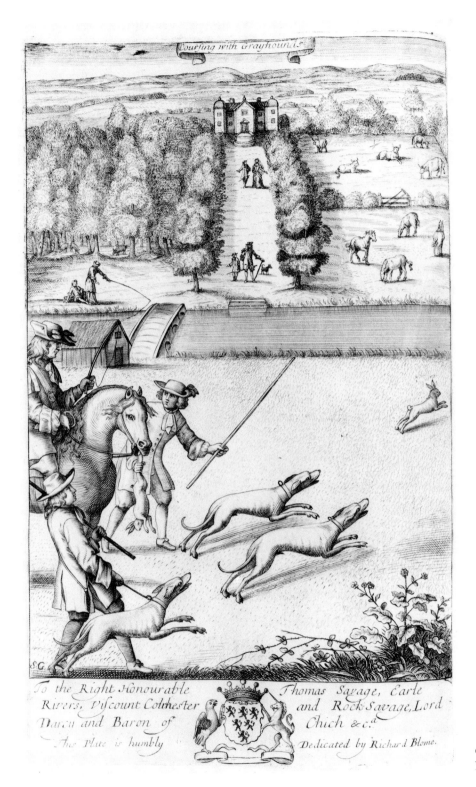

Coursing with greyhounds: R. Blome, 1686

the village, acquire a new site. Sometimes it was possible to extend an existing deer park and thereby surround the manor house. Often, though, a public way separated the park from the house and extension was only possible if an alternative road could be built. In 1445 Richard Duke of York had to do precisely this in order to compensate for enclosing the existing road in his park at Hunsdon, Hertfordshire.[12]

One of the things that made this trend towards isolation possible was the dissolution of the monasteries. Many abbeys and monasteries in the middle ages had been sited in remote places to protect their former occupants from worldly temptations or religious persecution. Most of them had home parks, and though many of these were disparked after the dissolution, many others were retained, and passed on intact to their new owners. The years 1536–9 saw the biggest transference of land since the Conquest. One third of England was said to have changed hands.[13] And between 1540 and the end of his reign, Henry VIII sold, gave away or exchanged two thirds of the monastic lands, distributing them among roughly one thousand people.[14]

Longleat, Wiltshire: J. Siberechts. 1678. This first great renaissance-style house was surrounded by its now spectacular park. Here it is shown a hundred years later.

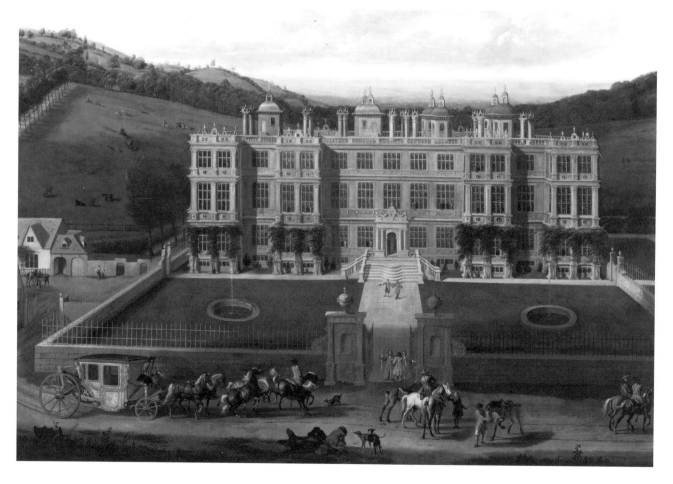

Some of these people were granted the properties as rewards or payments for services rendered. Robert Palmer, a mercer, was granted the manor of Parham, Sussex, previously a monastery property;[15] the first Earl of Pembroke was likewise granted the manor and abbey of Wilton;[16] Sir Anthony Denney was given the manor of Tyburn in return for 'services to the Crown'.[17] Others like Nicholas Bacon, a typical representative of the new age, who in early life had been a Suffolk yeoman but had risen to be Lord Keeper, were well placed to exploit the new opportunities by investing in property. Bacon bought lands at Gorhambury in Hertfordshire, building his seat there between 1563 and 1568.[18] In the 1540s John Thynne, a farmer's son, purchased an old priory in Wiltshire called Longlete with sixty-three acres, adding a further six thousand acres over the following years. There in 1547, he built Longleat House, one of the first great houses to be fully isolated and sited in the centre of a vast walled park.[19]

William Harrison (1534–93), canon of Windsor and author of the *Description of England* (1577) included by Holinshed in the *Chronicles*, noted that many of the beneficiaries of the dissolution, particularly among the peerage, resold their lands to astute yeomen like the above, who by their purchases could leave their sons sufficient lands 'whereupon they may live without labor, [and] do make them by those means to become gentlemen'.[20] Social mobility in Tudor and Elizabethan society was not nearly so disapproved of as it was in succeeding centuries. Wolsey's father had been a butcher. Society, though highly stratified, 'was based on freedom of opportunity to move about'.[21]

Between the years 1570–1620 more new country houses were built in some parts of England than in any other half century.[22] A park was *de rigueur* and sealed the arrival of the arriviste. By Queen Elizabeth's reign it was clear that a park had become the sign of a gentleman; 'as much a demonstration of social rank as the pedigree and coat of arms'.[23] Shakespeare imports this sixteenth-century emphasis into *Richard II* where he has Bolingbroke berate his enemies for having

> Dispark'd my parks and felled my forest woods
> . . . leaving me no sign, –
> Save men's opinions and my living blood, –
> To show the world I am a gentleman.[24]

Many former religious properties had had buildings which lay in or just outside their parks. Some were converted by their new owners into private dwellings; others were pulled down, their stones used to build new houses on an adjacent site. Likewise many former hunting lodges, earlier examples of dwellings enjoying remote or rural settings, were turned into second homes or even major seats. John Leland, on his ten-year travels

Survey of Holdenby in 1580
before emparkment.

Survey of Holdenby in 1587
after emparkment. The house
is now almost encircled by the
park which forms the major
views from the house. Rides
have been cut through the
wooded areas (bottom left), to
which further plantations
have been added. Clearly the
park was used both for raising
timber and as a hunting
ground.

around England between 1534 and 1543, noted numbers of parks with buildings or ruins of buildings – many of them casualties of the Wars of the Roses – lying within or nearby. He rated these buildings as 'mene', 'fair', 'pratie', and 'great maner-places'.[25] Some like the 'Duke of Excester's' at Dartington were still inhabited and were the main dwellings or 'chief houses' of their owners. Lord Souche had his 'maner-place' in a park near Pipewell in Northamptonshire, as did Lord Audley in Somerset. Leland also noted parks surrounding new houses such as Lord Russel's at Chenies in Buckinghamshire. Quite often, if the park did not lie near the house, new hunting lodges were built within it as in previous times, though now often in an exuberant or 'fanciful' style befitting their function as places of pleasure. Mark Girouard writes that most large Elizabethan and Jacobean houses had a lodge attached to a deer park lying no further than a mile away from the main house, used either as 'a destination for outings, or as a place of residence when the family wanted to withdraw from the main household'.[26] For some, like Lord Burghley who built a lodge at Wothorpe only one mile from his great house at Stamford, the purpose was merely one of convenience: *'to remove to, and to be out of the Dust, while* Burleigh House *was a Sweeping'*.[27] Sir Philip Sidney relates how Basilius Prince of Arcadia, on his return from Delphos, built for his family in a forest just such a retreat to retire to.[28]

As in most of the fashions of his day, Henry VIII was himself the park-maker par excellence, exchanging, creating and collecting parks all over England. His methods of acquisition were not always as admirable as their results. He forced Archbishop Cranmer to yield several parks belonging to the see of Canterbury, including Knole, Otford, Burstow and Wimbledon.[29] Similarly he took Hatfield from the Bishops of Ely, and acquired Penshurst from the Duke of Buckingham.[30] At Hampton he audaciously emparked ten thousand acres, enclosing several villages, which required an Act of Parliament. It was paled, quickset and ditched for fourteen hundred pounds. Ten years later, after his death, a Proclamation to dispark it was issued in answer to vociferous protests.[31]

As he grew older, his inclination was to have as many hunting grounds as possible near at hand, and it is his predilection for hunting that Londoners have to thank for the royal parks that exist there today. He had already enclosed Whitehall Park (St James's Park) in 1532, and he now set about creating and acquiring parks on the outskirts of London. He acquired in 1536, by compulsory exchange with Westminster Abbey, the manors of Neyte, Hyde and Ebury, emparking their lands in 1540 to form Hyde Park.[32] Likewise after the dissolution he kept for himself a former abbey property, the manor of Marylebone; acquired some further acres of wooded lands nearby, and emparked a total of five hundred and fifty-four of these acres, creating Marylebone Park and thereby providing himself with a hunting ground to the north of London within easy reach by 'horse

or litter' from Whitehall. In the nineteenth century this was transformed into Regent's Park.

Queen Elizabeth was said to have inherited over two hundred parks from her father. During her reign the initiative in building passed from the Crown to the aristocracy with the mansions of the great nobles providing the outstanding architecture of the day. Lord Burghley was pre-eminent in this respect. In 1564 while he was also building Burghley House, he began work on Theobalds in Hertfordshire which became one of the most

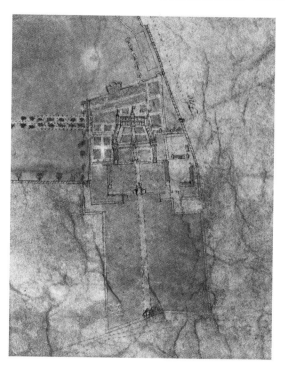

Detail from the map of Theobalds: John Thorpe, 1611. Note the avenue planted on the southern approach to the house (left of plan). In 1620, James I enclosed the whole estate (which he had acquired through exchanging the old palace at Hatfield) with a brick wall nine and a half miles long.

important houses of the period.[33] Westminster was now established as the seat of power. Nevertheless Tudor monarchs and Queen Elizabeth in particular still felt a need to 'show themselves to their loving subjects',[34] and in the summer the Queen set off on her famous progresses through the country accompanied by an enormous retinue. It was for the purpose of accommodating and entertaining the Queen and her entourage on these tours that great mansions like Theobalds — termed 'prodigy' houses by the architectural historian Sir John Summerson — were built to accommodate the Queen and her Court. Whilst economising on her own housekeeping she almost bankrupted her hosts.

Burghley had bought the manor of Theobalds and the parsonage of Cheshunt in 1563; in 1570 he acquired Cheshunt Park,[35] ensuring once again continuity for an old deer park. By 1585 the house was nearly finished. It stood close to the London Road in the east end of the park

which was some three miles long and eight miles in circumference.[36] It was surrounded by vast gardens apart from the east side, where an avenue of trees planted through the park[37] led to the main gateway. The planting of avenues of trees in various forms became the outstanding feature of parks during the next hundred and fifty years, especially in the approach to the mansion. The first avenue in the Mall was planted during Elizabeth's reign and an avenue of walnuts was also planted in Hyde Park.[38]

At Theobalds the gardens were looked after by Gerard, author of *The Herball*, the most famous of all Elizabethan gardening books. Burghley had spent almost as much on his park and gardens as on the house itself. He was described as having 'greatly delighted in making gardens, fountains and walks, which at Theobalds were perfected most costly, beautifully and pleasantly where one might walk two miles in the walks before coming to the end . . .'[39] It was Burghley who designated the new mansions of his day 'castles of Pleasur' after the gardens which surrounded them.[39]

A comparison of two surveys of Holdenby, Sir Christopher Hatton's great house — built like Theobalds to host the Queen — shows clearly the developments in parkmaking at this date.

The first was taken in 1580. A new mansion had been built, more or less surrounded by gardens, orchards, woods and fish ponds, separating it from the large open fields of the 'working' part of the estate. To the west of the house lies the site of the old hall and church, standing adjacent to Parke Field, in what was probably an earlier small deer park. To the north-east lies the village, consisting of twenty houses. A long straight road cuts through the fields from the east as far as the Greene.

By the time of the second survey, in 1587, six hundred and six acres out of a total of one thousand seven hundred and nine were enclosed by a park pale sweeping round from the north-west to the north-east and all but encircling the house and gardens, and significantly, forming the view from the house. Only the much reduced and resited village lies outside this area, its houses now numbering no more than eight. A new inn has been built. The two approaches, from Harlston and Brampton, now lie within the park, both of them double gated. A gatehouse further screens the house from public view. The park is shown with deer, conies, and huntsmen bearing hawks, as well as many additional plantings of trees.

Many of these changes must have already occurred by 1583, for they elicited much praise from Sir Thomas Heneage, who visited at that date and wrote to Sir Christopher Hatton to give him his opinion: 'Nothing pleaseth me more than your park, which you dispraised; your green and base court, that you devised; your garden which is most rare.'[40] Unusual at the time was the large, long, straight fair way[41] by which the house was approached, a feature which was much admired by Lord Burghley in 1579 and which anticipated the long axial approaches that were to become a major characteristic of parks.

In 1591 the surveyor and topographer Sir John Norden gave a fuller
description of Holdenby, which clearly takes account of the whole estate:

> The Scituation of the same Howse is very pleasantlie contrived,
> mountinge on an hill, environed with most ample and lardge Fieldes
> and goodly Pastures, manie yonge Groves newly planted, both
> pleasant and profitable, Fishe Ponds well replenished, a Parke
> adjoyninge of Fallowe Deare, with a large Warren of Conyes, not far
> from the house, lyinge between East Haddon and Long Bugbye. About
> the house are great store of Hares. And above the rest is ... the
> Garden ... raised, levelled, and formed out of a most craggye and
> unfitful grounde now framed a most pleasante, sweete, and princely
> place, with divers Walks, manie ascendings and descendings,
> replenished also with manie delightful Trees of Fruite, artificially
> composed Arbours, and a Destilling House on the west end of the same
> Garden, over which is a Ponde of water, brought by conduite pypes,
> out of the feyld adjoyninge on the west quarter of a myle from the
> same house ... [42]

Clearly the terrain in the garden had been considerably altered,
anticipating the huge earth movings of the eighteenth century.

It was now accepted that a 'park replete with deer and conies is a
necessary and a pleasant thing to be annexed to a mansion'.[43] Moreover,
as manor houses were increasingly sited in or nearer their parks, so
aesthetic considerations began to play a greater part, and writers like
Andrew Boorde and Gervase Markham urged their patrons to choose
appropriately 'divers Groundes' for their parks.[44] Stephen Switzer,
writing a hundred years later, said that Tudor parks only needed water to
become what the eighteenth century would recognise as landscape
gardens.[45] Indeed water, long an essential element of gardens in the form
of fountains and pools, began to be used ornamentally in parks as well
towards the end of the sixteenth century. In 1591 Lord Hertford dug a huge
cresent-shaped lake in his park as an emblem of the queen in her symbolic
character as Cynthia, goddess of the moon. Though created merely for the
occasion of a royal spectacle, it nonetheless presaged the ornamental lakes
of the Brown and Repton eras.[46]

The park had become the approved setting for the great house. But
despite the spate of parkmaking in the first half of the sixteenth century,
disparking began to offset emparking in the second half. Some parks were
merely reduced in size while others were completely disparked and made
over to more profitable agriculture or to new mineral and coal industries.
Many of the private parks which disappeared at this time were ones which
were not linked to a house – confirmation that the park was now
considered an integral part of the house and its lifestyle.

The county maps of England made by the cartographer Christopher
Saxton between 1575 and 1580 show some eight hundred and seventeen

Map of Kent, Sussex, Surrey and Middlesex: Christopher Saxton, 1575. Parks are identified pictorially by ring-fences and sometimes shown with the addition of a symbol of a building to suggest a house, or a tree to denote woodland. Sometimes parks are also named but by no means always. For example Lancaster Great Park is a ringed area lying within Ashdown forest but is not named.

parks scattered throughout England, with twenty-one in Wales. Many of these are shown with a symbol of a lodge or house attached. One difficulty of assessing the number of parks at any period is the fact that after a piece of land has been disparked, the word park is often retained in the place-name, as happened for example with the Great Park at Petworth when it reverted to farmland in 1610. Whatever the truth of their numbers, it is certain that parks were the focus of much activity at this period and that many were made and unmade within a generation. Often this was a reflection of the changing fortunes of their owners. Parks seldom brought in sufficient revenue to cover the cost of their upkeep and for this reason were always vulnerable to economic pressures. Nevertheless they still remained a sufficiently significant feature of the English countryside for William Harrison, the sixteenth-century historian, to write:

> In every shire of England there is great plenty of Parks, whereof some here and there, to wit, wellnear to the number of two hundred, for her daily provision of that flesh appertain to the prince, the rest to such of the nobility and gentlemen as have their lands and patrimonies lying in or near unto the same. I would gladly have set down the just number of these enclosures to be found in every county, but, sith I cannot so do, it shall suffice to say, that in Kent and Essex only are the number of an hundred, and twenty in the bishopric of Durham, wherein great plenty of fallow deer is cherished and kept ... generally enclosed with a strong pale ... the circuit of these enclosures in like manner contain oftentimes a walke of four or five miles, and sometimes more or less.[47]

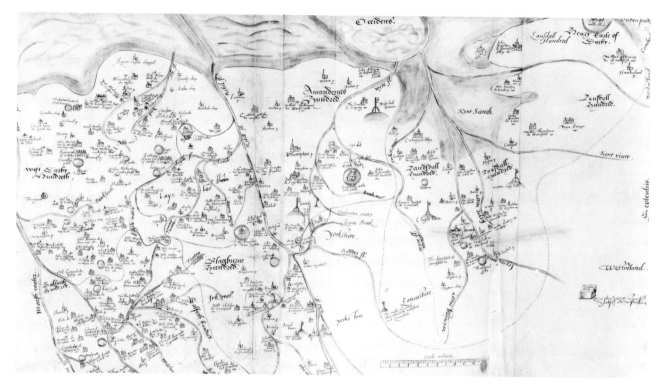

Lord Burghley's map of
Lancaster, 1590. The purpose
of this map was to mark the
homes and parks of Catholics.
In Elizabethan England,
Catholics were thought of as
fifth-columnists who might
use their parks to harbour
arms.

Pleasure, as Burghley had said, was the purpose of the country house.
Like the Italian *villeggiatura* of the Cinquecento, the lifestyle generated by
the English country house and its estate marked the beginning of what has
come to be thought of as a particularly English type of genius, a unique
talent for country living. Domestic peace and greater prosperity had
brought leisure. Landowners began to learn about gardening, agriculture
and husbandry, and field sports in general. Intellectual pursuits were not
yet fashionable – 'the study of letters should be left to the sons of
rustics'[48] – but sons of the nobility and gentry were recommended to
'learn to blow the horn nicely, to hunt skilfully and elegantly, to carry and
train a hawk'.[49]

Behind some of this advice lay new attitudes to health. The relationship
of exercise to health was frequently noted by Francis Bacon in his essays
on both the body and the body politic – 'No body can be healthfull
without Exercise'.[50] For him the site of a house should be chosen with the
occupants' health in mind – ' . . . it is an ill Seat', he wrote, 'where the
air is unwholesome; but likewise where the air is unequall . . .'[51] He did
not approve of the current fashion for setting a house on a 'knap' – the
summit of a hill – exposed to the elements. For Andrew Boorde, the most
famous physician of his day, east–west was the healthiest way to site a
house, and a 'beautiful prospect' was 'a matter of comfort and rejoice'.[52]
Henry VIII appreciated his 'Auncyent castels' for being places 'with good

eyre for our resort and pleasur'.[53] 'Nothing so refreshed a man's spirits as a garden,' said Sir Francis Bacon, and 'buildings and Pallaces without a garden are but Grosse Handy-works'.[54] Likewise the landscape of the chase was praised as much for its 'goodly green and pleasant woods . . . as no less pleasant and delightful in the eye of a prince than the view of wild beasts of forest and chase . . . '[55]

Another growing pastime, which subsequently became a national characteristic, was walking. Walks had become a major feature in gardens and were to become so in parks. From Tudor and Elizabethan times walks were created indoors and outdoors. There were exercise galleries inside the house for inclement weather, more perilous walks on the roof, raised walks in gardens and rougher ones in woods and parks. Queen Elizabeth added a raised terrace walk to Windsor Castle where she walked daily one hour before her dinner if it was not too windy.[56] At Petworth in 1557 there was a paled piece of ground within the larger park called Arbour Hill ' . . . which hath in it divers pleasant walks divided with quickset hedge used to be cut'.[57] Walks also began to be laid out in towns. In Gray's Inn during the 1560s the ground was levelled and a railed walk was laid out in the Field, Francis Bacon again being among those credited with the inspiration for this undertaking. The fields were enclosed, gardens were developed, and the walkways were gravelled. These were among the first walks in London, though they were not public, being for members and their guests only. In James I's reign Moorfields was also levelled and turned into tree-lined walks. It has the distinction of being credited as London's first civic park. Frequented by the fashionable part of the citizens, it was known as the 'City Mall'.[58] There were walks in churchyards in many provincial cities such as Norwich or Shrewsbury, a tradition continued in cemeteries during the nineteenth century.

In the country, however, hunting remained the pre-eminent exercise for Tudors and Elizabethans of both sexes. As forests diminished and more land was given over to agriculture, deer had to be restrained from eating the crops by being kept within the park pale. The park thus became an even more important hunting ground.

Hunting was as much a spectator sport as one to participate in. The high point was of course the kill, the privilege of the most illustrious person present. When Henry VIII grew too fat to ride, he restricted himself to park hunting, and would stand, as had his ancestors, waiting for the deer to be driven at him, whereupon he would shoot them with a crossbow (this in spite of his dismay at the demise of the longbow which he formerly used and considered the real weapon of a sportsman).[59] Queen Elizabeth similarly hunted in parks, especially in her old age, and liked to shoot her deer to the accompaniment of songs and music played by her court musicians. At Nonsuch as at Petworth, she would wait for the deer on a camouflaged platform in an enclosure within the park. This 'battue'

system of beating and driving deer from their cover gradually fell into disuse, as did some of the more barbaric customs developed at the time; Blome recorded that sometimes when a deer was selected for hunting, it would be shot in the foot to maim it before it was driven round and round the park.[60] The point of such practices was convenience and the certainty of a quarry, presumably an advantage when certain guests and foreign dignatories were being entertained. Such sport was as much a ceremony intended to enhance the prestige of the monarchy as it had been in ancient times. Old tapestries show the magnificent costumes which men and women wore to view the chase, equivalent to what might be worn today to attend a gala performance at the opera.

'A keeper [in a park] choosing a fatt buck to be Shot and run downe'.

Parks had long been used as breeding places for horses; needless to say, a matter of great consequence at a time when horses were essential to both the army and transportation. In this period it became a park owner's duty, sometimes his obligation, to breed horses. In 1536 Henry VIII passed an act to encourage it. In 1577, during Elizabeth's reign, those who had 'inclosed grounds' were charged to keep mares for breeding, the number depending on the extent of the area; thus 'every man that hath a Park of his own, or in lease, or in keeping for term of life of the compass of one mile, shall keep in the same two mares, and every man that shall have a Park of the compass of four miles, shall keep four mares', and so forth.[61] In 1581 a list was compiled in Norfolk expressly to establish the number of horses kept in the parks of that county.[62] Various other encouragements for horse breeding were devised; the most popular, by the end of the Elizabethan period, being the new sport of horse-racing. Many parks became famous for their racecourses, and by the end of the seventeenth century no aristocrat worth his salt was without his thoroughbred racehorses and their panoply of pedigrees.[63]

Another role of the park was to provide the means of a special kind of patronage – gifts of deer alive or dead. Such gifts, formerly a royal and aristocratic prerogative, were now within the reach of others who could dispense them as rewards for services rendered. When deer hunting as a sport declined in the mid-eighteenth century this custom was revived, with culled venison distributed by royal warrant. It survives in token form to this very day.[64]

However, William Harrison complained that parks were not exploited

commercially. Certainly the deer park in the sixteenth century was designed for sport rather than profit, the more utilitarian functions tending to be skilfully disguised. As Dr Williamson says, status was indicated by the park's lack of practical purpose and its separation from the agriculture and labour of the rest of the estate.[65] Harrison's complaint was that such an extent of ground should be employed purely for pleasure. He considered a park a

> vain commodity which bringeth no manner of gain or profit to the owner, sith they commonly give away their flesh ... for venison in England is neither bought nor sold as in other countries but only maintained for the pleasure of the owner and his friends ... Where in times past many wealthy occupiers were dwelling within the compass of some one park, and thereby a great plenty of corn and cattle seen and to be had among them ... now there is almost nothing kept but a sort of wild and savage beasts, cherished for pleasure and delight; and yet some owners, still desirous to enlarge those grounds, as either for the breed and feeding of cattle, do not let daily to take in more, not sparing the very commons whereupon many townships now and then do live ... the twentieth part of the realm is employed upon deer and conies already ...[66]

However Harrison was not entirely correct, for the sale of underwood and the felling of trees to sell for timber continued even in parks, although concern over the rapidly depleting stock of trees had been registered since the end of the fifteenth century, leading to various acts of Parliament throughout the Tudor period to try and regulate felling and planting. The Statute of Woods of 1544 laid down certain regulations requiring, for example, the preservation of twelve standard trees per acre, and prohibiting the conversion of coppice and underwood to arable and pasture. Nonetheless demand for timber led to serious shortages before the end of the Tudor period. The idea that trees needed to be replaced to ensure an ongoing supply was slow to emerge, and landowners such as the ninth Earl of Northumberland suffered the consequences; after neglecting his trees at Petworth, he was to write regretfully to his son that 'Instead of preserving woods that might easily have been raised, the memory of good trees in rotten roots doth appear above ground at this day; being forced now for the fuel relief of your house at Petworth to sow acorns, whereas I might have had plenty if either they had had care or I knowledge'.[67]

In earlier times hunting had led to the preservation of trees in the vast and often wooded tracts of the royal forests, by placing the needs of the chase over those of agriculture. Disafforestation led to the reduction of woodland as increasing numbers of trees were felled to supply timber for houses, ships for Henry VIII's expanding navy and for a growing variety of industries. In 1629 thirty thousand oaks were said to have been felled

in Durham belonging to one man alone. At Higham Park, once extensively wooded, countless numbers of trees were felled in the fourteenth and fifteenth centuries, and by the sixteenth century timber actually had to be bought in to carry out repairs to the castle and other buildings. Finally in the Civil War the fences of the park were broken down; the timber trees, woods and all the deer were destroyed, and the soil was converted into arable land and pasture. Shortage of timber was one of the reasons why stone replaced timber in building. Trees had given way to cattle.

Writers on agriculture and husbandry joined in the chorus recommending both preservation and planting. Gradually plantations of straight rows of trees bisected by great swathes of grass made their appearance in the topography of parkland. The first of these was said to have been at Windsor, where thirteen acres were sown in 1580 on the instructions of Lord Burghley.[68] After the Civil War, when the shortage of trees was becoming critical, and John Evelyn exhorted landlords to address it, such plantations became ubiquitous.

By the end of the sixteenth century there was little land remaining in its natural state. Few would-be park owners were able to find virgin soil, as Henry Cheney had back in 1563, when he enclosed the unclaimed heathlands of Woburn Sands to make a new park at Toddington.[69] More often than not emparking now meant the destruction of previously cultivated arable land with all its attendant problems, and the enclosure of wastes and commons, which deprived the poor of their firewood, and was just as contentious as it had ever been.

Again, it was not just land which succumbed to the park. Whole villages were often removed and roads diverted. At Wilton Sir William Herbert was said to have enclosed several tenements into his park, while Guy Willistrop was accused of destroying the whole of Wistrop town for his park.[70] Violence frequently accompanied emparking; it broke out at Stoke Moor Park when Sir John Rodney enclosed two hundred acres of common land, pulling down several tenements and taking land from his tenants. There were similar protracted disturbances at Petworth. Even when emparking was carried out by agreement between, for example, common field tenants and their lord (a process known as enclosure by composition), and adequate compensation was paid – the case in many instances – it was still unpopular among country people. This was perhaps, as one commentator concludes,[71] because the purpose was pleasure: precisely the criticism which had been levelled by William Harrison.

But despite their unpopularity with the people, and despite the disparking of large numbers of them for economic reasons, parks continued to be formed. Many of the most famous deer parks were created or extended in the sixteenth century to complement the great houses such as Wollaton, Compton Winyates, The Vyne, Charlecote, Clarendon, Hardwick, Osterley, and many others built at this time.

4

RISE AND DECLINE:
The Park from James I to the Commonwealth

In 1617 the diarist and traveller Fynes Moryson observed that 'The English are so naturally inclined to pleasure, as there is no Countrie . . . wherein the Gentlemen and Lords have so many and large Parkes onely reserved for the pleasure of hunting, or where all sorts of men alot so much ground about their houses for pleasure of gardens and orchards'.[1] He reckoned that any man who had an income of between five hundred and a thousand pounds had a deer park.

The prime recreation in the park remained hunting. The daily hunt was a habit with many landowners, no doubt in imitation of their monarch. Increasingly the hare or more humble fox, rather than the stag, was the quarry, though for both James I and Charles I deer hunting remained supreme. On his accession, James I was said to have taken a month for his progress from Berwick to London, hunting in the parks of his hosts on the way, lecturing on the art of venery, and demonstrating his prowess in blowing a mort, the note sounded on a horn at the death of a deer. If he found a park too small for his hunting, or understocked as he clearly found that of the Earl of Westmoreland, he did not hesitate to order its enlargement. The earl empaled a further three hundred and fourteen acres at Apethorpe, and the king presented him with gifts of deer to stock the park.[2] Likewise James I enlarged his own parks, extending and walling the old deer park of Greenwich (emparked in 1433)[3]; adding nine and a half miles of wall to Theobalds, acquired from his chief counsellor Robert Cecil (Burghley's son) by forcible exchange for Hatfield; and adding one hundred and sixty-eight acres to Bushy Park.[4]

At the same time, however, he continued alienating Crown lands for revenue, and by 1609 the number of royal parks, which in any case had steadily declined under Queen Elizabeth, was little over one hundred.[5] Charles I also continued the practice, though his passion for hunting led him to enclose two thousand acres to form Richmond Park on the model of a medieval deer park and in a manner as autocratic as a medieval king.

It has been said the enclosure of Richmond Park was instrumental in his impeachment; in any case it was carried out in the face of opposition from Archbishop Laud downwards. Though the king owned some of the wastes and woods which lay within the proposed park, and had purchased the estate and manor house at Petersham, much of the land was owned by others. Those who refused to sell were threatened with dispossession, and the king went ahead and enclosed it in ten or twelve miles of brick wall. Walls gave a greater sense of privacy than pales, and were preferred by their owners for that reason, thereby creating even greater hostility among those whom they were designed to keep out. Pulling down the walls of the royal parks in London in the nineteenth century and replacing them by railings was regarded by the reformers of the day as a symbol of democracy triumphing over privilege. Richmond Park was begun in 1636 and finished in 1638. It was called variously Richmond New Park (the Old Park at Richmond became Kew Gardens), or Richmond Great Park. Over three hundred years later a scandalous royal indulgence turns out to be London's blessing: a miraculous illusion of country, albeit partially compromised now by the high buildings bearing down on it from Roehampton Estate.

The waning of deer hunting outside the court circle was caused by a number of factors. Fewer people could afford to maintain more than one or two of the many parks that had been the pattern of holding hitherto. Even fewer could afford to do it in the style of the flamboyant Lord Berkeley who with his wife and an entourage numbering 150 – he never travelled with less – spent thirty or so summers from 1559 on a progress of buck hunting through the parks of 'Barkewell, Groby, Bradgate, Leicester forest, Toley and others ... and after a small repose ... to the parks of Kenilworth, Ashby, Wedgenocke ... not omitting his own at Callowdon and in the county of Gloucester'.[6] The deer parks which survived tended to be on the principal seat of a great landowner.[7] Even the Dukes of Norfolk found it hard to keep their parks, and during the seventeenth century seven were disparked in Norfolk alone.[8] Among others disparked at this time were Petworth Great Park, Alnwick Park, Bigstock Great Park, Sudeley Park, Loughborough Old Park, Harringworth Park and Harrold Park.[9]

Deer require space and were always expensive to confine. Progress in agriculture removed their cover, as land was ploughed or turned to pasture for the more profitable sheep which many park owners could not resist. It has been computed that by 1617 for every deer in the forest of Pickering there were five thousand sheep.[10] Cattle were also replacing deer in parks, as Robert Carew's Survey of Cornwall carried out in 1602 made clear: 'Deere leap over the pale to give the bullockes place.'

Then too, there was the introduction of firearms at the end of the sixteenth century which made poaching – already rife – far easier,

resulting in fewer deer. Despite the harsh game laws introduced by James I to protect deer from poachers, under which an income from land of over one hundred pounds a year was required in order to hold a gun – a law, as in earlier times, intended to rule out all below the gentry – the numbers of deer still declined.

James I combined his sporting enthusiasms with an equal love of scholarship, and like Henry VIII, set the tone for his circle to follow. With the development of the 'gentleman', learning had ceased to be solely the province of clerks and clerics. The image of the 'barbarian baron' of medieval times or the hunting Tudor lord was largely laid to rest, at least until the nineteenth century, when Matthew Arnold resurrected the term in accusing the upper classes of intellectual barbarity.

In the early seventeenth century, London was the centre for intellectual ideas as well as cultivated society, and was a magnet for members of the aristocracy and gentry who were bored with the isolation and monotony of country life. Assisted by the development of the private coach they drove to London in growing numbers. Many acquired town houses, and entertainments developed to meet their needs. Sir Humphrey Mildmay recorded in his diary how he went to the theatre, to wrestling matches, played dice and cards, besides swimming, boating on the Thames and sometimes going 'a maying in Hyde Park to see the ladyes'.[11] However, the king disapproved of the gentry leaving their estates, denouncing those 'who at the instigation of their wives did neglect their country hospitality and cumber the city'.[12] Several Proclamations were issued in an endeavour to stem this influx into London, which was adding to its growth and bringing with it the attendant problems of overcrowding and disease. Charles I also censured attempts by some country ladies who tried in 1632 to parade in the park. Like his father he issued a Proclamation requiring them to return to the country. When they disobeyed, some two hundred and fifty of their husbands were prosecuted.[13] Despite his attempts to stem the tide Charles I himself added to the attractions of London by officially opening Hyde Park in the early 1630s and building the Ring – a semi-circular carriage track and racecourse, of six hundred and twenty-one acres[14] – so beginning Hyde Park's long history as a focus of fashionable life.

There was as yet no London Season but the idea had been born. Records of a race in Hyde Park in 1635 in which it is said that the course 'was to be run over in the usual way',[15] suggest that such races were indeed already common practice. That Hyde Park was a part of the public scene was also made apparent by a comedy of the name written by John Shirley in 1637 in which a race in the park is the main theme.[16]

One of the first people to promote the idea of a park as a public venue had been Bishop John Vesey at Sutton Coldfield near Birmingham, who bequeathed his park to the people of Sutton Coldfield. He was tutor to

Mary Tudor, and had been given the manor, chase and park of Sutton Coldfield by Henry VIII at the time of the dissolution. His bequest was an act of philanthropy to help ameliorate the hardship which many people, previously employed by the monasteries, had suffered at their closure.[17]

Queen Elizabeth had held military reviews in Hyde Park to which spectators were admitted, and it was perhaps she who began the gradual admittance of the public to royal parks, though in Charles I's reign it was still a limited privilege, as is clearly shown in a Proclamation of 1637 whose purpose was ' . . . to restrain the making or having of Keys for any [sic] His Majesties Houses, Gardens, or Parkes, without speciall warrant'. No locksmith other than the king's own was allowed to make keys for any of his parks, which included the following: 'the parke of St James' . . . Hyde, Maribone, Windsor, Oatlands, Hampton-Court, Richmond, Nonsuch, Greenwich, Eltham, Theobalds, Enfeild, Havering, or of any other of his Majesties Parkes of the like distance from Whitehall'. His locksmith was further charged not to make locks or keys for any of these parks except under special warrant from the 'principall commander in charge of each park'. Transgression would result in the 'severest punishment of the offenders'.[18] This suggests that the public were a highly selected key-holding class from the outset and probably only allowed in certain sections even of Hyde Park. Richmond, where the king was said to have been forced to open the gates to the public from the beginning, came under the same restrictions. Hyde Park, like Richmond Park, was still primarily a hunting park and the king even built a 'grand hunting lodge' there in 1634–5, possibly designed by Inigo Jones.[19] Full public admission seems unlikely under these circumstances.

Despite the growing attraction of London the roots of society remained firmly embedded in the country, with life for the landowning class centring around the country estate. Agriculture was still the main employer, its rhythms determining the patterns of life far beyond its compass. The long vacations of universities and the law courts, for example, corresponded in time with the harvesting season.

An easy retreat from London was becoming as important as the ease with which one could reach it. The rapid growth of London had already earned it a reputation for being an 'unhealthy and stinking city',[20] borne out by the plague of 1625. Smoke-laden air from the burning of coal made easy access to the country even more desirable, and country estates with their houses and parks continued as they had since the late middle ages to be concentrated in the Home Counties. By the early eighteenth century Daniel Defoe wrote of the ten miles from Guildford to Leatherhead, Surrey, that there was a continuous line of gentlemen's houses with ' . . . their Parks, or Gardens almost touching each other'.[21] Sussex, where there were fewer roads, developed later. Francis Bacon, whose father had

built Gorhambury in Hertfordshire as relief from the pressures of London, built close by a summer retreat called Verulam House for the same purpose. He gratefully acknowledged these refuges, writing: 'I am now gotten into the country to my house, where I have some little liberty to think of that I would think of, and not that which other men hourly break my head withal, as it was in London.'[22]

Renaissance civilisation, which had entered England with the Tudors largely via France and the Low Countries, now flowed directly from Italy, ushered in by Inigo Jones with the Queen's House at Greenwich, the first

Greenwich from One Tree Hill: attrib. J. Vorsterman, c. 1680. This painting shows Inigo Jones's solution to siting the house in the park. One elevation stands in the park while the other stands in the garden of the old palace, which thereby allows the

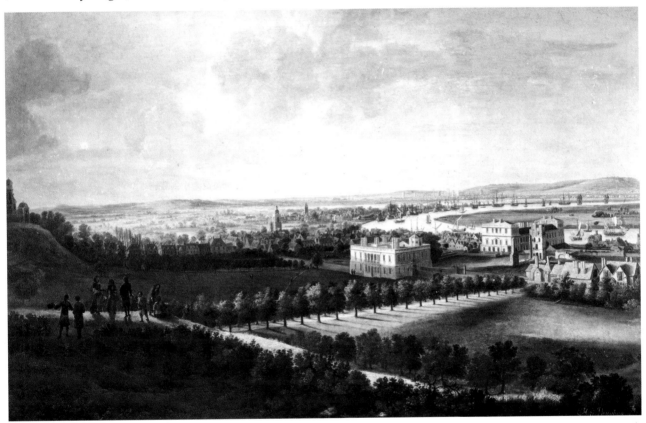

Palladian building in England. The old palace here was divided from the park by a public road, which Jones now straddled with his new building, thereby ingeniously satisfying the current desire to set buildings in the park itself.

Architecture in general, and the new country houses in particular, were arguably the greatest expression of the Renaissance in England at this time. Of equal importance with the buildings themselves, were the gardens and parks surrounding them. From the time of James I until the Civil War gardens were used as settings for grand parades, spectacles and fêtes. They continued to be designed as a complex sequence of vast walled

highway to run through the two halves. Thus the monarch could view the slaughter of the deer hunt in the park as if he or she was in a box at the opera.

rectilinear compartments laid out with terraces, gravelled walks, embroidered parterres (level pieces of ground on which elaborately shaped beds were planted with flowers in geometric patterns), fountains, statues and grottos. Sometimes the ground plan of these gardens not only exceeded that of the house but also threatened to engulf the park itself, as it increasingly appropriated acres that would otherwise have been designated part of the park.

Gardens were still enclosed behind high walls, and the only means of seeing out was from a mount, as in a Tudor garden, or a gazebo set high in one corner of the wall, or else from a raised terrace. At Wilton in 1632 a balustraded terrace was built on the perimeter of the garden, not only to view another garden lying below but also to look out into the park.[23] It was this desire for a view that later brought an end to the medieval tradition of the enclosed garden, the *hortus conclusus*.

As a principal component of this view, the park now began to be more consciously 'designed'. Stately avenues, bosquets, long 'allées' (walks), grottos, cascades, canals, even terracing as in the garden, began to overlay the rough hunting landscape of pales, ditches, deer leaps, woods and launds. Some of these features can be seen in an exquisite set of drawings of Albury Park, Surrey, made by Wenceslaus Hollar in the late 1630s. The art of topographical drawing and landscape painting was only just beginning, though these extraordinary drawings would be unique as representation of landscape at any period. Formal elements, such as a terraced walk in front of a great Italianate grotto, are shown here

Albury Park, Surrey, one of six views: W. Hollar, 1645. Hollar drew these while in exile during the Civil War. They were nostalgic evocations of Albury as it was in the late 1630s.

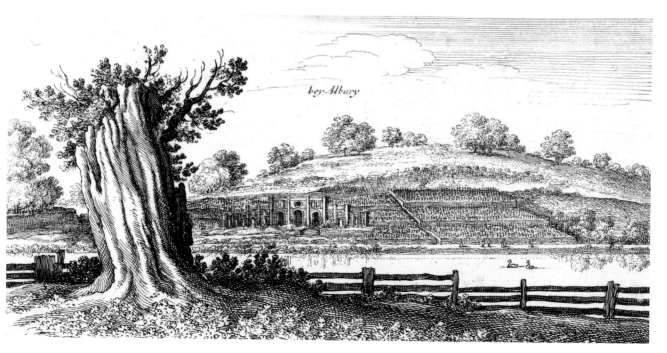

overlaying a deer park with a naturally contoured lake and irregular clumps of trees. A ruined tree is portrayed as a romantic evocation. The whole imagery anticipates or might even be mistaken for the idyllic landscape of an eighteenth-century park.

'Designing' the park and extending the formality of the garden into it was partly an expression of a desire to control nature and thereby add dignity to the landowner's seat, and partly also a means of extending views from the house and garden by creating vistas. The trend for planting long straight avenues, or lines of large forest trees leading through the park to the garden wall, or even all the way to the entrance court, developed rapidly during this period, becoming yet another distinctive sign of aristocracy. Audley End, built by the Earl of Suffolk in 1603–16, had an avenue of double rows of lime trees which led to the great entrance gateway. In 1611 James I replaced an already existing avenue in Hyde Park with one of two hundred lime trees. Another was planted at Buxted in 1630, and a map made in 1638 shows three more planted at Wimpole,

Map of Wimpole Parish: B. Hare, 1638. Drawn before Thomas Chicheley's alterations in 1640. It shows a moated manor house, a small deer park divided in two parts, one of which has three avenues of trees. The park is bounded by a pale and hedge, and on the north side a deer bank which is still to be seen today.

William, 2nd Earl of Salisbury: G. Geldorp, 1626. The earl is portrayed in Elizabethan costume after his illustrious Elizabethan ancestors. In the background is Hatfield house and park created by his father Robert Cecil, who died in 1612 just after its completion, but before he could move in.

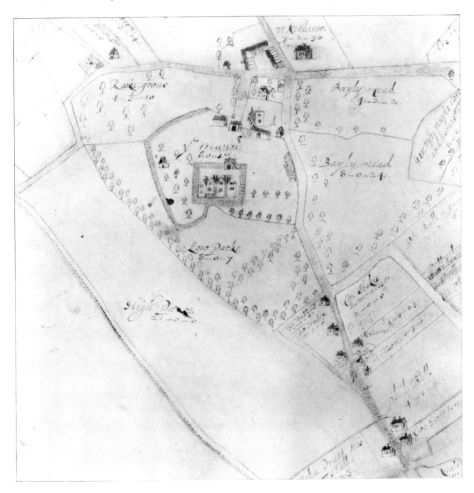

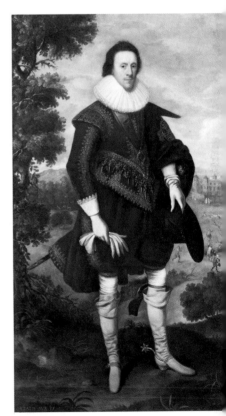

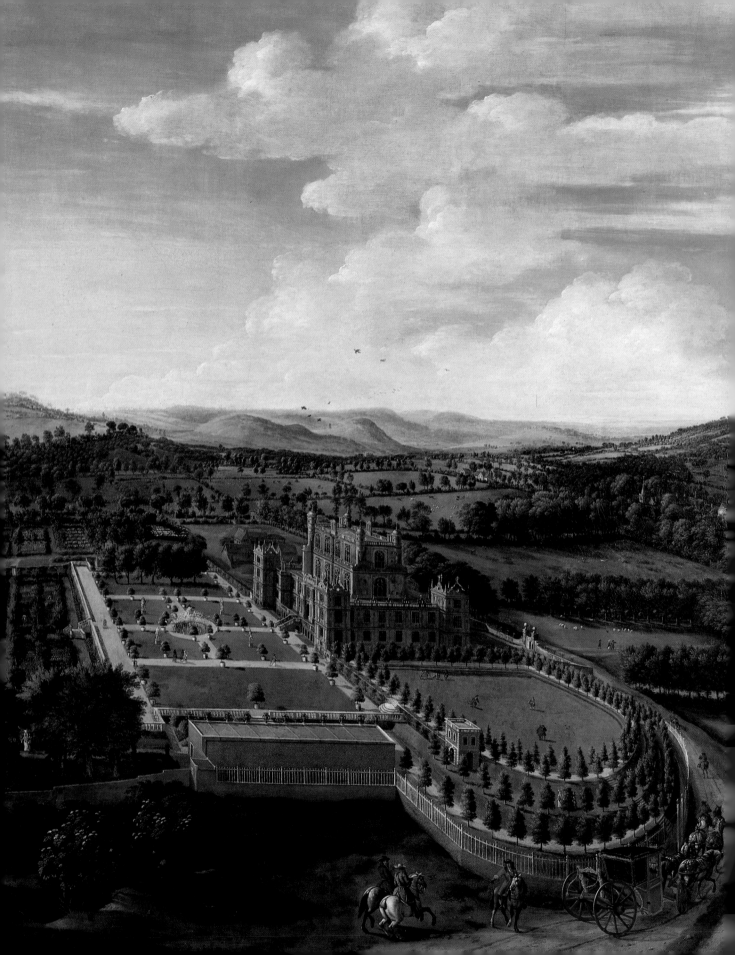

One of the earliest estates where the park was a part of the whole layout had been Robert Cecil's new house at Hatfield in 1607. There had been parks at Hatfield belonging to the Bishops of Ely since the early thirteenth century.[24] Henry VIII expropriated Hatfield at the dissolution and it remained a royal seat until Robert Cecil acquired it in exchange for Theobalds (his father's property) at the behest of James I. Cecil sited his new house on a prominence just inside the park known as 'Little Park'. He employed, among others, John Tradescant and the French gardener and hydraulic engineer, Salomon de Caus, to lay out his grounds. In order to have greater privacy he bought out the tenant farmers and turned their fields into parkland, thereby altering the whole surrounding countryside[25] to give a 'Prospect of nothing but Woods and Meadows, Hills and Dales', in the words of Samuel Sorbière, a French visitor to Hatfield.[26] The park was then planted with avenues of trees in double rows to create long walks and vistas. These, too, were described by M. Sorbière: 'When you come through the Chief Avenue to the Park Side, and when the Gates of the lower Courts are open, there are Walks present themselves to your View that reach to the further end of the park and make you lose your Sight.'[27] The trees were planted on sight lines projecting from the north and south of the house. This was an early attempt to connect visually the house and garden with the park, and an attempt also to exploit the new science of perspective. By planting avenues a link had been made between the fiercely formal garden and the 'natural' features of the park. Pre-empting the eighteenth-century landscapists as Lord Hertford had with his crescent-shaped lake in 1591, an artificial river was created outside the formal gardens and made to look quite natural. This, as Roy Strong suggests, was probably inspired by classical villa gardens as described by the younger Pliny.

Caus was also employed to transform the gardens of Somerset House, Greenwich and Richmond Palace for, respectively, James I, Queen Anne of Denmark and Henry, Prince of Wales. He and his brother Isaac were the first of the great French gardeners to come to England and influence the development of its gardens, and they were soon followed by the equally influential André Mollet (son of Claude Mollet, the gardener who trained Le Nôtre at the Tuileries).[28] Caus had seen and studied the Italian mannerist gardens, with their long vistas and surprises, and learnt about hydraulics, the science of controlling water and its use for ornamental effect. Under his influence water became a prominent feature of seventeenth-century gardens and parks.

As one writer has put it, 'The garden was an antechamber to the park, the whole landscape became a frame for the house and a status symbol.'[29] It was no coincidence that the term landscape began to be used in the seventeenth century, a term derived from the Dutch *landskip* paintings of the period. Although avenues began to be planted in parks, few yet were

Wollaton Hall and Park, Nottinghamshire: J. Siberechts, 1697. The painting is about a century after it was built. Soon the great house, like many of its contemporaries, lay in a circle of radiating avenues of trees, satisfying the dual purpose of 'setting off the house' and providing a sound investment in timber.

Badminton House,
Gloucestershire, from the
north: H. Danckerts, 1670s.
By aligning the trees either
side of the house, a visual
connection between house
and park was achieved.

axially planned with the house and the garden. Hatfield was an early attempt, but the sight lines to the east and west became lost in the less than clear interrelation of the different gardens. The Renaissance principle of house and garden as an integrated architectural concept, with the garden related axially to the house, was slow to be adopted in England, as was the principle of symmetry. Neither the great gardens of Henry VIII nor the Elizabethan gardens of Theobalds or Holdenby were structurally planned as a whole or aligned with their palaces. They consisted of separate geometrically planned entities or compartments, loosely linked together. Robert Smythson had been the first to align the house and garden in England when he built Wollaton for Sir Francis Willoughby, begun in 1580 and soon known as 'Willoughby's folly'. There he 'combined the house, gardens, courtyard and outbuildings around it in one scheme of fourway symmetry'.[30] The next step, as at Hatfield, was to try to extend this symmetry into the park by means of avenues and lines of trees; the result being a somewhat pale imitation of the great French axial gardens of the

sixteenth century. At Badminton, before the great axial tree planting of the 1690s, attempts at symmetry were made by planting two avenues on either side of the house.

The advent of civil war inevitably brought garden and park-making to a standstill. Parliamentarians tended not to be well-disposed towards parks and gardens, since so many of them had been created by royalists, and were in a sense symbols of monarchy – 'nature tamed by the royal will'.[31] Many parks were destroyed, their pales torn down for firewood, their trees uprooted for timber and their deer let loose. When the episcopacy was abolished in 1646 Parliament sold off the lands of bishops to pay the army. Lands of royalist supporters and rebellious clergy were confiscated. After the abolition of the monarchy and the execution of Charles I, Parliament took over the administration of Crown lands, with the object of selling them. An Act was passed in 1649, authorising the surveying and valuation of all the royal estates, together with church lands, for that purpose. The aim was to keep the Commonwealth solvent

by making good the annual deficit of four hundred and fifty thousand pounds. Some lands were spared for the use of the public under the Commonwealth, notably Charles I's New Park at Richmond, which was to be given to the City of London 'as an act of favour from this House for the use of the City, and their successors'.[32] But this tended to be the exception. On 9 July a warning came from the Council of State: 'To report to the House that the Act for the sale of the king's parks for securing the soldiers' arrears, ought to be speedily passed, it being of very great importance'.[33] Fines were also levied on royalist supporters, who often had to sell their parks and farms to pay them.

One beneficial development which this sale of land led to was in the field of surveying. Every estate had to be surveyed and valued before it was sold. During the Commonwealth period the Surveyor General, Colonel William Webb, devised a specimen survey based on an imaginary manor as a model for other surveyors to use, giving the science some uniformity of method. This manor he called the Manor of Sale, in the County of Surrey. Taken as a typical example of a manor it throws some light on what was considered an average park at the time. Of a total of 1,360 acres of land on the manor, nine hundred were described as park. These were subdivided into three parts of 450, 150 and 350 acres whose income, if let, would yield respectively three shillings, four shillings, and five shillings and sixpence per acre – a greater yield than if left undivided. There were four thousand five hundred trees valued at nine hundred pounds or four shillings each, and of these the navy claimed 1,650 for shipbuilding.[34] Numerous surveys of land were based on this model and nearly always some timber was reserved for the navy.

In all, ninety-three parks were surveyed and sold at this period. These were divided into three groups of which thirty-eight were metropolitan, forty-six extra-metropolitan, and nine in the Borderlands.[35] Among them was Lancaster Great Park, Sussex, its fourteen thousand acres parcelled out in lots together with its nine lodges. Enfield Chase was also sold. Holdenby, which had become a royal palace, was destroyed and its five hundred acre park disparked, as were one thousand acres of Sedgwick Park. Nonsuch Little Park and Great Park, Marylebone Park, Oatlands Park, Higham Park, Theobalds House and Park, Windsor Little and Great Parks, were all sold. At Hampton Court, Bushy Park and Hare Warren were similarly sold. However, when in 1653 Parliament decided to grant the palace as a residence to Oliver Cromwell, the parks – along with the furniture, hangings, and so forth – were quickly bought back.[36] This is the reason that Hampton Court survived while so many others did not. Bowood, Clarendon and Hyde Park were divided into five or more lots for sale. Hyde Park was sold in five lots to three owners. Many were bought whole to be resold in lots. It was a watershed in the history of the park.

5

THE RESTORATION:
A Return to Park-Making

With the Restoration came a return to garden and park-making. Many of the parks confiscated from the Crown and its supporters during the interregnum were returned to their former owners, though often in a state of devastation. Deer were so scarce that royalists ransacked republican parks to replenish their own. The king even bestowed a baronetcy on a gentleman from the Isle of Ely, who gave him deer for restocking his parks.[1] Deer hunting once again became the favoured sport among the higher echelons of the aristocracy.

Property remained a key to power. Estates grew larger;[2] the smaller landowner with no other source of income, hit by land taxes and low prices for agricultural produce, sold out to larger ones who often had other sources of income. Laws of inheritance were tightened so that those who inherited under primogeniture could not sell or divide their estates. This system was known as Strict Settlement, and only a private act of Parliament could break it.[3]

There were 160 peers and eighty to a hundred non-aristocratic landowners who owned more than ten thousand acres apiece.[4] A hereditary ruling class was restored which ran the administration of the country. Republican sentiment gave way to a renewed worship of birth, title, and all the attendant pageantry. A country estate was once again the aspiration of anyone with wealth. Those who could bought land, or better still, married into the landowning classes.

While hunting of all kinds was once again the major activity in parks, two other factors determined the way parks were to evolve during the next fifty or so years. One was a campaign to plant trees to replenish the diminished stocks, and the other, which the Civil War had interrupted, was to continue to make the park an appropriate adjunct to the house and its formal garden. Happily the two were compatible, the one instrumental in achieving the other.

Tree planting was in part a response to a national clamour. The stock of

52 T H E E N G L I S H P A R K

trees had been drastically diminished by the ravages of war, and was further depleted by the bad management which followed, as well as the growing demands of the iron furnaces. (It was in fact only the introduction of coal which finally prevented the complete destruction of the trees of England.) A number of storms were also to take their toll, and this kept up the impetus to replant. Pepys mentions the loss of one thousand each of oaks and beeches in one walk alone in the forest of Dean in 1662.[5] He tells of another 'dreadful storm' hitting the country in 1665.[6] John Evelyn records one in 1690, with a number of trees uprooted. And on 26 November 1703, there was the Great Storm, the like of which seems not to have hit England again until the night of 16 October 1987. The greatest damage was to trees. Rows of elms, great oaks and beeches were blown down, and whole orchards uprooted. Evelyn records '3,000 brave oaks, in one part only of the Forest of Dean blown down; and in New-Forest in Hampshire about 4,000; and in about 450 parks and groves, from 200 large trees to a 1,000 of excellent timber, without counting fruits and orchard trees *sans* number'.[7] Sir Edward Harley lost thirteen hundred trees, and Evelyn himself over two thousand: 'As to my own losses, the subversion of woods and timber, both ornamental and valuable, through my whole estate, and about my house the woods crowning the garden mount, and growing along the park meadow ... is almost tragical, not to be paralleled with anything happening in our age. I am not able to describe it; but submit to the pleasure of Almighty God.'[8] Daniel Defoe set out on a tour to assess the damage and counted seventeen thousand trees down in Kent before he gave up 'from weariness'.[9] He recorded twenty-five parks that had each lost over four thousand trees, and corroborated Evelyn's figures on the 450 parks and groves which had lost between two hundred and one thousand trees respectively.[10]

Evelyn, who at the time of the Restoration was already a noted gardener, as well as a royalist, and who had initiated the campaign to plant trees, declared after this storm that he would dedicate the rest of his life to the service of arboriculture. In the event he lived less than three more years, and it was left to Joseph Addison, one of the first of his followers, to convince recalcitrant members of the upper classes of Evelyn's wisdom. In 1714 he was suggesting they spend less time following the chase and more time on the nobler pursuit of planting, tempting them, as Evelyn had previously, with the thought that by so doing they would not only enhance their estates but also enrich their purses.[11]

Charles II was in the vanguard of the campaign, planting six thousand elms at Greenwich in 1664, the same year that Evelyn planted elms on his estate, Sayes Court.[12] A shortage of oaks for ship building had prompted the Commissioners of the Navy to consult the newly formed Royal Society for Scientific Enquiry, and in 1662 John Evelyn was invited to address the Society on the subject of forest trees. His disquisition was published by the

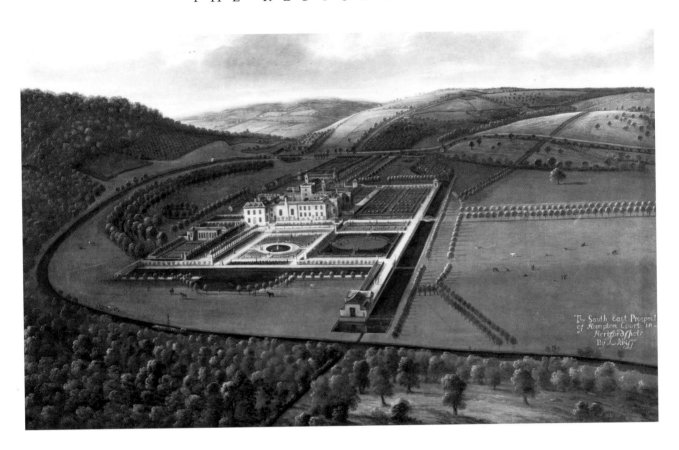

Society two years later, under the title of *Sylva, or a Discourse of Forest Trees*. Addressed to 'gentlemen' as opposed to 'rustics' (his words), it ran to four editions in his lifetime, and several more later. Although not the first book on the subject, it was probably the most influential in its time.

Evelyn used every ploy he could to encourage landowners to plant. He appealed to their sense of national pride, arguing that they had a patriotic duty to plant trees. He equated cultivation with education. He encouraged their vanity and desire for self-aggrandisement, by reporting how avenues were all the rage in French country palaces, a fashion set at Vaux-le-Vicomte in 1651 by Le Nôtre. He told landowners that horse chestnuts in particular were planted in France, and 'that for avenues to our country houses, they are a magnificent and Royal ornament',[13] and he maintained that great persons should plant trees as access to their houses.

He praised the stateliness and beauty of the natural shapes of trees and argued that they should be left unpruned and unpollarded, claiming that their shady boughs and venerable age appeared 'more ornamental' when so left. 'I did much prefer the walk of elms at St James's Park, as it lately grew, branchy, intermingling their reverend tresses, before the present trimming them up so high ... '[14] Though large trees such as elms, limes

Southeast Prospect of Hampton Court, Herefordshire: L. Knyff, c.1699. Originally a hunting lodge built in the reign of Henry IV, William Talman transformed it into the mansion shown here which stands in splendid isolation surrounded by its walled park. George London of London and Wise laid out the grounds.

and oaks had been planted for ornamental reasons in parks since the early seventeenth century, their tops were usually taken out and their branches lopped to correspond with the clipped and shaped trees within the garden. Few large trees were planted in Tudor gardens, the 'groves' usually consisting of fruit trees.[15] In all this Evelyn pre-empted the return to 'naturalness' in the eighteenth century, and was perhaps more instrumental in the change of taste than is generally acknowledged.

He recognised that there was an ambivalent attitude towards forests (in the modern sense of the word), which were still perceived in part as hostile places. He tried to remedy this by suggesting forests were 'the glory of our nation' – their oaks the means of preserving that glory, as the support of the navy 'whereby we are fear'd abroad and flourish at home'. His most persuasive and popular concept was that planting forest trees could provide 'profit and pleasure', and to this end he gave instructions on how to 'lay out walks, groves and rides for riding, health and prospect',[16] covering every detail as to the planting, spacing and transplanting of new trees, and the management of old ones. During the Civil War he had travelled in France and Italy, where he experienced the Renaissance at first hand, and in a sense he was using trees to spread its ideas. By replanting the ancient hunting parks he can also be credited with introducing the idea of 'restoring'.[17]

Euston Hall, Suffolk, the east front: E. Prideaux. The great avenues shown here were Evelyn's means of bringing Lord Arlington's park nearer his house, a solution clearly resembling that at Badminton.

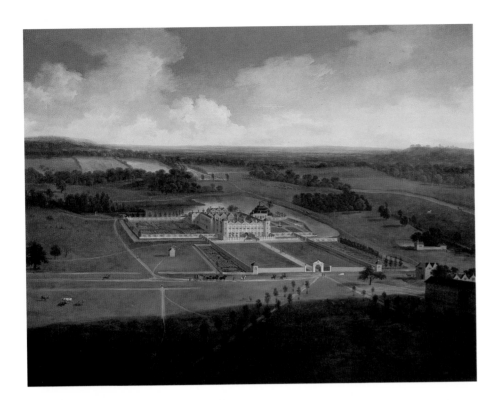

Dunham Massey, Cheshire:
A. Van Diest. 1696.
Painted before the planting of
the park.

Below
Dunham Massey, Cheshire: J.
Harris the younger, 1751. One
of four superb bird's eye
views said to have been
painted to celebrate the
building of the park wall in
1748–50. Despite the apparent
regularity of the massive
replanting, such layouts were
much praised at the time for
their 'Natural Beauty.'

Overleaf
Chatsworth: T. Smith.
c.1743–4. painted as laid out
by the first Duke who died in
1707.

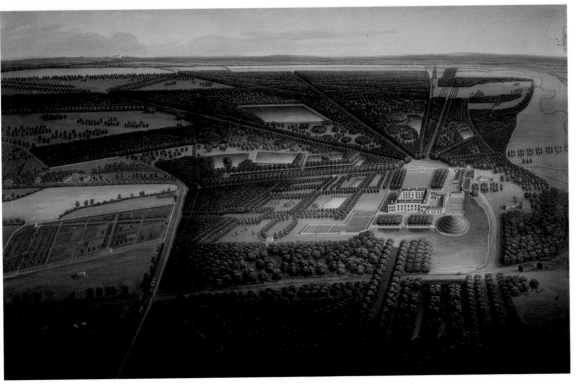

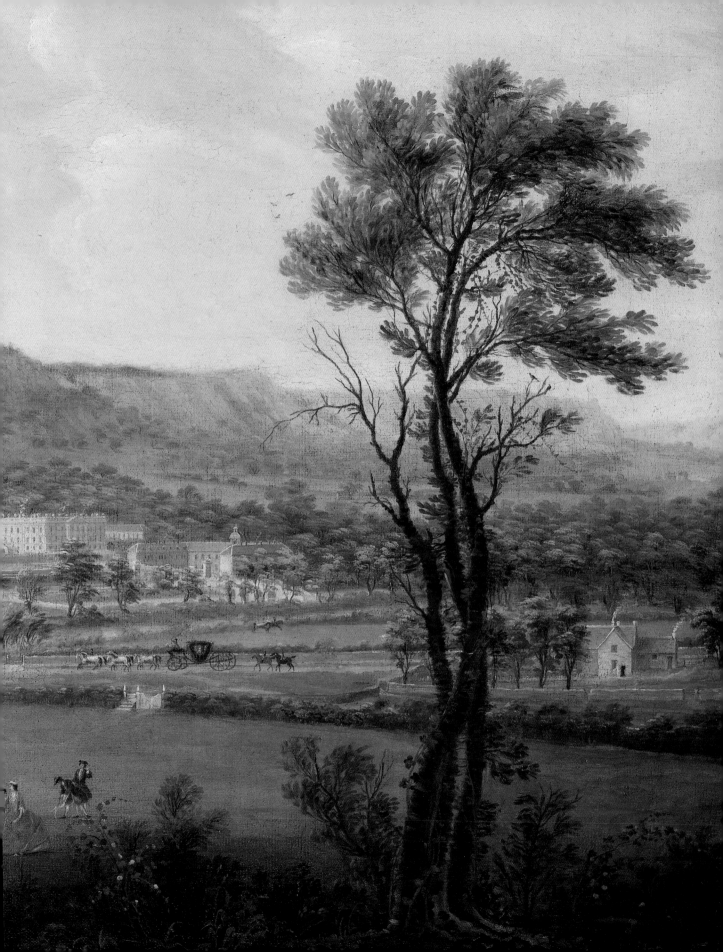

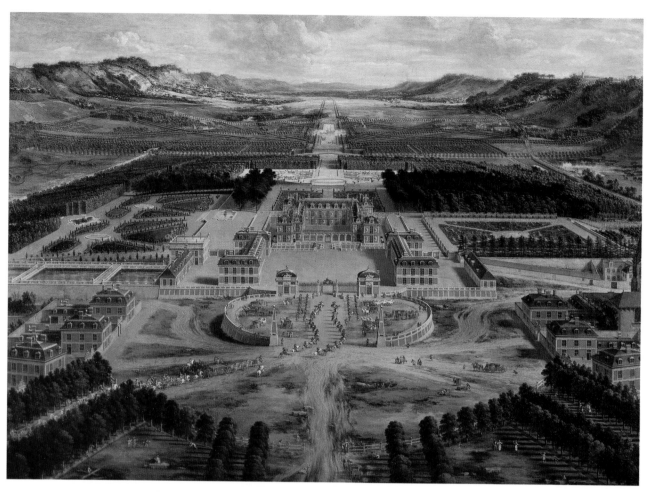

Perspective view of Versailles:
P. Patel, 1668. Le Nôtre's tour
de force and the inspiration
for a generation of Europe's
parks and gardens.

Thus he urged gentlemen to 'delight in tree planting as much as they do in their hunting and dogs', and berated those landowners who had 'ploughed their parks or let them out to gardeners . . .'[18]

For most landowners now the park was almost as important a part of the estate as the house and garden. It 'afforded a most suitable abode', so thought the Grand Duke of Tuscany describing a house which he saw on his travels in England, round which was a park three miles in circumference.[19] Often the size of a large farm, its unploughed and empty acres, of no very visible economic use, advertised the extent of its owner's property, inseparable from his social status. Parks were a buffer, both metaphorically and physically, between the mansion and the more overtly mundane, working parts of the estate. They made an appropriate setting for palatial country houses, and could also be used as a means of integrating the house and walled garden into the larger landscape, softening the transition between the two, which could be quite abrupt, especially in a landscape of open ploughed fields or barren heaths.

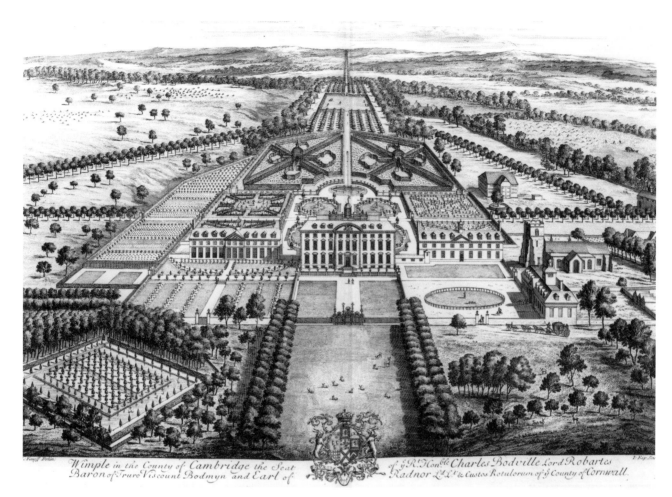

Wimple in the County of Cambridge the Seat ... of ȳ Rᵗ Honᵇˡᵉ Charles Bodville Lord Robartes Baron of Truro Viscount Bodmyn and Earl of ... Radnor Lᵈ & Custos Rotulorum of ȳ County of Cornwall.

Landowners whose parks still lay some distance from their houses were, as ever, advised to bring them closer. In October 1671, Evelyn enjoined the Earl of Arlington at Euston 'to bring his park so near as to comprehend his house within it; which he resolved upon, it being now near a mile to it'.[20] By November, Arlington had obtained a royal licence to empark a further two thousand acres to effect this. Again on Evelyn's advice he planted a number of avenues and plantations of 'firs, elms, limes etc. up his park and in all other places and avenues'. One such was an ascending walk comprising a double avenue of four rows of ash trees which stretched from the 'front into the park'[21] all the way to its pale, a distance of one mile.

With a change in architectural styles banishing the inconvenient court where the visitor was forced to descend from his carriage and walk through a second court to the house, these new avenues could lead right up to the great house itself. Striding through the deer park they gave a dignified approach, and with their ancestry as ridings-out for hunting, gave an added resonance of the ceremonial and processional routes of

Wimpole, L. Knyff & J. Kip. 1707. Obviously Lord Radnor's improvements at Wimpole owe much to Le Nôtre. (cf. Hare's map, p.45). Needless to say, Wimpole could not compete with Versailles in extent, so Radnor artfully concealed his boundary by planting belts of trees (top left), a ploy to be much used by Capability Brown.

ancient times. Where trees already existed, wide vistas were increasingly achieved by cutting swathes through them; a further means of making the park more formal.

Like the Earl of Arlington, other landowners enlarged their parks in order to incorporate these new features. Thomas Chicheley increased the forty acres of his park at Wimpole in 1638 to over two hundred acres by 1686. In 1693 the Earl of Radnor, the subsequent owner, enlarged it even further in order that all the land seen from the house should be his own parkland. Thus he anticipated by some seventy years a major characteristic of Capability Brown's work.

Avenues were also a part of what Keith Thomas has termed 'planting for ownership'. In one way or another nearly all the planting at this time, whatever its ostensible motive, was an assertion of ownership.[22] Sheer acreage being the pre-eminent symbol of social and economic power, tree-planting was one way of making that ownership and power appear as extensive as possible. Aggrandisement, so overtly encouraged by Evelyn, was plainly the objective.

Whatever the reasons for this development, the skill with which it was put into effect, and the inherent beauty of so much of the English landscape, made riding through the park the most delightful means of approach to a great house. Celia Fiennes described such pleasure many times in her travels around England. At Up Park in 1695, she wrote of 'riding through a very fine park of the Lord Tankervaille's, stately woods and shady trees at least 2 mile, in the middle stands his house which is new built . . . in the midst of fine gardens, gravell and grass walks and bowling green'.[23]

For Thomas Baskerville Cobham Park, Kent, in 1670 was akin to paradise itself.

> . . . From hence your way leads on foot through Cobham Park, a place which will feast the spectator's eyes with delightful objects, fair lawns bedecked with flourishing groves of yew, oak, teal, and hawthorn trees, under which nimble deer and coneys do sport the time away. This park or rather paradise, I may call it, belongs to the Duke of Richmond and Lenox [sic], in which he hath at the upper end a fair palace surrounded with stately groves of elm and walnuts, and such tall sycamore trees that had I not seen them I could not have imagined a sycamore could have attained to such height and bigness.[24]

The significance of owning a park seems to be finally established when the word itself is used in the name of the estate, often replacing court, manor, place, grange or hall as the suffix. Compton Hall was renamed Moor Park by Sir William Temple. Twickenham Park and Up Park, pre-Civil War examples, seem to have been so-named from the start, and by the end of the eighteenth century the greater number of estates had the word 'park' in their names.

The desire for grandeur and formality reflected the return to a Court-centred taste, the inspiration for which was Louis XIV's Versailles (originally a hunting lodge). The ideas of its landscapist, Le Nôtre, were brought to England by Charles II on his return from exile. Le Nôtre's designs reflected the elaborate artifice of court life as well as the supreme prestige of the monarchy. Under him the formal garden, where the aim was now to subdue nature by art, was brought to its apotheosis, on a scale which made it appear literally unbounded.

His vast formal and ceremonial gardens at Versailles (two hundred and fifty acres by 1668) exploded into the parks and forests beyond, in one great sweep stemming from the chateau and placed on its central axis. This grand single vista was reinforced by huge phalanxes of groves planted either side, urging the eye ahead and stretching some three quarters of a mile, where a great canal later continued it all the way to the horizon. All the elaborate fountains and waterworks created to dazzle, divert and amuse could be seen in this one glance or *point de vue*.[25]

To achieve some of the effects he wanted immediately, Le Nôtre transplanted oaks which Daniel Defoe surmised from their girth to have been over a hundred years old.[26] Avenues on other axes were driven through the great park to link the 'retreats' of Trianon, the Petit Trianon, Clagny and Marly to the palace and garden. Novelty and entertainment had to be provided for a leisure-loving Court, and the Trianon, a teahouse built in the park for Madame de Montespan, set a fashion for such buildings which by the eighteenth century became commonplace in parks in England and the rest of Europe.

Traditional elements of a hunting landscape were used by Le Nôtre when he cut numbers of rides through the parks of his clients. He aligned them on the various axes of the gardens, partly to give a greater sense of extent and partly also to cater for current rituals of hunting. Cut as wide and straight as possible, these rides converged at various points so that if anyone lost the chase they could look down the different rides to find it again.[27] Louis XIV used to follow the hunt along such rides, alone in an open carriage with a team of ponies. Later on in England, Queen Anne hunted in the same manner when she gave up hunting on a horse, as did Queen Caroline in the reign of George II.[28]

Forerunners of these *allées* or swathes had been cut through the vast forested parks of Blois and Chambord in the previous century, and had indeed existed since medieval times. Ladies of the court were said to have gathered at the great clearings or *ronds-points* where the paths intersected, to picnic and watch the progress of the hunters crossing the rides.[29]

The *patte d'oie*, or goose foot – a device for opening views from the garden into the park in a number of directions – was another development of this system. Possibly invented by one of the Mollet family in the 1650s (Claude Mollet had trained Le Nôtre), it was used extensively in England.

In form it was simply a semi-circular open space with three, five or occasionally seven avenues radiating off it. In 1651 André Mollet (one of Claude's three sons) published *Le Jardin de Plaisir*, which shows plans for a *patte d'oie* to be placed on the axes of a castle and its parterre, in order to extend the view from the castle. Sometimes he placed the *patte d'oie* at the end of the garden where it abutted the park, with the same purpose: that of leading the eye out.

Le Nôtre remodelled the gardens of the Tuileries Palace in Paris, planning avenues and walks which were to radiate to the outer edge of the city. Parading in coaches in these gardens, or in the Cours la Reine (laid out in 1616 for Marie de' Medici), was a favourite pastime of fashionable Parisians.[30] The London equivalent of the 'Cours' was the Ring in Hyde Park, which was made hugely popular by Charles II, who attracted a throng of fashionable people, as John Evelyn relates in his diary: 'I went to Hyde Park to take the air, where was his Majesty and an innumerable appearance of gallants and rich coaches, being now a time of universal festivity and joy.'[31]

But Charles II was not content merely to imitate the rituals of the French Court; he wanted to outdo its magnificence with some of his own. He invited Le Nôtre to make designs for the improvement of Greenwich Park, and a drawing exists of Le Nôtre's proposals. He is also said to have invited Le Nôtre to do the same for St James's Park, though there is no evidence that plans were actually made, and in the event it was André Mollet and his brother Gabriel who were employed to lay out the grounds of both St James's Park and also Hampton Court. The Mollets began to transform both parks by superimposing on meadows and pasture-land formal elements – avenues, walks, lines of trees and a canal. Canals, originally a feature of Dutch landscape design, were used ornamentally to reflect buildings and trees during the baroque era. The canal at St James's was dug in 1660–2, seven years earlier than at Versailles. It was 2,560 feet long, 125 feet wide and flanked either side with an avenue of trees.[32] It was formed by joining several existing ponds, one of which was excluded and made 'formal' – straight-sided. Formerly called Cowford pond, its name was changed to Rosamond's pond or pool, and it became a famous haunt for lovers and suicides; a melancholy echo of its namesake at Woodstock until it was finally filled in in 1770.

Additional pools and channels were cut at the southern side of the canal to make a 'decoy' – a swampy area with small artificial islands fenced off from the park and used as a game preserve for breeding fowl.[33] Among the birds that lived there were some pelicans presented by the Russian ambassador. Storks, along with specially constructed nesting grounds to entice them to lay their eggs, were also a prominent feature of the colony of exotic fowl which has remained a characteristic of the park.[34]

The Mall was also laid out at this time as a ground for the highly

fashionable game of pall-mall.[35] Originating in Italy and much enjoyed in
Paris, where it was called *paille maille*, the game was played in a long fenced
piece of ground, and consisted of hitting a ball with a mallet through a
hoop. The poet Waller, in his eulogy on the improvements which Charles
II made in the park, remarks upon his sovereign's 'matchless' expertise at
the game:

> No sooner has he touched the flying ball,
> But 'tis already more than half the Mall.[36]

It was a summer game, and therefore normally laid out between an avenue
of trees to provide shade. At St James's the ground was set between four
lines of trees forming a double avenue, similar to the ground at the Arsenal
in Paris. One avenue was to shade the king and his courtiers while they
played, the other – very considerately – to shade the promenaders who
watched them.

An aviary, removed from the Volary Garden of Whitehall Palace, was
established in the park in 1667[37] and was in all likelihood the reason for
Birdcage Walk being so named. The menagerie which James I had begun
was enlarged, with new houses added for a considerable variety of
animals, including every kind of deer. It was said there were even
crocodiles, which would have certainly been a curiosity at that date.
Menageries of wild animals had been popular in parks since medieval
times, and the wild-life parks of today merely continue a long tradition.

Another diversion was skating on the canal, a new sport from Holland
and observed by both Pepys and Evelyn in December 1662.[38] There were
also refreshments, including a milk fair where passersby bought milk
straight from the cow, a custom which continued through to Queen
Victoria's reign.[39] Charles II is supposed to have invented syllabub there
by mixing his milk with wine.[40] And in spite of all these distractions the
king still used the park for hunting. As Evelyn said of St James's, for being
'near so great a city, and among such a concourse of soldiers and people,
[it] is a singular and diverting thing'.[41]

In 1668 Charles II also acquired six acres of land to the west of St James's
Park which he enclosed with a brick wall and stocked with deer, calling it
Upper St James's Park. This was the beginning of Green Park[42] and the
king was said to have taken his 'constitutional' among his subjects here,
giving the hill its present name, and making it fashionable as a place for
parading and promenading. Queen's Walk in Green Park was named after
Queen Caroline in the eighteenth century.[43]

While St James's Park was being made fit for the king, Hampton Court
underwent a similar transformation. There, great avenues were also
planted, and the Long Water was dug in the House Park directly under the
balcony of the apartments of the new queen, Catherine of Braganza,

presumably in her honour. In its length and layout this great canal was similar to one dug at Fontainebleau in 1608; 3,800 ft long and 125 ft wide, it flowed three quarters of a mile through the park towards the river, flanked by a double avenue of lime trees set on the main axis of the east façade of the palace, and ending in a semicircle, the land inside which remained a part of House Park.[44] André Mollet is generally credited with the design[45] and once again John Evelyn found much to praise in it. Such canals soon featured in other parks. At Euston in 1677, where Lord Arlington had rebuilt his house in the French manner, a canal full of 'carps and fowl' was placed in a similar position to the one at Hampton Court, under the 'dressing-room chamber' of the earl's wife.[46]

Hampton Court Palace, Middlesex: L. Knyff, c.1700. The great *patte d'oie* formed by the addition of two avenues, c.1689, was planted either side of Charles II's earlier avenue. Note how they stretch to the perimeter of the park and thereby give long views back to the Palace. The view of one's mansion from a distance was as important as the view from the mansion itself.

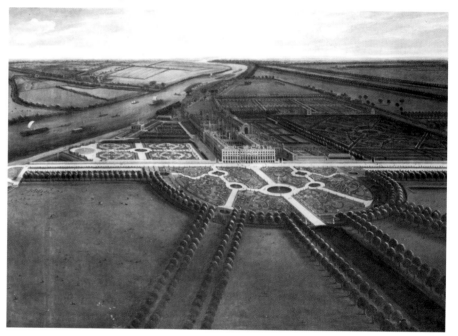

Probably as part of the great alterations undertaken to the palace, park and gardens at Hampton Court for William and Mary, two majestic diagonal avenues were added, one on either side of the central avenue. They were aligned on the queen's balcony (or the room which replaced it), when Wren remodelled the eastern façade. Although in the manner of a Mollet plan, they were almost certainly not planted until 1689, some thirteen years after Mollet's death.[47] This trio of avenues formed a magnificent example of the *patte d'oie*, giving vistas from the palace through what is now the great parterre garden, to the far-off boundaries of the park. This was not the first such trio of avenues in England, the honour for which belongs to Moses Cook, who planted one in 1672 for the Earl of Essex at Cassiobury, Hertfordshire, formerly a hunting preserve of the Abbots of St Albans.

The Great Avenue or 'Chestnut Avenue' in Hampton Court's Bushy
Park was also planted under William III, on the axis of the north façade of
the palace, where it was intended as a grand approach, to complement
Christopher Wren's projected plans. It was originally planted with over
one thousand lime trees, to which were added in 1690 the horse chestnuts
which have given it its name.[48] A great 'bason', reflecting the façade of
the palace, was created along this avenue in 1699 by William Talman, who
was also responsible for the cascade at Dyrham. An even grander project
was envisaged which was to link the south avenue of the *patte d'oie* with
the other side of the Thames at Thames Ditton by building a 'Trianon'
round which formal gardens were planned. However, this was not carried

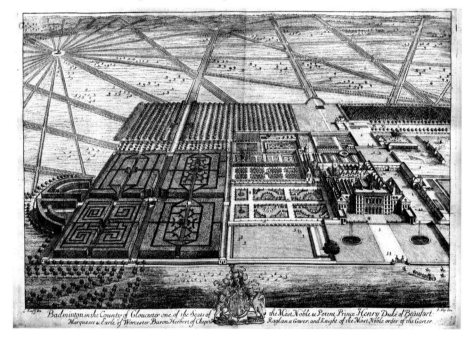

Badminton House,
Gloucestershire: L. Knyff & J.
Kip 1707, after the axial tree
planting (cf. with Badminton
on pp. 48 & 49).

out, probably because the king died. Nonetheless, by superimposing these
formal elements on the 'natural' parks of Hampton Court and by setting
them on the axes of the palace, a vista garden in the French manner had
been created – perhaps more in the style of Mollet than Le Nôtre.[49] A
union of palace, gardens and parks according to the Renaissance principles
of symmetry and axiality had been achieved. The old deer parks were an
integral part of the scheme and essential in giving the necessary scale and
extent.

It has been calculated that by 1700 there were over four thousand trees
in all the avenues at Hampton Court. The need for timber and the desire
for grandeur had been simultaneously satisfied.

In such layouts the palace or mansion was the fulcrum, the centre of a
radial of avenues diverging from it. For Charles II, who like Louis XIV

believed in the absolute power of the monarchy, this formed a fitting metaphor, suggesting a power that centred on the palace and radiated outwards into the world beyond. It was adopted in the 1680s and 90s by many of the aristocracy on their own estates as a symbol of their own sphere of influence, and it continued as a means to express this until the so-called revolution in taste in the next century.[50] At Badminton in 1682 the Duke of Beaufort crossed his park and grounds with dozens of avenues. Over twenty walks sprang from one point like the centre of a star, radiating even into the lands of his compliant neighbours.

The most ambitious avenue created – or at least attempted – was the first Duke of Montague's at his estate at Boughton, Northampton, between 1684 and 1705. The duke had been ambassador at the Court of France, and he built his house in the manner of Versailles, laying out gardens with parterres, fountains and canals in the manner of Le Nôtre, all surrounded by a vast park from which he planned an avenue to stretch seventy miles to London.[51]

At Wimpole, the Earl of Radnor planted five new avenues which, together with those already in existence, set the house in a 'landscape of radiating avenues', the whole park encircling his formal gardens.[52] These avenues provided the shade and shelter for walks which, having been made fashionable by Charles II, were now becoming *de rigueur* in parks. Pepys had claimed that 'the best gravell walks in the world were in England'. Certainly the liking for air and exercise was already considered an 'English' taste.[53] Walks were now laid out by private owners in their country parks, and walking became as much a part of the pleasure of a park as hunting, driving and riding.

The walks themselves were made increasingly interesting, with aesthetic considerations developing from the simple static vista from a window or terrace, to something that took account of a more mobile point of view. At Wimpole the walk was plotted to go through the earl's new plantings and avenues, to cross the brow of a hill called Park Hill and connect with the West Avenue from where a medieval post-mill could be admired, and finally join a new beech avenue that took the walker back to the garden. The walker in fact made a circuit, and in the eighteenth century this was to become the standard manner for viewing gardens and parks. The days when it was only safe to walk on the castle terrace – the *allure* – had long since passed.

Walks such as these were a symptom of growing interest in the land outside the garden. Changes were being made in the garden to give more views of the countryside beyond. If the garden was still enclosed, its walls might now be pierced with *clairvoyées* – grates of wrought iron where a garden walk ended. Lower brick walls, set with iron railings and great iron gates through which the park could be glimpsed, began to replace solid high walls. All this was part of a new ethos brought over from Holland by

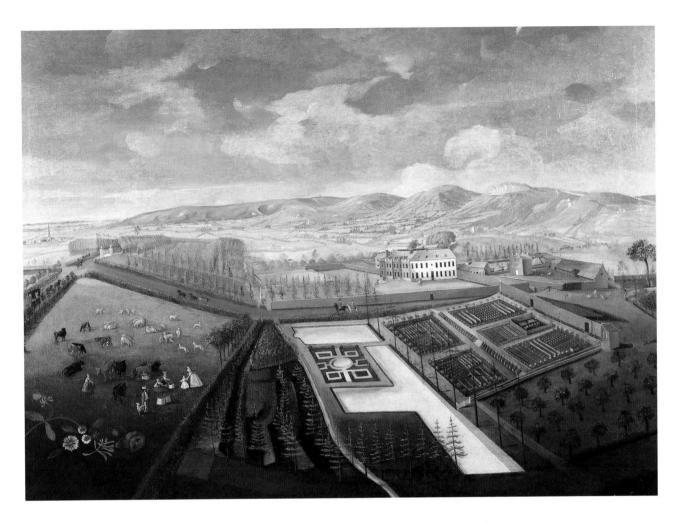

William III; an ethos that idealised country life and was summarised in the Dutch word *rust*, meaning 'rural contentment'.[54] It manifested itself in the so-called country house poems of the day, where country life was celebrated in the manner of classical writers such as Varro and Columella, or Virgil in his *Georgics*.

There was in fact a growing literature on the subject. Jan van der Groen, gardener to King William, wrote a seminal work praising the merits of country living in general. Published in 1669 as *Den Nederlandtsen Hovenier* (The Dutch Gardener), it was reprinted nine times before 1721 and was translated into French and German. Groen claimed that country life generated better bodily and moral health than town life, an idea that echoes the reverence for Arcadia in classical poetry, itself a potent theme of English poetry of the sixteenth and seventeenth centuries. Then too, with the beginning of the era of the Grand Tour, classical writers were more widely read among the propertied classes in England, and soon

Charlton Park, near Cheltenham, Gloucestershire: T. Robins the elder, c.1740. Despite the date, Charlton Park's old fashioned air corresponds more with the Dutch ethos than with the ideas of its own time.

A general view of Vauxhall Gardens. These famous commercial Pleasure Gardens were opened in c.1661 and closed in 1859.

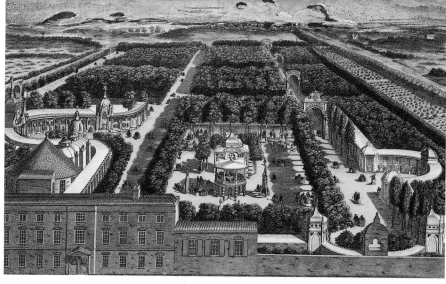

A view of the Mall from St James's Park: M. Ricci, c.1710. Ricci's painting shows a wide social mix promenading in the Mall.

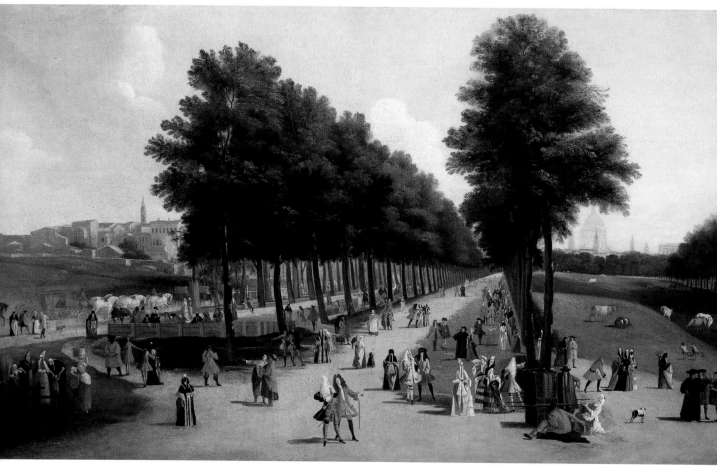

many of the grander aristocracy, like latterday Ciceros, were recreating on
their own estates the Roman villa with its geometrical garden surrounded
by rolling countryside. Their efforts were widely praised in country house
poems such as Andrew Marvell's 'Upon Appleton House' or Ben Jonson's
'To Penshurst' in whose grounds, he claims, the gods of Greece reside –

> Thy Mount, to which the Dryads doe resort,
> Where Pan, and Bacchus their high feasts have made,
> Beneath the broad beech, and the chestnut-shade;

The Dutch love of nature is not to be confused with romantic yearnings
for the untouched wilderness. Far from it; the abiding concern, especially
that of Van der Groen, was to 'improve by means of art'[55] using math-
ematics and geometry as well as horticulture and husbandry. Tulips and
topiary became synonymous with the Dutch style. Topiary derived from
ancient Rome and was a feature of the formal parts of the gardens of Pliny

Charlecote Park,
Warwickshire: anon,
1695–1700. Topiary avenues
in the park form the axial
approach to the house.

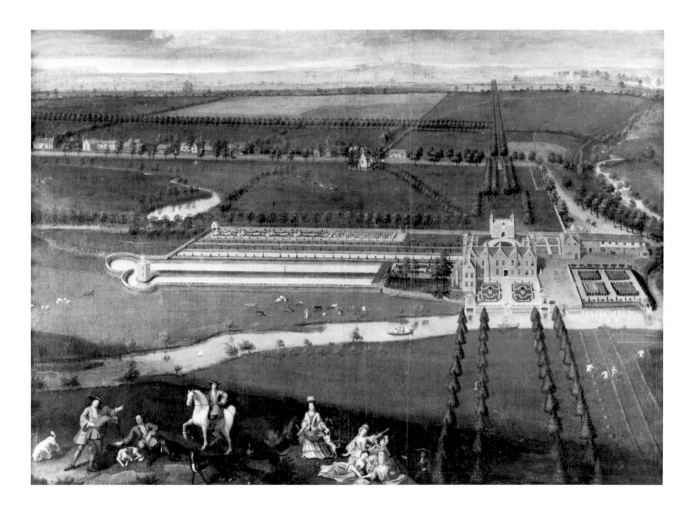

and Virgil. At Heemstede in Holland, an estate famous for its gardens and magnificent parkland, every walk in the park had topiary,[56] and under Dutch influence topiary appeared in English deer parks too. Celia Fiennes described the Duke of Bedford's deer park at Woburn with its trees ' ... cut in works and the shape off [sic] sevrall beasts'.[57] Charlecote was another estate with a famous topiary avenue running through the park. The popularity of topiary in England at the time can be assessed by the violent reactions to it of Pope, Addison and Stephen Switzer – some of its more famous critics in the next century.

In Holland as in England, scarcity of trees had been the catalyst for much planting. There too the arrangements were in axial or radial avenues, or woods planted in geometric stands constellated with intersecting paths. Rows of large trees were planted to protect orchards and gardens from wind, to give shade for walks, and as elsewhere to trumpet the presence of a royal or aristocratic domain. Indeed the fashion for similar features in England can in some cases be attributed as much to the influence of the Dutch as to the French.[58] Hampton Court, with its new alterations, was the equivalent of William III's palace, Het Loo, where the park was a 'great space of Ground containing many Long Green Walks, Groves, Nurseries, Fountains, Canals, Cascades, the Viver, and divers corn-fields, within the Pales. So that when his Majesty is pleased to take diversions at Home, there is not wanting game for Shooting, Setting etc ... '[59] The complex waterworks included a vast monogram fountain displaying the initials of William and Mary, and various motifs of classical gods – further emblems of the king and queen in their role as harbingers of the new era of peace and prosperity.[60]

Under the Dutch influence, water was used increasingly as an ornamental feature in the English park. Canals flanked by high-hedged, turf-covered walks, cascades of water tumbling into stone carved basons, fountains with statues, were all soon to be found in the grander country house parks of England. At Dyrham Park William Blathwayt (1649–1717), who had lived in Holland as secretary to Sir William Temple when the latter was ambassador at The Hague 1668–71, laid out the old deer park and garden on his return to England in the Dutch style, at least in so far as the undulating topography of Gloucestershire – so different from that of Holland – would allow. The greatest feature of the park was the cascade where water poured down 224 steps on the face of a spur opposite the house. It was described as 'the finest in England except the Duke of Devonshire's', where even mightier waterworks cascaded downwards to feed innumerable fountains.[61]

Chatsworth, the most famous of the gardens laid out on the Franco-Dutch principle, was created by George London and Henry Wise as a seat for William Cavendish after he was made Duke of Devonshire by William III.[62] George London, who also advised on Dyrham, had worked for

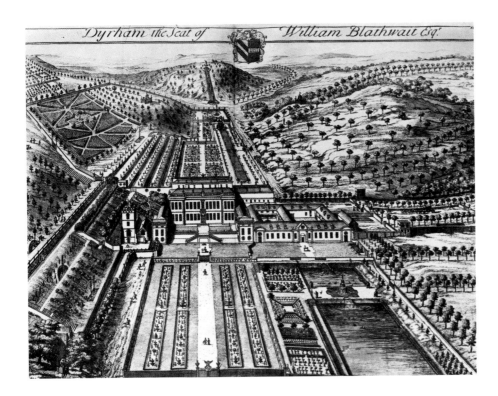

Dyrham the Seat of William Blathwait Esq.

Dyrham, Gloucestershire: J. Kip. 1712.
Blathwayt re-sited the earlier park. This view to the east shows the cascade situated (upper centre) in it. The vast walled gardens shown here were all 'landscaped' away in the 1790s.

Charles II's gardener and was sent by him to France, where he observed the new styles at first hand. He later became superintendent of William and Mary's gardens and the most influential gardener of his day, often riding fifty or sixty miles a day as he toured the gardens and plantations of Great Britain. Wise had been London's pupil, and was to become gardener to Queen Anne. The apotheosis of the formal style was reached under these two.

They were also famous for their commercial enterprise, Brompton Park nursery, which they took over from the four head gardeners who had founded it before the Civil War.[63] Evelyn had set off quite a mania for tree-planting, and London and Wise's nursery was one of the main suppliers of trees for the constant demand that ensued. One of its first undertakings had been Lord Weymouth's Longleat, and by 1718 its estimated value was between thirty and forty thousand pounds, 'more than all the nurseries put together of France'.[64]

Another pioneer in this field was William Windham, at Felbrigg in Norfolk. In his 'Green Book' Windham recorded many improvements to his estate (which included a park of 160 acres), carried out between 1673 and 1687. Among these was the establishment of a nursery to supply young trees for his plantations. In 1676 he transplanted four thousand oaks and two thousand other trees, along with scores of 'acorns, ashkeys, hollyberries, haws, maple and sycamore keys, beech mast and

chestnuts'.[65] He raised a stock of young trees capable of planting at one hundred to the acre. He planted the Great Wood in the old deer park and laid out a vast walk which went past the west front of the house and into the old park.[66] This walk was ninety feet wide and probably grassed. He dug several ponds in the park which also had an ice house probably dating from this period. Ice houses were common features in parks until 1844 when the domestic ice box was invented.

Windham also recorded planting a 'quincunx' of trees in the park.[67] In like manner was Thomas Chicheley's south avenue at Wimpole in which the trees were staggered to form a quincunx. This was repeated in the later planting by Bridgeman in 1721 which formed the still extant Great South Avenue. A quincunx is an arrangement of objects in groups of five, placed so that four of them make the corners of a rectangle, while the fifth is placed in the centre. The objective of such an arrangement in tree-planting was that 'when view'd by an Angle of the Square or parallelogram, [the disposition] presents equal or parallel Alleys'.[68] Quincunxes had been

Ashdown Park, Berkshire: L. Knyff & J. Kip. 1707. Too like some of the Forestry Commission's less than successful planting of our own time.

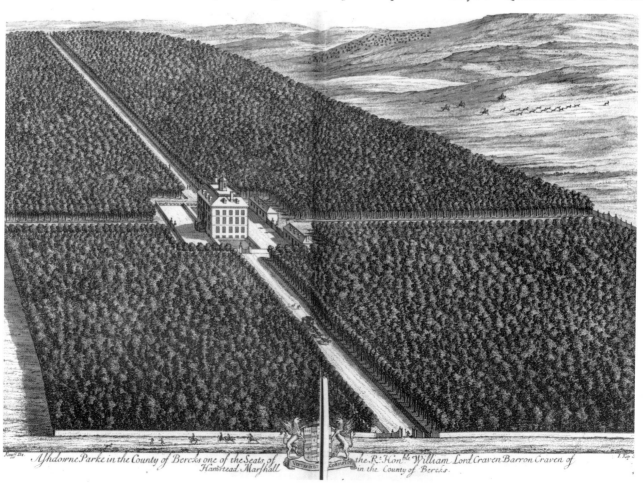

Ashdowne Parke in the County of Bercks one of the Seats of the Rt Honble William Lord Craven Barron Craven of Hamstead Marshall in the County of Bercks.

made fashionable by Sir Thomas Browne, with his discourse of 1658, entitled *The Garden of Cyrus, Or The Quincunciall, lozenge or Net-work Plantations of the Ancients, Artificially, Naturally, Mystically considered with Sundry Observations*. A history of horticulture from the Garden of Eden to the gardens of the Persians, it also incorporated an elaborate investigation into the 'quincunx' whose form like a 'five-spot' dice, or the plan of a byzantine 'quincunx' church, had – so Browne argued – a range of properties including the magical. He also, incidentally, talked here of the charm of weeds, and was one of the first to do so. Like Windham he lived in Norfolk, and they knew one another.

Not all the planting at this time can be considered an aesthetic success; large sections of England must have begun to take on the darned sock effect of the Forestry Commission's soft wood plantations in modern times. A recent survey at Felbrigg suggests that Windham's efforts, while good as forestry, left something to be desired in terms of design, making Felbrigg 'all woods behind and all emptiness in front'.[69] Likewise at

Moor Park, Surrey: attrib. J. Kip. The 'labyrinthine wilderness' (seen left) is generally considered to be Temple's interpretation of irregular planting seen in Chinese gardens, and which he called *sharawadgi*.

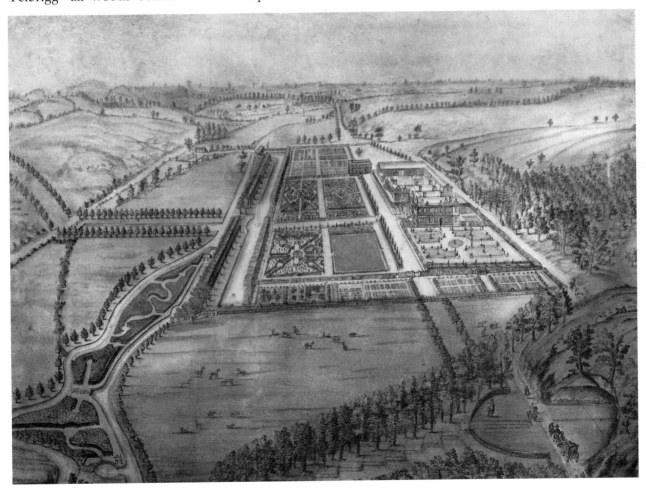

Ashdown aesthetic considerations can hardly have been a priority, as Kip's engraving makes clear. Here profit appears to have won out rather emphatically over adornment.

In fact, in the effort to link the park to the garden or to the surrounding countryside, avenues marching across parkland began to acquire a certain monotonous consistency which eventually contributed to their downfall.[70] And even while the taste for formality and regularity was at its height, signs of an impending reaction were already in the air. Andrew Marvell in the 1650s was rueing the lack of appreciation of the natural world –

'Tis all enforced, the fountain and the grot
While the sweet fields do lie forgot.[71]

Sir William Temple in 1685 questioned whether there might not be another order of beauty than that which relied on regular forms, citing as an example the Chinese art of *sharawadgi* (a name that appears to owe more to Temple's imagination than any word in the Chinese vocabulary).[72] Though he advised against experimenting with this widely in England on the grounds that it would be difficult to achieve, and failure would look worse than failure in the regular style, he nonetheless tried it himself as the new owner of Moor Park.

But taste changes slowly, and even as reaction to formality and regularity reached a height in 1712 with Joseph Addison's outburst in *The Spectator*, the most authoritative work extolling formality was published for the first time in English. This was John James's translation in 1712 of A. J. Dézallier d'Argenville's work *La Théorie et la Pratique du Jardinage*, 1709, called in English *The Theory and Practice of Gardening*. Effectively it was a 'How To' book on the making of gardens in the manner of Le Nôtre.[73]

Perhaps the most far-reaching developments of the park in the seventeenth century, in terms of their contribution to the formation of civic parks some two hundred years later, were those that took place at St James's Park and Kensington under Charles II and William III respectively. The concept of preserving a large tract of country in the middle of the city was one of the greatest contributions to town planning of the baroque era. St James's Park in Charles II's day was partly bounded on two sides by Whitehall and the city of Westminster – already an example of *rus in urbe*, as the motto emblazoned on the front of Buckingham House (later Buckingham Palace) was to proclaim when it was built in 1709.

Despite the formal elements imposed by Charles II on the park, it still retained a rustic quality, with its meadows and cows. According to the Swiss traveller Béat de Muralt, this was so admired by the French landscapist – possibly Le Nôtre – whom Charles II had invited to redesign the park in 1660, that he declined the offer saying that the 'Park's . . . native beauty, Country Air, and deserts, had something

greater in them, than anything he could contrive'.[74]

The contrast between the pastoral, unimproved parts of the park with their meadows and milkmaids, and the improved part with its formally attired strollers, corresponded with the enjoyment of looking out of a highly ordered garden on to the rough hunting park. Pepys relished the effect; at St James's he could fall asleep on the grass while nearby the players of pall-mall were required 'to fight it out bewigged, jacketed and waistcoated'.[75] Daniel Defoe felt a similar frisson when he first saw Chatsworth lying in a delightful valley surrounded by untamed moorlands.[76] In the eighteenth century, as the countryside became relatively ordered and regular, with lines of hedges enclosing the fields, so gardens and parks began to throw off their regularity. Likewise in the nineteenth century writers and designers like J. C. Loudon and the American landscape architect F. L. Olmsted were to recommend that urban parks be irregular in contrast to the rigid network of roads and buildings surrounding them.

By opening the park to the public (the first use of the term 'public park' was in 1661), Charles II initiated a new social ritual. Not only was the park the means by which he presented himself to his people but it also provided a new venue for social intercourse. Long after the game of pall-mall went out of fashion the promenaders remained.[77] Strolling up and down the Mall had become a routine whereby 'polite society' took the air and exchanged gossip from midday until the time to change for dinner.[78] Ladies, who had been packed off to their estates by James I for trying to parade on foot in the Mall, were free to come and go as they pleased, now that Charles had made such walks fashionable.[79] By 1722 Thomas Fairchild was urging the creation of more such parks and gardens in cities.[80] With its shady walks and beautiful scenery, exotic animals and curious birds, sports and games, refreshments and social intercourse, Charles II's creation set a model for the public parks of the future – retreat, recreation and refreshment. No wonder that St James's Park was simply called 'The Park' for the next hundred years or more. A new denomination of time had come into being: Park-Time –

What o'clock does your Lordship think it is?' – . . .
'Tis Park-time[81]

Town walks proliferated, and soon few self-respecting towns were without them – at first on the outskirts, and later, as the town grew up around them, in specially laid out architectural settings called Parades and Promenades.[82] Their salutary reputation was such that by the nineteenth century, when industrialisation hugely swelled the populations of towns and measures were sought to alleviate the distress this caused, it was automatically assumed that the creation of more public walks would ease

the problem.[83] At this time also commercial pleasure gardens were beginning to spring up in London.

Unlike Charles II with his *beau-monde* entourage, William III wanted to spend as little time as possible at Westminster; partly because its acrid air exacerbated his asthma, and partly because he could indulge more easily his passions of gardening and hunting at, respectively, Kensington and Hampton Court. Kensington Palace – originally Nottingham House – was purchased by William and Mary as a suburban retreat in 1688. It lay adjacent to Hyde Park, and the extension of its original seventeen-acre garden to its present 275 acres has been achieved over the centuries mainly by hiving off acres from Hyde Park.

A road had to be built to bring the king from Westminster to his new palace. This was called King's Road and it was the first lantern-lit road in the city. However, it was constantly in need of repair and in 1735–6 it was replaced by King's New Road – now South Carriage Drive. When the Crown wanted to put William's old road back to turf there was an outcry, and the public were able to take it over as a riding parade. It immediately usurped the popularity of the Ring, and was in fact the cause of the latter's demise, despite the fact that carriages were not permitted, this privilege being retained on the new riding ground as a solely royal prerogative.[84] It became known as Rotten Row and was soon one of the most famous places in the world for horse riding. It was one of the features that contributed to the subsequent development of Hyde Park as a 'royal' public park.

Just as residential development had begun around St James's Park and Green Park as a result of Charles II's improvements, so similar development began around the perimeter of Hyde Park and Kensington Gardens. This was facilitated by the road, and it indicated a growing desire among city dwellers to be near, or better still, overlooking a park. Vanbrugh sited private houses for himself and his family around Greenwich Park in 1709. Likewise, outside London, towns were growing up around parks – Petworth and Stamford, for example, around the parks of Petworth and Burghley. This trend continued to the nineteenth century, when it was exploited to pay for the creation of both speculative and public parks.

Thus by his search for a life outside the public eye, and by building his palace in what was then a suburb, William III made his own contribution to the concept of *rus in urbe*.

6

THE LANDSCAPE PARK:
From Bridgeman to Brown

The eighteenth century was an era of triumph for the park. As it progressed, gardens shed their unnatural forms to emulate the features that had been characteristic of parks before they too had had straight lines and symmetry imposed on them. Walls were pulled down to allow these new gardens to merge with the park, which in turn was landscaped to create a perfect harmony with the garden. The landscape garden was born – the outcome of a desire to 'cashiere that Mathematical Stiffness in our Gardens, and imitate Nature more', as Stephen Switzer, writer, nurseryman and gardener, put it.[1] The formal, geometric style was rejected in favour of what was variously called the 'natural' or 'informal' style of gardening, or 'modern gardening'. The result was what foreigners were to call *il giardino inglese*, *le jardin anglais* or *das Englische Garten*.

Some have speculated that this revolution in taste was a natural consequence of political changes, not least the Whig success in replacing royal absolutism with government by consensus. Parallels between freeing men and freeing plants from their respective tyrannies have frequently been drawn, and although, as the garden historian David Jacques has pointed out, a number of Whigs continued to spend large sums of money on French-inspired gardens, there is obviously some connection. The geometric garden had been an apt expression of the Cartesian view of nature as part of a divine order of mathematical regularity. In the Age of Enlightenment, however, these strictly patterned creations must have given some people an unwelcome reminder of the autocratic past. In 1709 Lord Shaftesbury wrote of his inability to '... resist the passion growing in me for things of a *natural* kind; where neither *art*, nor the *conceit* or *caprice* of man has spoil'd their *genuine order*, by breaking in upon that *primitive state*'. In his view 'Even the rude *rocks*, the mossy *caverns*, the irregular unwrought *grotto's*, and broken *falls* of waters, with all the horrid graces of the *wilderness* itself, as representing NATURE more, will be the more

overleaf
Blenheim Palace, showing Brown's famous 'improvements' 1764–68. Note the parkland brought right up to the house.

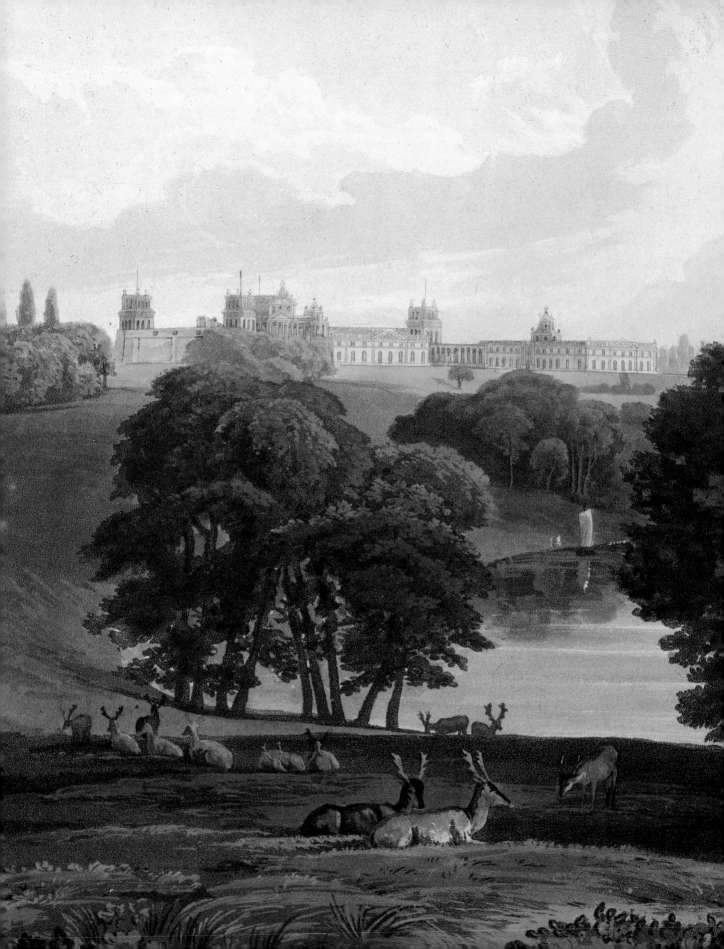

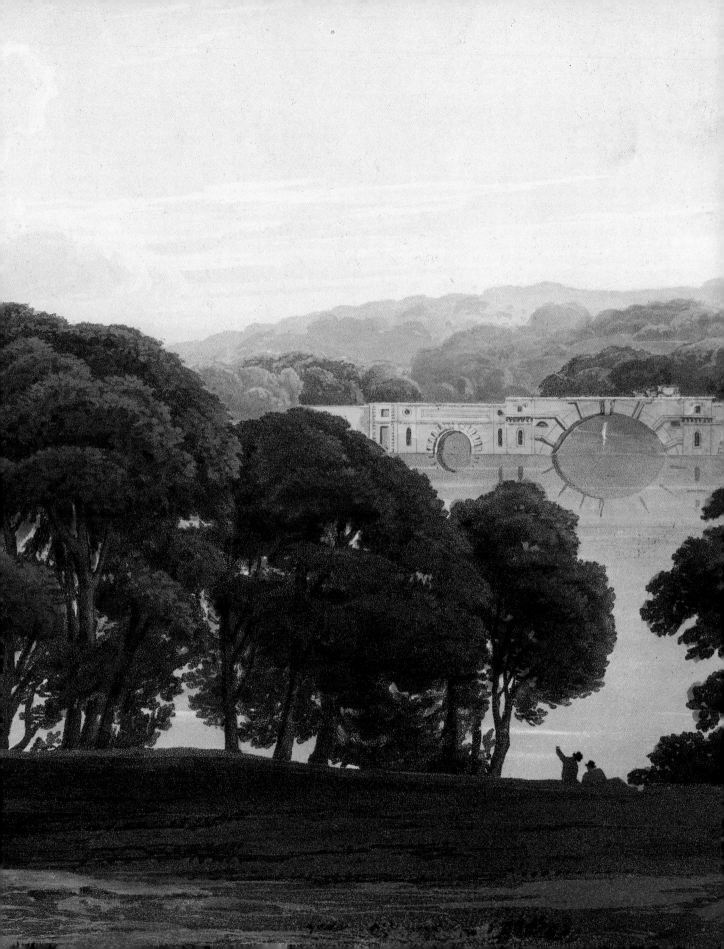

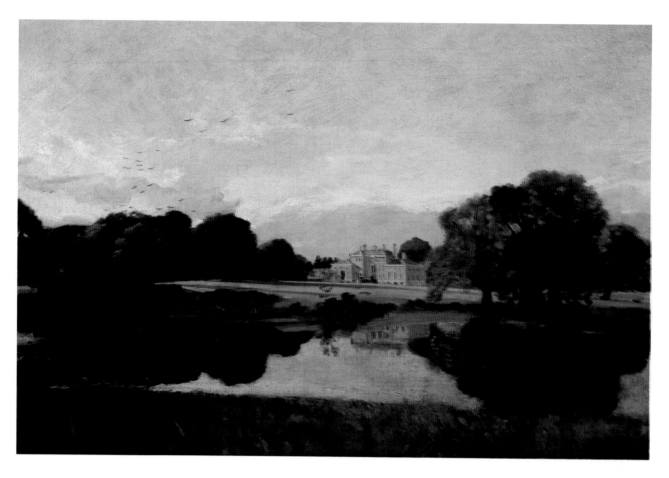

Malvern Hall, Warwickshire:
J. Constable, 1809. Despite his
reluctance to paint 'a
gentleman's park', Constable
managed to convey its
essence.

engaging, and appear with a magnificence beyond the formal mockery of princely gardens'.[2] Shaftesbury's attitude endorsed the criticism of these great formal gardens that had been heard increasingly since the Revolution of 1688. The desire to demonstrate mastery over nature began to give way to a different attitude in which the aim was to make, as Switzer wrote, 'design submit to nature'.[3]

Milton's Paradise, with its 'enclosure green', was effectivelya park in the older, pre-Le Nôtre style. Certainly 'flours . . . in Beds and Curious Knots' had no place in his Eden, and Horace Walpole credited Milton's imagery with giving the new landscape gardeners their first ideas.[4]

Increasing travel was another influence. This was the age of the Grand Tour, and those who made it saw for themselves the ruins of classical villas they had read about in Tacitus or Pliny the Younger, lying amid their vineyards, with their agriculture close at hand. Then too, in the landscape paintings of Claude Lorrain and Nicholas Poussin, they saw idealised renderings of the Italian *campagna* complete with classical allusions. It was these images that they set about trying to recreate on their return. The

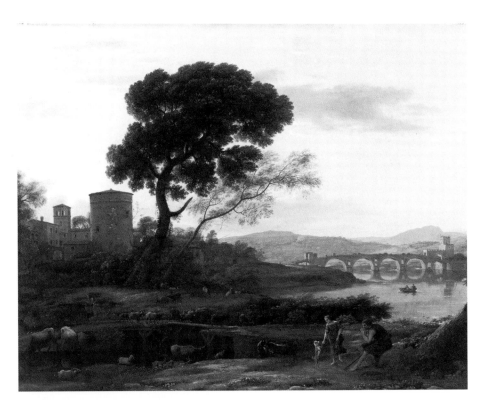

Landscape near Rome with a view of the Ponte Molle: Claude Gellee (Claude Lorrain), c.1645. Claude's imagined rendering of the Roman campagna with arcadian peasants appears as almost a direct source for Vanbrugh and Hawksmoor's landscape design rendered below by Hendrik de Cort in his view of the Mausoleum with Castle Howard in the distance, 1800. The painting itself was a conscious echo of Lorrain's.

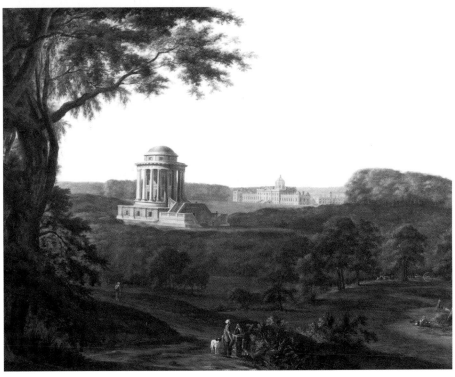

View of the Lake in the Villa Cusani at Desio, 1801. Laid out in the style of an English landscape garden which, as shown overleaf, was largely inspired by Claude Lorrain's idealised landscapes of the Italian countryside.

landscape paintings gave rise to the use of the word 'landscape' for the parks and gardens they inspired, and their influence was such that a contraption called a Claude Lorrain glass was invented; a convex mirror in which the viewer, finding a choice vista and turning his back on it, looked at it reduced, reflected, and framed in the hand-held glass, where it was hoped it would resemble a Claude landscape painting. Today's equivalent would perhaps be those tourists who only appreciate the view through the lens of a camera.

The 'revolution' in taste was fuelled also by the sheer expense of maintaining grounds in the French or Dutch style. With their clipped hedges and numerous walls they were, again in Switzer's words, proving 'a Burthen too great for the biggest Estate . . . and not at all answerable to the needless Expence that is laid out upon them'.[5] Even the Crown was finding the outlay a strain, and royal gardeners had their budgets cut from £60 to £20 an acre.[6] Some landlords were ruined by the sums expended on their grounds. The Earl of Radnor had to sell Wimpole because of the financial difficulties he found himself in after having spent £20,000 on his parks and the great formal garden.[7]

There was also the unproductiveness of such gardens at a time when agricultural improvement and sylviculture were both vitally important to the national economy. Alexander Pope developed Evelyn's views in his Epistle to Lord Burlington, 'Of the Use of Riches'. First published under the title 'False Taste', it was a virtual manifesto for the new ethos:

'Tis use alone that sanctifies expense,
And splendour borrows all her rays from sense.[8]

Other writers weighed in, their sentiments eagerly discussed among
the members of the influential Kit-Kat Club,[9] who disseminated their
ideas in books, essays and articles some time before they were translated
into a reality upon the ground. Pamphlets and tomes once again
proliferated, intended to persuade the great landowner that he had a moral
duty to improve agriculture and forestry on his estate, and as before
encouraging him by the suggestion that he would increase the value of his
property at the same time. Ironically, the cost of landscaping estates in the
new manner was often considerably more than anything that could have
been spent on the upkeep of their formal predecessors, and ambitious
landowners continued to be ruined.

Joseph Addison was one of the chief popularisers of the new ideas. In
his famous *Spectator* essay of 1712 he condemned the artificiality of
contemporary gardens, not only for the reasons already mentioned, but
also for the limitations they posed in comparison to the variety offered by
nature. He complained of the 'Neatness and Elegancy' of English gardens
influenced by the Dutch, lamenting the absence of areas of 'artificial
rudeness' that he admired in gardens on other parts of the continent. As
his phrase suggests, the new thinking by no means involved a complete
abandonment of nature to its own devices, and he was careful to remind
his readers that the idealised countryside of the poets was not achieved
without human effort. He had visited Italy between 1701 and 1703, but it
was an English example, Greenwich Park, that he chose as an illustration
of what he had in mind. With a cautiousness characteristic of this pre-
romantic era, he still seems to prefer his nature mediated through a
controlling agency – in this case not a Claude glass, but a camera obscura
standing in the middle of the park. It was, he wrote,

> The prettiest landskip I ever saw ... the Green
> Shadows of Trees waving to and fro in the Wind,
> and Herds of Deer among them in Miniature,
> leaping about upon the Wall ... its near
> Resemblance to nature gives us a nobler and more
> exalted kind of Pleasur than what we receive from
> the nicer and more accurate Productions of Art.[10]

Like Evelyn before him, Addison also endeavoured to change the current
perception of beauty. He was aware that enclosure was still a contentious
issue among the peasantry, and that the sequestration of large tracts
of pasture for purely ornamental reasons was becoming politically
unacceptable. He suggested that landowners could satisfy their aesthetic
requirements with less offence if they began to view their whole estate –
garden, park and farmland – as a source of potential visual pleasure, as

well as profit. If the layout and care of the walks between the working parts of the estate were improved and if the corn-fields and meadows, and the wild hedgerows were set off by skilful planting of trees and flowers, he proposed that 'a Man might make a pretty Landskip of his own Possessions'; that is, without adding to them with further enclosures.[11]

He condemned the practice of planting in straight lines, and like Sir William Temple he praised Chinese gardens where planting was irregular, and trees were allowed to grow naturally, instead of being pruned to uniform size, or sculpted into 'cones, globes and Pyramids'.[12] Not unexpectedly he found an orchard far more beautiful than an elaborate parterre. He fired a parting shot by implication at London and Wise and their Brompton nursery by suggesting that their commercial instincts had perpetuated the planting of small evergreen trees for topiary. Having raised the trees they had to sell them, he argued, and therefore they made designs for parks and gardens which demanded their use. He also blamed them for tearing up orchards in order to plant their evergreens. Pope endorsed him with a derisive attack on topiary in *The Guardian* the following year,[13] though more important among Pope's contributions was his own garden at Twickenham, where from 1719 he put into practice his ideas on 'naturalism', later to have the satisfaction of seeing them embodied in the great parks of his clients.

Stephen Switzer was another populariser of these ideas. He had been an assistant to London and Wise, and a colleague of Charles Bridgeman. He did not baulk at criticising his former associates, and became very influential through his writing, much of which was in fact little more than a collage of other people's work. He wrote *The Nobleman, Gentleman, and Gardener's Recreation* in 1715, expanding it into the *Ichonographia Rustica*, published in 1718 and reprinted in 1742. His arguments for change were largely economic. Borrowing Pope's phrase 'the simplicity of unadorned nature', he proposed in this book a new, less costly system of gardening, which he called 'rural or extensive gardening', basing it on three precepts: *Utile Dulci*, 'profit and pleasure agreably mixed'; *Ingentia Rura*, walks and groves with open views to the adjacent country; and *Simplex Munditiis*, simplicity.

Like Addison, he urged the aesthetic improvement of the whole estate. His specific suggestions included surrounding coppices, paddocks and corn-fields with little walks and purling streams; not levelling the land; making any extra soil into mounds and planting it with clumps of trees; dispensing with stiles and gates, and using just water to keep the cattle out; dividing areas by means of hedges or avenues, with gravel or sand paths. 'What could be more diverting?' he asked.[14] He claimed this was a recipe suitable for thirty acres to one hundred.

The *ferme ornée*, such as the poet Shenstone had at The Leasowes in Shropshire, developed out of these ideas. Here, a walk extended round the

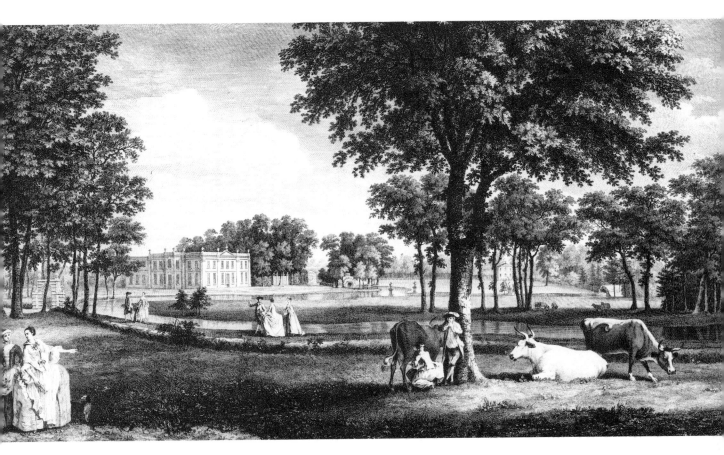

perimeter and down into the wooded valley of the estate, giving views through the trees within the estate and out into the countryside beyond. Statues, seats, urns, and tablets with classical inscriptions were placed for effect at certain points; the rousing of a whole range of emotions in the spectator, as he walked around these private landscapes, was to play an increasingly important role in the layout of parks and gardens as the century progressed. Such *fermes ornées* were obviously ideal for the smaller landowner who had no park.

Switzer was against flowers, except in town gardens, noting that they bloomed when their owners were absent, most likely enjoying the season in London, and that in any case there was no profit in them. He was also against symmetry, quoting Pope's couplet decrying Blenheim where

> Grove nods at grove, each alley has a Brother
> And half the Platform just reflects the other.[15]

Despite his opinions, however, his own designs actually look highly regular and formal to a modern eye, reminding us again of the relativity of such terms as 'wild', 'natural' and 'artificial'. Indeed, to confuse matters

Woobourn Farm, Surrey, the seat of Philip Southcote. A *ferme ornée* similar to Shenstone's more famous 'The Leasowes'. Woobourn in fact predated 'The Leasowes' by ten years, being laid out from 1735.

further, he chose Dyrham – the Dutch-inspired masterpiece of the preceding century – as an example of what constituted his notion of the 'rural'.

Classical descriptions of estates, such as Pliny's of the gardens of Epicurus outside Athens, epitomised in some respects what was being recommended. According to Pliny, Epicurus was the first person to include the pleasures of woods and fields under the general title of the *hortus* or garden. The Romans took up the idea, and the gardens of Nero as described by Tacitus sound little different from the parklike concept of gardening which was now being advocated.

One of the first parks to embody the new thinking was Lord Carlisle's at Castle Howard, begun in the first decade of the eighteenth century. George London had made a formal design for the whole park complete with canals and a great star of intersecting avenues which would have cut through a wooded hill called Wray Wood. This was rejected, and John Vanbrugh, who had replaced Talman as architect for the house, was now also given the planning of the park. He transformed it into a vast, irregular, highly contoured elysium, complete with temples, obelisks,[16] each of which was placed on a hill, thereby exploiting the natural contours of the site. Here for the first time the architecture and the whole surrounding landscape were conceived together in 'a scenic relationship to one another',[17] even though straight lines still dominated the approaches and a large parterre garden remained enclosed behind fifteen-foot high walls.

By turning the park into one great landscape – the first of its kind in England – Vanbrugh had translated Addison's belief that 'a Man might make a pretty Landskip of his own Possessions'[18] into irrefutable fact. The buildings in the park were designed and placed for their scenic effect, for their associative connections with the ancient past, as *points de vue*, and as places to visit and use. It was a classical vision, inspired by Pliny's description of his villas at Tusculum and Laurentium,[19] themselves inspired by imagery of the lost Golden Age in the pastoral poetry of ancient Greece, with its flocks and herds grazing amid temples and sacred groves, watched over by nymphs and shepherds who live in a world of eternal spring. Lord Carlisle's version of this elysium was described in the following extract from a poem in 1733 attributed to his daughter, Lady Irwin.

> From ev'ry Place you cast your wand'ring Eyes,
> You view gay Landskips, and new Prospects rise,
> There a Green Lawn bounded with a Shady Wood,
> Here Downy Swans sport in a lucid Flood.
> Buildings the Proper Points of View adorn,
> Of *Grecian*, *Roman*, and *Egyptian* Form.
>
> These interspers'd with Woods and Verdant Plains,
> Such as possess'd of old th' *Arcadian* Swains.

Hills rise on Hills; and to complete the Scenes,
Like one continu'd Wood th' Horizon seems.
This in the main describes the Points of View,
But something more is to some Places due ...

Lead through the Park, where Lines of Trees unite,
And Verdrous Lawns the bounding Deer delight:
By gentle Falls the docile Ground descends,
Forms a fair Plain, then by Degrees ascends.
These Inequalities delight the Eye,
For Nature charms most in Variety.
When ev'r her gen'ral Law by Arts effac'd,
It shows a Skill, but proves a want of Taste.
O'r all Designs Nature shou'd still preside;
She is the cheapest, and most perfect Guide.[20]

In creating this idyll for himself and 'the happiness of his dependants' (as he is purported to have said), Carlisle apparently thought nothing of destroying — and not re-building — the entire village of Henderskelfe, church included.[21] Nonetheless he and his architect brilliantly combined a high order of imagination with the practicalities of improvement and planting, and in so doing set a new standard in the pursuit of perfection, the pastime of the ruling class.

The originality of Vanbrugh's layout at Castle Howard was signalled by the entrance to the park: a massive machicolated arch surmounted by a pyramid, built in 1719. By 1725 great bastioned walls, turreted and battlemented, extended either side of this gate like the fortifications of some great castle, which in a sense they were, for gradually the great baroque mansion became 'Castle' Howard — an echo of the old medieval Henderskelfe Castle which it replaced. Vanbrugh sited the house with the main avenue lying parallel to it instead of perpendicular, again breaking with tradition. The outworks which came later were increasingly picturesque in style, and Vanbrugh's return to medievalism presaged the Gothic revival of the latter part of the century.

At Blenheim in 1709, Vanbrugh tried to preserve a *real* medieval ruin — the old Woodstock Manor which stood in the ancient deer park. After five hundred years as a royal residence, it was destroyed in the Civil War, leaving behind a swampy steep-banked wilderness of some two thousand acres. In 1705 Queen Anne conferred the manor and park on the Duke of Marlborough, who renamed it Blenheim, and appointed Vanbrugh as the architect for the new palace. Vanbrugh recommended preserving the ruins of the old manor to improve the northern view, which was otherwise rather featureless. He wanted to create a picturesque setting for the ruins by surrounding them with a thicket of mainly evergreens, from which they would rise up to form 'one of the most agreable objects that the best landskip painters can invent'.[22] However, this painterly use of ruins to

Plan of Blenheim: C.
Bridgeman, 1709. This shows
the woodwork (lower right)
and the great avenue, on
either side of which are trees
arranged in 'platoons'.
Military formations and terms
were much used in the
disposition of plants and
trees.

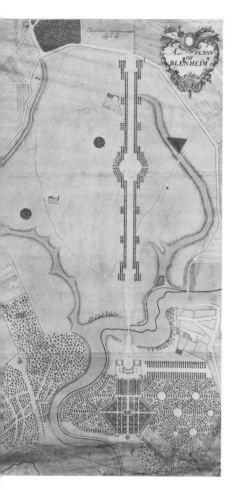

enhance a real landscape was too novel an idea, and they were pulled down.[23]

Vanbrugh had in fact also suggested that Marlborough hire a landscape painter to lay out the park and gardens, but Henry Wise (of London and Wise) was appointed, and charged to make the grounds comparable with those of Versailles. Wise set the garden proper within Vanbrugh's vast, hexagonal enclosure (more like the fortifications of a town than a garden), creating a grand terrace and a great formal parterre covering 250 yards and laid out with flowerbeds, all of it doomed to be out of fashion soon after completion. Also within this enclosure was the 'Woodwork' – a large formal wilderness planted with oaks and evergreens in graduated heights, and cut through with walks both straight and winding though always symmetrically laid out. It was this wilderness which had provoked Pope's couplet quoted above. A 'Roman' bridge spanning the steep valley of the small river Glyme like a viaduct; canals, grottos, lines of trees radiating from circuses, and a great avenue of elms leading the eye to distant vistas, made Blenheim in its first phase a great formal park, though even then some irregularity and asymmetry was introduced by Vanbrugh's contouring, especially to the north where the valley swept round to offset the symmetry of the bridge and avenue.[24]

There is a drawing of the kitchen garden at Blenheim in 1709 by Charles Bridgeman (who worked on the design under Wise), showing it to be enclosed only by a ditch.[25] Similarly at Seaton Delaval, one of Vanbrugh's projects, the whole garden gave an appearance of being virtually open to the surrounding land. It would seem that Vanbrugh and Bridgeman had anticipated a major step in the evolution of both park and garden: the replacement of walls by a fosse or ditch with a sunken fence to keep out the deer, allowing the eye to sweep from the garden into the park in one uninterrupted view.

This device was of course what became known as the ha-ha. It was originally employed in a military context, to keep out the enemy, and a rudimentary version of it in its ornamental application was first used in some of the French walled gardens of the seventeenth century. This prototype was described in John James's translation of A.J. Dézallier d'Argenville's book *The Theory and Practice of Gardening*, 1709 (published in England in 1712). The book was the definitive work on the formal garden, though paradoxically the ha-ha was to become one of the principal features facilitating the reaction against formality. At first merely a ditch behind the wall, enabling the wall to be lowered and gaps to be cut in it without fear of animals getting into the garden, the ha-ha eventually dispensed with the wall altogether. The strollers' surprise at this sudden unseen 'check to their walk'[26] was supposed to have produced the exclamation – or something like it – that gave this device its name.[27]

The development of the ha-ha can be charted at Stowe, a palimpsest of

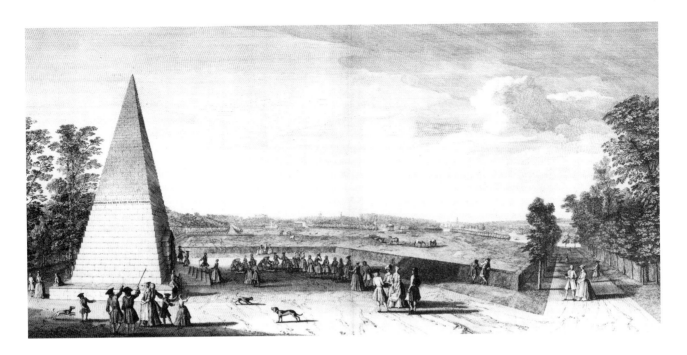

the styles that prevailed during the sixty or more years over which its grounds evolved. All the great innovative architects and landscape designers worked at Stowe, creating a seminal garden of the period. Four hundred acres of garden and park were merged together between 1713 and 1776, making Stowe the prime exemplar of the new form of landscape garden, the first of its kind on such a large scale.

Stowe had belonged to the Temple family since 1571. In the 1680s Sir Richard Temple built a new house, to the north of which lay a park called Stowe Ridings, described by Celia Fiennes in her diary in 1694 as being planted with 'rows of trees'.[28] Temple's son, also Richard, was rusticated like other Whigs in 1710 when the Tories came to office, and set about enlarging his garden at Stowe. In 1713 he employed Charles Bridgeman, who had succeeded Henry Wise at Blenheim and had also collaborated with Vanbrugh, to 'lay out the grounds and plan the whole'.[29] Though trained by Le Nôtre and London and Wise in the formal style, Bridgeman's layouts marked the transition between the old and the new.

Among Bridgeman's innovations at Stowe was the use of the ha-ha not only to open up the garden but also as a means of uniting two large areas of garden previously unconnected with each other. Two limb-like gardens had developed, one lying to the south of the house and one to the west. The area lying between them was called Home Park, a swampy piece of ground. In 1718 Bridgeman had a stockade ditch dug, the prototype of the ha-ha. This ran along a lime walk which bounded the gardens on the west, opening them up to give vistas across the park towards the south garden.

View from the foot of the Pyramid, Stowe: J. Rigaud, 1739. Shows how Home Park linked the gardens in the forefront with those in the distance.

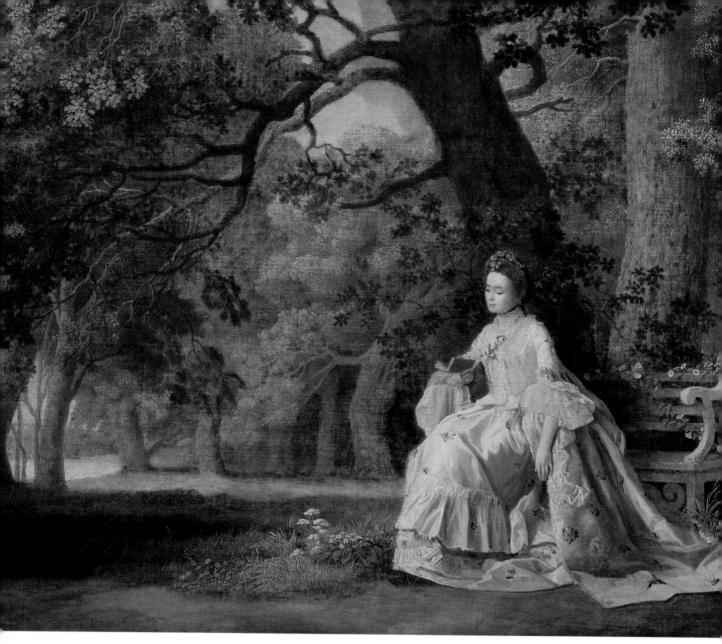

Lady reading in a wooded
park (detail): George
Stubbs, 1768–70.

Two years later he and Vanbrugh — whom Temple had by now engaged
to remodel the house and design the garden buildings — devised an
asymmetrical plan in which the ha-ha was extended to enclose both areas
of garden adjacent to Home Park, and the park in turn was to act as a
linch-pin, linking and locking the two areas of garden into one whole
design. Cattle and horses grazed in the comparatively small park area,
ornamenting the view. On a knoll in the park, formerly a garden mount,
Vanbrugh placed a 'Rotondo' with views out over the park to the
countryside and back into the gardens.

The next stage was to define Home Park on its exposed boundary. In
1725 work was begun on the perimeter ha-ha which exists today and was

Detail of the staked ha-ha at
Stowe dug in 1718. This
separated Home Park from
the garden and was an
intermediary stage in the
development of the ha-ha.

to enclose the park completely, making it a part of the whole garden in
which it now lies. This, finally, was a ha-ha proper: a dry trench dug with
the outer side sloped and the inner vertical, both sides ending at ground
level.

Having dissolved the visual boundary between the garden and park, the
next step was to harmonise the two. Among other things this meant
getting rid of what Switzer called the 'vast and expensive Gardens . . . the
folly of this and the past ages.'[30] At Stowe, Bridgeman pulled down the
walls of the compartmented gardens, making their intricate parterres into
a single large one, which he grassed over, echoing the park. Great grass
parterres became one of his hallmarks, and he was criticised for the

Kent's curving ha-ha at
Claremont has done away
with the military overtones of
bastions and stockades
common in earlier forms.

immensity of some of these, which at times threatened to dwarf the houses they surrounded.

At Houghton, the home of Robert Walpole, Bridgeman made similar innovations, described here by Walpole's son Horace: 'the contiguous ground of the park without the sunk fence was to be harmonised with the lawn within: and the garden in its turn was to be set free from its prim regularity, that it might assort with the wilder country without'.[31] As Sir Thomas Robinson confirmed when visiting Houghton in 1731, the gardens, which he calculated as covering forty acres, were 'only fenced from the Park by a *fosse*'.[32] The park consisted of seven hundred acres and was in its turn 'very finely planted and the ground laid out to the greatest advantage'.[33] Bridgeman planned large plantations of trees in 'plumps and avenues' to go completely round the park pale, a total of twelve miles in circumference.[34] Bridgeman's use of plumps as opposed to straight lines was also innovative, predating by some twenty years William Kent's similar designs in 1737 for Euston Hall, Suffolk. The arrangement of trees in such plumps or clumps was criticised by Walpole in 1743 as looking like the 'ten of spades'.[35]

Holkham Hall: W. Kent. Kent's clumps at Holkham are similar to those he proposed for Euston. The diarist Mrs Lybbe Powys wrote that the first avenue of clumps was planted at Heythrop Park.

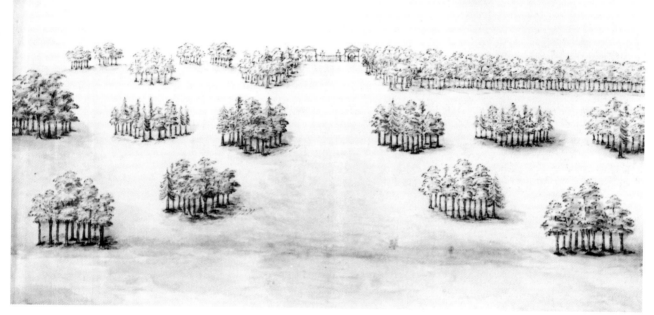

It was Kent, along with James Gibbs, who succeeded Vanbrugh as architect at Stowe, though Kent's supreme contribution was the deformalising and development of Bridgeman's scheme into a great landscape garden. In 1739 they placed new ornamental buildings in a belt of trees planted along the furthest boundary of Home Park, siting them to face Vanbrugh's Rotondo, from which they could be viewed in one great panoramic sweep, while for the walker on the ground they provided a

series of changing scenes across the park as he strolled by.

Series such as these were characteristic of Kent's work. He was trained as a painter and tended to see gardens pictorially, as three-dimensional landscape paintings, showing a distinct scene from every vantage point. Under his influence, a new generation of gardeners worked 'without level or line' to achieve 'the appearance of beautiful nature' where 'without being told, one would imagine art had no place in the finishing'.[36] According to Walpole, he used 'perspective, light and shade' to determine the reshaping and planting not just of the garden but of the whole estate.[37] At Stowe he erected temples and sculpture as focal points for his 'pictures'; serpentined the water; cut, thinned and replanted Bridgeman's recent landscape, breaking the regularity of his lines.[38] For his extensions to the gardens, he received from Walpole the accolade that 'he leaped the fence and saw all nature was a garden'.[39]

Like Vanbrugh before him, Kent also created evocations of classical landscapes. He had visited Italy between 1710 and 1719, and studied both the antique and the renaissance. At Holkham he turned the great park into a Plinyean landscape for his patron Thomas Coke, complete with an

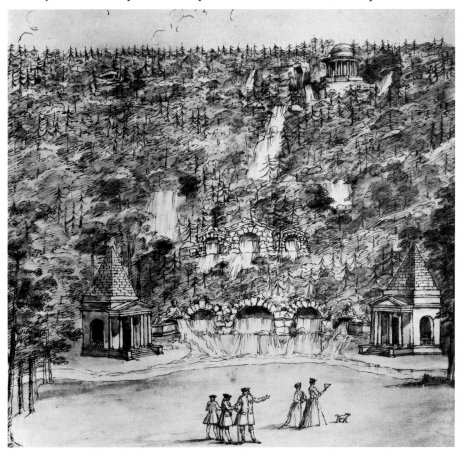

Proposal for the hillside in the park at Chatsworth: W. Kent. c.1725. This design is typical of Kent's way of setting features from ancient Rome and contemporary Italy into English parkland.

Wimpole: R. Greening's plan, c.1752. Winding walks, turf and clumps of trees replace the formal gardens to the north of the house, 'enclosed by a sunk fence that lets the park quite into the garden', wrote Lady Grey in 1753. (cf.Kip's view of Wimpole, p.59)

obelisk set in a grove of ilexes, a triumphal arch, and a neo-Palladian temple. And at Chatsworth – recently completed by London and Wise as England's Versailles, and epitomising the formal style – he made similar proposals to turn the park and hillside into yet another evocation of ancient Tusculum.[40] At Chiswick House with Lord Burlington he transformed the formal gardens into what was intended to be a replica of the grounds of a Roman villa, full of allegory and allusion. A ha-ha was dug to give views over the surrounding fields, where deer were placed in a paddock for ornament, as at Stowe. A pair of deer houses were built straddling the ha-ha, allowing the keeper to enter them from the garden side, and the deer to go in from the paddock. In 1727 Lord Burlington acquired an adjacent property, Sutton Court, and created a proper deer park. He pulled down the south deer house, replacing it with the Inigo Jones gateway acquired from Beaufort House, Chelsea, and turned the paddock into an orange tree garden.

Though his 'ruling principle was, that *nature abhors a straight line*',[41] Kent planted many, for example at Chiswick, where his *patte d'oie* avenues and small, hedge-compartmented gardens were far from 'natural' in the sense implied by the term at the end of the century. Change was still hesitant, and sometimes less bold than the rhetoric that accompanied it. But from the 1730s it became noticeably more rapid. Parks and gardens that had been only recently planted might now be ripped up and replaced in one generation. At Wimpole the great formal garden laid out by the Earl of Radnor in the middle of the park between 1693 and 1710, had completely gone by 1753, the ground given back to the park. One visitor described in a letter how 'instead of straight grand walks with borders and cross plots surrounded by walls and views unto the park through iron gates, there is now a large green lawn behind the house bordered by clumps of trees and flowering shrubs, a broad serpentine walk through them and enclosed with a sunk fence that lets the park quite into the garden'.[42] In the park itself the great south avenue was felled, vistas cut through the regular plantations, and the first 'picturesque' buildings planned.

The need to conserve trees saved many avenues from destruction by the new generation of designers. Those that formed the approach to a house tended to be looked on more forgivingly than others. In his *Observations on Modern Gardening* (1770), the writer Thomas Whately acknowledged that his readers were used to straight lines of trees in cultivated nature and conceded that an avenue still 'gives to a house otherwise inconsiderable, the air of a mansion'.[43] Still, the toll was high; as Sir William Chambers, a critic of the current fashion, wrote: 'the ax has often in one day laid waste the growth of several ages; and thousands of venerable plants, whole woods of them, have been swept away, to make room for a little grass ... Our virtuosi have scarcely left an acre of shade, nor three trees growing in a line, from Land's-End to the Tweed.'[44] He feared that soon there would

not be a forest tree left standing in the whole of England.

Also fast disappearing were gardens like those at Castle Howard and Blenheim from which all rural resonances had been removed and whose iconography was more like a city in the country, an *urbs in rure* as the poet Mason called them in his lighthearted skit on Chambers.[45] Chambers was in fact himself as critical of the old style as the new, and was championing oriental gardening, having just brought it to Kew. For him these gardens, with their straight walks like streets, open spaces resembling public squares, trees carved as obelisks and pyramids, walls of hedges adorned with niches for sculpture, green arcades and colonnades, were 'mere cities of verdure'. Steps, terraces, balustrades, cascades, fountains, basons, sculpture, urns, vases and embroidered parterres were torn up and thrown out, replaced by a groundbase of undulating turf, clumps, plumps and belts of forest trees, meandering streams, serpentine lakes and sinuous walks, all melding with the park, and flowing together to merge with the countryside beyond.

This new wave of naturalism marked the triumph of the park, the integration of park with garden reaching its apotheosis in the designs of Capability Brown between 1750 and 1780. In fact he dispensed with the garden altogether. Working with the natural ingredients of turf and trees, light and shade, water and the topography of the land, and relating each part to the whole, Brown created idealised, 'total' landscapes. He looked for, and rediscovered, the intrinsic formal qualities of his sites, and his parks have come to be considered more typically English than the countryside which surrounds them. Inspired by paintings, they have themselves been painted and reproduced in thousands of prints and on countless pieces of porcelain and pottery, providing a kind of archetypal image of rural England. Hand-painted or transfer-printed views of English parkland travelled the world. Even the famous Imperial Russian service made by Wedgwood in 1773 and numbering nine hundred and fifty-two pieces, was decorated with such scenes.

At Blenheim in 1764 Brown wiped out the Great Court built by Vanbrugh and Wise. He flattened its walls, pulled up its topiary and grassed the whole. He contoured the land, built a large dam and flooded a hundred acres of park, ponds and canal to make the incomparably beautiful lake, above which Vanbrugh's bridge now majestically strides. He replanted the park – save for the great avenues on the north and east – with 'clumps and belts'. Dark cedars spread in groups over the bright turf and circles of beeches echoed the cumulus clouds. Limes, chestnuts and sycamores hung over the lake, mirrored on its surface. A Gothic, or 'Gothick', boating house and a castellated folly completed the transformation.

Brown brought his parkland right up to the houses, which now appeared like ships floating in a green sea. By working with nature and using the innate contours and characteristics of each site, he was effectively

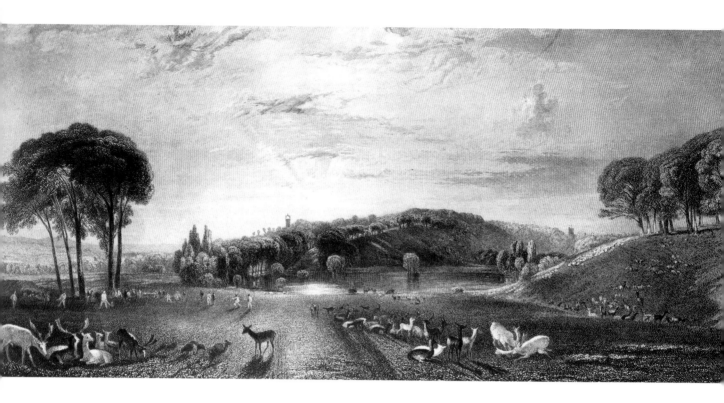

Petworth Park, Sussex:
engraving after J.M.W.
Turner. Part of Brown's lyrical
landscaping of Petworth Park
which he began in 1751.

following Virgil's exhortation for gardeners to be ruled by the *genius loci*; advice recalled by Shaftesbury in 1709 and more famously reiterated by Pope in 1731 in his Epistle to Lord Burlington.

> Consult the genius of the Place in all;
> That tells the waters or to rise or fall;
> Or helps the ambitious hill the heavens to scale,
> Or scoops in circling theatres the vale;
> Calls in the country, catches opening glades,
> Joins willing woods, and varies shades from shades;
> Now breaks, or now directs, the intending lines;
> Paints as you plant, and, as you work, designs.[46]

It goes without saying that Brown's parks were as contrived as the most formal of their predecessors. Planted, plotted and laid out to look natural, they too had their detractors. Such parks were despised by Constable, who said 'a Gentleman's park ... is my aversion. It is not beauty because it is not nature.'[47] But on the whole they were welcomed. Walpole, an enthusiast, considered the new style in some respects a rediscovery of 'the good sense' of the gentry's ancestors, who had wanted 'something at once more grand and natural'. He thought it 'more extraordinary, that having so long ago stumbled on the principle of modern gardening, we should

have persisted in retaining its reverse, symmetrical, and unnatural
gardens'.[48] Brown's alterations at Temple Newsam, Yorkshire, for the
ninth Viscount Irwin, were celebrated in an anonymous poem addressed
to the viscount and called *The Rise and progress of The Present taste in Planting
Parks, Pleasure grounds, Gardens etc.* (1767). As its title suggests it was also
a history of garden design, which in fact predated Walpole's history of
gardening, though at the time Walpole was unaware of the existence of
this poetic epistle.[49] In the address written in prose, the author called
Brown 'the finest genius this nation has produced for laying out a pleasure
ground . . . for uniting powers of painting and poetry'. It was of course
Pope who had asserted that 'all gardening is painting'.

Changes outdoors reflected ones taking place inside the house itself. The
innovations that had marked Houghton in 1717 as a harbinger of change,
were by no means limited to the grounds. The house was built in the new
Palladian style, and though still a formal house in the symmetry of plan
and grandeur of its principal rooms on the *piano nobile*, the way in which
it was inhabited looked forward to the relative informality of the country
house party that characterised the lifestyle of the next generation. Its 'base
or rustic storey' was laid out for the use of 'hunters, hospitality, noise, dirt
and business', while the *piano nobile* was dedicated 'to taste, expense, state
and parade'.[50] Walpole held week-long gatherings in the rustic twice a
year. These 'congresses' – all male apart from Walpole's wife and sister
– were made up of members of the government who spent a week or so
in a cheerful routine of political confabulation '. . . interspersed with
hunting feasting and boozing with the local gentry'.[51] Gradually the
informality of life in the 'rustic' made the Saloon – the great chamber or
room of the house – obsolete, leading eventually to the demise of the
formal house plan. By the 1750s a circuit of communal reception rooms
running into each other became the fashionable plan.

Outdoors, these changes were reflected in the introduction of the Circuit
or Anfilade into the layout of parks and gardens. A short circuit, for
walking, led round the garden or pleasure grounds, while a longer one for
driving or riding led round the park.[52] In some cases there would also
be an outer circuit taking in the whole estate.[53] The circuit enabled a tour
of the whole grounds to be made, with an orchestrated succession of
picturesque scenes unfolding before the viewer (at this date 'picturesque'
meant literally like a picture, and had none of its later romantic
connotations). Switzer had recommended that the circuit be at least six or
seven yards wide, and take the spectator over the tops of the highest hills
in the estate, to give the best views.

Mark Girouard in his *Life in the English Country House* draws an analogy
between the circuit indoors and that outdoors: 'Guests or visitors, having
done the circuit of the rooms, did the circuit of the grounds. Just as, at a
big assembly, tea was served in one room and cards laid out in another,

the exterior circuit could be varied by stopping at a temple to take tea, or at a rotunda to scan the view through a telescope, or in general by reading the inscriptions and enjoying the sentiments expressed on various monuments.'[54] Special excursions were also made to various points of interest on the circuit: cooking fish in a pavilion on a lake, taking a cold bath in a bath house, making an expedition to a 'hermitage'.

Picturesque circuits on a large scale became a major feature of parks during this period. For Bridgeman the circuit of an area had been as important as the vista from it or across it, and he had taken pains to give visitors at Stowe distinct views of such things as garden buildings or statuary.[55] By the 1760s, Stowe's landscape had been further developed by Brown, and its circuit, with its multitude of buildings to visit, had become one of the most famous and frequented in the country.

At Painshill Park, Surrey, the creation of Charles Hamilton between 1738 and 1776, the whole scheme was designed as a circuit revealing to the viewer a series of scenes evocative of Claude and Salvator Rosa landscapes. Each 'picture' was intended to evoke a different emotional response, ranging, for example, from surprised delight at the sight of a Gothic temple, to deepest melancholy on arriving at the mausoleum. Each was placed in a setting calculated to maximise its dramatic effect and reinforce the mood it was trying to convey. A hermit was even hired to heighten the – presumably pious – experience of visiting the hermitage. The layout was a masterpiece of surprise and illusion, propelling the visitor along a series of winding paths which continually changed direction as they skirted the small hills thrown up to mask the view, and at the same time gave the sensation of having covered a much larger area of ground than was actually the case.

Driving around the park on the longer circuit was facilitated by the improved design and springing of carriages, which greatly contributed to the increasing mobility of society. Roads too were improving; before 1712 there were no gravelled drives in parks, and even at Blenheim the best a visitor could hope for was 'an absence of anthills and molehills on the main drives'.[56] With these advances, 'visiting' became a major occupation among what Oliver Goldsmith termed 'polite society'. Staying with one's friends in their country houses or visiting those of strangers (whose houses and grounds were usually open to view), had arrived as the new pastime for people with time on their hands.

Where walking was inconvenient, chaises, curricles and phaetons (the 'sports car of the eighteenth century'[57]) conveyed visitors effortlessly past the pictorial scenes. A prototype of the tour bus was even introduced in the form of the Dutch *Waske*. This was a long open carriage 'holding fifteen or sixteen persons drawn by six horses', as the diarist Mrs Lybbe Powys described it when she saw the Duke and Duchess of Marlborough driving around in one with their guests to view the new works at Blenheim.[58]

Meanwhile the use of the ha-ha became steadily more sophisticated. Low hillocks were placed in front of it to conceal its line; the ground level on either side might differ; groves or clumps of trees were planted astride it. At times the ha-ha was completely dispensed with and deer came right up to the house. William Kent had anticipated this in 1740 in his proposals for a new mansion at Euston for the first Duke of Grafton, where he showed the park coming right up to the house on one elevation, with freely planted forest trees grouped around it.[59]

In this instance the park is clearly defined by being grazed; not a characteristic of a garden. But so successful now was the unifying of park

Overleaf
Stourhead: F. Nicholson, 1813. A landscape like that of Painshill where garden and parkland are often indistinguishable.

Painshill Park, Surrey: S. Gilpin & G. Barrett. The Gothic folly overlooking the lake was built c.1770, to look like a ruined abbey.

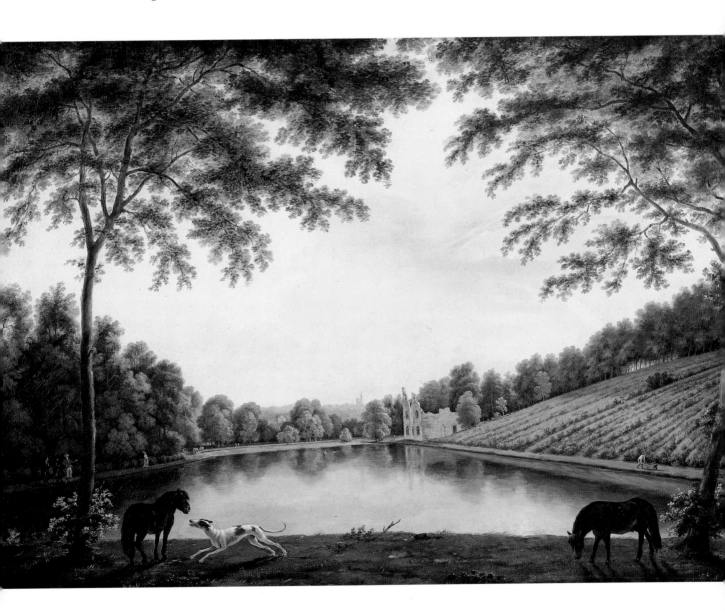

and garden, that in many cases there was confusion as to which was
which. As the poet William Mason wrote in his poem *The English Garden* –

> The wand'ring flocks that browse between the shades,
> Seem oft to pass their bounds; the dubious eye
> Decides not if they crop the mead or lawn.[60]

Pope suggests such confusion was intentional:

> He gains all points who pleasingly confounds
> Surprises, varies and conceals the bounds.[61]

But the truth was that even those laying down the principles of the
new mode of gardening were themselves having to redefine the terms Park
and Garden, both topographically and aesthetically, now that the garden
had as it were been given back to the park. For Thomas Whately, the
distinctions were also far from clear.

> The affinity of the two subjects is so close that it would be difficult to
> draw the exact line of separation between them: gardens have lately
> encroached very much both in extent and in style on the character of
> a park; but still there are scenes in the one, which are out of reach of
> the other; the small sequestered spots which are agreeable in a garden,
> would be trivial in a park; and the spacious lawns ... of the latter
> would in the former fatigue for want of variety ... flowers and
> flowering shrubs in the garden, specimen trees, little groups of trees
> would all be out of scale with the surrounding woods and forests and
> delicate ornament lost in the park.

Open views and distant prospects were appropriate to parks, whereas in
gardens concealment giving nearer views and glimpses of various scenes
were more suitable. Nevertheless, Whately continued, both park and
garden should be 'highly cultivated ... in a manner consistent with each
of their characters; and may in both be of the same kind, though in
different degrees'.[62]

 He cited Painshill Park as a model for the 'perfect coalescence of park and
garden'. There, he wrote, 'park and garden mutually contribute to the
beauty of several landskips; yet ... are absolutely distinct; and not only
separated by fences very artfully concealed, but the character of each is
preserved pure in the spots, from which the scenes wherein they mix are
commanded'.[63]

 Similar transformations to the landscape were taking place at Stourhead,
Hagley, and West Wycombe during the same period. At West Wycombe,
Sir Francis Dashwood of Hell-Fire Club fame complemented the alterations
to his father's house (which he turned into a Palladian masterpiece) by
setting it in a neo-classical landscape. He replaced the formal dutch garden

with lawns, shrubs and trees, which, with the aid of a ha-ha, appeared to
flow into his park. A gentle descent led to the swan-shaped lake which
formed the view from the house. He ornamented the lake with decorative
bridges, a cascade flanked by classical plinths surmounted by reclining
nymphs (replacing the rococo rockwork seen in the painting on the jacket),
and an island temple. To these he added other temples, a hillside
mausoleum, and a golden ball to crown the hilltop church tower. 'A palace
and a park ought ever to be inseparable', wrote Joseph Heeley in the 1770s.
At West Wycombe this was achieved.

 In such layouts the difference had become one of little more than a
difference of 'grain'; rougher and broader in the park, tighter and more
polished in the garden, with the wilder elements of the former 'softened
by distance' – Whately's words.

*Practical Treatise on
Planting and the
Management of Woods &
Coppices:* Samuel Hayes,
1794. Tree-moving.

Paradoxically the 'natural' style that finally resulted in landscape parks which scarcely differed from the 'common fields',[64] altered nature more than the tastes of any previous age. Besides the razing of villages and the re-routing of roads, great tracts of earth were contoured, acres flooded, woods uprooted, and rivers dammed. The creation of ever greater heights of Edenic sublimity was an aristocratic pastime prevalent enough by the early nineteenth century to have produced a welter of literature both praising and satirising it. Perhaps Goethe's novel *Elective Affinities*, where the main characters are engaged in creating an English landscape park, not least to alleviate their boredom, is most revealing of the ethos out of which they came. Such a need is made clear by Charlotte, who with her husband is creating the park. When her husband was away for a while she allowed the work in progress on the park to continue. When it was completed she was shrewd enough not to embark on another stage, because 'she wanted him to find enough pleasurable activity left to do to keep him busy'.[65]

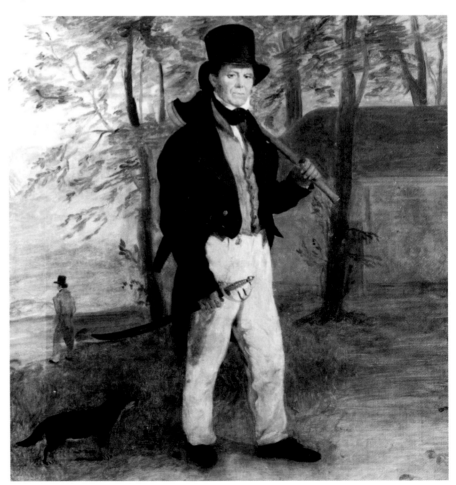

'The Woodman': 1830. From a rare series of paintings at Erdigg of servants and estate workers.

7

PAVILIONS FOR PLEASURE:
Park Buildings

Amid the vagaries of its aesthetic development, the park in many instances still retained its traditional role as a place for sport and a kind of auxiliary farm.[1] It remained a part of the economy of the estate, although its use as a larder of fish and game was no longer essential except in remote areas. The medieval stewponds, which stocked the fish so necessary before the Reformation, were formed into ornamental lakes, their fish now providing a quiet reclusive sport for the solitary fisherman who played his own part in the general *mise en scène*. George IV in his later years spent much of his time fishing in Virginia Water, enjoying the peace and seclusion of Windsor Great Park, much as Edward III had done four hundred years before.[2]

The obsession with hunting was as great as it had ever been. Together with fishing and shooting it helped form the stereotype of the English country gentleman. One of the signs of the importance of sport was the advent of the sporting picture, an early exponent of which was John Wootton who was already established as a sporting painter by 1714. Robert Walpole set a fashion when he had himself painted in hunting gear, rather than in the formal dress of a statesman. Members of the aristocracy employed painters like John Wootton to paint their horses and dogs, and produce hunting scenes that rendered their park settings as Claudian landscapes. (Constable some decades later declared his particular dislike of the Italianate landscape settings habitual in these sporting pictures: part of his general disapproval of country house parks.) There was, as John Macky wrote to his foreign friend, an 'abundance of Gentlemen's Seats . . . each with their little Parks stocked with Deer', something 'rarely seen abroad'.[3]

However, the deer in these parks were increasingly kept for ornament rather than hunting (though they were culled in season by their owner or the gamekeeper to provide food for the table). For though great landowners still hunted deer, the lesser landowners were changing their

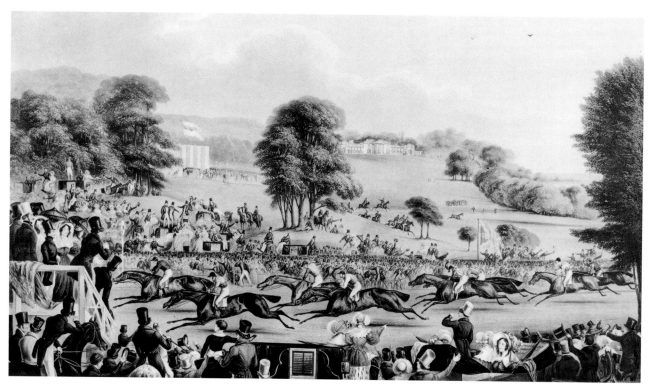

Heaton Park Races: 1835, engraving by R.W. Reeve, after a painting by F.C. Turner. An early eighteenth-century park where race meetings were held between 1827 and 1839. Heaton has been a public park since 1902.

quarry to the hare and the fox. As early as 1711 Addison was writing about some 'Rural Andromache' as one of the greatest fox hunters in the country who 'talks of nothing but horses and hounds and thinks nothing of jumping a five bar gate'.[4] It was Robert Walpole yet again who was instrumental in making hare and fox-hunting fashionable. He was reported to have entertained his 'congresses' with hunting 'six days in the week, three times with Lord Walpole's fox-hounds, and thrice with Sir R[obert]'s harriers'.[5]

Timber flourished: little round clumps of trees or rough scrub were planted as coverts to harbour the fox, scattered among the open glades of parks or the ploughed ground of fields. The driven shoot, which was to become immensely popular, was pioneered at Holkham. Birds were driven to a clump of trees where standing guns awaited them.[6] Clumps of woodland 'à la Brown' on the tops of hills, belts of trees round park and estate boundaries and groups of trees scattered throughout were probably planted as much in the interest of sport as in support of any artistic theory. At any rate, the huge success of the 'landscape' movement was no doubt in part due to its compatibility with economic and sporting interests.

Horse racing and racecourses had also long featured in parks – there was a racecourse in the park at Blenheim before 1708. Improvements in the breeding of horses added to the excitement of both racing and hunting. A further reason for the prevalence of parks even on quite modest estates

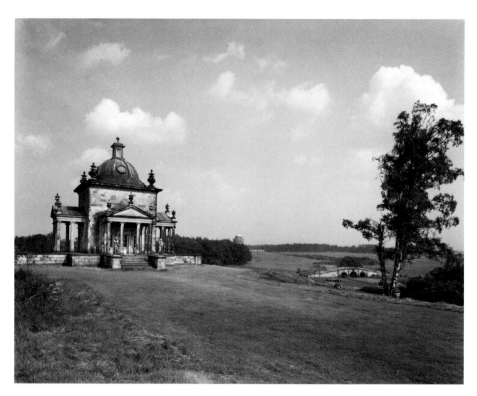

was the space they allowed for the exercising of the owner's horses, as well as the owner. In their passion for racing, landowners did not limit themselves to their four-legged dependents: races between 'running' footmen – so-called because they ran before their masters' and mistresses' carriages – were frequent events. An observer of one which took place at Blenheim Park in 1720 over a four-mile course, described the contestants running quite naked, without even shoes or pumps. Such a display of nudity was, he said, 'looked upon deservedly as the Height of Impudence, and the greatest affront to Ladies, of which there was a great number'.[7]

The different ways in which the park was used in the eighteenth century also gave rise to a new category of design – landscape architecture. There had always been buildings in both gardens and parks: lodges, towers, stands, dovecotes and ice houses, for example, were common in medieval hunting parks. But in the eighteenth century the increasingly diverse requirements of the leisured classes led to the development of an even greater variety of such buildings. Vanbrugh had pioneered the placing of formal buildings in informal landscape with the dual purpose of enhancing the landscape and serving a practical need. Soon there were pavilions or temples, such as the Temple of the Four Winds at Castle Howard, in which to take tea or shelter from the weather. There were bath houses, waterhouses, bridges to cross lakes; mausoleums for the family's dead; churches and chapels for their prayers. There were buildings to house

Vanbrugh's classical temple at Castle Howard built after his death in 1726 and now called the Temple of Four Winds. Seen here with Hawksmoor's Mausoleum in the distance.

animals: deerpens, kennels and stables. There were fishing pavilions and boathouses. In addition were monuments, obelisks and pyramids, erected to commemorate events or persons. During the second half of the century buildings or structures were raised which had no practical purpose at all, placed purely as eyecatchers or prospect towers in the form of hermitages, temples, or false ruins of castles and abbeys – appositely called follies.[8]

The styles of such buildings were as varied as the roles they performed. Generally small in size, and built for a single need, park buildings were ideal for architectural experiment and the search for perfect form. Precedents for this went back at least to the sixteenth century: in their

The Triangular Lodge at Rushton, Northants, was built by Sir Thomas Tresham (a convert to Catholicism) as a banqueting house despite being called a lodge. All its ornamentation was in multiples of three to celebrate the Trinity.

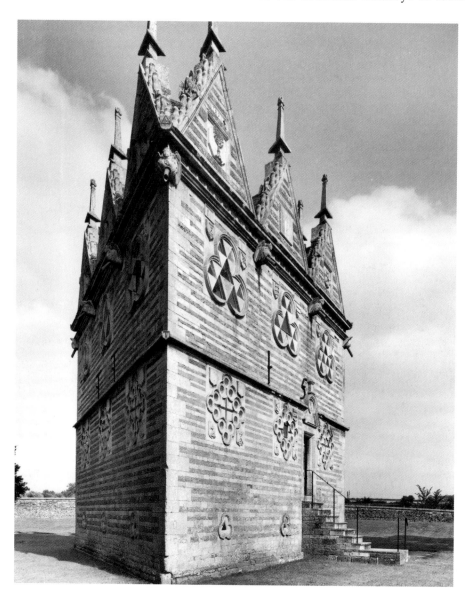

preoccupation with the relationships between geometry and divinity, the Elizabethans had raised triangular buildings, symbolic of the Trinity, as lodges or banqueting houses in parks and forests. The fantastical lodge at Rushton (in fact a banqueting house, possibly with accommodation above to house a keeper) was not only triangular in form, but also had all its decorative features expressed in multiples of three.

Quite often the prototype of a new style was tried out in a park building before entering the mainstream of architecture. The first 'pure' neo-Palladian buildings were the temples in Lord Burlington's garden at Chiswick, built between 1717 and 1721. The first Roman-style building in England was Hawksmoor's design for the Mausoleum at Castle Howard, erected in 1731. And the first 'Greek' building anticipating the Greek revival in architecture was 'Athenian' Stuart's Doric temple in Lord Lyttelton's park at Hagley in Worcestershire in 1758.[9] Even more exotic and eccentric styles proliferated during the latter part of the century: Arab, Moorish, Turkish, Chinese and, above all, Gothic – or rather Gothick. There came a time when hardly a park, from the smallest gentleman's to the vastest duke's, was without its Gothick ruin – fake or real. Vanbrugh had tried and failed to preserve a genuine Gothic ruin at Blenheim in 1709.

King Alfred's Hall, Cirencester Park: T. Robbins, 1763.

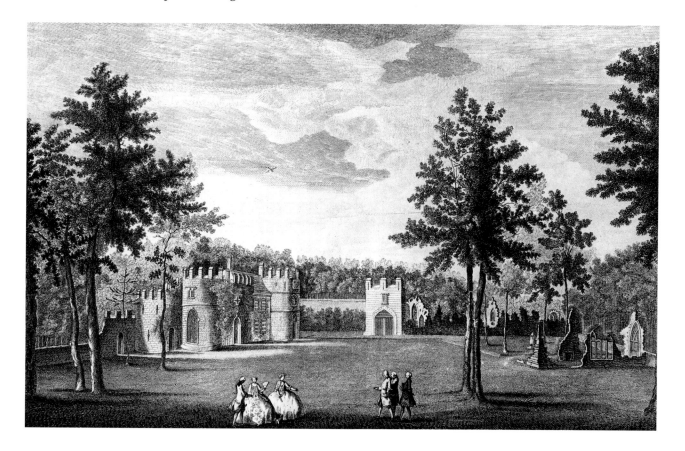

Just thirteen years later, in 1721, the first Gothic ruin was *created* by Lord Bathurst and Alexander Pope in Cirencester Park. It began as a rustic cottage in a wood. With the addition of medieval features taken from a genuine manor house, it developed into a kind of castle called Alfred's Hall – hardly authentic Gothic, but the education of the upper classes tended to be less strong in English history than it was in classical history, and their idea of what constituted 'Gothic' owed as much to personal whim as to historical accuracy. Sanderson Millar was one of the most prolific creators of Gothic ruins for the aristocracy, and one of his creations still stands in the park at Wimpole.

Pattern books also circulated to help those unfamiliar with the range of styles. The title of one of these provides a glimpse into the fantastic world of these ornamental buildings; this was William Wright's *Grotesque Architecture or Rural Amusements* of 1767, subtitled 'plans, elevations and sections, for huts, retreats, summer and winter hermitages, terminaries, Chinese, Gothic and natural grottos, cascades, baths, mosques, moresque pavilions, grotesque and rustic seats, greenhouses, etc. many of which maybe executed with flints, irregular stones, rude branches and roots of trees'.[10]

Predictably, during the latter part of the century a reaction set in to the

Basildon Park lodges, Berkshire, 1816. An octagonal pair built by John Carr in 1776.

numbers of such buildings in parks and the exotic style of their architecture, which hardly added to the 'naturalness of the scene', as Thomas Whately complained.[11] No garden or park had collected a greater number of buildings than Stowe – to its detriment – and many were pulled down. Even by 1753 Walpole had criticised Lord Cobham's use of buildings at Stowe, with their facetious use of statues of living politicians: 'I have no patience with building and planting a satire.'[12] Buildings were to play little part in a Brown landscape park; the need for Arcadian allusion was already out of fashion. And the ruin, that once too novel idea, had become in Thomas Whately's opinion merely a 'hackneyed device'.[13] Repton considered sham buildings of any kind deplorable, though his recommendation that Thomas Cubitt should place a tower on the top of a hill next to his park at Honing seems a little inconsistent with this view.[14]

Perhaps the most significant and enduring image of all park buildings is the gatehouse at the entrance to the park. Once the approach to a great house had been laid through the park, rather than directly off the highway, entrances to the park were signalled by various architectural devices which might also serve to arouse the expectations of the visitor. No visitor, having circled Vanbrugh's battlemented and bastioned walls at Castle Howard before entering through his great pyramid-topped gate, could

The Kill at Ashdown Park: (detail) James Seymour, 1743. Horses and foxhounds leap over the wall of the still densely wooded park. (See Kips' earlier view, p. 72).

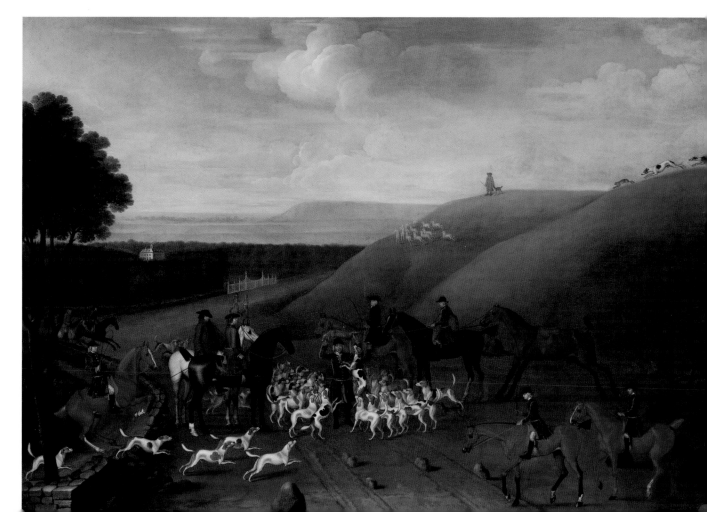

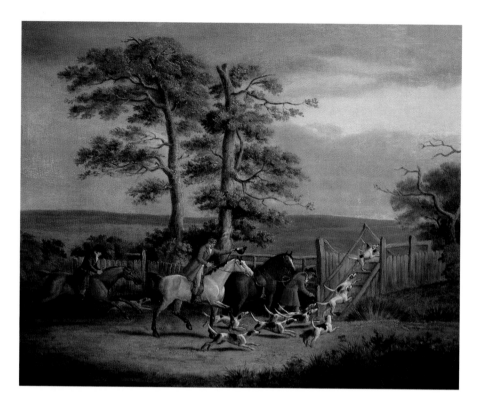

Hunting Scene : D.
Wolstenholme (1798–1822). A
rare picture of a ladder stile
over a park pale. Stiles were
often more popular than
gates, which could be left
open.

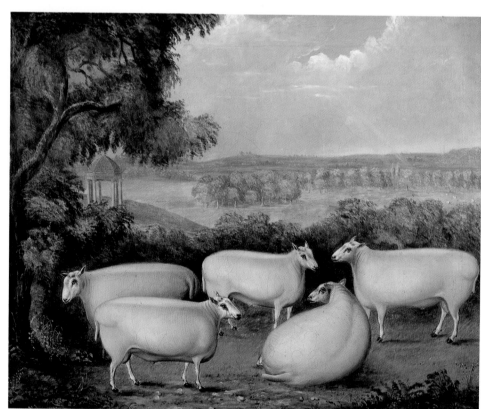

Rams at Stowe Park, Stowe:
J. B. Wood, 1831.

have expected to find anything less than a castle inside. Likewise at Blenheim, Hawksmoor's great triumphal arch at the entrance to the park was an appropriate portent of the splendours within. It is hard to think of any other architectural form which could so explicitly signal an owner's opinion of his worth and at the same time deliberately awe the visitor.

As carriage drives were laid down, small buildings were erected specifically as accommodation for the keeper and his family to guard the entrance to the park. These buildings usually took the form of single or twin pavilions either side of a gate. Sometimes accommodation was provided above an arched gate tower – a kind of modified triumphal arch. William Kent probably more than any other architect set the fashion for these buildings, with his entrance lodges at Holkham (his first), Claremont, Esher Place, Stowe and Badminton, where he built his most famous of all, Worcester Lodge. By 1740 porter's lodges at park gates appeared in a pattern book by Batty Langley.[15]

In contrast to the eclectic styles of the buildings which might lie within the park, these little outposts of the great house generally shared the same architectural language as the house itself. Together with the pale or wall circumscribing the park, they defined the private territory for which they stood sentinel. They also made more architectural sense of the great avenues, which had previously begun often at just a gate in the wall.

On some estates the wall itself was an object of no small magnificence

Proposed ruin to be built at Kedelston, Derbyshire: R. Adam. c.1759–61. One of the grandest attempts to recreate the Antique.

A crinkle-crankle wall at Easton, Suffolk, c.1790s – early 1800s. Built to surround the park of the Dukes of Hamilton, and the longest serpentine wall in the world. In its present poor state of repair, this will not be so for much longer.

and could signify the epitome of 'taste', that great eighteenth-century concern. The serpentine or 'crinkle crankle' walls were supreme in this regard, since they were the highest expression of the bricklayer's art and only mastered by the French. These walls were constructed of 'reversed, perfect semicircles of only one brick thick'.[16] The uniqueness of such walls to East Anglia was due to the presence there during the Napoleonic period of French prisoners of war who erected them for rich landowners. Rather less perfect copies were later made by local workmen. The acme of park and garden design at the time was the interpretation of Hogarth's 'lines of beauty' – the 'waving' or 'serpentine line'.[17] It was clearly the height of fashion, as the following excerpt from David Garrick's *The Clandestine Marriage* confirms.

> *Sterl.* How d'ye like those close walks, my lord?
> *L. Ogle.* A most excellent serpentine! It forms a perfect maze, and winds like a true lover's knot.
> *Sterl.* Ay – here's none of your strait lines here – but all taste – zig-zag – crinkum crankum – in and out – right and left – to and again – twisting and turning like a worm, my lord![18]

To have your entire park encircled by a wall designed in such a manner must have been the ultimate in taste.

Capability Brown died in 1783. His indisputable heir as England's leading landscape gardener was Humphry Repton, an admirer of Brown,

Wolverton, Hampshire. Folly in the grounds of Sir Charles Pole's house in 1810.

Small Rustic lodges with their plans, 1804.

who took over many of the latter's projects after his death. Repton advocated 'appropriation', which meant, he explained, 'everything nearby to appear a part of one's own property'.[19] In buildings this was achieved by designing not only park lodges but also estate cottages and whole new villages in the same architectural style as the mansion itself, or at the very least displaying their owner's arms on their elevations. In its emphasis on ownership, this development incidentally reveals an increasing search for privacy: by the beginning of the nineteenth century, not even 'polite society' was any longer welcome to look over the average landowner's house or park uninvited.[20] It was a great change from the days when Charles Bridgeman used to tell his clients that the 'making of a magnificent park was not just for oneself', but would be '... an ornament of the

Triumphal Arch, Holkham
Hall: W. Kent, post-1744.

kingdom in general', since, he continued, 'it would benefit all those who travel that way'.[21]

New barriers were erected to safeguard the privacy of the park. Notices were hung from trees warning that 'trespassers will be prosecuted', and as the new century progressed these were backed by increasingly harsh legislation; as in Norman times, crimes against property were more severely punished than those against the person. Still, despite Repton's measures to ensure that enclosure of a park should be 'for the peculiar use and pleasure of the proprietor',[22] his last published words make it clear that he was against landowners 'fencing off their parks'.[23] He wrote, 'For the honour of the country, let the parks and pleasure grounds of England be ever open, to cheer the hearts, and delight the eyes, of all who have

taste to enjoy the beauties of nature'.[24] In retrospect, these words place him as a pioneer at least in spirit of the public park movement of the later part of the nineteenth century.

Though many avenues remained to form the traditional approach through the park, the layout and planting of new drives was becoming quite different. Repton was famous for making circuituous drives to houses to give the impression of a greater extent of property. These drives, and his ideas of appropriation, were ridiculed by his critics in the great picturesque debate launched by Uvedale Price and Richard Payne Knight in the following parody of his work:

> As you advance into the palace gate,
> Each object should announce the owner's state;
> His vast possessions, and his wide domains,
> His waving woods, and rich unbounded plains.
> He therefore leads you many a tedious round,
> To show th'extent of his employer's ground;
> Then mounts again through lawn that never ends.[25]

Dismayed at the way Brown's followers had reduced his parks to mere formulae of belts, lakes and clumps with no regard to the uniqueness of the site, Repton introduced greater variety, and greater comfort and convenience for the user. One of the charges brought against Brown in the next century was that people had no place in his parks.

A garden seat: J.B. Papworth (1775–1847).

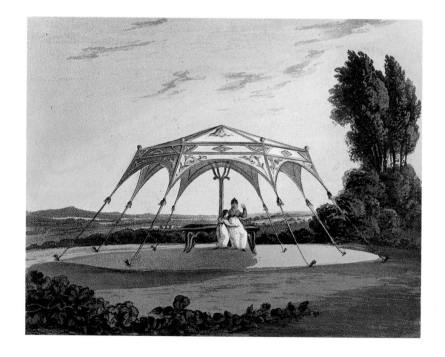

8

RUS IN URBE:
The Royal Parks of London

Parallel with the innovations in country house parks were those taking place in the royal parks in and around London. Queen Anne had begun the transformation of William and Mary's seventeen acres of garden at Kensington when she added thirty acres lying to the north of the palace in 1704, and in 1705 took one hundred acres from Hyde Park to make an enclosure for deer and antelope, forming the area called the Paddock. The palace was now surrounded by its own land on all sides.[1] Henry Wise, who had been working at the palace with George London since the reign of William and Mary, was appointed to look after the gardens. He laid out the thirty acres as an upper garden, creating a formal

St James's Park from the terrace of 10 Downing Street: G. Lambert, c.1736–40. To overlook a park was as desirable in London as it was in the country.

wilderness with turf walks, a terraced sunken garden, and a mock mount – 'a pyramidal structure of trees'.[2] He also enlarged and redesigned the original gardens of William and Mary, replacing their elaborate geometric parterres with equally elaborate ones of his own design. These new gardens were laid out between 1702 and 1711, and while no traces remain of their design, the additional acreage, the Wren Alcove – alas, no longer in its rightful place – and the building of the orangery by Vanbrugh, are lasting memorials to the Queen Anne era.

Wise had his contract renewed in 1715 by George I who added further acres to the south, almost doubling the size of the Paddock. This involved re-routing Rotten Row, and building a new brick wall around the altered boundary. In 1726 Charles Bridgeman joined Wise.[3] It was in the reign of George I that the essential features of Kensington Gardens, still apparent today, were created in the area of the Paddock. The layout of the walks, the Round Pond (the Great Bason) and the Long Water (the name of the Kensington Gardens end of the Serpentine) were all begun in the last two years of his reign, 1726–7.

Though landscaped, the Paddock was still kept primarily as an enclosure for animals, to which were added a greater and more exotic variety,

Windsor Castle, view in the Home Park: Paul Sandby (1725–1809). This park, which was open to the public in the eighteenth century, is now private.

including tigers and civet cats. The Round Pond, which was formed out of a rectangular reservoir that had probably supplied the house with water at the time of William and Mary, was given over to the king's tortoises and turtles, and nearby he also made a snailery, a copy of one in Richmond Park (1725). The Round Pond formed the focal point of a *patte d'oie* or 'Great Bow' of tree-lined gravel walks; one of them, the Broad Walk, being fifty feet wide and planted with elms. Between them Wise and Bridgeman planted 23,500 trees, mostly varieties of elms and limes, elms being the most commonly planted trees in England.[4]

After the accession of George II in 1727, the gardens were further improved by his wife Queen Caroline, an inveterate gardener who spent £20,000 on them, all out of the royal purse. Her appointment of Charles Bridgeman as her sole gardener in 1728 brought to Kensington many of the innovations already seen at Stowe. Bridgeman respected the structure of the avenues, enlarging and elaborating them, and creating more walks lined with espaliers of limes. Some of the formerly wooded areas were grubbed out to make more lawns, the trees replanted elsewhere as formal groves. Apart from the Broad Walk, which remained gravelled, all other walks were grassed so that only the lines of trees defined them. One of

The Temple of Concord, Green Park: 1814. Built to celebrate one hundred years of the Hanoverian dynasty, the temple was burnt down during the opening firework display.

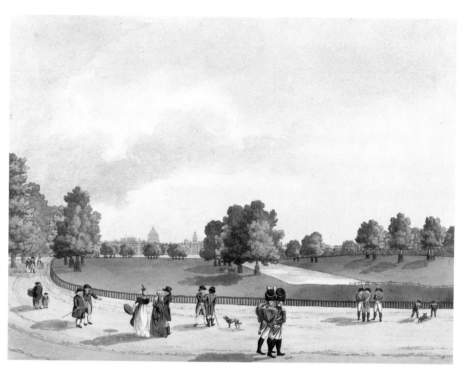

St James's Park: F.J. Mannskirsch, 1809. At this date the canal and central part of the park are still railed off from public access.

Bridgeman's more bizarre touches was the replanting of '1,195 dead elms costing £597 10s',[5] said to be at the request of Queen Caroline. In *Modern Gardening*, Walpole cited Kent as having planted dead trees to give a greater truth to the scene, adding that 'he was soon laughed out of his excess'. But it seems the implementer, even if not the originator of this idea, was Bridgeman and not Kent as is generally held.

At the queen's request the animals were removed from the Paddock, or at least kept within wooded enclosures sown by Bridgeman. True to his manner, Bridgeman also grassed over the complex parterres of Queen Anne's gardens and at the direction of Queen Caroline removed the evergreens. A *berceau* or 'walk of shade' was made '. . . in the spinneys next the boundary walks';[6] in the same area he made a number of serpentine walks, while the wilderness in the upper garden was opened up. By these plantings and additions of walks, he made George I's relatively open Paddock more formal and a place for people rather than animals. The tiger's den built in 1725 was demolished in 1729.

Bridgeman also improved the water elements of the gardens. An ornamental reservoir had been built in 1725 in Hyde Park by the Chelsea Water Works to meet the needs of the now larger palace and gardens at Kensington. This was used to supply the Round Pond, now deepened. In 1728, as well as 'deepening . . . raising & finishing the head of the Long Water',[7] Bridgeman joined a number of old fish ponds to the east of the Long Water into a great serpentined lake, hence its name. It was completed

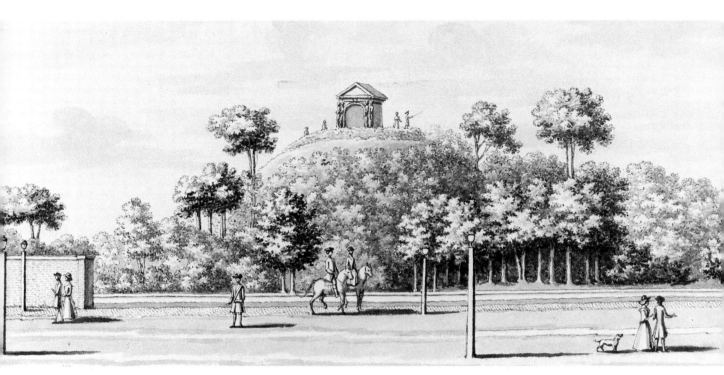

in 1737 when a further lake was constructed at the Knightsbridge end to improve and receive the outlet.[8] It was part of the genius of the eighteenth century to make such an ornament of a utilitarian feature.

To enable the queen to enjoy the views from her newly landscaped garden, Bridgeman dug in 1730–1 a bastioned ha-ha to replace George I's high wall on the east of the gardens. In this way she was able to look across Hyde Park, which was still largely a rough hunting park. She had William Kent build two summer houses: the Temple overlooking the Serpentine, and a revolving summer house on a mount made from earth excavated from the Serpentine. From this the queen could see into the sweep of surrounding countryside beyond Hyde Park. As from the Rotondo at Stowe, the views were extended both within the garden and without. The mount was celebrated in verse in the April 1733 edition of *The Gentleman's Magazine*,[9] which also 'commended the good taste of the whole garden in contrast to the ostentation of Louis XV'. Kensington Gardens at this time was in the vanguard of the current transition from formal to informal. Though little remains of the underplanting and shrubs of this period of the garden, the basic outlines are still there. The finely manicured lawns of that date reverted to a more parklike state when sheep were introduced to graze in the nineteenth century.

Unlike St James's Park and Kensington Gardens, few improvements were made to Hyde Park directly after the ravages of the Civil War. Charles II restored the deer, did some planting and walled the park. More interest

A view of the ha-ha and mount in Kensington Gardens: B. Lens the younger, 1736. Formed out of earth from digging the Serpentine and topped with Kent's revolving summerhouse for Queen Caroline. In the foreground is the King's Old Road or Rotten Row.

developed when William III took up residence at Kensington Palace: a magnificent avenue of walnut trees was planted alongside Park Lane,[10] while straight-sided clumps of trees were planted both in the park and alongside Rotten Row.[11] George II made a new road, King's New Road (South Carriage Drive), in 1735–6. It was intended to replace Rotten Row, so-called because its poor surface required constant repair,[12] but there was a public outcry at the plan to put the old Rotten Row back to turf, and the king was forced to allow the fashionable world to use it as a riding parade.

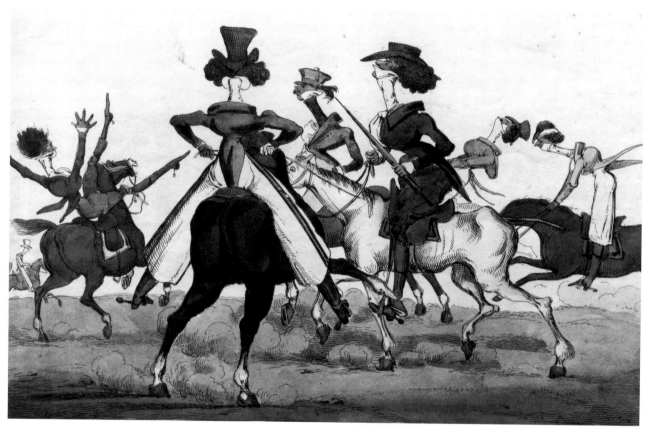

Dandies in Rotten Row: 1819.

It supplanted the Ring in popularity despite the fact that only royalty were allowed to use it as a carriage drive, and horse riding has continued there up to the present day. After the death of Queen Caroline in 1737, royal interest in Hyde Park waned, leaving it to a growing local community who increasingly resorted to it to walk, swim, skate, ride and drive. The growth of public use (which included all classes by the mid-nineteenth century) was to determine the development of the park.

St James's Park was known throughout the eighteenth century simply as 'The Park' among fashionable Londoners who paraded in the Mall. It remained much as Charles II left it until 1826, when John Nash re-designed

it to give it its present form. In the early eighteenth century replenishing and replanting within its formal layout was continued by Henry Wise and then by Bridgeman; it is on a plan attributed to Bridgeman that the *patte d'oie*, one of the earlier uses of this form, can be seen. Between 1703 and 1709 Henry Wise began planning Upper St James's Park, as it was still called (it was not called Green Park until 1746 when the name appeared on a plan by John Rocque). Bridgeman later laid out a canal, and in 1730 made a private walk for Queen Caroline. In 1737 Kent built a kind of

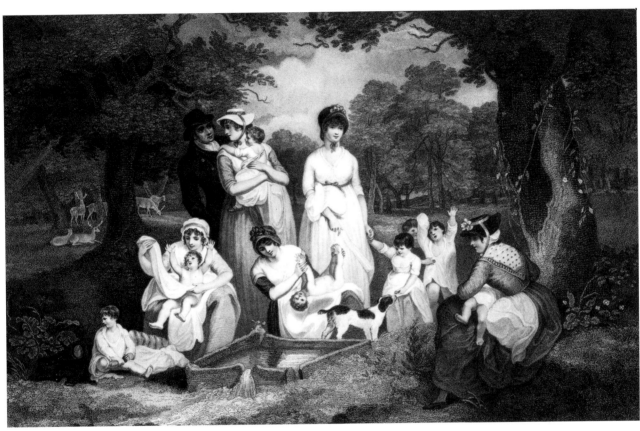

pavilion for her which was called the Library, overlooking the green glades of the park. The walk which ran in front of this was known as Queen's Walk. It became the most exclusive of all walks in the latter part of the century when it superseded the Mall. The hours of promenade in the eighteenth century were between midday and two p.m. and again at seven p.m. When the dinner hour changed in the nineteenth century – from between four and five to between eight and nine in the evening – Queen's Walk was abandoned by the fashionable world and left to nursemaids and children.[13]

Public access to royal parks developed slowly over the years. Entry was

The Bathing Well, Hyde Park: engraving after Francis Wheatley, 1802. Nursemaids washing their charges as if performing an ancient rite in some Elysian glade.

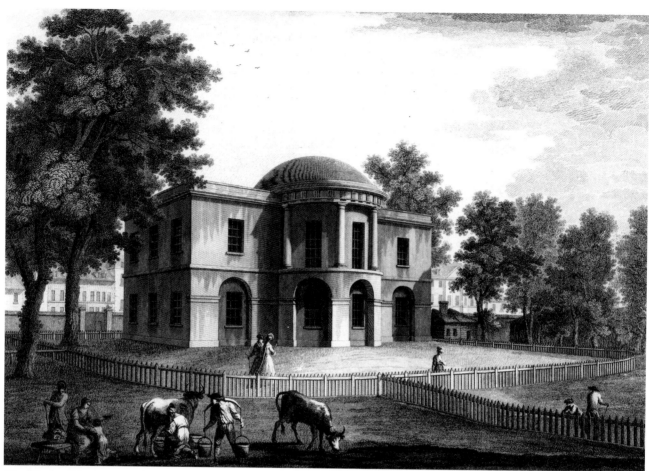

The Deputy Ranger's Lodge, Green Park, rebuilt by Robert Adam in 1768. This was demolished in 1841–2.

a privilege granted by the monarch – though once gained it was jealously guarded. Any threat to withdraw or limit that privilege was fiercely fought, and petitions to extend it or make the parks more accessible were continual. There were frequent requests, for example, for private doors and gates of entry to be built. There were over six thousand five hundred keys issued by the authorities for St James's Park alone, and perhaps as many counterfeits were made.[14] Not all monarchs shared Charles II's enthusiasm for seeing his subjects and being seen by them. Charles II's own liberality occasionally put him at risk: St James's Park had to be closed at certain times during the Oates Plot and the Rye House Plot because of threats that his life would be taken while he walked in the park. It was also closed at the height of the Plague in 1665, but in general the park was open to all during Charles II's reign.[15]

Under Queen Anne a less liberal view was taken of entry by commoners. To limit access to St James's a proposal was put forward to levy a halfpenny tax on all who entered, apart from 'foreign ministers, nobility, members of Parliament and the Queen's household'. The tax was designed

to exclude the 'meanest people', and at the same time raise an annual revenue to pay for the upkeep and ornamentation of the park.[16] However, political pragmatism served to prevent its introduction. The queen did close certain routes across the park, although this was in protest at the excessive appropriation of parkland by the Duke of Buckingham for the garden of his new mansion, Buckingham House. To add to the queen's 'displeasure', the house was sited so that it seemed that 'the park had been laid out for the house rather than vice-versa'.[17]

Another more revealing anecdote, demonstrating the importance to the public of continuing access to the royal parks, is the much quoted story of Queen Caroline wanting to reclaim St James's Park as a garden for her private use. On asking the prime minister Robert Walpole how much it would cost her, she received the cryptic reply 'only three Crowns'. She had similar designs on Hyde Park when the Serpentine was formed. There she placed two yachts solely for royal use and at the same time had plans drawn up by William Kent for a new palace, for which no doubt the park would have been intended to serve as a private pleasure ground. These plans were wisely dropped.[18]

The pressure for public access to royal parks was partly a reflection of the fact that London was gradually growing up around them. The pattern had been forming since the Restoration when the aristocratic quarter of Mayfair, and parts of Westminster, Kensington and Marylebone began to develop around the perimeters of St James's Park, Green Park, Hyde Park, Kensington Gardens and Marylebone Park. Similarly, the villages of Richmond and Greenwich grew up around their respective parks. Such proximity was not always welcomed by the monarch who resided within;

The view from Buckingham House which had so irritated Queen Anne. Buckingham House became a royal property when George III bought it in 1761.

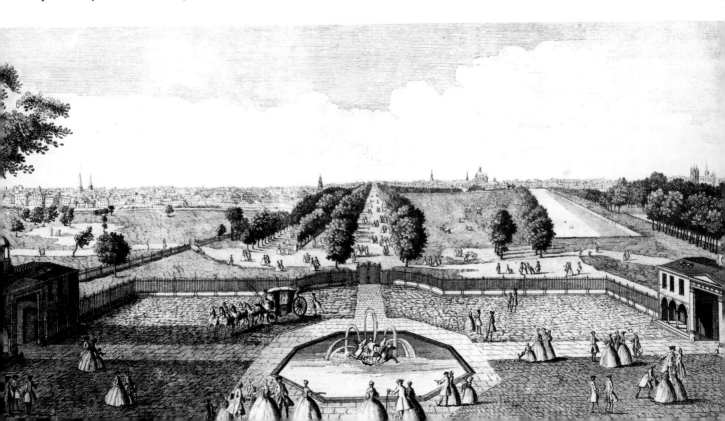

George I's new wall had been expressly built at his command to 'be of a height to hinder the houses of the Gravel Pitts looking into the kings gardens at Kensington'.[19]

Though Marylebone Park had been disparked after the Civil War, the land was not built on. Some of its acres became Marylebone Gardens, which were commercial pleasure gardens similar to Vauxhall and Ranelagh, and the rest was farmed countryside, used mostly to provide hay for London's horses. The area of Cavendish Square and Portland Place grew around its grassy fields in the eighteenth century. So strong now was the desire to live near a park, away from the increasingly smokeladen air of the city, that Nash used it as an argument for the economic viability of his scheme for Regent's Park, saying 'The preferred parts of London were those near to the parks'.[20] The Duke of Buckingham had been instrumental in starting the trend, by siting his new house on the west end of the Mall. Buckingham House was soon followed by Marlborough House (1710) and a string of royal palaces.

The royal parks for the most part remained walled until well into the nineteenth century, when public pressure, led by J. C. Loudon, was sufficient to bring about their gradual replacement by railings. St James's Park was shut every night at ten, though the numbers of counterfeit keys defeated all efforts to keep people out and it had a notorious reputation after nightfall. Railings replaced the walls of Hyde Park in 1828 and were put up along Rotten Row in 1837, reflecting a more open society and increasing appropriation of the parks by the public. Nonetheless, even by 1868, when the last wall went down,[21] the concept of public access was still relative. By no means everybody was covered by the term 'Public': entry fees as well as selective opening hours were still used to filter out the lower echelons of society, and a recent survey suggests that even under Charles II the opening of St James's Park was restricted to 'limited sections of the public'.[22]

A copy of a Treasury minute pertaining to a proposed new design for St James's in 1827, makes clear that exclusion of the public from various parts of the park had until then been the rule: 'My Lords perceive that by this Plan, the whole of the space in St James's Park, now laid out in grass, and from which the Public are excluded, will be thrown open (with the exception of the parts to be planted) for use of persons on foot.' The plans were by Nash, and when he put them into practice and laid out the park anew in 1828, it was expressly as a public park though belonging to the Crown. It was, in other words, to be a royal public park.[23]

Access to Kensington Gardens had increased once the Court was no longer based there. The gardens were opened at weekends when King George II and Queen Caroline were absent. In 1733 it was described as

That Retreat (blest with the summer Court)
Where Citizens on *Sunday* Nights resort.[24]

Even so it was only open in spring and summer at that period, and then to a restricted public, covered by strict rules of dress designed once again to preclude the lower orders. Restrictions on entry to the gardens remained even after they were opened daily during the reign of George III, who had ceased altogether to live at Kensington Palace. Daily opening of the gardens continued throughout the nineteenth century, when liveried gate keepers controlled the entrances to the park, only admitting 'the respectable public'.[25] Even such a carefully vetted public was far from welcome among the aristocracy, as Princess Lieven made quite clear in the following comment: '... for some years that lovely garden has been annexed as a middle-class rendezvous, and good society no longer goes there, except to drown itself.'[26]

George II's daughter Princess Amelia had tried to close Richmond Park when she was appointed Ranger there but legal proceedings brought by a certain John Lewis recovered the right of way.[27] In 1841 there was an outcry when the public were deprived of admission to Richmond Park, and the poor who used to pick mushrooms there could no longer walk on the grass. As reported in the *Westminster Review*, keepers were employed to turn people away, especially on Sundays when more came. Neither horse riders nor carriages were admitted unless having first applied for permission, and then they had to keep to the gravel road. Dogs were only allowed on leads and any dog found 'straggling or hunting would be shot'.[28] The implication was that the park was no longer a public thoroughfare. The writer went on to say that he 'always thought it bad taste of a gentleman with a large park not to allow in his poor neighbours',[29] and that it was still worse if he was royal; the people 'pay £100,000 annually for the upkeep of the royal parks and are not getting their return'. The reason given by the Duke of Cambridge for excluding the public from Richmond Park was that only by doing so could game be preserved.[30]

The greatest outcry came with the formation of Regent's Park, named for the Prince Regent. When leases of small-holdings fell in at the end of the eighteenth century in the area which had been Marylebone Park, it was decided to form a park there again – Regent's Park – and an Act of Parliament was passed in 1811 which unequivocally stated that it was to be for the public. In practice, however, it was a commercial development by the Crown and conceived as a residential area for the 'highest of the land'.[31] Considerable pains were taken to keep others out. This remained a bone of contention until 1838, when in response to continual pressure on the Commissioners of Woods and Forests, who looked after the royal parks, Regent's Park finally became another 'royal public' park.

Regent's Park marked a new concept in parks: instead of the town growing around a park without any planning as had previously occurred, a residential quarter was laid out around a park solely conceived for,

and integral to, the scheme. The prime force behind the Regent's Park development was John Fordyce, the Surveyor General. Noting the riches accrued by the Bedfords and Grosvenors from the development of their land, Fordyce realised a similar development by the Crown would bring in a substantial revenue. His plans for the quarter were intended to rival Napoleon's Paris. Nash was appointed architect in 1811; his scheme was for two eccentric circles of terraced houses with their backs turned on the outside world, while their palatial façades looked out onto the romantic and picturesque landscape of the park they surrounded. Villas were placed within the park, out of sight of one another and so positioned that each should appear to own a park or at least a portion of one. This was in the tradition of Repton's theory of appropriation (Nash had been Repton's partner from 1795 to 1802). To ensure exclusiveness, entrance to the area was only at three points, all in the wealthy districts around Baker Street, Devonshire Place and Portland Place. There were no entrances where it bordered on the poorer streets. It began to be laid out in 1812.

Following a report on the state of London's royal parks, George IV (formerly the Prince Regent) instructed that 'the whole range and extent of the Parks should be thrown open for the gratification and enjoyment of the Public'.[32] Despite this, Regent's Park, apart from its roads, remained fenced off from the public. Considerable portions of ground had been leased to various people, among them the nurserymen Jenkins and Gwyther (they were succeeded in 1838 by the Royal Botanic Society of London), and the Zoological Society. People who had houses immediately around or adjoining the park were allowed to use it, and were provided with keys at two pounds per annum. Nobody else was admitted. The excuses given in the first instance were the fear that the park might be used for immoral purposes and that the care of the newly planted trees precluded public use. But as the years passed and the trees became established with no change in policy, Regent's Park became the focus of sharp criticism.

It is an absurdity to think of it as a place of recreation and use by the public. It is not a public park, but a place set apart for the use of the wealthy only, and the people are permitted to grind out their shoes upon the gravel merely because they cannot be prevented. The ground is Crown land. It was formerly an open field, in which thousands found recreation and health. It was laid out with the avowed intention of converting it into a place for the public under conditions similar to those which regulate other parks, but the promise has never been fulfilled; and unless the loud voice of the people force the managers to a discharge of their duty towards them, it is too probable that it never will be. Thus it always is; that which belongs to the public, some private individual finds it convenient to take; and there is no machinery to prevent it ... until universal suffrage and annual parliaments.[33]

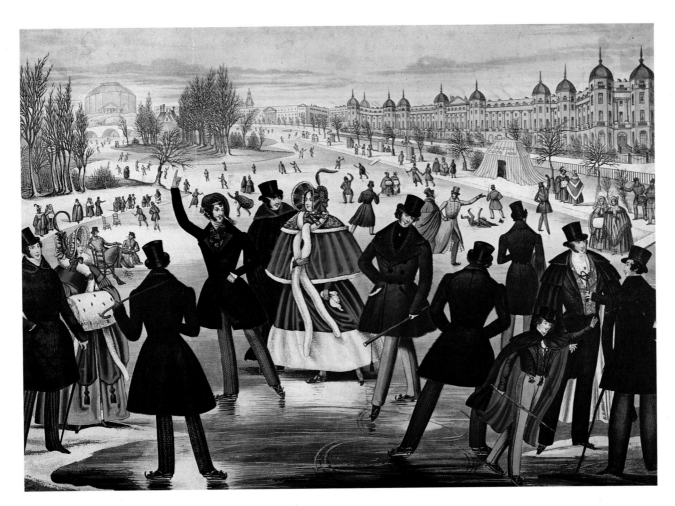

The following year eighty-eight acres on the east, together with a narrow piece of land beside the canal, were opened to the public: the beginning of its life as a royal public park.

Skating in Regent's Park, 1839.

Despite this controversy, the development of Regent's Park as a residential quarter integral with a park produced many imitators during the nineteenth century, though none so grand. One of the first was Calverley Park in Tunbridge Wells, designed by Nash's assistant Decimus Burton and begun in 1828. Prince's Park, Liverpool, followed in the 1840s, and many more were created throughout the century. It has been claimed that the concept of the Garden-City was directly inspired by Regent's Park. The development was to form a part of a royal mile connected to Charing Cross by Portland Place, the grandest eighteenth-century street in London, and a new street of equal grandeur, Regent's Street. If not overtly for the people at the outset, it did set a precedent in town planning and ensured that parks should be a feature of every civilised town of the future.

The needs which initially prompted the creation of royal parks have been

Richmond Park: J. Martin, 1843. Still looking like an ancient deer park, yet increasingly becoming considered as one of London's open spaces, which it officially became in 1904 when Edward VII made it fully open.

extraordinarily enduring, and have largely formed our expectations of what public parks should offer. For example, it was Henry VIII's insatiable appetite for outdoor recreation and exercise, especially hunting and horse riding, which had originally led to the creation of Hyde Park and St James's Park. Precedents for public gatherings, mustering troops and military reviews – celebrations of national pride – were also set in Hyde Park some three hundred years ago. Kensington Gardens began its existence as a semi-rural retreat where William III could indulge his love

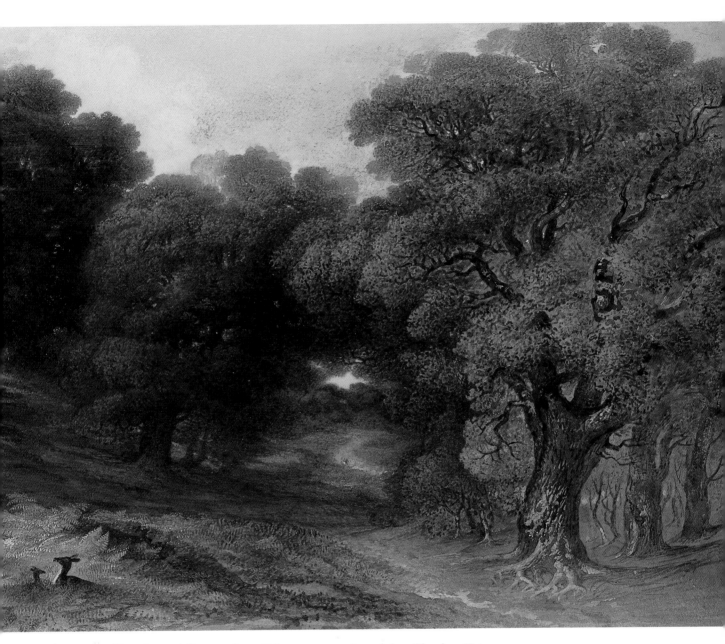

of nature. Hunting, riding and walking were enjoyed by Charles II in St James's Park and Green Park. Charles II developed Green Park also as a place for public parade and promenade, for games, refreshments, instruction, diversion, amusement and retreat.

The list of established uses is long and includes lawful and unlawful pastimes, not least of which were duelling and soliciting. This variety consolidated the tradition which continues in parks today – perhaps more strongly than ever – of containing a diversity of behaviour, much of which

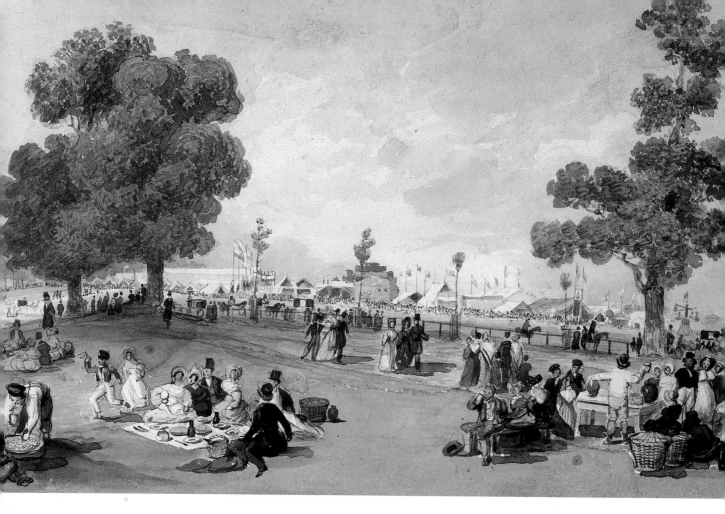

A view of the Coronation Fair
in Hyde Park, June 28, 1838.

might be thought odd elsewhere.

It was this very diversity and the ability to contain such opposites as a
public parade and peaceful seclusion without detriment to each other,
which gave the royal parks of London their uniqueness. Such contrasts
fascinated foreigners like Baron Bielfeld who in 1741 expressed delight at
St James's Park for being '. . . at once a scene of the country, of a retreat,
of an army, of the city, and the Court'.[34]

9

THE PUBLIC WALKS DEBATE:
Or Parks for the People

The increased public use of royal parks in London brought an awareness of the need for more areas like them. Steps were taken to create new royal parks explicitly for the public, situated in areas of London where none existed. Victoria Park and Battersea Park, both designated 'royal', were among the early fruits of this campaign, its great moment coming with the birth of the Municipal Public Park: a publicly owned urban park. This marked yet another stage in the evolution of the park, which had moved from country to town, and now changed from royal and private ownership to public.

The force behind this development was the threat of social unrest. It was hoped that the municipal park would help alleviate the chaos generated by rapid industrialisation and a rising population. The first third of the nineteenth century saw much of England scarred by unchecked, unplanned and unprecedented building. Industrialisation undid much of the work done in the previous century, which as we have seen consisted of beautifying large tracts of landscape. It turned a chiefly agricultural population into a mainly urban one, adding to the slums already in existence.

The environment suffered – especially the metropolis of London and its spreading suburbs, the Midlands and the North of England – as did the people who lived and worked in those areas, particularly the labouring masses. They found themselves in a world of unremitting squalor, without fresh air to breathe, sky to see or space for exercise; a world in which cholera and other diseases were endemic. The new manufacturing industries, with their rapacious appetite for land, had spread so rapidly that by the 1830s it was noted with alarm that

> Buildings have risen 'like an exhalation,' till villages have swelled in to
> towns, and towns into crowded cities; the uninclosed lands have been
> wrested from the poor in the country; the village green, the fields and

open spaces in which the youth of the towns and cities were accustomed to take their sport and exercise, have been built upon, or forbidden to them, till the health and spirits of hundreds and thousands – may it not be said millions – have been sacrificed, and their morals corrupted by the pernicious amusements to which under the privation of natural relaxation, they have been forced.[1]

The rise in manufacturing was accompanied by a continuous rise in population: nine million in 1801 to nearly fourteen million by 1831; an increase of around forty-five per cent, most of it occurring in the principal manufacturing towns. London and its suburbs grew from nine hundred thousand to one and a half million in this period, while Manchester quadrupled its population from forty thousand to 187,000.[2] The next ten years were to see an even greater concentration of people in towns, a pattern which would continue throughout the nineteenth century and the next.[3]

There was no town planning in the first part of the nineteenth century beyond the determining of the main streets, and no building regulations.[4] The basic order of sanitation administration differed little from medieval times. Building was in the hands of the private speculator in conjunction with the large landowner. It was an age when economic individualism and private enterprise had made the strides in industry, and individual freedom and private property were almost sacrosanct. There was neither the machinery nor the will to protect the interests of the poorer members of society from either the greedy speculator or the exploitative millowner. Town councils were still geared to the days when they represented small country towns; they had not yet adapted to the present needs of society. There was virtually no local government and central government was still loath to interfere in local issues.

As a result industrial wastelands grew without the provision of basic services, without any cultural or recreational opportunities, and without the maintaining of open spaces where those who had neither time nor means of access to the country could exercise and take the air. The death rate in cities was considerably higher than in the country: in London the death rate for those under five was eighty-six per thousand, as against thirty-six per thousand in Wiltshire.[5]

The state of early nineteenth-century cities merely reinforced the desire of the upper classes to live in the country, as they had always preferred. G.M. Young noted 'that the best society of Manchester was trying to get out of it', and this was true in other cities.[6] 'No wonder aristocrats left London for the country to escape its bleak, black foggy atmosphere and smoke of sea coal', was the observation of one foreign visitor.[7] The newly rich continued the tradition of buying country estates and building country houses, with money more often than not coming from the new industries which were disfiguring the land. Landownership conferred the highest

Fore Street, London, showing a heritage of slums.

economic, political and social status, as it always had.[8] And, as J. C. Loudon the garden historian noted, '"The *beau idéal*" of an English villa still included a park of some 100–150 acres ... bounded by lofty wooded hills and ... enclosed by the country of the district.'[9]

By contrast, the labouring masses, newly designated the 'working classes', usually had to live near the factories where they worked. Millworkers, for example, worked a fifteen-hour day from 5.30 a.m to 8.30 p.m. – hours laid down in the 1833 Factory Act – and found that their new wages did not necessarily improve their quality of life over that of their rural forebears. Most workers lodged in confined courts or in 'narrow, ill ventilated, unpaved'[10], almost pestilential streets, in houses whose notoriously squalid cellars teemed with humanity – often several families to a single room. One tenth of the population of Manchester lived in such cellars, and in Liverpool one seventh or thirty-one thousand people, most of them in courts with only one outlet.[11] The metropolis, which in 1833 boasted more 'inhabitants than any city in the world had ever possessed', included those whose 'wealth had never been surpassed by that of any other men, in any times whatever, and the most wretched outcasts, whose miserable condition was not equalled by that of the poor of any other city in Europe'[12] – a contrast that remained throughout the century. Even after half a century of social reform the East End was still described in 1894 as 'An evil plexus of slums that hide human creeping things; where men and women live in penn'orths of gin, where collars and clean shirts are decencies unknown, where every citizen wears a black eye, and none combs his hair'.[13] Today's nostalgia for the Victorian city ignores the inhuman conditions of life within it. Living and working under such conditions led to a sharp rise in crime, in social unrest and to outbreaks of disease. Another consequence was a rise in alcohol consumption, which trebled in the twenty years before 1837, while the population had increased by a third. 'Spirits were the poor man's opium. It was spirits which gave him some little relaxation from the misery by which he was surrounded.'[14]

One of the first responses to the appalling conditions of the urban poor was an influential report by Dr J. P. Kay (later Kay-Shuttleworth) resulting from his investigations into the conditions of the Manchester cotton workers in 1832. This was followed by the appointment of Edwin Chadwick to the Poor Law Commission, where 'The idea of eradicating disease took over his mind'[15] – with far-reaching effects. Chadwick led the way to the first Public Health Act in 1848. A Benthamite, he was to challenge the laissez-faire spirit of the day with his contention that disease was more expensive than its prevention. This was to prove the most effective argument throughout the age.

Meanwhile, a reformed House of Commons had met in 1833 in which for the first time a number of members were representatives of the large

towns. It was they who had most interest in what had by then become known as the 'sanitary idea'. Its loudest advocate was the member for Shrewsbury, Robert Slaney, who was to prove indefatigable in his efforts to improve the conditions of the working classes. An urgent need for open spaces for exercise and walks was identified, though it still had to be rediscovered over a hundred and fifty years later, after the Toxteth riots, when Michael Heseltine realised the importance of providing such spaces for the people of Liverpool. Ironically Toxteth had replaced the once medieval and royal glades of Toxteth Park.

Travel between England and the continent was resumed after the Napoleonic wars, and in 1828 J. C. Loudon embarked on a tour. Like many other travellers, he noted the superiority of open spaces and walks in foreign cities. Reminding readers of his *Gardener's Magazine* that in 1810 the only public gardens for horse riders in the whole of England were Hyde Park and the Meadows in Edinburgh, he made it quite clear that it was the influence of the continent after Napoleon's downfall which led to the establishment of similar places of public recreation in England. Like Repton, Loudon was concerned that the public should have greater access to parks, and he began campaigning as early as 1826 for new public parks. At the same time, he pressed for the improvement of existing ones, which

View of Liverpool from Toxteth Park before the park was swallowed up to become a suburb of Liverpool.

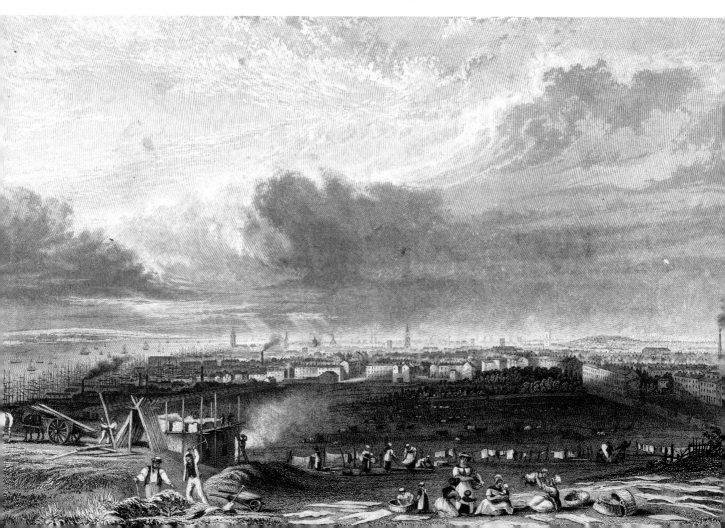

had suffered lamentably from neglect during the wars. 'The present time seems to be favourable for improving our public parks and gardens which foreigners justly observe are inferior to those of every other great city of Europe.'[16] By public he meant the royal public parks. He was only interested in the royal parks in relation to their use by the public and was highly critical of royal extravagance – including the improvements lately carried out at Windsor and Buckingham Palace by George IV for himself.

During his tour Loudon noted that most foreign cities had public parks either created and maintained by their governments or thrown open to the public by the Crown. London had nothing like the gardens, promenades and boulevards of Paris – 'breathing zones', as he called them, which were 'more truly scenes of enjoyment than the gardens of England'. There chairs might be cheaply rented for the people to sit and chat while watching riders and carriages parade down the centre of the road. Itinerant sellers of refreshments, musicians and entertainers, wandered among this colourful scene. Open too were the Champs Elysées, which became municipal property in 1828 and at the time were more like Hyde Park or Kensington Gardens in aspect. The Jardin des Plantes, the greatest botanical garden in Europe, was also open to the public, unlike Kew which did not throw open its gates until 1841. (Before that date it could be viewed only by special appointment.) Also open were the garden of the Palais Royal, the Bois de Boulogne, the gardens of the Tuileries and Luxembourg with their groves or bosquets; great luxuries in the midst of a crowded city, used by riders and walkers alike. Loudon particularly admired the abundance of flowers and flowerbeds, since English parks and gardens had been starved of flowers by the great landscape gardeners.[17] This view marked a swing of taste already apparent in the gardens of England, and like most swings, was soon to produce its counter-reaction: by the end of the nineteenth century the sight of another lurid coloured annual scattered over our public parks was likely to bring a torrent of abuse from the taste-makers of the time.

Loudon was also impressed by the numbers of promenades, public gardens and royal parks and gardens in Germany, all of them open to the public of all classes, and many laid out in the natural style of the English country gentleman's landscape park. Horace Walpole had correctly anticipated that it would be German princes who would more than any other Europeans imitate our landscape gardens and parks '. . . as their country and climate bear in many parts resemblance to ours'.[18] Loudon observed that '. . . a prince in Germany enjoys nothing in the open air that is not partaken by all his people'. Since the upkeep of the German parks was paid for by taxes taken from the people it was only politic that the people should have 'as much enjoyment of them as if they were their own'.[19] One feature of such parks was the playing of strolling military bands which went on throughout the day in summer for the amusement

of the public, a forerunner of the bandstands of our public parks.

Apart from the private or royal parks fully open to the public, there were a large number of truly public parks already in existence both in Germany and elsewhere on the continent. These had been created and were maintained by the public authorities, who in this showed themselves far in advance of their English counterparts. Indeed, one of the differences between the German public and the English, a difference many would say still exists, was the respect with which the Germans (as well as other Europeans) treated their public places, in contrast to the English. Loudon described the impact of public ownership of a garden in Frankfurt which had been created and maintained by the corporation. The garden or park laid out in the 'English style' was fully accessible night and day to the public, having no gates at the entrances to keep people out, and separated from a public road only by a low hedge over which anyone could climb. It was full of flowers yet always appeared in perfect order; the flowers never picked, the beds never trampled upon, despite being used by fifty thousand people, including children. Loudon compared the likely manner in which such a place would be treated by the English public:

> This garden affords a striking and to an Englishman, very mortifying, proof of the great superiority of the manners of the German lower classes over those of the English ... It is needless to say how utterly impossible it would be to have near any large English town a similar garden thus open to the public, and thus scrupulously kept from injury; and yet there were apparently no persons to watch; and instead of threats and heavy penalties, a printed paper was affixed to a board at each entrance saying that the public authorities having originally formed, and annually keeping up the garden for the gratification of the citizens, its trees, shrubs, and flowers are committed to their individual protection.[20]

In England, by contrast, several parks and gardens had suffered vandalism at the hands of the great British public: plants and flowers were removed from Kensington Gardens and graffiti were daubed on walls of grottos and on sculpture in private gardens. Those responsible were not just the lower classes but the middle classes too. The *Westminster Review* put the trouble down to the fact that 'the people of the continent have long been trusted in all public places, and have been educated to respect the privilege; while the people of this country have been trusted scarcely anywhere, except where money has procured admission'.[21] It was on the basis of trust that Prince Pückler-Muskau had opened his vast park at Bad Muskau. In his *Hints on Landscape Gardening* published in 1834 he related: 'I allowed everyone, without consideration of persons, access to my grounds, although many landowners assured me that ... people would cut down all the young trees and pluck all the flowers.' Though some

damage did occur, the culprits were punished accordingly when caught, and in any case the damage repaired. When the public accepted that his gates remained open despite their misdemeanours, he claimed they began to respect the park more and more.[22]

Loudon's impressions of the superior public amenities on the continent were endorsed by foreigners visiting England. Lenné, the royal gardener at Potsdam and creator of the public park and gardens of Magdeburg, Prussia, laid out in 1824 and consisting of some 120 acres, was scathing about English parks, which he said 'were kept for the nourishment of game instead of human beings'.[23] He was 'shocked' at Blenheim, Woburn and Ashridge by the number of deer – between two and three thousand in each. 'The arrogance, extravagance and egotism of the English', he hoped, would not be imitated in Germany. He was a critic of the work of Kent and of Brown, and found the parks of London inferior in every way to those on the continent, as they seemed 'more intended for cattle than for the enjoyment of man'. That man was as much a part of nature as sheep or cattle was a notion that seldom registered in the ideal landscapes of the Brown school of design; this was now one of the charges brought against it.

Like Loudon, Lenné also found that London had no public walks, where all classes mingled, to compare with those in continental cities. In London one 'either had to be a man of fortune on horseback or in a carriage'. He found the trifold fence of the circus at the end of Regent's Street and the double fences and locked gates of most of the squares 'truly English', compelling him to 'reflect on the liberality of his king and other German princes who generously throw open their gardens to the public at every hour of the day ... and without any distinction of persons and without any fee to the gardener'. What was more, Lenné added, corroborating Loudon's observations, 'the public respect them too'. On the question of fees, Loudon confirmed that 'Such fees were almost unknown on the continent whereas in England they form the principal part of the gardener's income in all the so-called "Show Places"'.[24] Lenné's rebukes were reiterated by others, for instance, Jacob Rinz, a nurseryman and son of the gardener to Prince Metternich and Louis Sckell, who planned in 1789 the famous Englische Garten of Munich as a public garden for the great anglophile Count Romford, its five hundred acres laid out in the 'natural' style to give it a park-like appearance.

Loudon dedicated himself to the establishment of new parks, prophesying optimistically that the time was not far distant when every country town and village would have a park. Most importantly, he understood that to be of use to the poorer members of society, parks must be close at hand. In 1829, expanding on William Pitt's celebrated words that the parks were the lungs of London, which had been repeated in Parliament in 1808 by William Windham, Loudon published an article in

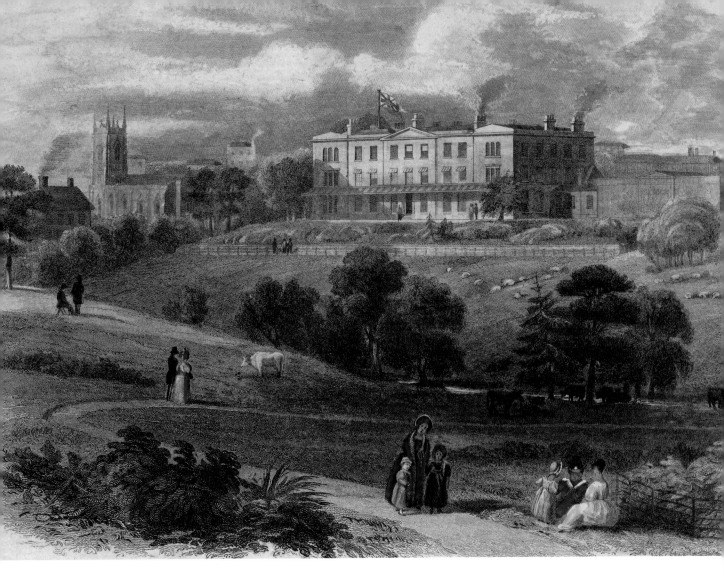

the *Gardener's Magazine* entitled 'Hints for breathing Places for the Metropolis, and for country towns and Villages, on fixed Principles'. Loudon was reacting to the threatened attempt by Parliament to enclose Hampstead Heath for building upon, together with the rapid extension of buildings on every side of London. He urged the intervention of central government to devise a plan to ensure that development was no longer at the expense of a healthy environment. He put forward his own plan which was to all intents and purposes a series of green belts about half a mile wide, alternating with concentric zones of town, and beginning between one and one and a half miles from St Paul's. As London spread, the system might go all the way to the sea. Knowing full well that nothing short of a revolution or natural disaster would make the realisation of such a plan possible, he nevertheless sowed the seeds for the green belts of the future. He suggested that all country towns likely to develop beyond half a mile in diameter should have a breathing ground marked out as not to be built

Calverley Park, Tunbridge Wells, as laid out by Decimus Burton.

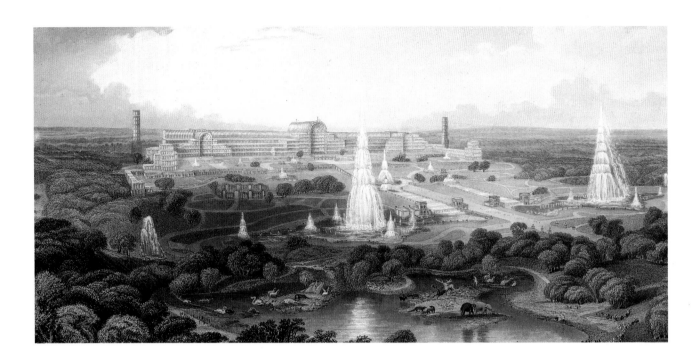

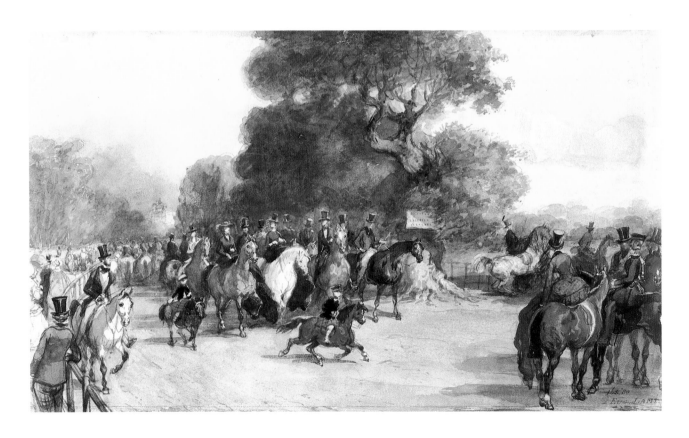

upon, for the sake of the health of the poorer inhabitants.

More enlightened than subsequent planners have shown themselves to be, he realised that for those who could not afford horses, hackney carriages or any form of street conveyance, the first zone of green had to be within a quarter of a mile of their habitats, an easy distance to walk. In 1829 he reminded his readers that during the last fifty years not a single provision had been made in the numerous enclosure acts for a public green, playground or garden, and he hoped that in future enclosure bills the legislature would take into consideration the subject of breathing

Above left
View of the Crystal Palace re-erected at Sydenham, showing its great formal gardens and park laid out by Joseph Paxton in 1854.

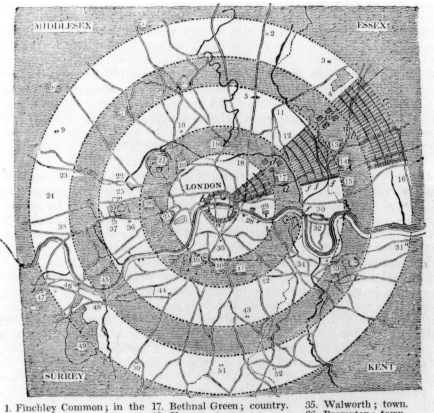

Below left
Scene in Hyde Park: Eugene Lami, 1880. The fashionable world at play.

1. Finchley Common ; in the zone of country.
2. Tottenham ; in the zone of town.
3. Walthamstow ; town.
4. Forrest House ; town.
5. Stoke Newington ; town.
6. Highgate ; country.
7. Hampstead ; country.
8. Kingsbury ; country.
9. Wilsdon ; town.
10. Kentish Town ; town.
11. Clapton ; town.
12. Hommerton ; town.
13. Stratford ; country.
14. West Ham ; country.
15. West Ham Abbey ; country.
16. East Ham ; town.
17. Bethnal Green ; country.
18. Hoxton ; town.
19. Islington ; country.
20. Somers Town ; country.
21. Regent's Park ; country.
22. Paddington ; town.
23. Paddington canal ; town.
24. Six Elms ; town.
25. Bayswater ; town.
26. Hyde Park ; country.
27. Green Park ; country.
28. Southwark ; town.
29. London Docks ; town.
30. West India Docks ; town.
31. Woolwich ; town.
32. Isle of Dogs ; town.
33. Greenwich Park ; country.
34. Deptford ; town.
35. Walworth ; town.
36. Brompton ; town.
37. Kensington ; town.
38. Hammersmith ; town.
39. Lambeth ; country.
40. Kennington ; country.
41. Camberwell ; country.
42. Peckham ; town.
43. Dulwich ; town.
44. Clapham ; town.
45. Fulham ; country.
46. Putney ; town.
47. Roehampton ; country.
48. Wandsworth ; town.
49. Wimbledon Park ; country.
50. Tooting ; town.
51. Norwood, town.
52. Sydenham ; town.

Loudon's proposals in 1829 for alternate zones of town and country anticipated the green belts of today.

spaces on some systematic plan, calculated for the benefit of all ranks in all parts of the metropolis.[25]

The city of Bath, not London, picked up the gauntlet, using private initiative as opposed to public. The member for Bath in the reformed Parliament of 1832 was John Arthur Roebuck, a Whig and a vociferous reformer, active in promoting the subsequent park movement. Although Bath was no new industrial city, it was, like other cities, suffering from the effects of economic recession. Thanks to the initiative of a handful of private individuals, Victoria Park was formed in Bath between 1829 and 1830, almost entirely paid for by public subscription. The enterprise was begun by a couple of tradesmen, Messrs Davies and Coward. Their chief incentive was economic: to improve the tourist facilities of Bath in the hope of reversing the effect of recession. Businesses were closing, unemployment rising, and there was the concomitant threat of social unrest. Since there was an 'absence of shady walks and drives' it was thought a park might help Bath become 'a place of summer residence as well as of winter resort'.[26] There was also, however, a philanthropic desire to provide recreational facilities for the people of the city, a response to the social climate in which 'calls on the wealthy to assist the poor' were ever more frequent, there being no other funding available.[27]

The wisdom of improving the lot of the working class was becoming more generally acknowledged. The tradesmen Davies and Coward formed a committee of twenty 'public spirited' members to create a park. The Corporation of Bath wanted particularly that any park should be 'within the limits of the city to give access to its inhabitants', that is, all its inhabitants, as Loudon had advised. At a meeting in August 1829, at which representatives of the corporation were present, it was decided to develop the existing gravel walk, a subscription walk which was then of limited extent, and to add Crescent Fields, the treeless meadows lying to the west, through which the public had a right of way – and which was threatened by development. Crescent Fields belonged to Lady Rivers, who gave her consent. The corporation also agreed to give £100 immediately and thenceforth annually.[28] In the event their munificence had to be withdrawn after the Municipal Reform Act of 1835 ironically rendered such payments illegal.[29] The rest of the funding was to come from public subscription and donations which would be invested to produce interest and pay rent to the parties concerned. By 1830 over £4,000 in donations had been made and nearly one thousand subscriptions varying from £1 to £100 per annum had been promised. The park was still funded by voluntary subscription in 1889, having suffered a precarious existence through dependence on these means alone. Victoria Park was important as the first of its kind to be formed through public subscription: it paved the way for other parks before public funding was provided. It was designed by Edward Davis, an architect, and its laying out gave

The laying out of Corporation Park, Blackburn in 1864 during the cotton famine, by unemployed Lancashire operatives as a part of the government's Public Works Act.

THE ILLUSTRATED LONDON NEWS.

No. 1241.—VOL. XLIV. SATURDAY, JANUARY 16, 1864. WITH A SUPPLEMENT, FIVEPENCE

THE NEW-YEAR'S GIFT TO ENGLAND.

ON Friday evening last, a minute or two before nine o'clock, her Royal Highness the Princess of Wales gave birth to a son. The Princess had been present during the day with a party of ladies and gentlemen (many of the latter being members of the London Skating Club), who met the Prince and Princess for diversion on the ice at Virginia Water. Her Royal Highness, who is said to be an excellent skater, did not, of course, take part in that exercise, but was occasionally driven about in a sledge. She watched with much interest the game of hockey which was played upon the ice by the Prince of Wales and his companions, and did not leave for Frogmore Lodge until near four o'clock. The health of the Princess must, therefore, have been vigorous up to the hour of her confinement, and the successive bulletins which followed the first announcement of the auspicious event have been of a most satisfactory character as regards both the Royal mother and her babe. The news was conveyed within an hour of the accouchement to her Majesty at Osborne, who started betimes on Saturday morning for Windsor, at the station of which town she was met by the Prince of Wales, who accompanied her forthwith to Frogmore, where she also passed the afternoon of Sunday.

It were superfluous to remark that the announcement was received by the British public with the liveliest joy. Never was foreign Princess adopted into the great English family with more hearty or unreserved enthusiasm than the Princess Alexandra of Denmark ; and, since the memorable day of her entry into London, she has not only preserved unimpaired, but, by the graciousness of her bearing, has, if possible, improved, her hold upon the loyal sympathies of all her Majesty's subjects. The movements of the Royal couple have been watched from that day to this with unabated interest, and no incident has occurred tending to chill in the slightest degree the warmth of popular affection. The birth of a son, and an heir to the throne in the second degree, is welcomed by the people of these realms with something of the pleasing excitement of a household event, and there were probably but few families within the four seas which engirdle these islands to whom the news did not impart a thrill of gladness—gladness for the sake of the Princess herself, of her husband, of the Queen, and of Old England, who now sees three generations of Sovereigns in a direct line, and who indulges in the hope that the Royal virtues as well as dignities will be hereditary.

The news is, assuredly, none the less acceptable in that it is

the first break, since the beginning of the new year, in the monotonous succession of sinister forebodings which the last few days have thrust under our notice. The grandsire, on the mother's side, of the infant destined, in the natural course of things, to ascend the throne of an empire second to no other in the world, has but recently succeeded to a position of Royalty ; and one of his uncles, who has hardly yet attained to manhood, has received the insignia of sovereignty over a little kingdom created but thirty years ago by European diplomacy, convulsed two or three times by revolution, and still disturbed throughout its narrow area by political factions. In neither instance has elevation to supreme rule brought increase of happiness, and time alone will show whether it may be recognised as a starting-point of distinguished and successful service. King Christian IX. of Denmark, exalted to his post by a treaty not yet twelve years old—the binding obligations of which upon one of the parties interested is denied—is already doomed to choose between having the better half of his kingdom wrenched from him or plunging into a war which will probably involve all the Powers of Europe. The German people, possessed by an idea over which they have brooded for years, and stimulated by petty Princes who appear to have looked upon a foreign and

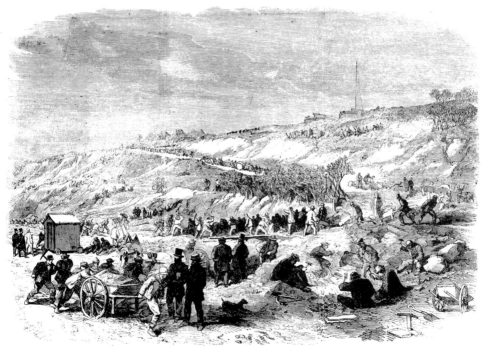

EMPLOYMENT OF LANCASHIRE OPERATIVES, UNDER THE PUBLIC WORKS ACT, AT REVIDGE HILL, CORPORATION PARK, BLACKBURN. SEE PAGE ...

employment to over two hundred formerly unemployed men. The creating of new parks was one way of alleviating the unemployment problem, since new jobs were also created in the process. The laying out of Moor Park, Preston, designed by Edward Milner in 1867, took up some of the slack caused by the cotton famine during the American Civil War.[30]

The twelve acres of Victoria Park were laid out at a cost of between seven and eight thousand pounds, the whole amount being raised in two years. It was formally opened by Princess Victoria on 21 October 1830. 'A decent appearance and good behaviour ... [were the] only passports for admission and free enjoyment of its beauties.'[31] Upon her accession to the throne Victoria pronounced the park the 'Royal' Victoria Park. Its standard of design set a precedent for future parks and twelve years after its formation it was still considered 'A place which was unsurpassed in any provincial town of the kingdom now considered essential to the prosperity as well as to the health and comfort of the inhabitants'.[32]

With the success of Victoria Park, created by private enterprise, the initiative passed to Parliament. In 1833 Loudon noted with agreeable

Greenwich Park, 1804: Easter Monday. When ordinary people had the time and the place to enjoy themselves they took full advantage. Greenwich was one of the few places, and the subject of popular verses and songs on that account.

surprise that the subject he had dwelt on at length in 1829 had now been taken up in Parliament by Robert Slaney, and by all the newspapers – though with no acknowledgement to himself. Slaney reminded the House that the pattern of employment of the working classes had been completely reversed in the last thirty years. At the beginning of the century two thirds had been employed in agricultural labour and one third in manufactures, but now it was the other way round. Living and working for the most part under conditions already described, it was apparent that few people had anywhere to go for exercise and air.

Apart from the considerations of health, there were those of amusement and recreation. The powerful nonconformist lobby had abolished many of the hitherto traditional amusements like wakes and fairs. With only 'holidays [holydays] and Sunday as a free day and a few hours in the evening', the working man of a large manufacturing town had little alternative but the ale house, 'there being no other place for him to amuse himself'.[33] In Manchester, for example, which had a population of one hundred and eighty-seven thousand, there was nowhere for the working man to take his family for an outing or an airing. Threats of prosecution for trespassing or intimidation by steel traps or guns – meant to keep the populace out of private parks – would greet him if he strayed from the dusty cartridden roads which led out of the town. Even in London with its three large parks – St James's, Green Park and Hyde Park – there was the same problem, since only one, Hyde Park, was open to all classes. (Green Park was partly closed for works, while St James's and Kensington Gardens were said to be open only to 'persons well-behaved and properly dressed'.)[34] These parks, said Slaney, 'did not afford sufficient space for the healthful exercise of the population'. On Sundays thousands flocked there with their families, many having to trudge four or five miles from the East End where none existed. 'Many Londoners only knew what the country was by description of the pastoral ruralities of Hampstead and Highgate'[35] – still largely unbuilt in 1833, though Hampstead Heath had not yet escaped the threat of enclosure and development.

Using these arguments Slaney moved that a Select Committee be formed for 'An Enquiry into the means of providing Open Spaces in the vicinity of populous towns as public walks and Places of Exercise, calculated to promote the Health and Happiness and comfort of the Inhabitants'.[36] With the agreement of the House, a Committee was appointed, with Slaney as chairman, and in due course the Committee told the House that its findings endorsed the view that open spaces were lamentably scarce, or absent, in poor urban areas.

Primrose Hill, which the poorer classes had visited since time immemorial, was threatened at this period with development as a private cemetery. The Committee recommended the government to secure it, which it did, thanks to the intervention of Joseph Hume, member for

Montrose and a radical. Its fifty-eight acres were purchased in 1836 for £300.

But from Regent's Park in the north to Limehouse in the east, there was not a single place preserved as a park or public walk; and south of the river there was only one, near Lambeth Palace. Making an 'airy walk on Waterloo bridge'[37] which people still had to pay to cross, was suggested – despite its reputation of foul smelling. In 1833, apart from the Temple Gardens, the terrace in front of Somerset House, and the Adelphi walk, there were no walks on the north bank. This was in marked contrast to cities on the continent such as Paris, Florence and Lyons, which all had thoroughfares for the public beside the water.

Outside London the story was the same. Only Liverpool, Bristol, Norwich, Nottingham and Shrewsbury had preserved open spaces in their immediate vicinity, and these, said the Committee 'are not enough'. The nearest open land to Birmingham was at Sutton Coldfield six miles away, available to the public thanks to the far-sightedness and philanthropy of Bishop Vesey. Hull had none, apart from the quays; nor did Leeds or Blackburn, and Manchester had only Salford lying to its west as open space.

The Committee's recommendations for London included acquiring, before it was too late, fifty acres called Copenhagen Fields which were about to be sold for development. These duly became Hackney Downs. Also recommended was the extension and improvement of the embankment from Limehouse to Blackwall by the creation of a public terrace walk. On the south bank of the Thames the Committee found only Kennington Common still unenclosed; it was suggested that, if the commoners who had grazing rights there agreed, this could be laid out with a walk and planted round its edge, reducing the grazing by very little.

Although in the first instance only walks were being proposed, the Committee was aware that something much more in the way of space for exercise and recreation was needed. 'It was not gravel walks but public grounds which were really needed. The foot is freer and the spirits more buoyant when treading the turf than the harsh gravel; one game at cricket or football would to the young and active, be worth more than fifty solemn walks on a path beyond which they must not tread and beyond which they are therefore perpetually thirsting to go.'[38] Despite Loudon having publicly campaigned for public parks in the 1820s, the word park was not used in the terms of reference adopted by the Committee. But in practice the spaces created, ultimately, were parks. Perhaps the idea of creating in the name of the people something that had hitherto been the most exclusive of spaces, largely conceived to keep the 'people' out, was too radical a concept for the times. Yet the provision of recreational places continued to be urged in the press: 'the sooner these places, together with public bathing, are provided, the better for the comfort, the health, the

morals of the people and the credit of their rulers', was the opinion of the *Westminster Review* in 1834.[39]

Police were continually shutting off bathing places in rivers in the name of public decency and morals, but the benefits of river bathing were obvious. One of the witnesses who gave evidence to the Committee, describing the various mechanical processes in which the people were employed, said they caused 'workers' clothes to become saturated with dust, smoke, perspiration, and their bodies [also] partially covered over with similar incrustations', which the witness considered led to a number of diseases. As the workers had no means of keeping clean in their miserable houses, river bathing would be a practical solution.[40]

Behind all these recommendations was a real fear of some sort of repeat of Peterloo, where the yeomanry had charged a public meeting in 1819, held to press for parliamentary reform. 'If no such facility for regulated amusement be afforded, great mischief must arise,' the Report warned.[41] The Committee found that 'The spring to industry which occasional relaxation gives, seems quite as necessary to the poor as to the rich'. One can only wonder that this revelation apparently came as a surprise.

There would be other benefits too, as Gally Knight told the House of Commons. On the Sabbath in the metropolis, he said, 'when the poor are released and catch a glimpse of the aristocracy in our parks it gives them pleasure as it does the aristocracy. It is to provide more frequent unions such as these that I desire public Walks – also as a means to stop inebriety which lower orders of other countries which have had them for longer do not have.' As the *Manchester Courier* put it, such walks would be 'a means of throwing all classes together'.[42]

Five parks were consequently planned for the metropolis, though by 1835 none had been put in hand: there were neither the economic nor the administrative means to implement them. Before the Public Health Act of 1848, in which municipal authorities could purchase and maintain land for parks, authorities had in the main no power to buy land to make a park except by a special act of Parliament, a cumbersome and costly method. The Municipal Reform Act of 1835, which professed to give the inhabitants of towns the power of self-government, limited this financial power to such an extent that the acquisition of land to create a park was still virtually impossible. The Act even prevented local authorities from contributing to the maintenance of a park if it was gifted land – as at the Royal Victoria Park – unless authorised by a private act of Parliament.[43]

In 1836 James Silk Buckingham, member for Sheffield in the reformed Parliament of 1832 and particularly active in social reform, proposed that people should be allowed to rate themselves to provide local parks. His bill was thrown out on the grounds that public ownership was not a good idea; private subscription was better.[44] Buckingham also wanted to institute public libraries, but that idea too was dismissed; he was ahead of his time

A song sheet. Riding in Hyde Park remained fashionable throughout the nineteenth century, and it too was the subject of popular songs and satires.

Pages 154, 155
Summer Day in Hyde Park: J. Ritchie, 1858. A wide social mix enjoy the pleasures of the park.

on both counts.

In the same year the intervention of Joseph Hume, member for Montrose, had saved Primrose Hill from development; the next year Hume succeeded in getting Parliament to agree that all new enclosure bills should allow some portion of the land scheduled for enclosure to be put aside for the 'healthful recreation of the inhabitants of the neighbouring towns or villages'. But in 1839 it was brought to the attention of the House by another member, Mr Harvey, that in practice the measure had still not been carried out. Harvey proposed a new standing order to enforce the ruling: 'That in all bills for enclosing commons or waste lands, provision be made for leaving an open space in the most appropriate situation, sufficient for purposes of exercise and recreation of the neighbouring population.' At the present time, he said, 'if some great man wished to have the place included in his park', there was nothing to prevent him.[45] Furthermore, he advocated the maintenance and fencing of the public acres to be paid for out of the poor rates. The idea of taking money out of the public purse for such purposes still brought opposition, though the principle of saving land for recreation was agreed,[46] and several hundred acres of land which otherwise would have become private property were 'secured to the public'.[47] This important step was applauded by Edwin Chadwick, writing under a pseudonym in the *Westminster Review*, in which he urged the need for public parks.[48]

In the same year, 1839, Slaney was again addressing the House on its duty 'to take measures to provide Public Walks ... in the vicinity of large and populous towns'. Again the House expressed sympathy but could not agree on the means of paying for them, so the motion was withdrawn.[49]

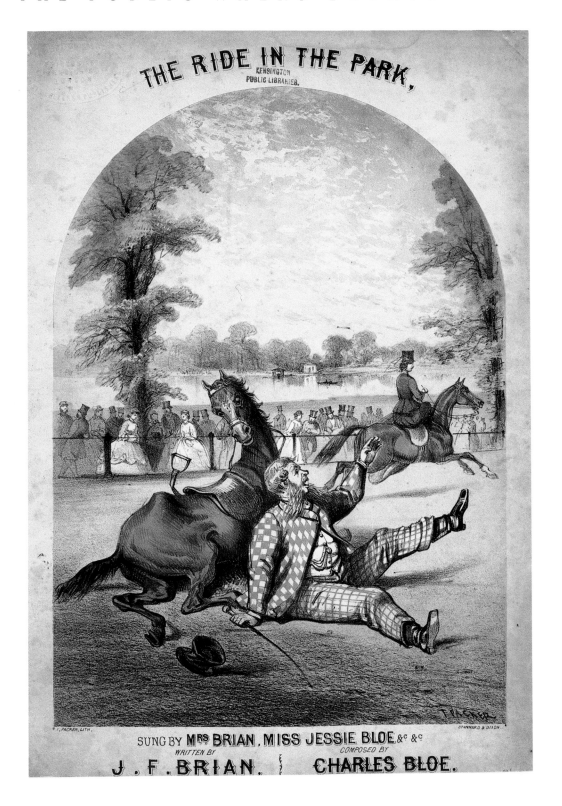

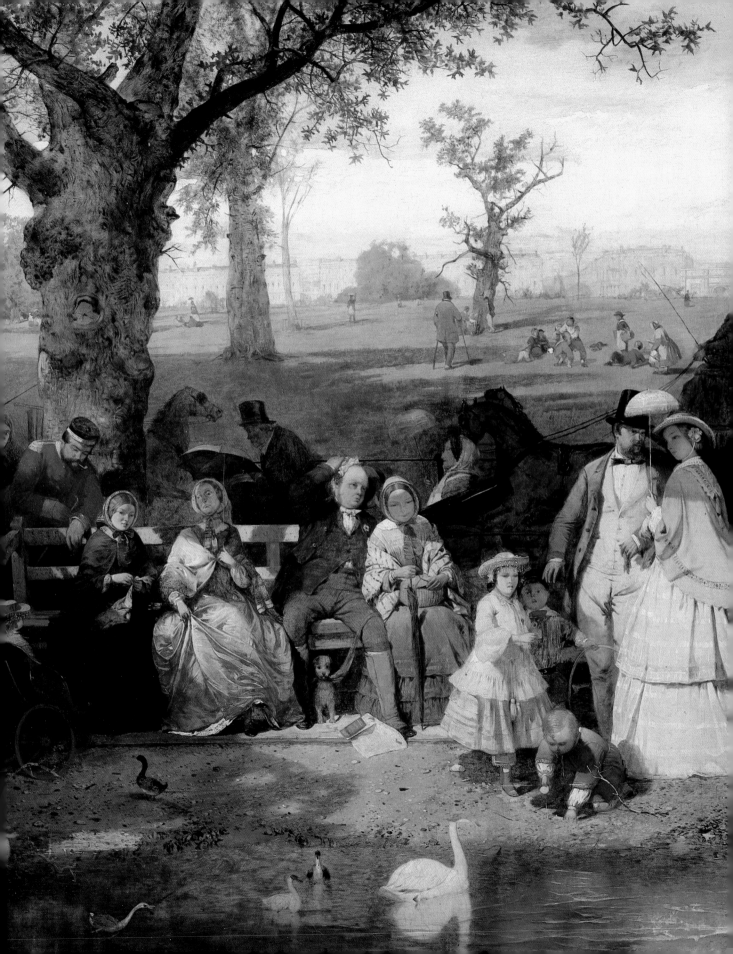

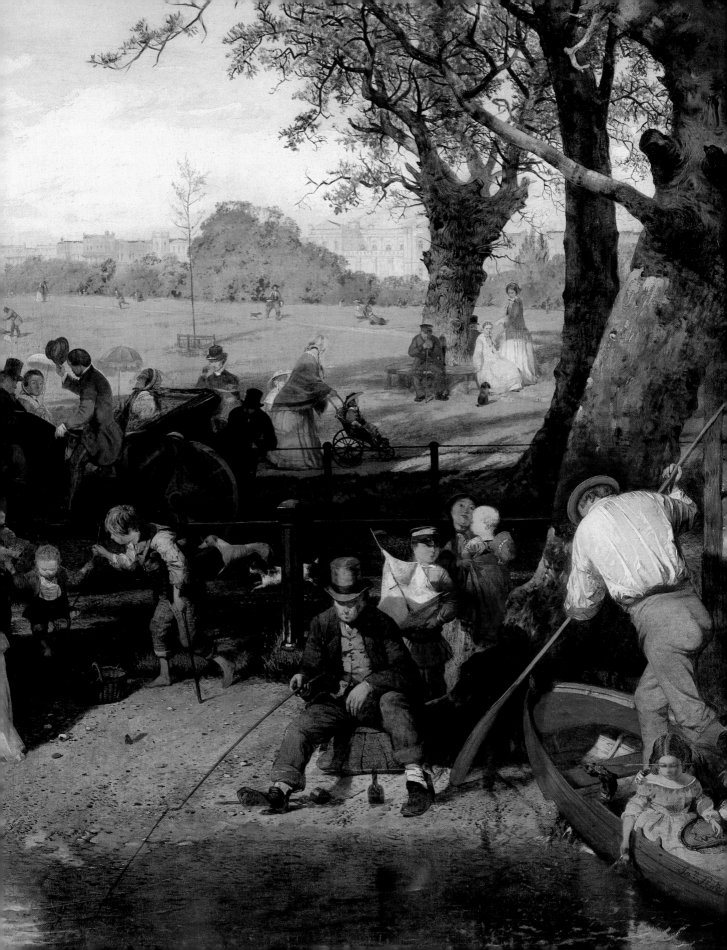

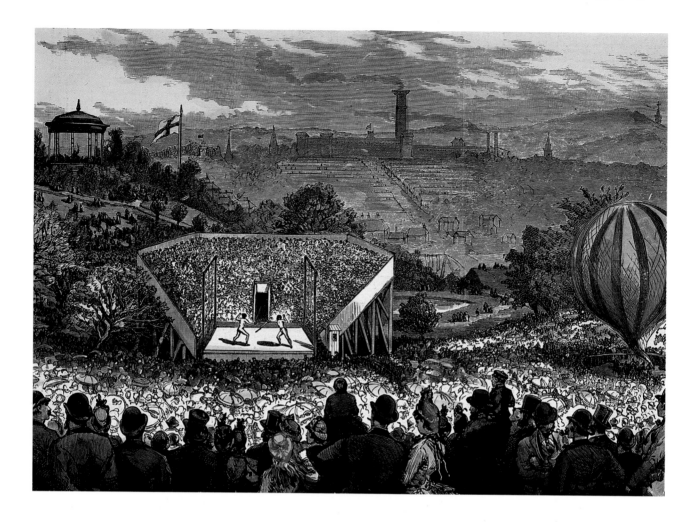

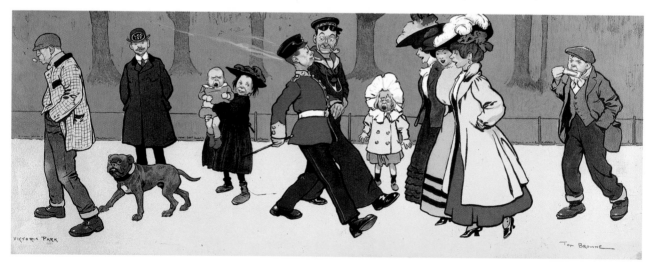

10

PARK MANIA

In the laisser-faire climate it was not surprising that new parks continued to be made on the initiative of private benefactors. In the opening years of Victoria's reign Joseph Strutt of Derby acquired eleven acres on the city outskirts, for the purpose of providing 'Public Walks for the Recreation of the Inhabitants' and uniting 'Information with Amusement'. Thus was created the Derby Arboretum, as a gift to Strutt's fellow-citizens. Its designer, J. C. Loudon, had worked on a similar project when in 1835 he had laid out a public garden of three acres for the

'Monster Free Gala in Peel Park', Bradford.

Victoria Park, London: Tom Browne (the cartoonist Phiz). As the working classes took to the parks they too became subject matter for caricaturists and satirists.

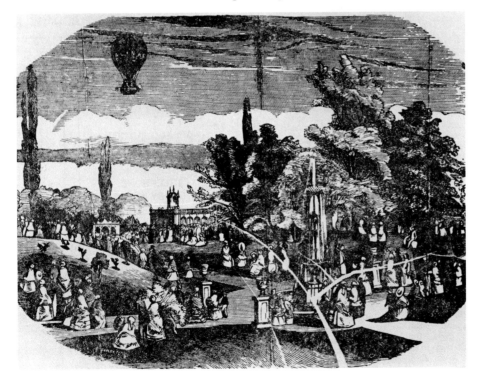

Balloon Ascent from Derby Arboretum.

Corporation of Gravesend, a pioneering event in municipal patronage.

Loudon set out to transform what at first had been a very dull site. He did so by making the ground more uneven, by laying out winding walks whose views continually changed, by concealing the boundary, and above all by planting trees and shrubs whose variety was unequalled outside any botanical garden.[1] Loudon held that arboretums containing both foreign and native trees should be established in all our large towns as part of their public gardens. 'Indeed the entire garden, park or promenade may be planted as an arboretum.'[2] He recommended moreover that never more than one specimen of each kind be included. It was a creed that spelt disaster for the 'landscape' school of gardening by leading to 'spottiness' in planting instead of grouping.

At the time there was only one arboretum in England, at Chatsworth. Thus at Derby Loudon was able to lay out the country's first public arboretum. Eight hundred and one varieties of trees and shrubs were planted, all carefully labelled for the instruction of the townspeople. It was opened with great ceremony on 16 September 1840, an early demonstration of civic pride and a characteristic feature of future new parks.

In its actual design the Derby Arboretum was curious rather than aesthetically pleasing. Many of the specimen trees were planted singly on small grassy hummocks with gravel paths winding round their bases. The park was crossed by a broad central walk. To give seclusion a perimeter walk planted with shrubs concealed the railed and gated extent. From Arboretum Square, the park was entered through an Italianate gateway, and two entrance lodges housed its keepers, in the manner of a country gentleman's private park.

Strutt did not endow the Derby Arboretum with funds for maintenance, and on five days of the week admission charges were made. In the absence of public funds, levying charges and private subscriptions was unavoidable. Indeed, had the town council voted ratepayer's money towards the Arboretum's upkeep, it would have exceeded what powers it then had. Nonetheless that did only leave two days a week when poorer people had access, during which, as the reformer Edwin Chadwick pointed out, it might well rain.[3] Thus despite a declaration by Strutt that the park was open to all classes, it was still not fully available to the poor.

The Derby Arboretum was nevertheless an important innovation – the more so since its lack of a maintenance fund, and its restricted admission for the people who most needed it, did raise comment. Today, one hundred and fifty years on, the Arboretum is maintained by the town. It is fully open to all, and still provides an oasis of greenery. Though it is reasonably well kept, however, it contains fewer plant varieties, all of them more overgrown than Loudon intended: it was his aim that the trees should not be allowed to grow higher than fifty or sixty feet, in case they

cast too much shadow. He also recommended that the entire collection should be rearranged every thirty or forty years to admit new species. In contrast with its actual trees, the garden's pavilions and other buildings are today decrepit and its public amenities are dirty and out of order.

Strutt's benevolence paved the way for other developments. In Sheffield the Duke of Norfolk, who owned large territories nearby, followed suit by making fifty acres of land available for a public park.[4] A new park and surrounding residential area was also laid out in Liverpool, as a speculative development where the middle classes could escape the miseries of the city. It was commissioned in 1842 by Richard Vaughan Yates, and named Prince's Park. Joseph Paxton, the Duke of Devonshire's head gardener at Chatsworth, designed it, on principles similar to those of Regent's Park. Other forerunners included Edensor, Paxton's own residential development (1838–42) on the Chatsworth estate. Maintenance costs at Prince's Park were met by rents from the surrounding villas, and the park itself was exclusively for the use of the villas' occupants. It remained private until 1918 when Liverpool Corporation took it over.[5]

By contrast with these mainly private endeavours, little was achieved at first in the public domain. In 1839 the 'Public Walks Debate' was once more on the parliamentary agenda, no doubt prompted by recent Chartist demonstrations. Again Slaney had pointed out that it was 'the duty of the House of Parliament to take measures to provide Public Walks'. But again the motion was withdrawn, as no means were agreed on.

In 1840 the Select Committee on the Health of Towns included in its findings a reference to the 1833 report, endorsing the fact that 'not much had been done ... in the meantime'. Problems of public health had become even more pressing as the population increased. At least one witness claimed that the condition of the poor had worsened. If on no other grounds, 'improvements [were] necessary not less for the welfare of the poor than the safety of property and the security of the rich'. Among the Committee's recommendations was a General Act to facilitate improvements, extending to all towns above a certain population.

This was not fulfilled. Instead, however, £10,000 was voted to promote the opening of public parks, on the condition that bodies wishing to benefit from this fund should match such loans with at least an equal amount of their own money. Between 1841 and 1849 Dundee, Arbroath, Manchester, Portsmouth and Preston all made use of this scheme, with applications still pending in 1849 from Leicester, Harrogate, Stockport, Sunderland and Oldham.[6] As early as 1841 it was claimed that throughout the country seventy-seven additional parks, public walks and places for the people 'were in the process of formation'.[7]

In London at this period conditions were deteriorating fast. The 1840 report urgently recommended creation of a park at the east end of the metropolis. It was suggested that this would probably diminish the local

death rate, and spare thousands from years of sickness. Moreover it would be 'to everyone's interest as epidemics start in the East End and travel to the West'. Around Bethnal Green there were still open spaces; but they were unusable for recreation, being full of stagnant water and rotting waste, and a general source of disease. In local schools, playgrounds barely existed. Many children never went to school; from the age of seven they could be employed by their parents, winding bobbins, or else sent out to beg, with the penalty of being beaten if they did not bring back enough money. Throughout the East End people were so poor that, unable to afford fuel, they went to the public house to keep warm. The Bishop of London, joining the debate on their living conditions, 'trusted that some parks, public walks, or other means of healthful recreation would be afforded to the miserable and neglected inhabitants of Bethnal Green and Spitalfields, and that neighbourhood, which was in a state none could conceive'.[8]

Slowly, the government were waking up to the fact that if they did not move fast they would 'soon find it difficult to get any eligible spot'.[9] It was Slaney once again who moved that a committee should be established to consider the creation of a new royal park in the East End near Spitalfields.[10] This would offer the beneficial effects of 'exercise in the open air on the population', numbering four hundred thousand in the area.

Support for these proposals came from the people themselves. In 1840 a petition to the Queen, and pleas to Parliament, were signed in Bermondsey and its environs by thirty thousand people; by 1842 the means of establishing a park were being seriously considered. The government should raise the money, it was suggested, by 'exchange of Crown property in one place to procure appropriate sites in another'.[11] By 1843 the ground, already named Victoria Park, had been reserved, but no progress had been made towards laying it out. Yet another report, in 1844, noted that it was still only being talked about.[12]

Finally the government responded. York House, in Westminster, was sold with the intention of helping to establish the new Victoria Park, on about 244 acres to be purchased in Hackney, Bethnal Green and Bow. Following the precedent set by Regent's Park, thirty-two acres on the perimeter were to be appropriated for new villas, whose leases would be sold to defray the overall cost. It had been recognised that the value of land adjacent to a new park would always increase. Consequently it became government policy, wherever such a development was proposed in the metropolis, to acquire an extra strip of land that could be let out as building plots. At last the inhabitants of areas such as Tower Hamlets were to have a park, provided at public expense. More than ten years had passed before the government's deliberations became reality. Victoria Park was opened in 1846.[13]

At the time of its creation Victoria Park was uniquely 'public', being the first royal park made for use by the people as opposed to the Crown.[14] Other metropolitan schemes followed. Kennington Common was by definition already a public open space; in 1848 it had been the scene of a Chartist demonstration at which 200,000 people had been expected to muster before marching on Parliament to present a petition – in the event, they were dispelled by police and soldiers. In 1852, largely through subscriptions organized by a small number of local gentry, the Common was enclosed as a park. In 1887 it was transferred to the Metropolitan Board of Works,[15] which in turn was succeeded by London County Council. Meanwhile, on the city's northern outskirts Primrose Hill, which had been saved from development, had been purchased by the government and likewise enclosed for the public. From 1848 it also included the country's first children's playground to be funded by government money.

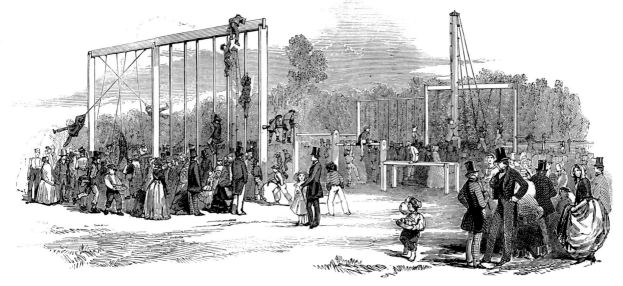

GYMNASIUM, PRIMROSE-HILL.

South of the river there was also urgent need for a new park, according to 'The fifth report of the Commissioners for the Improvement of the Metropolis in 1846', which repeated a recommendation made three years before. The report urged the immediate purchase of at least 150–200 acres of Battersea Fields, 'otherwise [they] will be swallowed up by building'. Thomas Cubitt, giving evidence, declared that such a site 'would be without parallel as there would be no other such open space by a large river and constant steamboat travel in the whole country for use of "common people"'. He reminded the government that by appropriating part of the land for building, it would reimburse itself and perhaps even make a profit.

Gymnasium, Primrose Hill, 1848. Note that only boys are using the apparatus.

OPENING OF THE PARK.

The opening of the Birkenhead Park, showing Paxton's classical boathouse.

This time the authorities acted promptly. At last it was appreciated that as London continued to expand, the value of land within its limits would rise, making such projects more expensive with every year of delay. In 1846 an Act of Parliament duly empowered the Commissioners of Her Majesty's Woods and Forests to form a park in Battersea Fields. Two thousand pounds was voted to cover laying out, enclosure, planting, and constructing lodges, museums or other ornamental buildings; and another 'royal' public park was in the making. The ideal of surrounding London with a belt of parks was taking physical shape, if in piecemeal fashion.

Beyond London, public demand for parks was also bearing fruit. At Birkenhead, a dormitory of Liverpool, history was being made: in 1843 the Royal Assent was given to the town's third Improvement Act, under which its commissioners were allowed to purchase land, with a loan of £60,000 made by the government. The money was to be borrowed on behalf of the ratepayers, with the proviso that not less than seventy acres were to be set aside for the 'free recreation of the town's inhabitants'.[16] Of the 226 acres bought by the town, 125 were for public use in perpetuity and the rest was to be sold as building plots for houses.[17] It was the first time money had been raised in such a manner for the purpose of laying out a public park.[18] It was immediately dubbed the 'People's Park'.

In its layout too, Birkenhead Park was seminal. Of the several public parks created by its designer, Joseph Paxton, it is held to be the finest. It was to have considerable influence on Frederick Law Olmsted, who subsequently laid out Central Park, in New York. Olmsted, visiting in 1850, was impressed by the park's scale – despite its size, it lay entirely within the town – as by its variety and the way it dealt with traffic. All these elements were to help him formulate his own urban ideal, based on a synthesis of landscape and cityscape.[19]

In Manchester similar measures were being taken, on the initiative of a handful of individuals. A meeting of 111 local dignitaries was organised, in August 1844, to discuss the financing of open spaces for recreation. In the previous session of Parliament a Bill had been passed enabling a rate to be levied in the borough for such improvements. However, the meeting declared this levy unjust, on the grounds that a rate would fall on rich and poor alike. It was therefore decided to raise the money by voluntary subscription. Like Birkenhead, Manchester should sell a third of the grounds for villas, both to pay for the original purchase and to maintain the new parks in a proper condition.[20] Within the parks themselves not only should walks be provided, but in due course they should be 'embellished with flowers and shrubs'. For, as Mark Philips, the local MP put it, 'I know not why the weaver and the mechanic should not cultivate a taste for flowers as the first nobleman in the land.'[21] James Heywood, who pledged £300, likewise considered that the more amusements people had the more contented they were. He cited the example of Hyde Park, in London, where the one hundred people who gathered for the Coronation of Queen Victoria had behaved in exemplary fashion. Also, as others before him had discovered, greater provision in these respects had been made by countries with far less liberal governments than their own. Another motive – the main one – was to ventilate and purify the air of the town. In the years between the censuses of 1831 and 1841, Manchester's population had increased enormously, from 186,145 to 242,983.

The subscription scheme launched in Manchester quickly proved a success; by the end of 1844, £26,701 had been raised. Quoting from the *Manchester Guardian*, *The Times* pointed out that 'These subscriptions are by far the most significant and decisive answer to those who object that when parks are provided the people will not use them – few suppose that likely when they find workmen in a calico-printing concern (Messrs Thomas Hoyle and Sons) have subscribed £67 odd – and another machine-making establishment £50 in aid of the fund for public walks and parks – if these were not satisfactory of the earnest approbation and cordial support of those for whom these parks are mainly needed, we know not where to seek them.'[22] Many contributions were small sums – 'under five shillings' – given by local work people;[23] *The Times* stated that the

'employees had been as liberal as their employers in proportion to their means'.[24] The money thus raised was used to buy and lay out the areas that in 1846 became Philip's Park and Queen's Park; also Peel Park, later taken over by Salford.

In Birmingham too it was voted to follow the example of Manchester and to establish baths and walks by public subscription. As *The Times* reported, 'It was the opinion of the meeting that due to the difficulty of ready access to places for ablution, fresh air and healthy recreation ... the formation of public baths and public walks or open spaces in the vicinity of the borough would greatly contribute to the health, rational enjoyment, kindly intercourse and good morals of all classes of our population.'[25]

The creation of parks was now a matter for public and legislative debate. Those already formed had come about by a variety of means ranging from private gifts, subscriptions or speculative development, to special Acts of Parliament and funding by central government. By the late 1840s the provision of open spaces, walks, parks or other recreational areas had clearly become a concern of the public health movement. Gaining momentum, by 1848 this movement had led to the first Public Health Act,[26] enabling local authorities to purchase and maintain land for the purpose of recreation: 'The Local Board of Health with the approval of the said General Board, may provide, maintain, lay out, plant and improve Premises for the Purpose of being used as public walks or Pleasure Grounds, and support or contribute towards any premises provided for such Purposes by any persons whomsoever.'[27]

Such legislation did not apply to London. To make up for this, in 1855 the Metropolitan Local Management Act was passed, enabling the Metropolitan Board of Works to apply to Parliament 'for the means of providing parks, pleasure grounds, places of recreation and open spaces for the improvement of the Metropolis and the benefit of the inhabitants'.[28] Three parks were to be planned, the first being Finsbury, the second and third, Hampstead. Back in 1842 almost all the inhabitants of Bermondsey had also signed a petition, which they had presented to Parliament, 'praying' for a public space similar to Victoria Park:[29] it had been desired too that Hampstead Heath be secured for public use. However, these two projects had been postponed after the government declared that there had not been sufficient notice given.[30] It was not until 1871 that Hampstead Heath was obtained for the public, after the Metropolitan Board purchased rights over it from the then lord of the manor of Hampstead, Sir John Maryon Wilson.[31]

In the meantime the creation of Finsbury Park, like that of Victoria Park, was a drawn-out affair. In 1851 submissions had already been made to the prime minister, Lord John Russell, for a new 420-acre enclosure, to be called Albert Park, for use by the inhabitants of Islington. In twenty years the area's population had doubled, and now numbered three hundred and

fifty thousand.

Before any legislation was drawn up, a change of government occurred and new applications had to be made, to Lord Derby. Again they were frustrated by a change of ministry; however, under an Act of 1855 plans for the new park finally got under way. Initial proposals had to be submitted to the chief commissioner of public works and buildings, who then sought the authorisation of Parliament. The Finsbury Park Act, passed in 1857, gave his Board powers of compulsory purchase; it also enabled them to make byelaws, to impose penalties and to 'plant as they think fit'.[32]

Fittingly, the 120-acre site finally chosen − no longer in Islington − had been a park since medieval times, when it had formed part of the extensive forest of Middlesex. By the nineteenth century it was still the site of Hornsey Wood, within which lay the park and grounds of Hornsey House. The new park, bounded by Green Lane and by the Great Northern Railway, was to extend north of Seven Sisters Road as far as the New River. In the words of the *Gardener's Chronicle*, 'a more fortunate piece of foresight than this event shows it would be difficult to name'.[33]

From Halifax at the same time, the lethargic central government was offered another example of a park created by private benefaction. The People's Park was the gift of the manufacturer Frank Crossley who, in borrowing Birkenhead Park's nickname as an official title, signalled the strides made by the public health movement. Crossley, whose wealth derived from the town's carpet mills, chose Joseph Paxton to 'arrange art and nature that they shall be within the walk of every working man of Halifax: that he shall go to take his stroll there after he has done his hard day's toil, and be able to get home again without being tired'.[34] Founded as it was through a mixture of paternalism and philanthropy, the Halifax People's Park, opened in 1857, expressed much of the spirit of the age.

One dilemma still impeded the public authorities. Should parks be funded locally or from the national purse? Was it fair for any neighbourhood to have to pay for another district's park? More questionable yet, should provincial cities have to pay for the outlay and maintenance of London's open spaces? As one MP asked, would Finsbury Park be of benefit to the inhabitants of Cornwall?[35] Though provincial towns were as much entitled to grants as the metropolis, there was a strong lobby against central government aid for local purposes.[36] The inherent English dislike of centralised government finally resolved the issue with Public Health Act of 1875. Under Clause 157 of the Act, headed 'Public Pleasure Grounds', it was declared that:

> Any urban authority may acquire, lay out, plant, improve and maintain lands for the purpose of being used as public walks or pleasure grounds, and may support or contribute to the support of public walks or pleasure grounds provided by any person whatsoever. In addition

THE QUEEN'S VISIT TO BIRMINGHAM—ASTON PARK, FROM ASTON HALL, BIRMINGHAM IN THE DISTANCE.

The Queen's Visit to Aston Park, Birmingham, in 1858, with the city of Birmingham in the distance. The city purchased the park in 1864 and opened it to the public.

any local authority may for the purposes of the Act purchase or take on lease, sell or exchange any lands or any rights in, over, or on lands, whether situated within or without the district.

This legislation did not apply to Scotland or Ireland 'save as by this Act is expressly provided'; nor to London, which continued to be governed by the Metropolitan Board until the creation of the London County Council (1889). In effect the 1875 Public Health Act enabled local government both to raise loans through Parliament and to levy its own rate. This was the signal that had been fought for all along. Councils like Manchester had resisted using ratepayers' money for the formation of parks; now they did so willingly. By the end of the century between one hundred and fifty and two hundred parks had been created or purchased in the name of the people.[37] Municipal park-making had become a 'mania'.[38]

Inevitably a new problem arose with urban parks. As land values around them shot up, so the poorer classes were driven out, once again finding themselves without the proximity of a public recreational space. Slaney, like Loudon, had recognised that if parks were to serve the poor they needed to be near at hand. He accordingly had urged the acquisition of land, small areas included, to serve their neighbourhoods as recreation grounds.[39] As London and other towns expanded, many owners of private parks which had once been in rural settings sold or donated their properties to town councils. Hence the number of smaller open spaces such as Ravenscourt Park, Hammersmith, and Waterlow Park, Highgate, both in London. Provincial examples included Ashbourne Park, Derby, Aston Hall, Birmingham, and the considerably larger Heaton Park, Manchester. Many parks, including Ashbourne and Aston, were originally old deer parks; their continued survival is little short of a miracle.

The formation of the first public parks has been given in some detail simply to try to show what a long and arduous effort it was. Under the leadership of a few public-spirited individuals moreover, it was, as J. C. Loudon said, a movement from the people rather than from government. Without their efforts there would now be far fewer green spaces throughout our cities.

11

ARCADIAS FOR ALL

With the establishment of public parks, the impetus in gardening and landscaping switched from the private domain to the public. Such parks were nonetheless laid out in the image of their royal and rural predecessors. 'Proceed as to private parks and pleasure grounds,' wrote Charles Smith, whose book *The Laying out of Parks and Gardens*, published in 1852, largely developed Loudon's ideas on the subject. Loudon, writing in 1835, had envisaged parks created not only for pedestrians but for horse riders and carriages. He had recommended laying them out in the informal landscape style, grazed by deer, sheep or cattle,[1] with a road around the circumference that would leave the interior for people on foot. 'The road should deviate at various points to give views of the exterior or interior; the latter not intersected by too many paths. Trees should be planted in such a manner as to give the greatest views across the interior of the park whilst at all times concealing its road and boundary.'[2] The aim was to make the area appear larger than it was, and for the same reason Loudon urged as few entrances as possible: for people driving around the park these too were a reminder of its limits.

One basic difference from private parks tended to be the absence of a mansion to generate an overall form and provide a focal point. Public parks nonetheless remained gated and fenced, and guarded by lodges. Like their rural counterparts they were refuges from the outside world, which was no longer a threatening forest but an increasingly hostile urban landscape. Charles Smith also perceived the new parks as swathes of country. 'Parks of more than sixty acres' – that is, 'parks in the proper sense of the word' – should be regarded as 'enclosures of pasture with broad well-formed walks and drives intersecting and sweeping round the whole together, with trees planted on a scale comparable to woods'.[3] He considered that on the other hand small parks of twenty to forty acres should be seen as pleasure grounds with walks, shrubberies and moderate-sized groups of trees, the whole maybe 'attached to a larger park' as on a country estate.

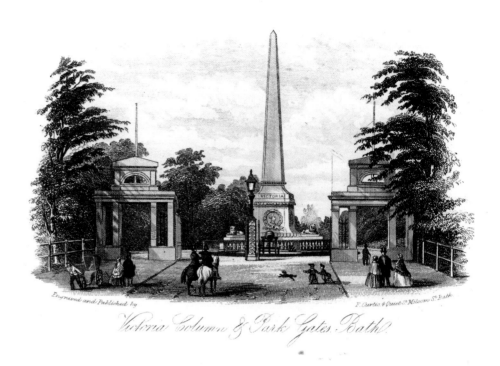

Victoria Column and Park
Gates, Bath.

Few buildings were necessary, but a museum or picture gallery, as at Peel Park, Manchester, could be a substitute for a mansion.

The Royal Victoria Park at Bath was an example of a public park designed on the principles of a private landscape park. It had a Tudor-style lodge, and a main promenade entered through a resplendent gateway designed by a pupil of Sir John Soane, Edward Davis.[4] Such promenades were to feature in most new parks. Victoria Park also had such traditional features as streams brought together to make an ornamental lake, fields turned into sweeping lawns and some twenty-five thousand forest trees and shrubs planted in belts and clumps. The *Bath Express* boasted that the whole effect gave

> A goodly prospect . . .
> Of hills and dales and woods and lawns, and spires
> And glittering stream.[5]

Temples, obelisks, fountains, statues and other emblematic devices soon became part of a public iconography commemorating people or events, just as they had in private parks. At Bath's Victoria Park, for example, an obelisk was raised to mark the queen's accession.

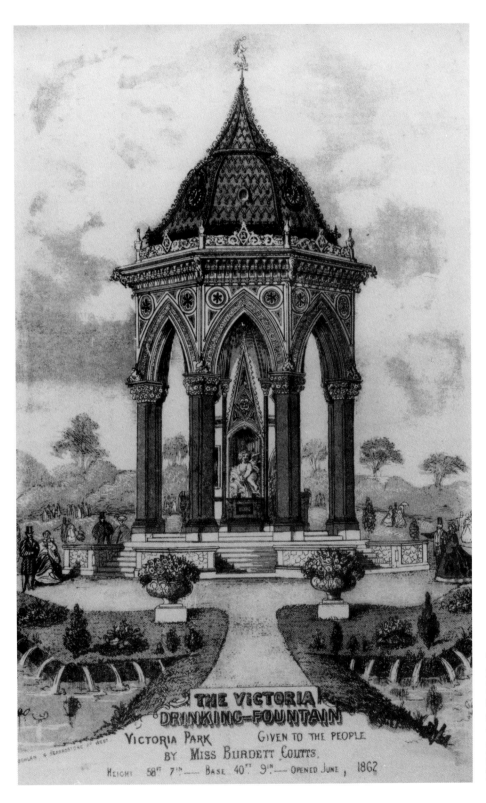

The Victoria drinking fountain, 1862, Victoria Park, London. The gifts of fountains, erected as architectural monuments, were not merely acts of philanthropy but also a means of the donor ensuring his or her immortality.

The first truly municipal park, as noted, was the one made to Paxton's design at Birkenhead, opened in 1847. Birkenhead Park was laid out by Edward Kemp, who had worked with Paxton at Chatsworth. It was, for Charles Smith, the exemplar of a public park: 'There is more to be gained by a study of it than any other.'[6] Like Victoria Park, it was conceived in the landscape tradition; a pastoral vision which would have looked quite in place surrounding a country mansion. Its islanded lakes, winding paths, open glades and wooded areas were made for gentle pastimes and quiet reflection. Paxton, in contact with Edwin Chadwick, and likewise concerned with the 'sanitary idea' and 'urban improvement', provided the open areas as places for games; nonetheless the design's main emphasis was on passive enjoyment of its scenery. From the earth and stone excavated for the lakes, undulating contours and screens of rockwork were formed at the intersection of the walks, to conceal their direction and thereby add interest and surprise. Birkenhead Park was an 'aristocratic' park created for the proletariat. Like Regent's Park and countless successors, however, it was surrounded by terraces and elegant villas in the then fashionable mixture of revivalist styles, with gardens extending to the perimeter drive. Of its many imitations, several were to be designed by Paxton himself, and others by his protégés, Edward Kemp, Edward Milner and John Gibson. It was the pastoral quality of Birkenhead Park amid a built-up suburban setting which so influenced Frederick Olmsted, inspiring him to design Central Park as an idyll, contrasting 'streets and shops' with 'what we want ... tranquillity and rest of mind'.[7]

Unfortunately in England there was increasing boredom with the pastoral idyll: saturation had been reached and reaction against the 'natural' was setting in. Changes were taking place in the design of private parks, and these were to be echoed in public ones.

The landscape movement had reached its climax with Humphry Repton, who also ushered in the reaction against it. The improver par excellence, Repton beguiled his clients with the redbooks containing his famous before and after sketches, and left a legacy of some four hundred estates bearing the signature of his ideas. As mentioned, he endorsed Capability Brown's view that a country seat should reflect its owner's wealth, but criticised such 'unnatural' aspects of Brown's work as the siting of an artificial lake on top of a hill, and the lack of formality in the house's immediate setting.

In Richard Payne Knight's *The Landscape; a Didactic Poem addressed to Uvedale Price* (1794), Brown and his followers were taken to task for the formulaic way in which their grounds were laid out. He disliked the smooth harmonious serenity in their transformations of such parks as Blenheim with its

> Prim gravel walks, through which we winding go,
> In endless serpentines that nothing show.

Repton himself, as we saw earlier, was included among the targets of this poem, perhaps unfairly.

In the same year Uvedale Price's *Essay on the Picturesque* argued for a wilder, more rugged and dramatic style of landscape gardening – the picturesque, as he called it. Reprinted with Repton's own ripostes in 1810, Price's *Essay* had claimed that inspiration would again be found in paintings: this time the work of seventeenth-century artists such as Salvator Rosa, whose banditti were shown against wild mountainous scenery. These ideas corresponded with a new-found appreciation of rugged landscape like that of Wales and the Lake District, as painted and described by William Gilpin in three essays of 1792: 'On Picturesque Beauty', 'On Picturesque Travel', and 'On Sketching Landscape'. Wordsworth too was about to eulogise such scenes. The taste for the picturesque developed from the time of Edmund Burke's *Philosophical Enquiry into the Origin of our Ideas of the Sublime and the Beautiful* (1756), in which a vastness found in such phenomena as mountains, cataracts, storms and night skies was equated with the sublime. It was slow to develop at first, but from the last quarter of the eighteenth century, increasing travel and tourism instilled an appetite for such spectacles in a growing number of people. Repton himself favoured a middle course, liking neither 'the bare and the bald', nor the 'shaggy and harsh-featured

Hawkstone Hall, Shropshire. The park at Hawkstone was typical of the awe-inspiring and romantic topography that followers of the picturesque admired, a reaction to the smooth serene contours of a Brown landscape (cf. Petworth Park or Blenheim, pp.90, 96).

spirit' which 'knows no delight but in the scenes of Salvator Rosa'.[8]

.Having been brought to life by the written word, the landscape movement was also to be killed by it. In 1815 Thomas Love Peacock's satirical novel *Headlong Hall* was published, in which Repton is thinly disguised as the ridiculous Marmaduke Milestone. His fictional surname referred to an aspect in his practice of 'appropriation' – his habit of encouraging his clients to display their wealth by placing their arms on public buildings in the neighbourhood, or on 'a mere stone with distances'. Knight assumed, not unreasonably, that Repton meant a milestone. However, Repton strenuously denied this without explaining what he had meant – hence Peacock's parody. Peacock also parodied Repton, Price and Knight for their abstruse controversies, which included Price's insistence on making a distinction between the beautiful and the picturesque, a debate in which Knight would take no part. Peacock mocked these arcane concerns in the following exchange between Milestone, who takes Knight's viewpoint this time, and Sir Patrick O'Prism who represents Price.

> 'Sir,' said Mr Milestone, 'you will have the goodness to make a distinction between the picturesque and the beautiful.'
> 'Will I?' said Sir Patrick, 'och! but I won't. For what is beautiful? That which pleases the eye? Tints variously broken and blended. Now, tints variously broken and blended constitute the picturesque.'[9]

For the connoisseur Thomas Hope, the landscapists had succeeded only too well in creating scenes that concealed their man-made origin. In 1820 Hope announced he was 'bored with unassisted nature' and urged a return to straight lines: 'The discarding of covered walks, terraces, balustrades, parterres, berceaux and so on in country mansions which had increased the splendour of the scene is an abuse of terms as egregious as inconceivable.' The trouble was, he said, 'The English took ideas to extremes and gardens had become monotonous through trying to copy nature – asymmetry was all right in the darkest recesses of the park but pleasure gardens should have variety . . . if a row of columns is all right why not a row of trees?'[10]

Foreign designers like Jacob Rinz criticised the absence of shrubs and flowers from parks, and deplored the relationship of the house to the landscape, where it rose out of 'unshaven lawns'. The call for a return to a formal setting for the house had united even Repton and his antagonists, Price and Knight. Price wanted 'straight terraces, terrace walks, statues, fountains, flights of steps, balustrades, vases, architectural seats and formal parterres, knots, and flower-beds' to form 'a transitional zone between the formal house and the informal landscape beyond'.[11] A fashion for revivalist styles in architecture, especially Tudor, also encouraged a return to the architectural garden, at least around the house.

For both 'mock' houses and surviving authentic ones, it was considered appropriate to recreate the gardens of the period.

The eighteenth-century practice of melding house, garden and park into one integrated landscape with everything in it subordinate to the whole, was being rejected. Repton had argued against the ha-ha on the grounds that if the cattle were not allowed on the dressed lawn it was wrong to make them appear as if they were. While he mostly used open railings, which still allowed some continuity of vision, others actually suggested bringing back walls to separate the garden from the landscape beyond.

FENCES, CALLED INVISIBLE

Fences called invisible by Repton. Though the ha-ha still exists in the foreground of the lower picture, Repton obviously felt that it was necessary to make a visual distinction between garden and park.

In place of overall harmony, compartmentalisation was being reintroduced. With it came a new trend, specialisation. Life outdoors reflected that of indoors, where rooms and quarters for each different activity were now proliferating. And just as convenience, comfort and privacy were the paramount needs indoors, so they were now looked for outside. Even current taste in interior decoration was to extend outdoors. In the 1820s and 30s a preference for the baroque and rococo curves of Louis XIV and XV furniture and decoration appeared in the planting of flowers, and in the shapes of the flowerbeds themselves. The fashion spread from gardens into parks, both private and public, showing up in Repton's own plans for Lord Sidmouth's house at Richmond, as well as in the incongruously shaped beds of flowers in the Brownian park of Prince Pückler at Muskau.[12]

Increasingly, terrace walks overlooked the park, which was encroached upon not only by parterres of flowers but by enclosures for specialist

The flower-garden near the house with 'artistic' flowerbeds which littered Prince Pückler's Park at Muskau.

gardens and shrub-planted lawns. In keeping with the current opinion that 'there should be a decided division between the kept ground and the park',[13] balustraded terraces or iron railings were erected. Where a ha-ha survived, the retaining wall was made as visible as possible from the park. Even the sudden cessation of shrubs in the garden would do to mark a boundary. By trying to separate park and garden, a new generation once again rejected the theories of the preceding one, and as always destroyed much of its work. Though some support lingered for the natural style, the movement as a whole had ended.

These changes on private estates were soon to be reflected in public parks. Axial walks, mixed borders of trees, flowering shrubs, and beds of annuals were introduced, to form a new synthesis with large expanses of turf and trees. Town parks in particular were seen as needing more ornament. As Charles Smith put it, 'They should be gay though not glaring or obtrusively showy . . . [they need] therefore a variety of terraces, statues, monuments and water in all its forms of fountain, pond and lake.'[14] As substitutes for the private mansion, museums, picture galleries and conservatories became increasingly prevalent.

A major influence on the development of the park at this time was a growing public interest in gardening and botany. The establishing of botanical gardens commenced in the 1820s. Horticultural societies sprang up everywhere, encouraging the planting of foreign, or 'exotic' trees, shrubs and other plants. By 1838 over two hundred such organizations were listed.[15] Once again Loudon, through his *Gardener's Magazine* and his *Encyclopaedia of Gardening*, was instrumental in this development, evolving a whole theory of planting – 'gardenesque' – to accommodate the plethora of new species and varieties coming in.

The creators of the 'natural' style of gardening had planted trees that were either indigenous or, like the horse chestnut, introduced long enough ago to have become naturalised. Brown had confined himself to between five and eight varieties. But the increasing availability of foreign species in the nineteenth century naturally brought with it a pressure to use them, both to enhance the landscape and for their own intrinsic beauty. According to Jacob Rinz, indigenous species such as elm and oak could be improved if combined with other trees, and with shrubs and flowers.[16] The designers of Regent's Park were castigated by Loudon for planting only what he called a 'common mixture' when they might have made an arboretum.[17]

According to Loudon there were two forms of 'artistical Imitation of natural scenery – the province of landscape gardening'. In the picturesque or natural style, trees were planted in groups. Their aesthetic contribution lay in the effect they made en masse and in their relationship to other elements of the scene; in other words their effect as in a painting. Trees or shrubs were not to be seen in isolation, and were often planted so close

that they seemed to 'spring from the same root'. In contrast, the gardenesque approach valued trees for the perfection of their form as individuals. Each one should be perceived singly, even when planted as part of a straight line or within a geometric pattern. When a group was required, the distances between them, in addition to ensuring that they did not touch, should be as varied as possible. In his arboretum at Derby, where every tree had been given its own individual planting ground, Loudon not only labelled each of the original 802 varieties, but also numbered each with a brick tally referring to more detailed descriptions, available in one of his own publications for sale on the site.[18]

However, as Loudon himself was quick to point out, the effect of planting trees as individuals was often spotty. His prime example was Regent's Park where single trees were 'dotted over open spaces without the slightest regard to effect'. He asserted 'that to say they were in bad taste would be paying them a compliment, they showed no taste whatever'.[19] Unlike some of his successors, Loudon was still concerned with the overall scenic result, and his work can be seen as an attempt to reconcile conflicting ideals: the picturesque and his own gardenesque. On the assumption that the most beautiful objects or scenes in nature are symmetrical,[20] he advocated as one way of avoiding a spotty effect what he termed the axis of symmetry. Groups of trees not necessarily equal in size should be planted on either side of a central axis such as a path. In this he was influenced by foreign examples; throughout the centuries, public promenades and parks on the continent had mainly been planted in the geometric style, ignoring the 'natural' or 'English' fashion adopted in private parks.

Other landscape designers ceased altogether to regard paintings as appropriate sources. Joshua Major argued that:

> a view to be represented on canvass is necessarily limited ... as paintings cannot afford correct examples, because the painter has not space in his limited picture for the introduction of groups and single trees, displaying their full beauty and true character, are we to banish the majestic cedar ... the noble lime ... the deep-toned purple beech; the stately elm; the various pines, with their sombre shadows; or the pyramidal larch ... we ask also what has the painter to do with the gay parterre, the delightful flower garden – the soul's delight of the majority of mankind?[21]

Partly in response to the dazzling wealth of new varieties, horticulture came to be seen as a means of 'improving the quality of life of the masses'. The Temperance societies considered that 'We wail the depravity of the lower classes but forget how few enjoyments [are] within their reach'.[22] By developing an interest in botany and horticulture, even within the limits of a window box, it was thought that the poor would be less tempted

by the beer shop. And it was true that from being the prerogative of the nobility, parks and gardening were fast becoming pastimes of the people. In response a new literature of horticulture was developing, no longer concerned with the aesthetics of gardening, but with the correct way to grow individual plants. It was aimed mainly at artisans and at the vastly increasing middle classes, and its legacy today is the popularity of gardening over any other form of artistic expression in our national culture.

To assist the dissemination of this knowledge, a campaign was launched to label all the diverse plant material being introduced into public parks, especially varieties used for food, medicine, arts or manufacturing. Loudon was vociferous in this campaign, and following his own lead in the Derby Arboretum, the practice was taken up by the royal parks, in St James's and Kensington Gardens. In 1843 the *Gardener's Chronicle* remarked that: 'Naming of trees and shrubs in Kensington Gardens as anticipated, has a beneficial effect upon the public mind awaking a curiosity and a taste for botanical and horticultural pursuits so much so that gentlemen go straight from the gardens to the nurseries'.[23] It was particularly necessary to label plants in English where they were viewed by the larger public. However, rendering Latin names into English had its problems; the Colletia Horrida became the 'horrid-looking colletia', and there were doubtless many other unfortunate misnomers.

The greatest boost to horticulture and the one most responsible for the invasion of flowers into parks was without doubt Sir Robert Peel's removal of the tax on glass, in 1845.[24] Formerly, a duty had been levied by weight, and manufacturers had made glass as thin as possible, with the result that it was always breaking. The availability of cheaper and stronger glass brought a huge benefit to greenhouses and conservatories. Now that plants could be raised inexpensively under glass, the flowering season could be extended by bedding out tender varieties. This was to change the face of private gardens and public parks alike.

The system of 'carpet bedding', as it became known, was so called because its dwarf flowers were arranged in patterns and all of uniform height, like the pile of a patterned carpet. It had been pioneered in Phoenix Park, Dublin, in the 1820s.[25] In England the lead was taken by the royal parks, which the commissioners 'desired to beautify for the pleasure of the public'.[26] In 1843 flowers and shrubs were introduced into Hampton Court, and in Kensington Gardens the Long Walk was planted with thousands of verbenas and pelargoniums. The Serpentine's west bank was also newly planted with flowering shrubs including kalmias and 159 varieties of azalea. The result brought the comment from the *Gardener's Chronicle* that 'these shall be real gardens and deserve the name of Kensington Gardens'.[27]

The construction of Paxton's Crystal Palace in Hyde Park in 1851, and its

removal in 1854 to Sydenham, probably had a greater effect on the appearance and role of parks at this time than any other event. At Sydenham Paxton set his magnificent glasshouse on the top of a hill like a great seventeenth-century palace, commanding a panoramic view of the surrounding country. Though a commercial enterprise with an entrance fee, it 'had been erected for the intellectual improvement and physical recreation of all classes'.[28]

A vast formal garden with balustraded stone terraces led down the hill, divided on the central axis by a wide flight of steps. Carpet bedding ran riot, with 'ribbon' beds of red and yellow calceolarias and other flowers in red, white and blue; setting a fashion that other parks soon followed. The bedding also evoked the 'knot' gardens of the Renaissance; quite appropriate for this particular revival. Near the bottom on either side was a display of *jets d'eaux*, and the whole design was reminiscent of Versailles, which Paxton had visited earlier.

Below, screened by trees, lay a landscape park with an irregularly shaped lake – a perhaps necessary reminder that the same designer had laid out Birkenhead Park. Plaster models of animals were (and still are) displayed on islands in the lake, grouped in chronological sequence from the prehistoric to existing species. An aquarium and a model of an open-cast coal mine were also built. The object of what seems to have been the first theme park was to educate its visitors. Despite the entry charge, it was enormously popular with working-class families, as it also was with those who arrived in carriages. One great socialist however, Ruskin, was enraged by the arrival in a middle-class suburb of the Crystal Palace and its visitors. Writing to Octavia Hill, the founder of the National Trust, he complained that 'The Crystal Palace came, for ever spoiling the view . . . and bringing every show-day, from London, a flood of pedestrians down the footpath who left it filthy with cigar ashes for the rest of the week: then the railways came and expatiating roughs by every excursion train, who knocked the palings about, roared at the cows, and tore down the branches of blossom they could reach'.[29]

The Crystal Palace soon produced its imitators. In 1859 a second version, hailed as a Palace for the People, was planned on a 450-acre site at Muswell Hill. Two hundred acres were set aside for the grounds, including forty or fifty for a deer park, and thirty for a lake, both in the 'natural' style. Terrace gardens in the early Dutch style were also to be laid out, as part of a project aimed both at education and amusement.[30]

It may also have been in response to Paxton's creation at Sydenham that the royal parks underwent improvement. When the Crystal Palace was first erected, a number of objectors had insisted that a building of that size would leave Hyde Park permanently mutilated. As it was, a group of elms had had to be cut down; however, those that were left appeared to thrive under glass. Paxton had wanted to keep the Crystal Palace on its first site

as a winter garden. It was argued that indoor conservatories added greatly to parks that were otherwise only usable for six months of the year. In any event the Great Exhibition led to a much freer use of the park. By the end of the 1850s funds were allocated for establishing shrubberies and flowerbeds throughout the parks of London's West End, and in Hyde Park in particular.[31] In 1857 a new fifteen-foot wide gravel walk was laid out along the park's Bayswater Road perimeter, between belts of trees in which evergreens and low shrubs were interspersed with beds of annuals such as mignonette, marigold, sweet alyssum, wallflowers, and sweet william. It was praised as 'the great improvement of the year ... thirty thousand to forty thousand bedding plants planted this season meant that the working classes can see flowers without having to go to Kew'.[32] Elsewhere in the park geraniums, calceolarias and verbenas gave 'a blaze of bloom all the summer ... [the] turf [is] worn bare at the east end of the lodge near the bridge by the Serpentine by the public walking round the fence looking at them'.[33] Under the supervision of the Chief Commissioner of Woods and Forests, Lord Palmerston's stepson William Cowper, the new walk was extended down Park Lane to Hyde Park Corner. By 1865 the *Gardener's Chronicle* was ecstatic about the panorama which the 'equestrian' had on entering or leaving Rotten Row: 'the mixture of park scenery, picturesque trees and garden, producing a variety that may be set in friendly competition with the more stately splendour of the Champs Elysées. From the noise and bustle of Oxford Street, it is a sudden transition to the shade and comparative quiet of the garden.'[34]

Not everyone liked the introduction of flowers into the park; opponents of William Cowper's new walk included Queen Victoria. In reply however to the diminishing band for whom 'the unities in landscape gardening contend that a park is no place for floral prettiness but should be sacred to turf and trees', the *Gardener's Chronicle* declared that this view was only acceptable 'where a park surrounds a mansion and a mansion has terraces and flower gardens all properly disposed'. In public pleasure grounds, on the other hand, flowers were wanted 'just because the people's houses have no gardens and nine tenths of those who frequent parks have no opportunity of seeing flowers growing anywhere else'. The same magazine went on to say that

> even though there was opposition at first to Mr Cowper this has now given place to a general feeling that [he] has done much to improve the enjoyment of them by all classes but especially the poor. When Mr Cowper took office the London parks were large prairies fairly wooded, and pleasant enough at all seasons of the year. They are pleasant still, but a little artistic landscape gardening has given them a new character without robbing them of one of their old charms ... Between Marble Arch and the Hamilton Gardens is a feast of colour and beds of ivies, and periwinkle dotted among the trees and the pretty blending of fine foliage and bedding plants – a great attraction.[35]

In Regent's Park another great showplace of flowers was the geometrical garden by Markham Nesfield (1842–74), son of William Nesfield who had designed the gardens for the Horticultural Society's new premises in Kensington in 1861. There the elder Nesfield had used a formal layout with canals, fountains and Italianate arcades, and this being well received, he was invited to alter a number of royal parks. His son Markham was put in charge of the alterations to Regent's Park, but some people thought the stiffness of his designs inappropriate, and too much in contrast with the scenery of the park as a whole.[36] One can only wonder how Nash would have felt at such compromises to his designs.

Critics of the bedding system, however, were still in a minority. Municipal authorities followed the example of the royal parks, as theory succeeded theory on the best uses of ever brighter new species from South Africa or South America. Endless space was given to the subject in gardening magazines. Should colours be mixed or massed; should they contrast or harmonise; might different colours of similar tone be blended? During the 1850s, in gardening as in painting, the proper use of colour was the artistic question of the day. There was also much experimenting with shapes and sizes of flowerbeds in relation to the sizes and habits of plants. In municipal parks, the overriding favourites were 'ribbon borders', together with the most extreme form of carpet bedding, known as 'mosaic culture'. In mosaic planting, dwarf flowers or foliage were used to form intricate patterns, for example the coat of arms of the borough or some message of welcome; often these were placed on a slope so as to be better seen by the passer-by.

To their detractors, ribbon borders were 'the worst form of all'. Gertrude Jekyll described them as 'generally a line of scarlet geraniums at the back, then a line of yellow calceolarias, then a line of blue geraniums and lastly the inevitable line of yellow feverfew'. In her view the fashion for bedding in general was 'like a great inundating wave which spread like an epidemic disease and raged far and wide for nearly a quarter of a century'. For William Morris too, it was 'an aberration of the human mind'.[37] Not that in Gertrude Jekyll's view it was the fault of the flowers themselves, so much as the way in which they had been misused. As Loudon observed, it was rare to find in the same person a cultivator of plants and a sensitive user of them. In keeping with the prevailing view that no special qualification was needed for preserving or improving parks,[38] they were now the province of the cultivators – the head gardeners and plantsmen – few of them with the vision of a Kent or a Brown. Despite growing criticism the bedding system continued well into the 1890s, reaching its apotheosis in such bizarre forms as floral clocks. Inevitably with saturation came reaction, and in Hyde Park in 1904 the bedding system was banished.[39] Today such planting is still seen as the hallmark of municipal gardening, especially in seaside resorts. However, it tends to be viewed

From Repton's Red Book. View before improvement at Livermere Park, Suffolk, 1791, shown with one of Repton's famous 'flaps' down or shut and, below,

with the flap open revealing his proposals for improvement.

Repton's view from a new
Gothic window in 1816 at
Barningham Hall, Norfolk,
which was so placed in order
to give views over the park.

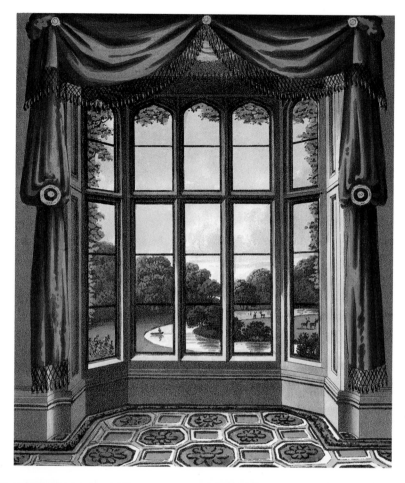

A floral coat of arms in carpet
bedding, c.1910–15.

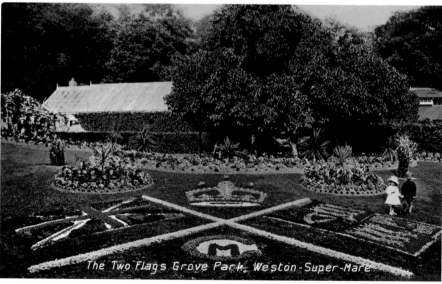

The Two Flags Grove Park, Weston-Super-Mare.

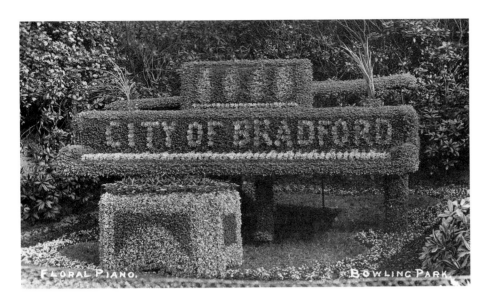

Floral piano in carpet bedding, 1925.

with nostalgic affection, rarity having once again brought an increase in estimation.

Meanwhile other forms of floral display entered the park. In Paris in 1855 the Parc Monceau had been transformed by the use of plants with very large leaves or with coloured foliage. Amid public acclaim this form of gardening, in England called 'sub-tropical', was introduced into Battersea Park in 1863 by the park's designer, John Gibson. Large glasshouses on the same site displayed exotic fruits and ferns.[40] Not all was praise, though; in the *Gardener's Chronicle* William Robinson lauded Gibson's tropical garden, but lamented the overall lack of 'verdure and leaf beauty'. He also criticised the use of ribbon bedding: 'long lines of colour of this, succeeded by long lines of colour of that'.[41]

More than instruction and horticultural display was being demanded of parks, and in ways that would affect their general appearance. Part of the initial impetus towards establishing parks had been aimed at providing healthful exercise. At the time this was synonymous with walking, and the main goal had been to provide ornamental pleasure grounds as pleasant places in which to promenade. Even in 1875 the new Public Health Act still used the term Public Walk rather than Public Park, and made no allusion to games.[42] But walking implied restriction, with people confined to paths by numerous rules of the 'don't' type,[43] 'Keep off the Grass' being the commonest of public park notices. Though Paxton had envisaged games being played in the open glades of his parks, it was in Manchester that areas specifically for sport were first made an integral feature of a new park. In 1846 Queen's Park was opened there, along with Peel Park, and Philip's Park, presumably named after Mark Philips, one of the town's Members of Parliament. Philips had expressed a fondness for 'manly

sports' and a desire to see cricket become a game for the working classes of this and every other community.[44]

Joshua Major, the designer of all these parks, described how he approached the problem of integrating areas for specific sports.

> In order therefore to make the most of the ground we had to operate upon, we designed the pleasure ground as near as practicable to the skirts of the plot, and then took advantage of every nook or recess which was to spare for the different playgrounds – for archery, quoit alley, skittle ground, bowling green, climbing poles, gymnasium, marbles, see-saws, etc. A general playground was formed in the centre [for] ... leaping poles, football and foot races, etc., and also for the additional purpose of large public meetings. Sheep were to graze the grassed areas for games which were to be separated from the pleasure grounds by a wire fence though in the event the wire fence was not erected.[45]

In the 1850s, still in the forefront of improvement, Manchester later opened a gymnasium for girls, in Peel Park.

So successful was the introduction of specialised playing areas that they were seen to threaten picturesque landscape as the principal form of most parks. When a park was proposed on a site next to the new Oxford University Museum, with 'picturesque' trees to surround thirty acres of grass for cricket, the sporting lobby protested on the grounds that this area – over a third of the total – would be inadequate. The question was asked whether 'Park or Playground shall carry the day?'[46]

In modern times the dilemma persists. Where a park is sufficiently large, provisions for sports – even those requiring levelled pitches – can be absorbed without too much detriment to the scenery. But in small parks the loss often seems to outweigh any gain, begging the question whether the two are compatible or might be better served by separate enclosures. Certainly Battersea Park has lost its reclusive quality in direct relation to its increasing sporting amenities.

The idea of increasing the entertainments in parks also led to regular musical performances, by military bands on permanent bandstands. The German custom of having strolling bands of musicians in public parks had inspired Loudon to urge a similar practice in England. In Karlsruhe, where the Duke of Baden's park was open to the townspeople, Loudon had felt that the music of the perambulating bands who played there all summer from dawn to dusk had contributed to the inhabitants' 'mild and gentle character'.[47] At opening ceremonies from that of the Derby Arboretum onwards, musical bands were much in evidence, and in 1855 they became a regular feature, when military bands began playing in the royal parks of the metropolis for a couple of hours every Sunday afternoon.

Needless to say, in a very short time objections were lodged by the Sabbatarians. The Archbishop of Canterbury, protesting on their behalf,

persuaded the prime minister, Lord Palmerston, to prohibit the playing of music on Sundays in London's parks, against Palmerston's personal judgement.[48] So strong was the religious lobby that the prohibition of refreshments, public games or music on Sundays became a standard feature of park regulations. In Hull, a Mr Pearson, donating land to make a People's Park, was publicly congratulated on having made such stipulations a condition of his gift. The public parks had of course been largely created to benefit the masses, for whom Sunday was their only free day, but instead of offering entertainments to rival the 'gin palaces' from which they were supposed to tempt the poor, they were now deprived of what even Lord Palmerston considered to be the 'innocent recreation' of music.[49] By the 1890s, however, a more liberal ethos prevailed, and the new London County Council was praised not only for having beautified the parks under its control, but also for providing facilities for games, music, cheap improved refreshments, and open-air gymnasia for children.

By the end of the century London could also congratulate itself on the extent of its parks: over three thousand acres of public open spaces covering more than ten acres each, and all within built-up areas. The battle for parks had been won. Nowadays, the besetting dilemma is that of balancing the conflicting interests of park users. Perhaps one should look back to Olmsted and those before him, who welcomed the sight of 'rural' landscape for its contrast with the surrounding city. In the case of St James's Park, this contrast was already perceived and valued as early as the eighteenth century.

One other important concern of the Park Movement was the creation of cemeteries, which were needed quite as urgently as 'public walks'. Rapid urban expansion was causing the overflow of church graveyards, with potentially dangerous consequences for public health. With the exception of Jewish cemeteries, the continental practice of removing burial places to the outskirts of towns had had few equivalents in England during previous centuries. There was the Rosary, in Norwich, created by a Dissenting minister in memory of his wife in 1665, and three nonconformist cemeteries: Bunhill Fields, in London (1665), Clifton Graveyard, Belfast (1774), and Calton Hill, in Edinburgh (1778). A parliamentary report of 1840 came out strongly against having burial grounds in the centre of cities.

The first of the new cemeteries was the Necropolis, established in Liverpool in 1825 by a public company of Dissenters, each of whom held a ten-pound share. Also in Liverpool, St James's Cemetery was laid out in 1825–9, in a disused quarry. The Necropolis in Glasgow followed, in 1828–32. Though created by Presbyterians it was available to all denominations. Dublin was next, with both Catholic and Protestant cemeteries. Despite proposals from a number of journals, London, with the most pressing need of all, did not get any new burial places until the 1830s. Following the cholera epidemic of 1832, Parliament finally acted,

authorising private companies to acquire land on the outskirts of the metropolis.[50] Between 1831 and 1841 seven cemeteries were laid out by private enterprise. Of these the most famous was Kensal Green, a 'sight of London', considered not unlike Birkenhead Park. As at Birkenhead the principal line was a curve. The grounds were shaped like a long pear, with a perimeter path, and the northern boundary planted with shrubbery to exclude the Harrow Road from 'sight and sound'. At the eastern end was a Dissenting chapel, and a large circular plot dotted with shrubs.[51]

The great model for cemeteries at this time was Père Lachaise, established on the outskirts of Paris from 1804. Loudon praised it for 'the beauty of the garden, variety of its walks ... the romantic nature of its situation and above all ... the commanding view of Paris and its environs'.[52] London's seven new cemeteries were similarly laid out, with ornamental trees and shrubs planted to achieve a picturesque effect.[53]

But despite being modelled on Père Lachaise, they were criticised by Loudon for being too frivolous. For him, their informality was too reminiscent of pleasure grounds, both by the disposition of their trees and shrubs, in belts and clumps, and by their choice of plant species.[54] In the absence of alternative parks nearby, he agreed that cemeteries near towns should double as promenades; but his views on their layout and the best way for people to disport themselves there were incompatible with using them as parks. In layout, as in public behaviour, they should reflect the solemnity of their main purpose.

Loudon accordingly recommended a return to the geometrical style. Straight walks and drives were more solemn and grand than curves. They were also more economical, as 'every grave was a rectangle and every rectangle a multiple division of every other'. The walks should be planted with erect trees rather than branching ones, to allow air to circulate; evergreens and other trees with dark foliage were particularly appropriate. Certainly evergreens without the light of a Mediterranean sun have a particularly melancholy aura. Since he held that instruction, unlike play, was compatible with the principal use of cemeteries, Loudon also suggested that they might include an arboretum. He welcomed the fact that in Abney Park Cemetery the old trees of the original enclosure were kept and 2,500 others planted.[54] Since Loudon's sentiments in regard to cemeteries were largely to prevail, it was fortunate that cemeteries did not become substitutes for parks. They would have made very cheerless alternatives.

12

PARKS UNDER THREAT

T he fortunes of the park have fluctuated throughout its long history, and the present century is no exception. The Victorians' great burst of civic parkmaking continued into the early years of this century, encouraged by the Public Health Acts Amendment Act of 1907, which gave greater powers to local authorities, strengthening the parks lobby. During the same period the Institute of Park Administration was formed, with the result that by the 1920s a town such as Manchester could boast some fifty-seven public parks.[1] By the first quarter of this century visits to the local park were a regular part of most urban childhoods. For townspeople generally, parks were the social centre of outdoor activity, and an expression of civic pride. Happily many parks still enjoy this role, and continue to embody their creators' dreams. Such places can be found in cities as scattered as Harrogate, Norwich, Bath, Bristol and Stafford, as well as in parts of London.

Nonetheless two world wars, each followed by depression or austerity, have taken their toll on this legacy, particularly in certain inner-city areas. Underfunded and undervalued, many parks have become little more than litter-strewn, dog-fouled wildernesses. No national authority or policy regulates their management, and there is no legal protection of their land. In London the royal parks are administered by the Department of the Environment; most others – the responsibility of the Greater London Council until its demise in 1986 – are now in the care of their local authority. Many poorer boroughs find it hard to keep up even the none-too-high standards set by the GLC, and inadequate resources have led in turn to a cycle of decline. Poor maintenance and underplanting have resulted in under-use, in turn prompting vandalism and other anti-social behaviour.

Nor has this been unique to London. Even Birkenhead Park did not escape neglect, despite its unique place in history, and its pre-eminence as Paxton's masterpiece. Though some measures have been taken to restore

it, its condition by the 1980s was an example of the fate to which many Victorian parks had succumbed. The fine classical boathouse had become roofless, its walls scored with graffiti. Vandalised footbridges had had to be closed, and the islands to which they led, left untended, had grown into impenetrable jungles. The lake had turned green with algae; belts of trees and shrubs had been decimated by Dutch elm disease or over-maturity; and the conservatory demolished. This picture of depredation was completed by the surrounding phalanx of formerly proud villas, the sale of whose plots had once financed the park – the houses now dilapidated, the ornamental railings of their gardens replaced, as often as not, by broken sheets of corrugated iron.[2]

This catalogue of neglect is typical enough to have brought into question the entire role of the park today. Even the word itself is in danger of losing its universal meaning as it becomes increasingly appropriated by other enterprises – business parks, industrial parks, theme parks, leisure parks and so forth. Victorian parks, as we have seen, were conceived mainly for passive use; for gentle exercise in fresh air, combined with listening to music, learning about plants and animals, or visiting an art gallery. Above all they offered the chance to enjoy nature in the company of others. 'A rural retreat', said Olmsted, was an 'essential recreational need in the heart of the city.'[3] Playgrounds and in particular areas for sport were carefully integrated and did not dominate the overall conception. In the words of W.W. Pettigrew, superintendent for twenty years of Manchester's public parks, 'fair balance' was the key issue.[4]

Since the 1920s the increasing demand for more sports facilities has sometimes led to the complete exclusion of ornamental features, as 'unwanted extravagances'.[5] On sites such as Crystal Palace, which now hosts the National Sports Centre (1964), purely aesthetic features continued to be displaced by playing fields, tennis courts, running tracks and so forth. Likewise since the 1930s many of the larger country house parks have been – and are still being – turned into golf courses. A part of Cassiobury Park which Evelyn praised is a golf course, as is Moor Park, once the seat of William Temple. Wollaton, Knole, Sudbrook, Hampton Court, Verulam, Stoke Poges, Goodwood, Repton, Kedelston, Brookman's, Ashridge are other examples of seats whose parks are now partly or totally golf courses. Even the small home park of Stowe succumbed to golf when a nine-hole golf course was laid out in the 1950s.

However, it is not just the bunkers and holes which pose an environmental problem. No longer able to pay for themselves, golf courses increasingly need to be accompanied by a host of subsidiary buildings such as holiday chalets, hotels or conference centres, thus despoiling an even greater acreage of parkland. In addition, the noise pollution generated by such enterprises carries far beyond the confines of the park's acres, especially when clay pigeon shoots or motorbike scrambling are added to

increase revenue. In recent years councils have been inundated with applications for such developments. Aylesbury Vale District Council in Buckinghamshire approved the construction of eleven golf courses on park and agricultural land between April 1989 and March 1990. The English Golf Union wants to build another five hundred by the year 2000.[6] The sports lobby has become by far the most vociferous and powerful of all recreational interests, being represented both by a Council and a Minister.

The ornamental horticulture characteristic of Victorian parks has also gone into decline. Critics of the fashion objected to the garishness of its effects, rather than the use of flowers as such, and it is certainly true that horticulture does not have to mean gaudy flowerbeds. It was horticulture in parks that helped create the modern passion for gardening – surpassed only by watching television and listening to records. Nonetheless in the eyes of the authorities flowers and sports were seen as mutually incompatible, and horticulture has been on the wane since the Second World War. In recent years the government has helped fund a spate of temporary garden festivals – but only in preference to reinstating a policy of planting for existing parks. The original purpose of such festivals, conceived in nineteenth-century Germany, had been precisely to encourage the creation of new urban parks.[7] This still prevails in Germany. Likewise in Holland, the *Floriaden*, a ten-year Dutch garden festival, is held to promote new public green spaces on a permanent basis.

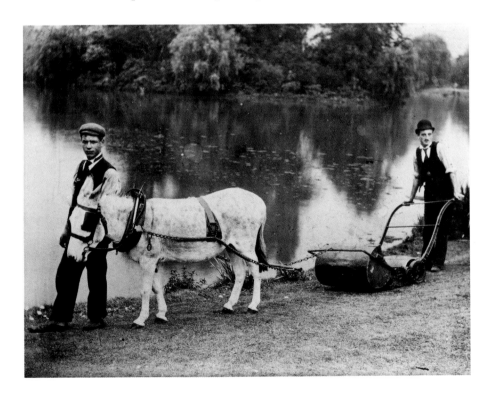

Dulwich Park, 1905. Mowing the grass.

The retreat from horticulture has also led to reductions in park staff, whose presence once gave a reassuring sense of safety to the public strolling among the shrubbery. Without them parks have had to choose between employing more supervisory staff or tearing up shrubberies to prevent evildoers hiding among them, the latter of course being the cheaper and more popular option. Loudon recognised the problem in 1837 when he remonstrated with those who tore up the ancient and overgrown yews and hollies in Kensington Gardens in the name of public decency, saying that 'a few additional policemen would have effectually prevented the commission of these offences than the means resorted to'.[8] Understaffing has also been a casualty of the shift of emphasis to sport rather than 'informal' recreation, especially following the transformation of the Institute of Parks and Recreational Administration, in 1983, into the Institute of Leisure and Amenity Management.[9] At local government level, too, parks departments have lost their autonomy.

The undervaluing of parks has also led to pressure on councils to release parkland for other purposes, notably roads, public housing and private developments. Over the years even such relatively well-kept amenities as London's royal parks have had to bow to the traffic lobby. Hyde Park, for example, has been assiduously nibbled away by road widening. Paradoxically, the more environmentally important a site, the lower the value of its land. A report commissioned by the Friends of the Earth found that the cheapest place to build a motorway is through a public park. Among the victims of such roads are Tring Park, Hertfordshire, and Chillington Park, Kent. Buildings once both useful and ornamental have too often become, like the Cake House in St James's Park, 'a litter bin for fast food and totally inappropriate to the character and use of the park', in the view of one critic.[10] Indeed the increasing number of artefacts and buildings in London's parks — six hundred in St James's Park alone, and the greater number in the last fifty years — is cause for concern.[11] With open space at an unprecedented premium, the case for any new building, or even sculpture, in parks, calls for more circumspect consideration than ever. When it was proposed to build a permanent theatre in Battersea Park, thus diminishing the acreage of landscape, the plan was cancelled largely in response to public protest — an encouraging sign of the awakening interest in preserving our green spaces.

Apart from those in the New Towns, few parks of any size have been created since the Second World War. Of these, two of the most ambitious are in London, Mile End Park and Burgess Park, in the borough of Southwark, the latter on the scale of the great enterprises of the Victorian era. Unfortunately, over forty years since its commencement, it is still incomplete. An under-used, under-planted, windswept prairie, it plays into the hands of those who say that the traditional park is obsolete. For all that, it is still a green, open space in the middle of a built environment

and, as such, a rare asset. With careful planning, the potential is there for a beautiful naturalistic environment large enough to accommodate a variety of interests both active and passive. For those who live in the giant housing scheme around it, Burgess Park could give immense pleasure as a place to relax. Its development is now the responsibility of Southwark Council, who aim to achieve just this, under a five-year plan in which the Department of the Environment will play a 'pivotal role'.[12] Will the money be forthcoming?

In contrast – though no better as a model for the future – is the Parc de la Villette, the first major public park in Paris since Haussmann. It was created by the architect Bernard Tschumi as an 'active' park – a synthesis of 'cultural pursuits and leisure' in which the tradition of *rus in urbe* has been wholly rejected. This rejection is based on the belief that in a modern city the 'time-honoured prototype of a park as an image of nature' is now invalidated'.[13] Such a banishment of 'nature' has resulted however in

Sheep leaving Hyde Park, c.1950.

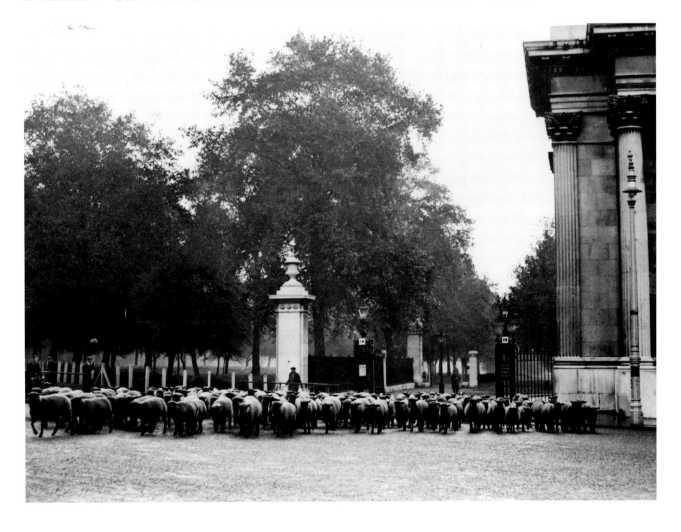

an arid environment that offers no relief from the harshness of the surrounding city. It embodies a viewpoint directly challenged by the experience of such a modern city as Athens, which without its oasis-like park would be insupportable. The Parc de la Villette may be a designer's paradise, but it cannot satisfy the enduring needs of contact with nature and sanctuary for contemplative enjoyment, offered by a well-designed, well-kept traditional park. If nothing else, it should make us re-evaluate what we have in Britain, even Burgess Park. Fortunately, the Park de la Villette is not typical. Unlike England, France has an enlightened parks programme based on public patronage which is restoring and rejuvenating existing 'landscape' parks while providing new ones – and not just in Paris, but throughout the country. Paris alone has acquired one hundred and two new *espaces verts* – parks, gardens and squares – since 1977, all under the mayor Jacques Chirac and his right-wing Rassemblement Pour La République party.[14]

Parks also play a large part in Barcelona's massive programme to 'monumentalise' the old city and its twentieth-century suburbs. Described as a 'hive of park-making',[15] Barcelona sees parks as the means to humanise its environment. Once again the continent leads in providing green public spaces in a civic context.

Contrary to the preconceptions of planners, recent surveys largely support the nineteenth century's recognition that most people want informal recreation in contact with nature. Ruth Glass, reporting for the LCC, stated that eighty-six per cent prefer passive enjoyments such as sitting or walking, and as Tony Aldous writes, 'it is belatedly recognised that the urban population craves rural recreation',[16] that visiting the countryside is second only in popularity to gardening. A recent survey by the Countryside Commission discovered that organised sport engaged only seven per cent of the population, whereas nineteen per cent preferred walking, eighteen per cent drives, outings and picnics, and twelve per cent informal sports. For many town dwellers, the Green Belts provide accessible countryside; but as Loudon realised, some cannot reach them, whether through lack of transport, money or time. Slices of rural landscape within the city are accordingly all-important. They provide a surrogate 'day in the country'; a contact with nature and a way of marking the changing of the seasons. Even using a park as a thoroughfare has a restorative effect, giving escape from the 'hustle and harassment'[17] of the city and the roar of traffic. In *The Ungreen Park, The Diary of a Keeper*, Gill Brason makes a touching tribute to city parks which should be read by anyone who thinks such places have had their day. She speaks for many when she describes her feelings on visiting Regent's Park: 'Entering the park makes me gasp with pleasure. Everywhere is so green and time has so blissfully stood still ... My pace slows, all my anger and aggression gone'.[18]

One of the great pleasures a park can offer is looking at other people in a relaxed context. 'Seeing and being seen' was identified by Pepys over three hundred years ago as the essence of a town park, and in the USA it has been said that 'People watching is now a national sport'.[19] Modern design too often clutters parks with objects to look at; sculpture, fountains, decorated buildings – anything but people. As Sir James Bird wrote in 1924, 'Parks should provide what the city cannot. They do not need to supply organised entertainment when situated in a city where it is freely available.'[20]

Space in which to make one's own entertainments is another under-rated amenity of the park, perhaps the most important it can offer us today. It is hard to think of anywhere that contains such a variety, in planners' terms, of 'informal' and 'unstructured' behaviour, all happening simultaneously. People can be seen playing with children, chatting to friends, reading, communing with nature, admiring the flowers when there are any, walking, jogging, practising karate, limbering up,

Overleaf
Park sketches: Susan Lasdun.

Holland Park, 1958.

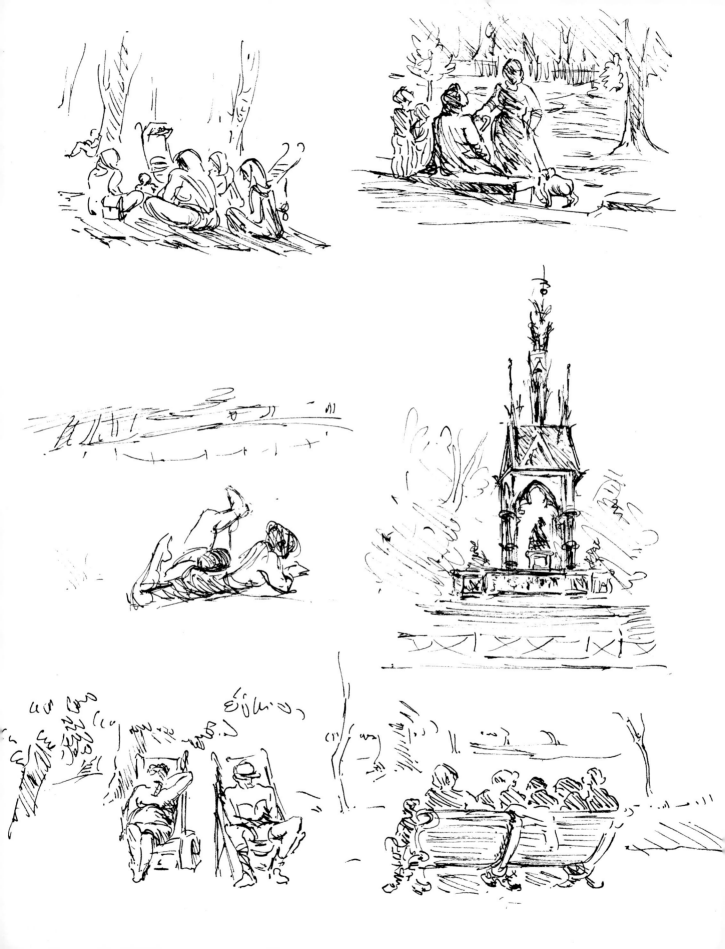

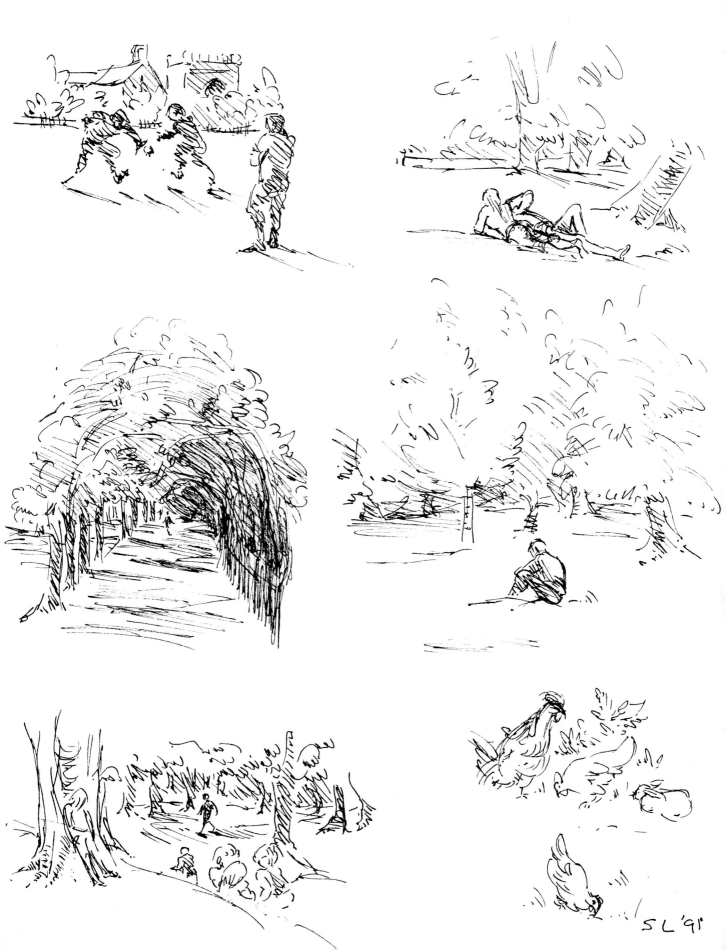

SL '91

sunbathing, sleeping, sailing toy boats, flying kites, kicking a ball, picnicking, talking to themselves or to the birds, walking a dog, declaiming poetry or learning out loud – or simply sitting on a bench and watching the world go by. As one commentator has put it, 'The park is a theatre, each activity a stage.'[21]

Parks need people and people need to see one another to feel secure. Whenever they have the choice they place themselves at comfortable distances from one another – not close enough to disconcert but seldom very far off either – whether they are watching a game or simply lying on the grass. At the cost of making the outsider feel an intruder, regular users of a park often lay claim to a particular area. In Hyde Park and Kensington Gardens before the war, the fashionable world, nannies with their charges, and even meths drinkers, each staked out their particular territory, separated from the others by an imagined line.

Over recent years appreciation of the informal, naturalistic elements of city parks seems to be returning, as environmentally concerned groups proliferate. On a national level such groups now have a political voice, through the Green Party. The government itself has commissioned a number of reports on open spaces, among them 'The Barriers to the

'Our Homeless Poor', St James's Park, 1887. Henry James called London's parks 'the drawing rooms of the poor'. Little has changed.

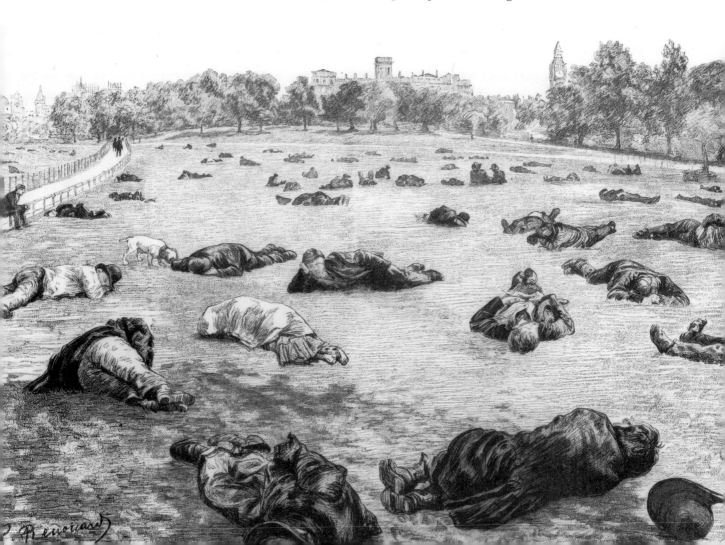

Provision and Protection of Open Space', which seeks ways of bringing people back to the inner cities. The surveys of the royal parks quoted in this book are encouraging signs of concern from the central authorities. At a local level the dozens of voluntary organisations springing up wherever the environment is threatened, confirm that the pastoral yearnings of the city dweller are still there. Recent innovations include city farms and city nature reserves, which have led to the making of small informal parks like London's Camley Street, on two acres in Camden, and the nearby Gillespie Park, in Islington. There are now more than three hundred nature reserves in our cities, most of them on formerly derelict industrial land.

New encouragement for parks also comes from the associations of 'friends' formed to safeguard their interests, and to impose a measure of accountability on those who run them. It was in this way that the plight of Birkenhead Park was first publicised, in 1976.[22] In 1990 'friends' formed the Regent's Park Protection Campaign and successfully fought plans by London Zoo to develop ten acres as a commercial theme park.[23] Friends of Holland Park likewise successfully opposed unwanted encroachments and engaged in a battle with the Thames Water Company, who wished to build a pumping station on 1,300 square metres of what is one of central London's few surviving natural woodlands.[24]

Individual protests have also proved effective. It was one woman's campaign which produced Richmond Council's voluntary 'dog watch' scheme, to control fouling by dogs. In recent years this has been one of the biggest problems besetting park administrators, and one of the most emotive. In the USA legislation has proved successful in forcing dog owners to clear up after their pets, thus raising the issue of whether a similar law might not be the answer in Britain. Given that this is a mainly law-abiding society, the likelihood is that most dog owners would respect such a demand.

There is no national organisation to protect public parks.[25] In London the houses and parks of Marble Hill, Chiswick and Kenwood have been taken over from the GLC by English Heritage – an arrangement that begs the question as to whether they or some similar agency might not take responsibility for other historic public parks or indeed whether all public parks, not just the royal parks, should come under state patronage.

Another solution might be on the lines of that which revitalised Central Park in New York. In the USA parks are a political issue, and their well-being is valued for both environmental and economic reasons. By 1970 it was realised that Central Park had fallen into serious decline. The city government had no funds with which to maintain or restore it; instead a non profit-making alliance, the Central Park Conservancy Trust – drawn from community leaders, members of the business community as well as the city government itself – was formed to halt its deterioration.[26] Funds

raised and administered by the Trust have restored the park, and improved its management. Elsewhere in New York, from Staten Island to the Bronx, other parks are being similarly restored. In Boston, the whole 'emerald necklace' of Olmsted parkland is undergoing a complete restoration funded by a combination of public and private investment. (Interestingly it is an English firm, Cobham Resource Consultants, who are advising on their maintenance.) Several factors have prompted this restoration: popular desire for physical fitness; a growing appreciation of historical landmarks; and a concern for flora and fauna, heightened by the environmental movement. Penalties are imposed on despoilers, but there is faith that the parks' regeneration will have a salutary effect on those who use them, as has been the case in other parks. In Prospect Park, New York, which has had an injection of over seventeen million dollars since 1981, the crime rate has been halved. A recent article in the *New York Times* claims that the future of New York depends as much on grass as on concrete and steel, and that a renaissance is re-invigorating the city's sanctuaries.[27]

Like their city counterparts, some English country house parks have suffered from lack of appreciation, despite the existence of the National Trust. Since the First World War they have too often drifted into decline, to disappear along with the house whose setting they provided. This process was accelerated during the Second World War, when the trees of many parks were felled and pasture was ploughed up in the 'dig for victory' campaign. During the years that followed, taxation and general austerity took a further toll on country houses and their surroundings. Gibside, in what is now called Tyne and Wear, was a post-war casualty of the plough.

Public awareness of the problem was awakened in 1975 by an exhibition at the Victoria and Albert Museum entitled 'The Destruction of the English Country House 1875–1975'. The exhibition's catalogue listed over 450 houses demolished, their parks sold in many cases for the golf courses mentioned above, or for building development. Every Ordnance Survey revision in recent times has shown a reduction in the number of country house parks. Until 1920 there were more parks within a twenty-four mile radius of London than anywhere else in the country. By the 1960s the number in Middlesex had been halved.[28]

Many houses and parks that survive have done so thanks to the National Trust, which began taking over country estates at a time when they were most at risk, in the 1940s. In response to the diminishing number of buildings of outstanding architectural value, in 1969 the listing of such buildings was introduced, together with legislation aimed at preserving them. However, in contrast with France for example, where central government offers statutory protection to certain sites, no listing has ever been introduced in England for private landscape parks or gardens. Obviously, as Marcus Binney, President of SAVE Britain's Heritage, has

'The Park': Victor Pasmore, 1947. Pasmore's distillation of a park, an amalgam of two real parks and the artist's imagination.

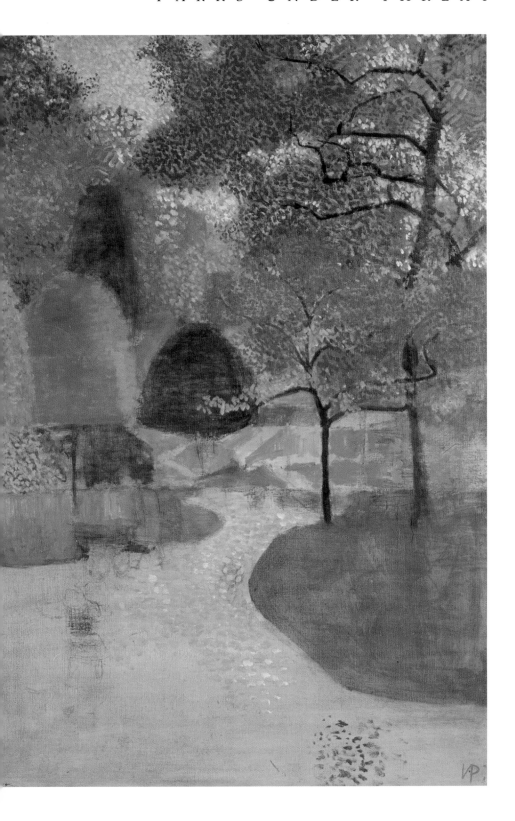

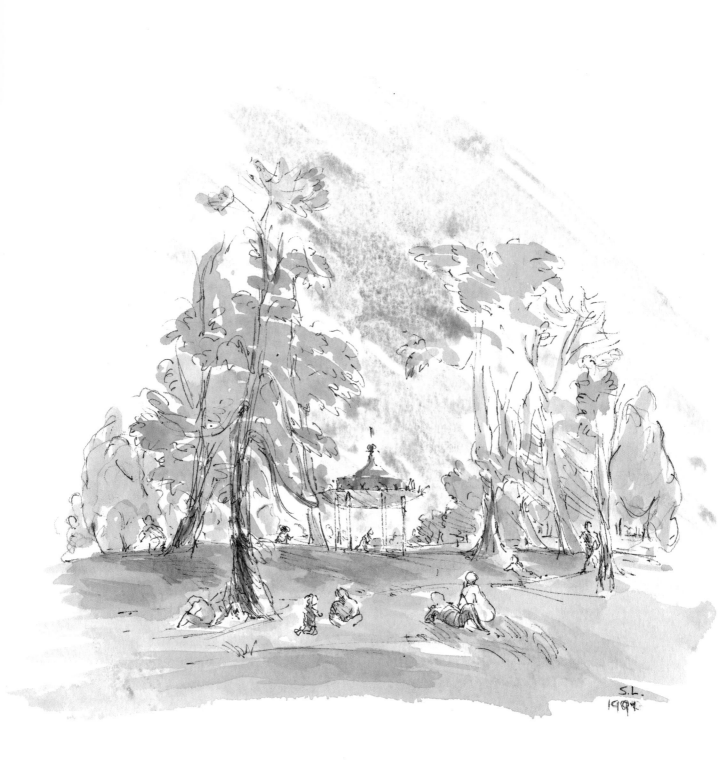

pointed out, listing privately owned parks would impose an intolerable burden on their owners. But in a shrinking countryside their loss is ever more significant. It is to be hoped that somehow they can be offered greater protection than at present.

The great rural English parks were, as we have seen, attempts to create ideal landscapes, often of several hundred acres or more. They offer some of the most beautiful countryside we have, introducing a breadth of scale in magnificent contrast to the intimate landscapes of hedges and fields. The sense of release they convey, as both Addison and Stephen Switzer realised, 'give an altogether exalted kind of pleasure' – one which only 'parks and distant prospects can give'[29] – a none too frequent experience in this small and overcrowded island. For Wordsworth, 'Laying out of grounds, as it is called, may be considered as a liberal art, in some sort like Poetry and Painting; and its object, like that of all the liberal arts, is, or ought to be, to move the affections under the controul of good sense.'[30] Lord Clark claimed landscape parks to be the most influential English artefact. The veteran landscape designer Geoffrey Jellicoe asked why such parks might not fill the same metaphysical role today as medieval cathedrals. Yet despite such acknowledgements of their unique value, there is no national landscape policy to ensure their survival.

There are signs however that the environmental lobby has injected public consciousness with a new sense of responsibility towards countryside and urban green spaces alike. For country parks the tide may be turning, as it perhaps already has for their urban counterparts. The Countryside Commission has now designated twenty-two per cent of land in England and Wales as areas of outstanding beauty or – stretching the term 'park' to designate something vaster and more nebulous than anything included in this book – as National Parks, to act in some sense as an extension to the nation's urban and country house parks. It also gives grants for the restoration of existing parks to which the public have access. For the first time, too, a register of historic parks and gardens, with over a thousand entries, has been completed, commissioned by English Heritage.

One of the most encouraging of park restorations is currently under way at Painshill Park in Surrey. Once again, this is being done on the initiative of an organisation of 'Friends' though it is also an outstanding example of council enterprise. Painshill had survived many owners until, in 1948, it was sold off in speculative lots. Determining to save it, a local pressure group persuaded Elmbridge Borough Council to buy back what remained of the land. Over a number of years this object was achieved, and in 1981 an independent trust was formed. Under the trust's director Janie Burford, a landscape architect, this great park is to be restored and opened to the public.

Other encouraging signs are the National Trust's purchases of Calke

The Bandstand in spring, Kensington Gardens, 1991: watercolour sketch, Susan Lasdun.

Abbey – principally to save its remarkable park – and Stowe, for whose restoration a £1 million appeal has been launched. An exciting attempt is also being made to reclaim Gunton Park, in Norfolk. Consisting at one time of an estate of seventeen thousand acres with a park of seventeen hundred acres which still bears the mark of Bridgeman, Repton and William Sawrey Gilpin (1761–1845), it too had been sold off in lots and was in multiple ownership. The architect Kit Martin, who bought and undertook the restoration of Gunton's historic mansion, began buying back the land wherever possible, and restoring the park, initially without resort to public money; at the time financial aid depended on all the owners agreeing to public entry. However, since the disastrous storm of 1987 attitudes have changed, and grant-aiding bodies such as English Heritage and the Countryside Commission are now contributing financially to its restoration, and a great tree-planting scheme is under way.

Five years ago, such help was inconceivable. Perhaps it is a pointer to a better future; perhaps the day will come when we will have enlightened patronage comparable with those parts of Europe where national policy is rejuvenating existing parks and creating new ones. While the Department of the Environment is the custodian of the Royal parks, it is the National Trust which has increasingly become the prime saviour of private parks. Through its ownership, the continued care of these once private landscapes is not only ensured, but also public access to them is now, for the most part, freely available – in both senses of the word.

Would that an equally happy solution could be found to the problem of caring for our too often neglected civic parks. As the nineteenth-century reformers recognised, tranquil havens are an essential for the well-being of those who live in cities. Today, it is up to the city dweller himself to safeguard their survival. Vigilance and concern not to lose his inheritance are probably the most effective means by which to ensure this and rouse public authorities to seek a solution. At least vigilance and concern have been awakened.

Jak's cartoon for the *Evening Standard*, May 3, 1990. Prompted by the heatwave during the local elections, Jak's cartoon expresses more succinctly than any words just what people really want from their parks.

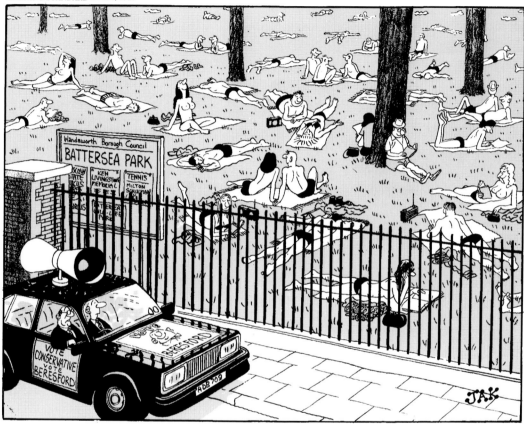

"Bloody weather! That could be our majority lying out there!"

NOTES TO CHAPTER 1

1 M. L. Gothein, *A History of Garden Art* (2 vols, J. M. Dent, 1928), vol. 1, p. 66.

2 J. Reade, *Assyrian Sculpture* (British Museum Publications, 1983), p. 36.

3 Greek – *paradeisos*: Christian Latin – *paradisus*. First used by Xenophon of the parks of Persian kings and nobles. In Avestic it was *pairadaēza*.

4 M. L. Gothein, *op. cit.*

5 Wu Hung, 'A Sanpan Shan Chariot Ornament and the Xiangrui Design in Western Han Art', from *Archives of Asian Art* (vol. XXXVII, 1984), p. 39.

6 *Records of the Grand Historian of China*, trans. from the *Shih Chi* of Ssu-Ma Chien by Bourton Watson (vol. 2, Columbia University Press, 1961).

7 I. Jenkins, *Athletics and Society in Ancient Greece* (British Museum Education Service, 1), p. 9, quoting J. Delorme, *Gymnasion: Etudes sur les monuments consacrés à l'éducation en Grèce*, Paris 1960.

8 Ibid., p. 10, translating *The Clouds* lines 1005–8.

NOTES TO CHAPTER 2

1 O. Rackham, *Ancient Woodland* (Edward Arnold, 1980), pp. 191, 197. *Deor* (O.E.) = deer: *hay, haie* (O.Fr.) or *hag* = an enclosure; also Latin *parcus*, translated in Saxon as *deor fald*. O. G. S. Crawford, *Archaeology in the Field* (Phoenix House, 1953), p. 191, suggests that the *deor falds* in Anglo-Saxon charters were parks.

2 *Dyrham Park* (National Trust, 1978), p. 34.

3 L. Cantor (ed.), *The English Medieval Landscape* (Croom Helm, 1982), p. 81. In contrast O. Rackham, in *Ancient Woodland*, has computed that there were over 3,200 parks.

4 O. Rackham, *op. cit.*, p. 193.

5 C. Hart, *The Vederers and the Forest Laws of Dean* (David and Charles, 1971), p. 36. Boars were still hunted in Windsor in 1617. The last recorded wild boar to be killed was said to be as late as 1676 in Cannock Chase.

6 G. Astill and A. Grant (eds), *The Countryside of Medieval England* (Basil Blackwell, 1988), pp. 144–5.

7 W. Smith-Ellis, *The Parks and Forests of Sussex* (H. Wolf, 1885), p. 54.

8 *Ministers' Accounts of the Manor of Petworth*, vol. 55 (1347–53; Sussex Record Society), Introduction.

9 R. W. Carter, *Parish Surveys in Somerset: Whitestaunton* (Somerset Archaeological and Natural History Society, 1981).

10 J. M. Robinson, *The English Country Estate* (Century/National Trust, 1988), p. 23.

11 M. Baxter Brown, *The History of a Royal Deer Park* (Robert Hale, 1985), Introduction.

12 Rev. W. J. B. Kerr, *Higham Ferrers and its Ducal and Royal Castle and Park*, quoting the Inquest Post Mortem at Higham Ferrers, 1299 (R. Harris & Son, 1925), p. 33.

13 Ibid. p. 33.

14 O. Rackham, *op. cit.*, p. 181.

15 J. M. W. Bean, *The Estates of the Percy Family, 1417–1537* (Oxford University Press, 1958).

16 A. Briggs, *A Social History of England* (Weidenfeld and Nicolson, 1987), p. 55.

17 Sir H. Ellis, *A General Introduction to Domesday Book* (2 vols, Public Commission of Public Records, 1833), vol. 1, p. 231.

18 N. Hone, *The Manor and Manorial Records* (Methuen, 1912), p. 357.

19 G. M. Trevelyan, *English Social History* (Longman, Green, 1944), p. 59.

20 S. J. Madge, *The Domesday of Crown Lands* (George Routledge & Sons, 1938), p. 254.

21 O. G. S. Crawford, op. cit., pp. 190–1.

22 M. Beresford, *History on the Ground* (Lutterworth Press, 1957), p. 220.

23 Ibid., p. 216.

24 L. Cantor, op. cit., p. 76.

25 H. M. Colvin (ed.), *The History of the King's Works* (6 vols, HMSO, 1963), vol. 1, p. 81.

26 Ibid., vol. 2, p. 910.

27 Ibid., vol. 1, p. 244.

28 PRO, *Calendar of the Close Rolls 1468–76* (vol. 2) (HMSO, 1953), No. 209, p. 55.

29 Ibid., No. 1408, p. 392.

30 L. Cantor, *The Medieval Parks of England, A Gazetteer* (Loughborough University, 1983), p. 3.

31 S. J. Madge, op. cit., p. 165.

32 J. R. Harvey, *Deer Hunting in Norfolk from the Earliest Times* (Norwich, 1910).

33 O. Rackham, op. cit., quoting W. de G. Birch, 1885–93; and C. Platt, *Medieval England* (Routledge & Kegan Paul, 1978).

34 L. Cantor, *Medieval Parks of England, A Gazetteer*, op. cit., p. 3; O. G. S. Crawford, op. cit.

35 O. Rackham, *Trees and Woodland in the British Landscape* (J. M. Dent, 1976), p. 116.

36 O. G. S. Crawford, op. cit., p. 194.

37 The park was granted to John of Gaunt in 1370 by his father Edward III who also had a hunting lodge there, which John of Gaunt enlarged, calling it the Palace at Notlye (Nutley).

38 W. Heneage Legge, 'Forestry', in the *Victoria History of the County of Sussex*, vol. 2, pp. 316–18. 'A Survey of the mannr of Duddleswell & The Great Park of Lancaster' refers to the '... impal'd parke ancently devided into three wards'.

39 Rev. W. J. B. Kerr, op. cit., p. 151: 'The entire circuit of the Park extending to a little over three and a half miles was fenced by a ditch and dead hedge.'

40 J. Whitaker, *A Descriptive list of the Deer-Parks and Paddocks of England* (Ballantyne, Hanson & Co., 1892), p. 6.

41 R. Trevor-Davies, *Documents of Medieval England* (Barnes & Noble Inc., 1926), rep. 1969, p. 59.

42 E. P. Shirley, *Some Account of English Deer Parks* (John Murray, 1867), p. 16.

43 Ibid., p. 105.

44 *Cannock Chase* (District Council Official Guide).

45 O. Rackham, op. cit., *Ancient Woodland*, p. 181.

46 T. Rowley, *The Making of Britain: 1066–1200, The Norman Heritage* (Routledge & Kegan Paul, 1983).

47 J. J. Norwich, *Kingdom of the Sun* (Longman, 1970) pp. 156–7.

48 H. M. Colvin, op. cit., vol. 2, p. 1016.

49 Ibid., vol. 1, p. 86.

50 Ibid., vol. 2, pp. 1016–17.

51 J. Harvey, 'The Medieval Garden before 1500', from *The Garden* (ed. J. Harris; New Perspectives Publishing Ltd, 1979), p. 8.

52 Ibid., p. 8.

53 J. M. Robinson, op. cit., p. 22.

54 *O.E.D.* In Law, 'A woodland district, usually belonging to the King, set apart for hunting wild beasts and game, etc., having its own laws and officers, ME'.

55 J. R. Harvey, op. cit.

56 K. Thomas, *Man and the Natural World* (Allen Lane, 1983), p. 200. According to W. Hoskins in *The Making of the English Landscape*, by the time of Henry II one third of England was royal forest.

57 Clause 47 of Magna Carta read at Runnymede.

58 W. H. Holdsworth, *A History of English Law*, vol. 1 (Methuen, 1922), p. 102.

59 S. J. Madge, op. cit., p. 26.

60 The numbers of requests for licences in the Close Rolls of the period reveal this.

61 A. Madden, *A Chapter of Medieval History* (John Murray, 1924), p. 14.

62 Ibid.

63 E. P. Shirley, op. cit., p. 15.

64 G. E. Mingay, *The Gentry* (Longman, 1976), p. 33.

65 K. Thomas, op. cit., p. 49.

66 Ibid., p. 184. Richard Cobden denounced hunting for this reason.

67 J. R. Harvey, op. cit.

68 E. P. Shirley, op. cit; quoting Maddox, *History of the Exchequers*, vol. 1, p. 557.

69 M. Beresford, op. cit., p. 193.

70 H. S. Bennet, *Life on the English Manor* (Cambridge University Press, 1937), p. 59.

71 M. Beresford, op. cit., p. 195.

72 W. G. Hoskins, *Heritage of Leicestershire* (City of Leicester Publicity Department Publicity Bureau, 1950), p. 60.

73 V. Sackville-West, *Knole and the Sackvilles* (Heinemann, 1923), p. 24.

NOTES TO CHAPTER 3

1 W. G. Hoskins, *The Making of the English Landscape* (Hodder & Stoughton, 1955), p. 126.

2 *The Domesday of Enclosures; 1517–1518* (Ed.) I. S. Leadham. 2 vols. vol. 1. For The Historical Society (Longman, Green, 1897), pp. 81–3.

3 S. T. Bindoff, *Tudor England* (Penguin Books, 1950), p. 29. Two dukes were 'demoted', one in 1477 and one in 1499, for not having sufficient land.

4 G. M. Trevelyan, *English Social History* (Longman, Green, 1942), p. 131.

5 Quoted in W. Smith-Ellis, op. cit. 'The Northumberland Household Book' 1512, p. x.

6 Richard II destroyed the medieval manor of Sheen which was rebuilt and became Henry VII's favourite palace until destroyed by fire in 1497.

7 Travers Morgan Planning, *Royal Parks Historical Survey: Hampton Court and Bushy Park* (Department of the Environment, 1981).

8 Ibid.

9 Ibid.

10 Quoted in J. C. Loudon, *An Encyclopaedia of Gardening* (Longman, Brown & Green, 1850), p. 238. First published 1822.

11 L. Munby, *The Hertfordshire Landscape* (Hodder and Stoughton, 1977), p. 142.

12 Ibid., p. 134.

13 N. T. Newton, *Design on the Land* (Belknap Press/Harvard University Press, 1971), p. 184.

14 S. T. Bindoff, op. cit., p. 114.

15 *Guide to Parham*, 1986.

16 *The Victoria County History, A History of Wiltshire* (ed. D.A.Crowley) Vol. 10. (Oxford University Press, 1980) p. 189. The manor was granted in 1544. Sir William Herbert was created first Earl of Pembroke in 1551.

17 G. E. Mingay, op. cit., p. 4. Denney was subsequently appointed first keeper of Marylebone Park.

18 Sir Francis Bacon, *The Essayes or Counsels Civill and Morall* (ed. Michael Kiernan; Clarendon Press, 1985), p. 277.

19 D. Burnett, *Story of a Country House* (Collins, 1970), pp. 15 and 20.

20 W. Harrison, *The Description of England* (ed. Georges Edelen; Cornell University Press, 1968), p. 118.

21 G. M. Trevelyan, op. cit., p. 162.

22 A. Briggs, op. cit., p. 118.

23 M. Beresford, op. cit., p. 211.

24 *Richard II*, Act III, Scene 2.

25 J. Leland, *The Itinerary* (ed. L. T. Smith; G. Bell & Sons, 1907).

26 M. Girouard, *Life in the English Country House* (Yale University Press, 1978), p. 106.

27 D. Defoe, *A Tour Thro' the Whole Island of Great Britain* (2 vols, Peter Davies, 1927), vol. 2, pp. 508–9.

28 Sir P. Sidney, *Countess of Pembroke's Arcadia* (ed. J. Robertson; Clarendon Press, 1973), p. 6, lines 10–15.

29 W. G. Hoskins, *Social and Economic History of England: The Age of Plunder* (Longman, Green, 1976), p. 140.

30 *DNB* (ed. S. Lee; Smith Elder, 1898), vol. 3, p. 858, s.v. *Stafford*.

31 *Topographical Dictionary of England* (ed. S. Lewis; 7th ed. S. Lewis, 1899), vol. 2, p. 392. An Act of Parliament was passed in 1538 to make and enclose Hampton Court Chase.

32 *Cal. of Henry VIII*, vol. 1, quoted in Land Use Consultants, *Royal Parks Historical Survey: Hyde Park* (DOE, 1982).

33 C. Read, *Lord Burghley and Queen Elizabeth* (Jonathan Cape, 1960), p. 121. Like many of his contemporaries he chose the site for its proximity to the three royal houses of Hatfield, Enfield and Hertford Castle, and also like these, for its closeness to London (unlike his seat at Stamford). In this he continued a trend begun in the fourteenth century.

34 L. Stone, *The Crisis of the Aristocracy 1558–1641* (Clarendon Press, 1965), p. 451.

35 C. Read, op. cit., p. 121, quoting *The Victoria County History*.

36 Ibid., p. 122.

37 Ibid., p. 123.

38 Land Use Consultants, *Royal Parks Historical Survey: St James's Park* (DOE, 1981), p. 8; ibid., *Hyde Park*, p. 9.

39 B. W. Beckinsale, *Burghley – A Tudor Statesman* (Macmillan, 1967), p. 263.

40 E. S. Hartshorne, *Memorials of Holdenby* (Robert Hardwicke, 1868), p. 17.

41 Ibid., p. 15.

42 Quoted in ibid., pp. xxxii–xxxiii.

43 A. Boorde, *Advice on building a house* (ed. F. J. Furnivall. *Introduction and Dietary* (EETS, e.s. X, 1870), pp. 232–42.

44 Ibid. and G. Markham, *A Way to get Wealth*, 13th edn (G. Sawbridge, 1676).

45 S. Switzer, *Ichonographia Rustica* (1st edn 1718; 3 vols, printed for J. & J. Fox, 1742), vol. 1, p. 273.

46 R. Strong, *The Renaissance Garden in England* (Thames & Hudson, 1979), p. 125.

47 W. Harrison, op. cit., pp. 253–5.

48 L. Stone, *The Crisis of the Aristocracy, 1558–1641* (Oxford University Press, 1965), p. 674.

49 R. Blome, *A Gentleman's Recreation*, pt 1 (first pub. 1686), 1709. Blome was a compiler of anecdotes of different periods.

50 Sir F. Bacon, op. cit., 'Of True Greatness of Kingdom', p. 97.

51 Ibid., 'Of Building', p. 135.

52 A. Boorde, op. cit.

53 H. M. Colvin (ed.), *The History of the King's Works*, op. cit., vol. 2, p. 258.

54 Sir F. Bacon, op. cit., 'Of Gardens', p. 139.

55 K. Thomas, op. cit., p. 202.

56 D. Defoe, op. cit., vol. 1, p. 303.

57 Quoted in W. Smith-Ellis, *The Parks and Forests of Sussex*, op. cit., p. 56.

58 Sir F. Bacon, op. cit., p. 285; D. Jacques, *Garden History*, vol. 17, No. 1, 1989; B. Lambert, *The History & Survey of London & Its Environs* (4 vols, printed for T. Hughes, 1806), vol. 2, p. 539.

59 A. S. Barrow, *Monarchy and the Chase* (Eyre & Spottiswood, 1948), p. 59.

60 R. Blome, op. cit.

61 E. P. Shirley, op. cit., p. 37.

62 J. Dye, *The Decline of the Deer Parks* (unpublished MA study on Norfolk deer parks, University of East Anglia), p. 16.

63 K. Thomas, op. cit., p. 59.

64 M. Baxter-Brown, *Richmond Park: The History of a Royal Deer Park* (Robert Hale, 1985), p. 18.

65 T. Williamson and L. Bellamy, *Property and Landscape* (George Philip, 1987).

66 W. Harrison, op. cit., pp. 255–6. It remained illegal to sell game until 1831.

67 W. Smith-Ellis, op. cit., p. 63.

68 K. Thomas, op. cit., quoting *The Victoria County History*, vol. 2, p. 349.

69 M. Beresford, op. cit., 190.

70 E. Kerridge, *Agrarian Problems in the Sixteenth Century and After* (George Allen & Unwin, 1969), p. 102.

71 Ibid.

NOTES TO CHAPTER 4

1 F. Moryson, *An Itinerary: containing his ten years travell through twelve dominions*, divided in 3 pts (J. Beale, 1617), pt 3, p. 147.

2 W. G. Hoskins, *The Making of the English Landscape* (Hodder & Stoughton, 1955), p. 131.

3 J. Charlton, *The Queen's House, Greenwich* (HMSO/DOE, 1976).

4 Travers Morgan, op. cit.

5 S. J. Madge, op. cit., p. 49. The 'Instrument and Schedules of Annexation' of 1609 lists 117 parks, whereas the British Museum Add. Ms 38444 lists 104 parks.

6 J. Smyth, *Lives of the Berkeleys* (3 vols, printed by J. Bellows, 1885), vol. 2, p. 285.

7 L. Stone, op. cit., pp. 302–3.

8 J. Dye, op. cit.

9 L. Stone, op. cit., p. 303.

10 R. Carr, *English Foxhunting, A History* (Weidenfeld & Nicolson, 1976; rev. 1986), p. 23.

11 H. St John Mildmay, *A Brief Memoir of the Mildmay Family* (The Bodley Head, 1913), p. 79: diary entry for 1 May 1635.

12 L. Stone, op. cit., p. 397.

13 *Stuart Royal Proclamations* (eds J. Larkin and P. I. Hughes; Clarendon Press, 1973), vol. 1. There were nine Proclamations between 1614 and 1627 in an effort to stop the growth of London.

14 G. Williams, *The Royal Parks of London* (Constable, 1978), p. 67.

15 J. Larwood, *The Story of the London Parks* (Chatto & Windus, 1881), pp. 17–18.

16 Ibid., p. 18.

17 D. V. Jones, *The Royal Town of Sutton Coldfield* (Westwood Press Publication, 1973), p. 26. Sutton Coldfield was first emparked in 1298 by Robert Tateshale, Earl of Warwick (PRO, Cal. IPM. 111, 376).

18 *Stuart Royal Proclamations*, op. cit., vol. 2, no. 236, pp 553–4.

19 Land Use Consultants, op. cit., *Hyde Park*, p. 123.

20 A. Briggs, op. cit., p. 126, quoting a foreign ambassador.

21 D. Defoe, op. cit., vol. 1, p. 146.

22 Sir F. Bacon, op. cit. (5 August 1616 XIII.5), p. 277.

23 R. Strong, op. cit., p. 156.

24 O. Rackham, *The Last Forest* (J. M. Dent & Sons, 1989), p. 80, and L. Cantor, *The Medieval Parks of England*, op. cit., p. 38.

25 L. Munby, *The Hertfordshire Landscape* (Hodder & Stoughton, 1977), p. 151.

26 *Voyage to England with observations on Sorbière's Voyage to England* by J. Sprat (1709), p. 64. Sorbière's voyage was undertaken between 1665 and 1668.

27 Ibid.

28 André Mollet was to design the royal park and gardens of Wimbledon Palace for Queen Henrietta Maria bought for her by Charles I in 1639 and originally built by Sir Thomas Cecil in 1588.

29 L. Munby, op. cit., p. 151.

30 M. Girouard, *Robert Smythson and the Elizabethan Country House* (Pothecary Ltd, 1983), p. 97.

31 R. Strong, op. cit., p. 136.

32 S. J. Madge, op. cit., p. 103.

33 Ibid., p. 79.

34 Ibid., see p. 175.

35 Ibid., p. 254.

36 Travers Morgan, op. cit.

NOTES TO CHAPTER 5

1 E. P. Shirley, op. cit., p. 112. The man was the son of a Dr Peyton.

2 A. Briggs, op. cit., p. 144.

3 T. Williamson and L. Bellamy, op. cit., p. 122.

4 A. Briggs, op. cit., p. 144.

5 *The Diary of Samuel Pepys, Esq. F.R.S.* (Frederick Warne, n.d.), p. 94: entry for 25 February 1662.

6 Pepys, op. cit., p. 274: entry for 24 January 1665.

7 *The Diary of John Evelyn* (3 vols, Macmillan, 1906), p. 269: entry for 11 January 1690; and J. Evelyn, *Sylva or a Discourse of forest Trees* (2 vols, Arthur Doubleday, reprint of 1960; 4th edn), vol. 2, p. 246.

8 J. Evelyn, *Diary*, op. cit., p. 367: entry for 26–27 November 1704.

9 L. G. Carr Laughton and V. Heddon, *The Great Storm of 1703* (P. Allan, 1927), p. 75.

10 Ibid.

11 J. Addison, *The Spectator*, No. 583 (ed. D. F. Bond; Clarendon Press, 1965), p. 593: 20 August 1714.

12 J. Evelyn, *Diary*, op. cit., 1664, p. 209.

13 J. Evelyn, *Sylva*, op. cit., vol. 1, p. 98.

14 Ibid., vol. 2, p. 13.

15 K. Thomas, op. cit., p. 203. Thomas quotes Leland on the 'pleasures of orchards' and notes the vast amount of fruit trees planted in the ensuing century and a half.

16 J. Evelyn, *Sylva*, op. cit., vol. 2, p. 178.

17 C. Hussey, *English Gardens and Landscapes, 1700–1750* (Country Life, 1967), p. 15. Evelyn's idea began an era of rural improvement.

18 J. Evelyn, *Sylva*, op. cit., vol. 2, p. 157.

19 L. Magalotti, *Travels of Cosmo the Third, Grand Duke of Tuscany through England, c. 1669* (J. Mawman, 1821), p. 141. Cosmo described the circumference of the park as being 'surrounded by a thick row of trees, between each of which is a terrace of turf; and where the trees begin to shoot out branches; these, intertwined together, form, along with the earth of the terraces, a fence of the strongest description'.

20 J. Evelyn, *Diary*, op. cit., p. 332: entry for 16 October 1671.

21 Ibid.

22 C. Hussey, op. cit., p. 155. Evelyn's method of bringing the park closer was to plant avenues.

23 *The Journeys of Celia Fiennes* (Cresset Press, 1947), pp. 39–40.

24 T. Baskerville, *An Account of some Remarkable Things in a Journey between London and Dover*, Portland Mss. vol. 2 (Eyre & Spottiswoode, 1893), pp. 276–81.

25 M. L. Gothein, op. cit., vol. 2, pp. 83–4, as described by Louis XIV in the guide to Versailles which he wrote himself.

26 D. Defoe, *A Tour of Great Britain* (2 vols; Peter Davies, 1927), vol. 1, p. 176.

27 D. Clifford, *A History of Garden Design* (Faber & Faber, 1952), p. 96.

28 P. Willis, *Charles Bridgeman and the English Landscape Garden* (Zwemmer, 1977), p. 91.

29 N. T. Newton, op. cit., p. 156.

30 M. Girouard, *Cities and People* (Yale University Press, 1985), p. 166.

31 J. Evelyn, *Diary*, 1 May 1661. The Ring remained a favourite venue until its demise in 1730.

32 Travers Morgan, op. cit.

33 J. Evelyn, *Diary*, pp. 223–4: entry for 9 February 1665. Though the canal at St James's Park preceded that of Versailles, the idea of such a canal no doubt came from there.

34 The avenues between the canal and the Decoy ended on a semi-circular double avenue – a *patte d'oie* at the Whitehall end near the tilt yard. Double avenues were added later on the line of Birdcage Walk and the Mall, laid out in a radiating pattern springing from the *patte d'oie* at the Whitehall end (see Land Use Consultants, op. cit., *St James's Park*, pp. 8 and 67: the Report noted Kip's view of the *patte d'oie* in 1700). These avenues formed the principal entrance to the park at what is now called the Horse Guards Parade, the intention being to open up vistas into the park. The Mollets laid out the four avenues which lined the canal. John Rose succeeded the Mollets as royal gardener to Charles II in 1666.

35 Formerly played on the site of what is now called Pall Mall, its name deriving from this fact.

36 E. Waller, *Poems of Edmund Waller: On St James's Park, as Lately Improved by His Majesty* (ed. G. T. Drury; Lawrence & Bullen, 1893), p. 170.

37 H. M. Colvin (ed.), *The History of the King's Works*, op. cit., vol. 5, p. 269: Whitehall Palace.

38 Blade skates were introduced at this period when skating was made fashionable by the Cavaliers who

learned to skate in Holland during their exile with Charles II.

39 Land Use Consultants, op. cit., *St James's Park*, quoting *Illustrated London News*, September 1885, says it started with Charles II in 1666.

40 Travers Morgan, op. cit.

41 J. Evelyn, *Diary*, op. cit., 1665, p. 224.

42 Land Use Consultants, *Royal Parks Historical Survey: Green Park*, 1981.

43 P. Willis, op. cit., p. 99.

44 Both the semicircle of land and the lime trees were appropriated from the park and were formed into the Great Parterre or Fountain Garden in c. 1690. The semicircle of limes is shown on a plan dated 1670, illustrated in the Travers Morgan Survey of Hampton Court (figure 4).

45 Travers Morgan, op. cit. See chapter 6, p. 19, para. 6.04 and chapter 6, note 13. There is some conjecture as to the designer and date of the avenue and its semi-circular termination.

46 J. Evelyn, *Diary*, op. cit., 1677, p. 5.

47 Travers Morgan, op. cit.

48 P. Willis, op. cit., p. 94, and Travers Morgan, op. cit. Henry Wise was the partner of George London.

49 *The Anglo-Dutch Garden in the Age of William and Mary* (ed. J. Dixon-Hunt), Taylor and Francis, 1989, p. 216. The design combined French and Dutch elements.

50 H. Walpole, *On Modern Gardening* (1771; *Works*, 5 vols, 1798), vol. 2, p. 544. Walpole seems to have been the first to call the change in taste a revolution, the term by which it has become universally described.

51 K. Thomas, op. cit., p. 209.

52 J. L. Phibbs, 'Wimpole Park, Cambridgeshire' (unpublished survey, 1980).

53 M. L. Gothein, op. cit., vol. 2, p. 116.

54 *The Anglo-Dutch Garden*, op. cit., p. 49.

55 Ibid. p 18, quoting an essay by Erik de Jong on 'Netherlandish Hesperides' Garden Art in the period of William and Mary 1650–1702'.

56 Ibid.

57 C. Fiennes, op. cit., p. 119.

58 *The Anglo-Dutch Garden*, op. cit., quoting T. Turner, *English Garden Design* (Woodbridge, Antique Collectors Club, 1988).

59 Ibid., quoting Walter Harris, *A description of the King's Royal Palace and Gardens at Loo* (London 1699), chapter VII, 'The Park', p. 331. A viver was a quadrangular-shaped pond supplying the fountains and cascades with water.

60 Ibid., p. 153.

61 *Dyrham Park*, op. cit., quoting from *The Diary of Dudley Ryder 1715–1716*.

62 Chatsworth was considerably grander than any palace the king himself possessed in England, which in an earlier era might have been dangerous, as it proved to be for Louis XIV's finance minister Nicolas Fouquet. He lost both his position and his possessions for building himself a palace at Vaux-le-Vicomte more magnificent than his king's.

63 These included Moses Cook, who had laid out Cassiobury for the Earl of Essex.

64 S. Switzer, *Ichonographia Rustica*, op. cit., vol. 1, p. 79.

65 *Felbrigg* (National Trust, 1984), p. 44.

66 Ibid., p. 44.

67 Ibid.

68 J. L. Phibbs, *Felbrigg Park: A Survey of the Landscape*, 1982.

69 J. L. Phibbs, 'Wimpole Park', op. cit.

70 Variety was the catchword of the eighteenth-century garden. Lack of variety was an important factor in the demise of the formal park and garden. See Batty Langley, *New Principles of Gardening*, 1728.

71 A. Marvell, *The Complete Works*. 4 vols, *Poems of the Country: The Mower* (ed. A. B. Grosart; private circulation, 1872), vol. 1, p. 65.

72 Sir W. Temple, *Upon the Garden of Epicurus: or Of Gardening in the year 1685*, in *The Works of Sir William Temple* (4 vols; printed for J. Rivington etc., 1814), vol. 3, p. 238.

73 J. Hadfield, 'Climax of England's Formal Gardens', *Country Life*, 21 June 1973, p. 1820.

74 P. Willis, op. cit., quoting Beat de Muralt, *Letters describing the Character & Customs of the English and French Nations* (2nd edn 1726).

75 S. Pepys, *Diary*, op. cit.

76 D. Defoe, *A Tour of Great Britain*, op. cit.

77 M. Girouard, 'Parades and Promenades', *The Listener*, 13 October 1983, pp. 16–17.

78 Ibid.

79 K. Thomas, op. cit., pp. 203–5.

80 T. Fairchild, *The City Gardener*, (London, 1722).

81 J. Dryden, *Marriage à la Mode*, 1673.

82 M. Girouard, 'Parades and Promenades', op. cit.

83 Report from the Select Committee on Public Walks, 1833.

84 Land Use Consultants, op. cit., *Hyde Park*, p. 13.

NOTES TO CHAPTER 6

1 S. Switzer, *Ichonographia Rustica*, op. cit., vol. 3, p. 9.

2 Earl of Shaftesbury, *Characteristicks, of Men, Manners, Opinions, Times, An enquiry concerning Virtue and Merit, from The Moralists; a Philosophical Rhapsody of Men*, vol. 2, treatise 5, pt 3, section 2 (1758; 1st printed 1709), p. 255.

3 S. Switzer, op. cit.

4 J. Milton, *The Poetical Works* (ed. H. Frowde), *Paradise Lost*, Book IV (Oxford University Press, 1908); H. Walpole, *The Works of Horatio Walpole, Earl of Oxford* (5 vols; 1798), vol. 2, *On Modern Gardening*, pp. 528–9.

5 S. Switzer, op. cit., vol. 3, p. 45.

6 C. Hussey, *English Gardens and Landscapes 1700–1750* (Country Life, 1967), p. 27 and P. Willis, op. cit.

7 National Trust, *Wimpole*, op. cit.

8 A. Pope, *The Works of Alexander Pope* (John Murray, 1881), vol. 3, *Epistle IV*, p. 184.

9 The Kit-Kat Club was founded at the beginning of the eighteenth century by a group of leading Whigs, amongst them Addison, Steele, Congreve and

Vanbrugh, who met in the house of a pastry cook who was famous for his mutton pies called kit-cats – hence the name.

10 J. Addison, *The Spectator* (ed. D. Bond; Oxford University Press, 1965), vol. 3, No. 414, 25 June 1712.

11 Ibid.

12 Ibid.

13 A. Pope, op. cit., vol. 10, *The Guardian*, No. 173, 29 September 1713.

14 S. Switzer, op. cit., vol. 3, p. 45.

15 A. Pope, op. cit., vol. 3, *Epistle IV*, p. 180.

16 K. Downes, *Vanbrugh* (Studies in Architecture, ed. A. Blunt, J. Harris and H. Hibbard, vol. 16; Zwemmer, 1977), p. 109. The first obelisk was raised in 1714. The realisation of Vanbrugh's ideas was helped by his coadjutor Nicholas Hawksmoor who designed such famous landmarks as the Pyramid and the Mausoleum at Castle Howard.

17 Probably P. Willis, op. cit. According to John Harris, Vanbrugh was the first architect to conceive a whole garden or parkscape in a picturesque manner (see 'Diverting Labyrinths', *Country Life*, 11 January 1990).

18 J. Addison, op. cit.

19 J. Harris, 'Diverting Labyrinths', op. cit.

20 Attrib. Lady Irwin, quoted in *The Genius of the Place*, ed. J. Dixon Hunt and P. Willis (Paul Elek, 1975), p. 229.

21 C. Hussey, *English Gardens and Landscapes 1700–1750* (Country Life, 1967), p. 115. Despite his predilection for retaining architectural ruins, Vanbrugh advised Lord Carlisle to pull down the old Henderskelfe Castle on scenic grounds.

22 D. Green, *Blenheim Palace* (Country Life, 1951), quoting Vanbrugh's *Memorandum*, 1709.

23 Though Vanbrugh is credited with being the first person to want to save a ruin for aesthetic reasons, Evelyn in 1675 had also shown his admiration for ruins when he praised those of Holdenby, Sir Christopher Hatton's great house for Queen Elizabeth, which had been destroyed in the Civil War, and which in Evelyn's opinion 'appeared like a Roman ruin, shaded by trees around it, a stately, solemn and pleasing view' (Evelyn, op. cit. vol. 11, p. 383).

24 K. Downes, op. cit., p. 107.

25 P. Willis, op. cit., p. 46, footnote 17. Both this plan and a plan in *Vitruvius Britannicus* have a ha-ha around the kitchen gardens.

26 H. Walpole, op. cit., p. 535.

27 Walpole credits Bridgeman with the ha-ha. However in John James's translation of d'Argenville's book, James writes: 'We frequently make through views, called Ah! Ah!' There was also a moat encircling the outside of the walled garden at Blenheim similar to such ditches.

28 *The Journeys of Celia Fiennes* (ed. C. Morris; Cresset Press, 1947), p. 30. With the accession of George I, Cobham was back in political favour and also soon married to an heiress – no doubt an economic incentive to the revolutionary developments about to be put in hand.

29 B.L. Add. Mss 47030 (Egmont Papers), fos 156–9 quoting Lord Perceval to Daniel Dering, 14 August 1724.

30 S. Switzer, op. cit., vol. 3, p. 45.

31 H. Walpole, op. cit., p. 535.

32 *Historic Manuscripts Commission. (Reports) 42. Carlisle*, 85.

Sir Thomas Robinson's Description of Houghton, writing to his father-in-law Lord Carlisle on 13 December 1731. Robinson was architect of the west wing of Castle Howard.

33 Ibid.

34 Robinson says that it was Bridgeman who laid out 40 acres of Houghton, whereas Horace Walpole says the gardens were 23 acres and were laid out by Mr Eyre, an imitator.

35 J. Dixon-Hunt, *William Kent* (Zwemmer, 1987), p. 135.

36 Ibid., p. 46, quoting Sir Thomas Robinson writing to Lord Carlisle, 23 December 1734.

37 H. Walpole, op. cit., p. 536.

38 G. Clarke, 'The Gardens at Stowe', *Apollo*, June 1973, p. 562.

39 H. Walpole, op. cit., p. 536.

40 J. M. Robinson, op. cit., on Holkham and J. Dixon-Hunt, *William Kent*, op. cit., p. 51.

41 J. Walpole, op. cit., p. 539.

42 National Trust, *Wimpole*, op. cit.: Lady Grey describing the garden in 1753 under its new owner Philip Yorke, later first Earl of Hardwicke (see illustrations of Kip and Greenings plan), p. 5.

43 T. Whately, *Observations on Modern Gardening* (first pub. 1770; 3rd edn 1771), p. 145.

44 Sir W. Chambers, *Dissertation on Oriental Gardening* (printed by W. Griffin, 1772).

45 W. Mason, *The Poetical Works of the Author of the Heroic Epistle to Sir William Chambers* (1805; first pub. 1773).

46 A. Pope, op. cit., vol. 3, *Epistle IV*, p. 176.

47 J. Constable, *Correspondence VI*, ed. R. B. Beckett, vol. 12 (Suffolk Record Society, 1968), p. 98.

48 H. Walpole, op. cit., p. 527.

49 *The Rise and Progress of the Present Taste in Planting Parks, Pleasure Grounds and Gardens*, facsimile with introduction by John Harris (first pub. 1767; Oriel Press, 1970).

50 Sir N. Pevsner, *The Buildings of England: North, West and South Norfolk* (Penguin, 1962), p. 208, quoting John, Lord Hervey of Ickworth, author of *Memoirs of the Court of George II*.

51 M. Girouard, *Life in the English Country House*, op. cit., p. 231.

52 Ibid., p. 210.

53 C. Hussey, op. cit., p. 164.

54 M. Girouard, op. cit., p. 210.

55 P. Willis, op. cit., p. 67.

56 D. Green, *Blenheim Palace*, op. cit.

57 M. Girouard, *Life in the English Country House*, op. cit., p. 190.

58 *Passages from the Diaries of Mrs Philip Lybbe Powys* (ed. Emily J. Clemenson; Longman, Green, 1899), p. 197.

59 J. Dixon-Hunt, *William Kent*, op. cit., p. 135, plate 49: Hussey, op. cit., Plate p. 228 and p. 156.

60 W. Mason, *The English Garden, A Poem* (printed by A. Ward, 1777), Book 2, lines 175–80.

61 A. Pope, op. cit., vol. 3, *Epistle IV*, p. 176.

62 T. Whately, op. cit., p. 192–3.

63 Ibid.

64 Sir W. Chambers, op. cit.

65 J. W. von Goethe, *Elective Affinities* (first pub. 1809; Penguin Books, 1983), p. 138.

NOTES TO CHAPTER 7

1 R. Williams, 'Rural Economy and the Antique in the English Landscape Garden', *Journal of Garden History*, vol. 7, No. 1, 1987, p.88.

2 J. M. Robinson, op. cit., p. 129.

3 J. Macky, *A Journey Through England. In familiar letters from a gentleman here, to his friend abroad*, 3 vols, 1714–29 (vol. 1, 4th edn 1722).

4 J. Addison, op. cit., No. 57, 5 May 1711, p. 241.

5 Sir Thomas Robinson, 'Description of Houghton, 1731 in a letter to Lord Carlisle', (see chapter 6 above, note 32).

6 J. M. Robinson, op. cit., p. 123.

7 D. Green, op. cit., p. 246, quoting Thomas Hearne.

8 In some cases this was a matter of retaining an authentic ruin rather than creating a false one: in either case the intention was the same.

9 A. Rowan, *Garden Buildings* (Country Life Books, 1968), p. 3.

10 *Georgian Arcadias*, op. cit., p. 15.

11 T. Whately, op. cit., p. 145.

12 Quoted in P. Willis, op. cit., p. 121. Horace Walpole in a letter to Chute, 4 August 1753.

13 T. Whately, op. cit., p. 122.

14 D. Stroud, *Humphry Repton* (Country Life, 1962), p. 36.

15 T. Mowl and B. Earnshaw, *Trumpet at the Gate* (Waterstone, 1981), p. 31.

16 *East Anglia Magazine*, May 1980.

17 W. Hogarth, *The Analysis of Beauty* (London, 1753).

18 D. Garrick and G. Coleman, *The Clandestine Marriage*, (1766) Act II, Scene 2.

19 G. Carter, P. Goode and K. Laurie, *Humphry Repton, Landscape Gardener 1752-1818* (Sainsbury Centre for Visual Arts, 1982), p. 34.

20 P. Willis, op. cit. There were always exceptions like Chatsworth which remained open from the outset.

21 Ibid., p. 52.

22 G. Carter, P. Goode and K. Laurie, op. cit., p. 42.

23 Ibid., p. 42.

24 Ibid., p. 42.

25 Ibid., p. 34.

NOTES TO CHAPTER 8

Sources for the royal parks and Kensington Gardens in particular have been drawn extensively from the Land Use Consultants, *Historical Surveys of the Royal Parks*, prepared for the Department of the Environment (hereafter referred to as LUC Survey).

1 LUC Survey, *Kensington Gardens*, p. 20. The main enlargements to Kensington Gardens now measuring 275 acres were made in the first thirty years of the eighteenth century and apart from the extensions to the east were mainly taken from Hyde Park.

2 Ibid., Appendix 3, 'Outline Chronology', p. 113.

3 Ibid., pp. 113–14.

4 Ibid., p. 114, quoting '*New Works* in the Paddock', Sept. 1726–June 1728, as described by Charles Withers, the Surveyor General of His Majesty's Woods.

5 Ibid., p. 115, 25 March 1728. See also p. 31: Queen Caroline's instructions to plant 'about 1,195 standard elms already dead'.

6 Ibid., p. 115, quoting Work 6/114, f. 30. This was to lessen the noise from outside and give greater privacy.

7 Ibid., p. 115. The Long Water was deepened in order to get clay for forming the walls of the Round Pond.

8 P. Willis, op. cit., p. 96.

9 Ibid., p. 116, quoting *The Gentleman's Magazine*, April 1733, p. 206.

10 LUC Survey, *Hyde Park*, p. 11.

11 Ibid., p. 11. These plantings show on a plan attributed by David Green to Henry Wise in 1706.

12 Some sources attribute the name to the king's use of the road.

13 J. Larwood, op. cit., pp. 315–16.

14 G. Williams, *The Royal Parks of London* (Constable, 1978), p. 32.

15 J. Larwood, op. cit., p. 355.

16 Ibid., p. 380.

17 LUC Survey, *St James's Park*, p. 10.

18 P. Willis, op. cit., p. 96; J. Larwood, op. cit., pp. 100–1.

19 LUC Survey, *Kensington Gardens*, p. 113.

20 A. Saunders, *Regents Park* (Bedford College, 1969), p. 69.

21 LUC Survey, *Kensington Gardens*, p. 22.

22 LUC Survey, *St James's Park*, p. 7. Cosmo de Medici (1669) recounted how footmen and servants had had to wait at the gates of Hyde Park for their masters and mistresses while they rode round the Ring.

23 Ibid., p. 16.

24 LUC Survey, *Kensington Gardens*, p. 40.

25 N. Braybrooke, *London Green* (Victor Gollancz, 1959), p. 28. Braybrooke quotes Surtees: 'None of the great unwashed were to be seen in the Park in those days.'

26 LUC Survey, *Kensington Gardens*, p. 40.

27 S. Lewis, *Topographical Dictionary of England* (S. Lewis, 1899), p. 663.

28 *Westminster Review*, July–October 1841, p. 470.

29 Ibid.

30 Ibid.

31 A. Saunders, op. cit., p. 72: 'the Park was to be an entirety in itself ... for "the wealthy part of the Public".'

32 LUC Survey, *Green Park*, p. 9, quoting from 5th Report (1826: 368XIV, Treasury Papers).

33 *Westminster Review*, 1834, p. 502. Report from the Select Committee on Public Walks (Parl. Papers, 1833).

34 P. Willis, op. cit., p. 104, quoting *Letters of Baron Bielfeld*.

NOTES TO CHAPTER 9

1 *Westminster Review*, April 1834, p. 499.

2 *Hansard*, 21 February 1833, p. 1054.

3 M. C. Buer, *Health and Wealth and Population, 1760-1815*, (G. Routledge & Sons, 1926), p. 225.

4 Ibid., p. 230.

5 Ibid., p. 226.

6 G. M. Young, from 'Puritans and Victorians' in *Daylight and Champaign* (Jonathan Cape, 1939), p. 229.

7 *The Gardener's Magazine* (ed. J. C. Loudon; Longman, Rees, Orme, Green, first pub. 1826), p. 311.

8 G. E. Mingay, *Rural Life in Victorian England* (Heinemann, 1977), p. 29.

9 J. C. Loudon, *Cottage, Farm and Villa Architecture* (Longman, Brown, Green and Longman, 1846), p. 790.

10 J. Kay-Shuttleworth, *Public Education 1832–1839–1846–1862* in *Papers*, Vol. 2., (Longman, Green, Longman and Roberts, 1862), p. 11.

11 *Hansard*, 1837, pp. 383–4: Slaney referring to the Report on Manufacturing Employment, 1830; Factory Commissioners Report, 1833; Report on the Handloom Weavers, 1834.

12 *Hansard*, 1833, p. 1051.

13 A. Briggs, *Victorian Cities*, op. cit., p. 315. Quoting Arthur Morrison, *Tales of Mean Streets*.

14 *Hansard*, 1837, p. 386.

15 *DNB*, Supplement, 1901, s.v. *Sir Edwin Chadwick*.

16 *Gardener's Magazine*, 1826.

17 Ibid., 1830, vol. 6, pp., 529–31, 644: 'Notes and Reflections made during a tour of France and Germany in the Autumn of 1828'.

18 H. Walpole, op. cit., p. 544.

19 *Gardener's Magazine*, 1833, vol.9, p. 262, 'Tour'.

20 Ibid., 1829, vol. 5, p. 209.

21 *Westminster Review*, April 1834, p. 503.

22 N. Newton, op. cit., p. 240, quoting H. L. H. Pückler-Muskau, *Hints on Landscape Gardening*.

23 *Gardener's Magazine*, 1826, p. 310.

24 Ibid., vol. 9, 1833, 'Reflections on a Tour made in 1828', pp. 387–8. Lenné's observations were made on his visit to England in 1826. See note 23 above.

25 Ibid., 1829, vol. 5, p. 690. The Green Belt did not become official until an Act of Parliament was passed in 1938.

26 *The History of the Royal Victoria Park, Bath* (pamphlet published by the Bath Express and County Herald, 1872), p. 2.

27 Ibid., p. 3.

28 *A Brief Account of the Proceedings relative to the formation of the Royal Victoria Park at Bath* (B. Higham, 1831).

29 *The History of the Royal Victoria Park, Bath*, op. cit.

30 S. Hardwicke-Carruthers, *The Early Environmental Movement* (unpublished document).

31 *Bath Argus*, 6 August 1889. These conditions create doubt as to whether the park was really intended for all or only for the middle classes.

32 Attributed to the *Bath Herald*, n.d. but probably 1842, since it was a tribute on the twelfth anniversary of the opening of the park.

33 *Hansard*, 1833, pp. 1050–8.

34 Ibid.

35 Ibid.

36 Ibid.

37 *Report of the Select Committee*, 1833.

38 *Westminster Review*, April 1834, p. 511, criticising the Report for only suggesting walks.

39 Ibid., p. 513.

40 *Report of the Select Committee*, 1833, quoting a letter from Sir Arnold James of Sheffield.

41 Ibid.

42 *Manchester Courier and Lancashire Advertiser*, 10 August 1841.

43 W. W. Pettigrew, *City of Manchester. Handbook of the City Parks and Recreation Grounds*, (Town Hall, Manchester, 1929).

44 *Hansard*, 1835, p. 561.

45 *Hansard*, 1839, 'Enclosure Bills', pp. 470–2.

46 Ibid.

47 'Parks and Pleasure Grounds', *Westminster Review*, 1841, p. 420.

48 Ibid. Chadwick used the initials H. S.

49 *Hansard*, 1839, p. 442.

NOTES TO CHAPTER 10

1 *Gardener's Magazine*, 1836, vol. 12, p. 13.

2 Ibid., 1835, p. 657.

3 'Parks and Pleasure Grounds', *Westminster Review*, 1841, p. 429.

4 Ibid.

5 *Register of Historic Parks and Gardens*: 'Prince's Park' (Royal Commission of Historic Monuments).

6 *Hansard*, 1849, p. 1009. Question on 'Public Parks'. It was noted that £10,000 had been voted in 1841 for establishing public parks.

7 Ibid.

8 Ibid., H of L, 1841, p. 1068, 'Metropolis Improvement'. The Bishop also made the point that when their Lordships were discussing the amusements of the public they generally meant the upper and middle classes.

9 Ibid., H of C, 1841, p. 723.

10 Ibid., 1841, p. 25.

11 Ibid., 1842, p. 128.

12 *Report of Commissioners*, 1844, vol. XXIV, Commission for

inquiry into the State of Large Towns and Populous Districts.

13 *Illustrated London News*, May 1846.

14 *Hansard*, H of L, 1842, p. 1067. Viscount Duncannon, Chief Commissioner of Woods and Forests, referred to it as the Royal Park.

15 J. J. Sexby, *The Municipal Parks, Gardens, and Open Spaces of London* (Elliot Stock, 1898), p. 153.

16 J. McInniss, *Birkenhead Park* (unpublished typescript).

17 Ibid.

18 Dr H. Conway, 'Victorian Parks Part 1' (*Landscape Design*, No. 183, September 1989), cites Moor Park, Preston, as being the first municipal park by an enclosure of common land in 1833. However this was not landscaped as a public park until 1877, whereas Birkenhead was designed as such from the outset.

19 *Landscape into Cityscape* (ed. Albert Fein; Cornell University Press, 1968). Agitation for a public park in New York began in 1845 in an article by A. J. Downing.

20 *Gardener's Chronicle and Gazette*, 1844, p. 702.

21 *Manchester Courier and Lancashire General Advertiser*, 10 August 1844.

22 *The Times*, 14 October 1844.

23 Ibid., 1 November 1844.

24 Ibid., 31 October 1844.

25 Ibid., 20 November 1844.

26 The Town Improvement Clauses Act, 1847.

27 An Act for Promoting Public Health, 1848.

28 *The Finsbury Park Act, 1857* (Eyre and Spottiswoode, n.d.).

29 *Hansard*, 1842, p. 128.

30 *The Finsbury Park Act*, op. cit.

31 *The Garden Oracle*, 1896.

32 *The Finsbury Park Act*, op. cit.

33 *Gardener's Chronicle*, 19 September 1863, p. 894.

34 'People's Inheritance: The People's Park Conservation Area of Halifax' (Metropolitan Borough of Calderdale Amenities and Recreation Department, 1984).

35 *Hansard*, 1857, p. 235.

36 Ibid., 2nd reading of the Finsbury Park Bill, 1857, pp. 233–48.

37 *Gardening Year Book*, 1902.

38 Sir J. A. Picton in 1875. See *Memorials of Liverpool* (2 vols; E. Howell, 1907), vol. 2, pp. 430–1.

39 The Metropolitan Open Space Act was passed in 1887.

NOTES TO CHAPTER *11*

1 *Gardener's Magazine*, 1835, vol. 11, p. 652.

2 Ibid., vol. 11, p. 652.

3 C. H. Smith, *Parks and Pleasure Grounds* (Reeve & Co. 1852).

4 Edward Davis (1802–52).

5 Quoted in a pamphlet taken from the *Bath Express and County Herald*, 1872.

6 C. H. Smith, op. cit.

7 S. Parsons, *The Art of Landscape Architecture* (G. P. Putnam's Sons, 1915).

8 H. Repton, *Fragments of Theory and Practice in Landscape Gardening*, 1816.

9 T. L. Peacock, *Headlong Hall and Gryll Grange* (Oxford University Press, 1987), p. 15.

10 Quoted in *Gardener's Magazine*, 1841, vol. 17, pp. 157–164: 'On gardening as an Art of design and Taste by the late Thomas Hope'.

11 B. Elliott, *Victorian Gardens* (Batsford, 1986), pp. 60–1.

12 Prince Pückler-Muskau was born at Muskau (now Bad Muskau), in Germany in 1785. Having visited England where he saw the work of Brown and Repton, Pückler-Muskau laid out a park on his ancestral estate and became a strong supporter of Repton. In 1834 he published *Hints on Landscape Gardening* which included a chapter on his park.

13 J. A. Hughes, *Garden Architecture and Landscape Gardening*, (Longman, Green, 1866).

14 C. H. Smith, op. cit.

15 *Gardener's Magazine*, 1838, vol. 14, p. 423.

16 Ibid., 1830, vol. 6, pp. 31–2.

17 Ibid., 1833, vol. 9, p. 698.

18 C. Wainwright, 'Municipal Parks and Gardens', *The Garden*.

19 *Gardener's Magazine*, 1826, vol. 1, p. 336.

20 Ibid., 1840, vol. 16 1840, pp. 233 and 620.

21 B. Elliott, op. cit., p. 23, quoting Joshua Major in 1852.

22 *Gardener's Chronicle*, 1860, p. 49.

23 Ibid., 1843, p. 649.

24 Ibid.

25 *Gardener's Magazine*, 1826, vol. 1, pp. 12–13.

26 *Gardener's Chronicle*, 1843.

27 Ibid., 1843.

28 *Gardener's Chronicle*, 1859.

29 S. Hardwicke-Carruthers, op. cit., p. 29.

30 *Gardener's Chronicle*, 1859.

31 Ibid., 1861, p. 923.

32 Ibid., 1859, p. 726.

33 Ibid.

34 Ibid., 1865, p. 889.

35 Ibid., 1866, p. 879.

36 Ibid., 1866, p. 879.

37 D. Clifford, *A History of Garden Design* (Faber & Faber, 1962), p. 188, quoting Gertrude Jekyll.

38 *Gardener's Chronicle*, 1865.

39 B. Elliot, op. cit.

40 *Gardener's Chronicle*, 1865.

41 Ibid., 1864.

42 W. W. Pettigrew, op. cit.

43 Ibid.

44 *Manchester Courier and Lancashire General Advertiser*, 10 August 1844.

45 G. F. Chadwick, *The Park and the Town* (Architectural Press, 1966), p. 99. *Illustrated London News*, 20 August 1846, pp. 143–4 claims Queen's Park as the only park to have such playgrounds.

46 *Gardener's Chronicle*, 1863, p. 1131, and 1864, p. 123 (see plan).

47 *Gardener's Magazine*, 1841, vol. 17, p. 283.

48 *Hansard*, 1856.

49 *Hull, East Riding and North Lincolnshire Times*, 1 September 1860, p. 2.

50 *An Act for Establishing Cemeteries for the Interment of the Dead Northward, Southward and Eastward of the Metropolis by a Company to be called The London Cemetery Company, 17 August 1836* (PRO).

51 *Gardener's Chronicle*, 1847, p. 417.

52 *Gardener's Magazine*, 1843, vol. 19, p. 101.

53 J. C. Loudon, *Encyclopaedia of Gardening*, 1846, op. cit. (first pub. 1822).

54 *Gardener's Magazine*, 1843, vol. 19, p. 146.

NOTES TO CHAPTER *12*

1 W. W. Pettigrew, op. cit., p. viii.

2 I. Thompson, *Weekend Guardian*, 14 January 1989.

3 A. J. Rutledge, *Anatomy of a Park* (McGraw-Hill, 1971), quoting Olmsted.

4 W. W. Pettigrew, op. cit., p. 4.

5 Ibid., p. 4.

6 *The Bucks Herald*, 7 June 1990.

7 *Landscape and Urban Planning*, September 1989.

8 *Gardener's Magazine*, 1837.

9 B. Elliott, 'From People's Parks to Green Belts', *Journal of Landscape Design*, February 1988, pp. 13–15.

10 H. Teggin, 'No Time Like the Present', ibid., February 1988.

11 LUC Survey, *St James's Park*.

12 It will be interesting to see what effect the government's policy of compulsory competitive tendering will have on plans for the restoration and development of parks. Will it, as critics anticipate, bring fresh restraints and compromises and further frustrate the development of Burgess Park and other developments?

13 P. Neal, 'Parc de la Villette', *Landscape Design*, February 1988, p. 30.

14 R. Holden, 'New Parks for Paris', *Architectural Journal*, 12 July 1989, pp. 57–67.

15 R. Holden, 'Barcelona Revitalised', *Landscape Design*, Jan/Feb. 1988, pp. 60–64. In Barcelona the term 'Monumentalismo' is used to define the improvements to the city.

16 *Building Design*, 20 October 1989.

17 G. Brason, *The Ungreen Park* (Bodley Head, 1978), p. 9. Gillian Brason was a keeper in poor concrete parks and longed for a patch of grass. See p. 6.

18 Ibid.

19 A. Rutledge, op. cit.

20 Sir J. Bird, *London Parks and Open Spaces* (Hodder & Stoughton, 1924).

21 A. Rutledge, op. cit.

22 G. Chadwick, 'Birkenhead Park', *Landscape Design*, November 1989, pp. 16–17. A year later Birkenhead Park was designated a conservation area.

23 *Hampstead and Highgate Express*, 22 December 1989.

24 *The Independent*, June 1990. The pump is now to be placed underneath the roundabout at Shepherd's Bush.

25 I. Thompson, 'Grounds for Pleasure', *Landscape Design*, October 1988, p. 18.

26 P. Beckett, *Central Park Conservancy* (M.I.T. Press, 1987, quoting from the restoration plan).

27 *New York Times Magazine*, 26 April 1987.

28 J. T. Coppock and H. Prince (eds), *Greater London* (Faber & Faber, 1964).

29 S. Switzer, op. cit., vol. 1, p. 9.

30 *Wordsworth Poetry and Prose*, selected by W. M. Merchant (Rupert Hart Davis, 1969), p. 850, letter to Sir George Beaumont, 17 October 1805.

INDEX

Abney Park Cemetery 186
Addison, Joseph 52, 70, 74, 83–4, 86, 106, 201
Albury Park, Surrey 44
Aldous, Tony 192
Alfred's Hall 110
Alnwick Park 40
Anne, Queen 61, 71, 87, 119, 120, 122, 126, 127
Anne, Queen of Denmark 47
Arlington, Earl of 59, 60, 64
Arnold, Matthew 41
Ashbourne Park, Derby 166
Ashby Park 40
Ashdown Forest, E. Sussex 12
Ashdown Park, Berks., 74
Ashridge 142, 188
Assur 1
Aston Hall, Birmingham 166
Audley, Lord 29
Audley End 45

Bacon, Sir Francis 34, 35, 42–3
Bacon, Nicholas 27
Bad Muskau 141–2, 174
Baden, Duke of 184
Badminton 49, 66, 113
Barcelona 192
Barkewell 40
Baskerville, Thomas 60
Bath 146, 187
 Crescent Fields 146
 Royal Victoria Park 146, 148, 151, 168, 170
Bathurst, Allen, 1st Earl 110
Battersea Fields 161, 162
Battersea Park 135, 183, 184, 190
Beaufort, Duke of 66
Beaufort House, Chelsea 94
Beckley, Oxon 6
Bedford, Dukes of 70, 130
Berkeley, Lord 40
Berners, Dame Juliana 17
Bethnal Green 160
Bielfeld, Baron 134
Bigstock Great Park 40
Binney, Marcus 201
Bird, Sir James 193
Birdcage Walk 63
Birkenhead Park 162–3, 165, 170, 178, 186, 187–8, 197
Birmingham 150
Bishops Castle, Merdon 8
Blathwayt, William 70
Blenheim 85, 87–8, 89, 95, 98, 106, 107, 109, 113, 142, 170
Blois 23, 61
Bois de Boulogne 140
Boorde, Andrew 32, 34
Boston, Mass 198
Boughton, Northants 66
Bourchier, Archbishop Thomas 20
Bowood 50
Bradgate Park, Leicester 13, 20, 40

Brason, Gill 192
Bridgeman, Charles 72, 84, 88–93, 98, 116–17, 120–23, 125, 202
Bristol 150, 187
Broad Walk, Kensington Gardens 121
Brompton Park nursery 71, 84
Brookman's 188
Brown, Lancelot 'Capability' 32, 60, 95–7, 98, 111, 114, 118, 142, 170, 175, 180
Browne, Sir Thomas 73
Buckingham, Dukes of 29, 127, 128
Buckingham, James Silk 151–2
Buckingham House (later Buckingham Palace) 74, 127, 128, 140
Bunhill Fields 185
Burford, Janie 201
Burgess Park, London 190–91, 192
Burghley, William, 1st Baron 29, 30, 31, 34, 38, 39
Burghley House 29, 30, 76
Burke, Edmund 171
Burlington, Richard Boyle, 3rd Earl of 94, 109
Burstow 29
Burton, Decimus 131
Bushy Park 24, 39, 50, 65
Buxted 45

Calendar of Close Rolls 11, 13, 16
Calke Abbey 202
Callowdon 40
Calton Hill, Edinburgh 185
Calverley Park, Tunbridge Wells 131
Cambridge, Duke of 129
Camley Street, London 197
Carew, Robert 40
Carlisle, Lord 86, 87
Caroline, Queen 61, 63, 121, 122, 124, 125, 127, 128
Cassiobury, Herts 64, 188
Castle Donington, Leics 20
Castle Howard 86, 87, 95, 107, 109, 111
Catherine of Braganza 63–4
Caus, Isaac 47
Caus, Salomon de 47
Cecil, Robert 39, 47
Central Park, New York 163, 170, 197–8
Central Park Conservancy Trust 197
Chadwick, Edwin 138, 152, 158, 170
Chambers, Sir William 94, 95
Chambord 23, 61
Champs Elysées, Paris 140, 179
Charlecote 38
Charles I, King 39, 41, 42,

49, 50
Charles II, King 52, 61, 62, 63, 65–6, 74, 75, 76, 123, 124, 126, 128, 133
Chatsworth 70, 75, 94, 158, 159, 170
Cheney, Henry 38
Chenies, Bucks 29
Cheshunt Park 30–31
Chicheley, Thomas 60, 72
Chillington Park, Kent 190
Chirac, Jacques 192
Chiswick House 94, 109, 197
Cirencester Park 110
'City Mall' 35
Clagny 61
Claremont 113
Clarendon 8–9, 12, 38, 50
Clark, Lord 201
Claude Lorrain 80, 82, 98, 105
Clifford, Rosamund 14
Clifton Graveyard, Belfast 185
Cobham, Lord (see Richard Temple) 111
Cobham Park, Kent 60
Coke, Thomas 93
Coleridge, Samuel Taylor 14
Commissioners for the Improvement of the Metropolis 161
Commissioners of Woods and Forests 129, 162
Compton Hall (later Moor Park) 60
Compton Wynyates 38
Constable, John 96
Cook, Moses 64
Copenhagen Fields, London 150
Cornbury, Oxford 11
Cornwall, Dukes of 8
Countryside Commission 192, 201, 202
Cowper, William 179
Cranmer, Archbishop Thomas 29
Crescent Fields, Bath 146
Cromwell, Oliver 50
Crossley, Frank 165
Crystal Palace 177–8, 188
Cubitt, Thomas 111, 161
Cumberland 7, 22

D'Argenville, A.J. Dézallier 74, 88
Dartington 29
Davis, Edward 146, 168
Dean, Forest of 17, 52
Defoe, Daniel 42, 52, 61, 75
Delorme, Jean 2
Denney, Sir Anthony 27
Derby, Edward Stanley, Earl of 165
Derby Arboretum 157–9, 176, 177, 184
Devonshire, William Cavendish, 1st Duke of 70
Devonshire, William

Cavendish, 6th Duke of 159
Dipylon Gate, Athens 2
Dorset, Thomas Grey, 1st Marquis of 20
Dudley, Baron 13
Dyrham Park 5, 65, 70, 86

Ebury manor 29
Edensor 159
Edinburgh (The Meadows) 139
Edward I, King 6
Edward II, King 17
Edward III, King 9, 15, 105
Edward IV, King 20
Eleanor, Queen 14
Elizabeth I, Queen 27, 30, 31, 35, 36, 39, 42
Elmbridge Borough Council 201
Eltham 42
Ely, bishops of 20, 29, 47
Enfield 42
Enfield Chase 50
English Golf Union 189
English Heritage 197, 202
Englische Garten, Munich 142
Environment, Department of the 187, 191, 202
Eridge park 11
Esher Place 113
Essex, Earl of 64
Euston Hall, Suffolk 59, 64, 92, 99
Evelyn, John 38, 52–4, 58–9, 60, 62, 63, 64, 71, 82, 83, 188
Everswell 14
Exeter, Duke of 29

Fairchild, Thomas 75
Felbrigg 73
Fiennes, Celia 60, 70, 89
Finsbury Park 164–5
Florence 150
Foix, Gaston Phoebus, Comte de 17, 18
Fontainebleau 23, 64
Fordyce, John 130
Forestry Commission 13, 73
Fountains Abbey 8
Francois I, King 23
Frankfurt 141

Gaillon 23
Garrick, David 114
George I, King 120, 122, 123, 128
George II, King 61, 121, 124, 128, 129
George III, King 129
George IV, King (formerly Prince Regent) 105, 129, 130, 140
Gerard, John 31
Gibbs, James 92
Gibside, Tyne and Wear 198
Gibson, John 170, 183

Gillespie Park, London 197
Gilpin, William Sawrey 171, 202
Girouard, Mark 29, 97–8
Glasgow (the Necropolis) 185
Glass, Ruth 192
Goethe, Johann Wolfgang von 103
Golden Palace, Rome 4
Goldsmith, Oliver 98
Goodwood 188
Gorhambury, Herts 27, 42
Grafton, 1st Duke of 99
Greater London Council (GLC) 187, 197
Greece 1, 2, 86
Green Belts 192
Green Park 63, 76, 125, 127, 133, 149
Green Party 196
Greenwich Park 39, 42, 47, 52, 62, 83, 127
Groby 40
Groen, Jan van der 67
Grosvenor family 130
Gunton Park 202

Hackney Downs 150
Hagley, Worc. 109
Halifax (People's Park) 165
Hamilton, Charles 98
Hamilton Gardens, London 179
Hampstead Heath 143, 149, 164
Hampton Court 23–4, 29, 42, 50, 62–5, 70, 76, 177, 188
Hardwick 38
Hare Warren 50
Harley, Sir Edward 52
Harringworth Park 40
Harrison, William 27, 33, 36–7, 38
Harrogate 159, 187
Harrold Park 40
Hatfield manor 20, 29, 39, 47, 48
Hatton, Sir Christopher 31
Haussmann, Georges, Baron 191
Havering, Essex 14, 42
Hawksmoor, Nicholas 109, 113
Heemstede 70
Henderskelfe Castle 87
Heneage, Sir Thomas 31
Henry I, King 8, 12, 14, 20
Henry II, King 8–9, 14, 16
Henry III, King 6, 13
Henry VII, King 22
Henry VIII, King 23, 26, 29, 34–5, 36, 41, 42, 47, 48, 132
Henry, Prince of Wales 47
Hentzner, Paul 24
Herbert, Sir William 38
Hertford, Lord 32, 47
Heseltine, Michael 139
Het Loo 70

Heywood, James 163
Higham Ferrers 6–9, 11, 12
Higham Park 38, 50
Hill, Octavia 178
Hogarth, William 114
Holdenby 31, 32, 50
Holkham 93–4, 106, 113
Holland Park 197
Hollar, Wenceslaus 44
Home Park 89–92
Honing 111
Hope, Thomas 172
Hornsey House 165
Hornsey Wood 165
Horticultural Society 180
Houghton 92, 97
House Park 63, 64
Hull (People's Park) 185
Hume, Joseph 149–50, 152
Hunsdon, Herts 26
Hursley Park, Hants 12
Hyde manor 29
Hyde Park 29, 31, 41, 42, 45, 50, 62, 76, 119, 122, 123, 124, 127, 128, 132, 139, 140, 149, 163, 177–80, 190, 196

Institute of Leisure and Amenity Management 190
Institute of Park Administration 187
Institute of Parks and Recreational Administration 190
Irwin, Lady 86–7
Irwin, 9th Viscount 97

Jacques, David 77
James, John 74, 88
James I, King 18, 35, 39, 41, 43, 45, 47, 63, 75
Jardin des Plantes, Paris 140
Jekyll, Gertrude 180
Jellicoe, Geoffrey 201
Jervaulx, Yorks 8
John, King 16
John of Gaunt 12
Jonson, Ben 69
Jones, Inigo 42, 43, 94

Karlsruhe 184
Kay-Shuttleworth, J.P. 138
Kedelston 188
Kemp, Edward 170
Kenilworth park 40
Kennington Common 150, 161
Kensal Green 186
Kensington Gardens 76, 119–23, 127, 128–9, 132, 140, 141, 149, 177, 190, 196
Kensington Palace 74, 76, 124, 129
Kent, William 92–4, 99, 113, 122, 123, 125, 127, 142, 180
Kenwood 197
Kew Gardens 40, 95, 140, 179

Kimbolton 8
King's Somborne, Hants 12
Kip, Johannes 74
Kit-Kat Club 83
Knight, Gally 151
Knight, Richard Payne 118, 170, 172
Knole Park 20, 29, 188
Knowsley park 11

Lake District 171
Lambeth Palace 150
Lancaster, Earls of 8, 17
Lancaster and Pickering forest 17
Lancaster Great Park, Sussex 12, 50
Langley, Batty 113
Laud, Archbishop William 40
Laurentium 86
Le Nôtre, André 47, 53, 61, 62, 65, 66, 74, 80, 89
Leasowes, The, Shropshire 84–5
Leicester forest 40
Leland, John 11, 27, 29
Lenné, Peter Josef 142
Lewis, John 129
Lieven, Princess 129
Lincolnshire 8
Liverpool 138, 139, 150, 162; The Necropolis 185; Prince's Park 131, 159; St James's Cemetery 185; Toxteth Park 159
London, Bishop of 160
London, George 70–71, 84, 86, 88, 89, 94, 119
London County Council (LCC) 161, 166, 192
London Zoo 197
Long Walk, Kensington Gardens 177
Long Water, Kensington Gardens 120, 122
Longleat House 27, 71
Loudon, J.C. 75, 128, 138–46, 148–9, 157–8, 166, 167, 175–7, 180, 184, 186, 190, 192
Loughborough Old Park 40
Louis XIV, King 61, 65–6, 174
Louis XV, King 123, 174
Luxembourg Gardens, Paris 140
Lyttelton, Lord 109

Macky, John 105
Magdeburg, Prussia 142
Major, Joshua 176, 184
Mall, The, London 62–3, 75, 124, 125, 128
Manchester 137, 138, 149, 150, 159, 163, 187, 188; Heaton Park 166; Peel Park 164, 166, 168, 183, 184; Philip's Park 164, 183; Queen's Park 164, 183
Marble Hill, Twickenham 197

Markham, Gervase 32
Marlborough, Duchess of 98
Marlborough, John Churchill, Duke of 87, 88, 98
Marlborough House 128
Marly 61
Martin, Kit 202
Marvell, Andrew 69, 74
Marylebone Gardens, London 128
Marylebone Park 29–30, 42, 50, 127, 128, 129
Mason, William 95, 102
Metropolitan Board of Works 161, 164, 166
Middlesex 198
Mildmay, Sir Humphrey 41
Mile End Park, London 190
Millar, Sanderson 110
Milner, Edward 148, 170
Milton, Richard 11
Milton Abbas, Dorset 8
Mollet, André 47, 62, 64, 65
Mollet, Claude 47, 61, 62
Mollet, Gabriel 62
Mollet family 61
Montagne, 1st Duke of 66
Montbray, Geoffrey de 14
Montespan, Mme de 61
Moor Park, Herts 74, 188
Moor Park, Preston 148
Moorfields 35
Morris, William 180
Moryson, Fynes 39
Muralt, Béat de 74
Muswell Hill 178

Nash, John 124–5, 128, 130, 131, 180
National Sports Centre 188
National Trust 198, 202
Nesfield, Markham 180
Nesfield, William 180
New Buckenham castle, Norfolk 8
New Forest, Hants 52
New York 198
Neyte manor 29
Nineveh 1
Nonsuch 23, 24, 35, 42, 50
Norden, Sir John 32
Norfolk 12, 36, 40
Norfolk, Dukes of 40, 159
Normans 5, 6, 13, 14, 17
Northumberland 8, 22
Northumberland, 9th Earl of 37
Norwich 35, 150, 187; The Rosary 185
Nottingham 150
Nottingham House see Kensington Palace

Oatlands Park 42, 50
Oldham 159
Olmsted, F.L. 75, 163, 170, 188, 198
Ongar Great Park 5, 11
Osterley 38

Otford 29

Paddock, The, Kensington Gardens 119, 120–22
Painshill Park 98, 102, 201
Pairidaēza 1, 2
Palais Royal, Paris 140
Palmer, Robert 27
Parc de la Villette, Paris 191–2
Parc Monceau, Paris 183
Parham, Sussex 27
Paris, Matthew 15
Paxton, Joseph 159, 163, 165, 170, 177, 178, 183, 187
Peacock, Thomas Love 172
Peel, Sir Robert 177
Pembroke, 1st Earl of 27
Penshurst 29
Pepys, Samuel 52, 63, 66, 75, 193
Percy, William de, 8th Baron 6
Percy family 7, 8, 22
Père Lachaise 186
Persians 1–2, 73
Petit Trianon 61
Pettigrew, W.W. 188
Petworth, Sussex 6, 8, 33, 35, 37, 40, 76
Peyvre, Paulin 15
Philips, Mark 163, 183–4
Phoenix Park, Dublin 177
Pickering forest 40
Pipewell, Northants 29
Pitt, William 142
Pliny 1, 2, 47, 69, 86
Pliny the Younger 80
Poor Law Commission 138
Pope, Alexander 70, 82, 84, 85, 88, 96, 97, 102, 110
Portsmouth 159
Potsdam 142
Poussin, Nicholas 80
Powys, Mrs Lybbe 98
Preston 159
Price, Uvedale 118, 170, 171, 172
Primrose Hill 149–50, 152, 161
Pückler-Muskau, Prince 141–2, 174
Purchas, Samuel 14

Queen's House, Greenwich 43

Radnor, Earl of 60, 66, 82, 94
Ranelagh Gardens, London 128
Rannes, Roger de 18
Ravenscourt Park, Hammersmith 166
Regent's Park, London 30, 128, 129–31, 150, 159, 160, 170, 175, 176, 180, 192, 197
Repton 188
Repton, Sir Humphry 32, 111, 114, 116, 117–18, 130, 139, 170–74, 202
Richmond, Surrey 174, 197
Richmond Palace 22
Richmond Park 39–40, 42,

47, 121, 127, 129
Rinz, Jacob 142, 172, 175
Rivers, Lady 146
Robinson, Sir Thomas 92
Robinson, William 183
Rocque, John 125
Rodney, Sir John 38
Roebuck, John Arthur 146
Roehampton Estate 40
Romford, Count 142
Romuald, Archbishop of Salerno 14
Rosa, Salvator 98, 171, 172
Rotten Row, Hyde Park 76, 120, 124, 128, 179
Round Pond, Kensington Gardens 120, 121, 122
Royal Botanic Society of London 130
Royal Society for Scientific Enquiry 52–3
Ruskin, John 178
Russel, Lord 29
Russell, John, 1st Earl 164

St Albans, Abbots of 64
St James's Park, London 14, 29, 42, 53, 62, 63, 74, 75, 76, 123–8, 132, 133, 134, 149, 177, 190
Sale Manor 50
Salford 150, 164
SAVE Britain's Heritage 201
Saxton, Christopher 32
Sayes Court 52
Sckell, Louis 142
Seaton Delaval 88
Sedgwick Park 50
Select Committee on the Health of Towns 159
Semiramis 1
Sennacherib 1
Serpentine, Hyde Park 120, 122–3, 127, 177, 179
Shaftesbury, Anthony Ashley Cooper, 3rd Earl of 77, 80
Shang-Lin Park 2
Sheen 22
Shenstone, William 84
Sheriff Hutton castle, N. Yorks 8
Shirley, John 41
Shrewsbury 35, 150
Sicily 5, 6, 13, 14
Sidmouth, Henry Addington, 1st Viscount 174
Sidney, Sir Philip 29
Slaney, Robert 139, 149, 152, 159, 166
Smith, Charles 167, 170, 175
Smythson, Robert 48
Soane, Sir John 168
Somerset House 47, 150
Sorbière, Samuel 47
Souche, Lord 29
South Carriage Drive, London 76
Southwark Council 191
Spitalfields 160
Sports Council 189
Ssu-ma Hsiang-ju 2

Stoke Moor Park 38
Stoke Poges 188
Stowe 88–94, 98, 111, 113, 121, 123, 188, 202
Stowe Ridings 89
Strong, Roy 47
Strutt, Joseph 157, 158, 159
Sudbrook 188
Sudeley Park 40
Suffolk, Earl of 45
Summerson, Sir John 30
Sunderland 159
Surrey 42
Sussex 7, 22, 42
Sutton Coldfield 41, 42, 150
Sutton Court 94
Switzer, Stephen 32, 70, 77, 82, 84, 85–6, 91, 97, 201
Sydenham 178

Tacitus 4, 80, 86
Talman, William 65, 86
Tankervaille, Lord 60
Temple, Sir Richard Bt. 89
Temple, Richard (son of Sir Richard) 1st Viscount Cobham 89, 90
Temple, Sir William 60, 70, 74, 84, 188
Temple Gardens, London 150
Temple Newsam, Leeds 97
Thames Water Company 197
Theobalds 30, 31, 39, 42, 47, 48, 50
Thomas, Keith 60
Thomas Hoyle and Sons 163
Thynne, John 27
Tiglath-Pileser I, King 1
Tiverton, Devon 11
Toddington 38
Toley 40
Tower Hamlets 160
Tradescant, John 47
Trianon 61
Tring Park, Herts 190
Tschumi, Bernard 191
Tuileries 47, 62, 140
Tuscany, Grand Duke of 58
Tusculum 86
Twici, William 17
Twickenham 84
Twickenham Park 60
Tyburn manor 27

Up Park 60
Upper St James's Park 63

Vanbrugh, Sir John 86–90, 92, 93, 95, 107, 109, 111, 120
Vatican Belvedere 23
Vaux-le-Vicomte 53
Vauxhall Gardens 128
Versailles 61, 66, 88, 94, 178
Verulam House 43, 188
Vesey, Bishop John 41–2, 150
Victoria, Queen 63, 148, 157, 160, 163, 179
Victoria and Albert Museum 198
Victoria Park, London 135, 160–61, 164
Villa d'Este 23

Virgil 1, 70, 96
Virginia Water 105
Volary Garden, Whitehall Palace 63
Vyne, The 38

Waller, Edmund 63
Walpole, Horace 80, 92, 93, 96–7, 111, 122, 140
Walpole, Sir Robert 92, 105, 106, 127
Waterloo Park, Highgate 166
Webb, Colonel William 50
Wedgenocke park 40
Westmoreland, Earl of 39
West Wycombe Park 102
Weymouth, Lord 71
Whately, Thomas 94, 102, 111
Whitehall Palace 63
Whitehall Park 29
Whitestaunton 6
William I, King 20
William III, King 65, 67, 70, 74, 76, 124, 132–3
William and Mary 64, 70, 71, 76, 119, 120, 121
William the Conqueror 14
Williamson, Dr 37
Willistrop, Guy 38
Willoughby, Sir Francis 48
Wilson, Sir John Maryon 164
Wilton 38, 44
Wilton manor and abbey 27
Wimbledon 29
Wimpole, Cambs 45, 60, 66, 72, 82, 94, 110
Winchester, Earl of 13
Windham, William 71–2, 73, 142
Windsor Castle 35
Windsor Park 12, 38, 42, 140; Great 50, 105; Little 50
Wise, Henry 70, 71, 84, 86, 88, 89, 94, 95, 119–20, 121, 125
Woburn 70, 142
Wollaton 38, 48, 183
Wolseley 13
Wolsey, Cardinal Thomas 23
Woodstock 12, 14–15, 62, 87
Woodstock Manor 87
Wootton, John 105
Worcester Lodge 113
Wordsworth, William 171, 201
Wothorpe 29
Wotton Lodge 12
Wren, Christopher 64, 65
Wren Alcove, Kensington Gardens 120
Wright, William 110

Xiangru 2

Yates, Richard Vaughan 159
York, Richard, Duke of 26
York, 2nd Duke of 17, 18
York House, Westminster 160
Yorkshire 7, 22
Young, G.M. 137

Zoological Society 130